COLOUR IN
TURNER
POETRY AND TRUTH

John Gage

STUDIO VISTA LONDON

For Flora
who did not believe a word
and Lynda, who did

Figures in bold type
in the text and notes refer to plate numbers in this book.

ABBREVIATIONS

BM — British Museum
G. & L. — T.Girtin and D.Loshak *The Art of Thomas Girtin*
NG — Turner Bequest (National Gallery)
R — W.G.Rawlinson *The Engraved Work of J.M.W.Turner* 1908/13
 Turner's Liber Studiorum 2nd ed., 1906
PRA — President of the Royal Academy
RA — Royal Academy
R. & B. — John Rothenstein & Martin Butlin *Turner* 1964
TB — Turner Bequest (British Museum)
TG — Turner Bequest (Tate Gallery)
V. & A. — Victoria & Albert Museum

ERRATA

plate 10, *The Burning of the Houses of Lords and Commons*, has been printed in reverse

page 244, note 104, the watercolour referred to was *not* in fact reproduced in reverse

© 1969 John Gage
First published 1969 by Studio Vista Limited
Blue Star House, Highgate Hill, London N19
Set in 11 pt Baskerville, 1½ pt leaded
Illustrations printed in Italy by Amilcare Pizzi SpA, Milan
Text printed by Richard Clay (The Chaucer Press) Ltd
Bound in Great Britain by Richard Clay (The Chaucer Press) Ltd, Bungay, Suffolk
SBN 289 79560 5

Contents

The colouring . . . which the artist infuses into, no less than that with which he clothes and surrounds his figures, is by no means arbitrary or local, or merely a matter of conformity to the natural object, or a sensible satisfaction to the eye; but has also in its ultimate view a rational and moral reference, dependent on the subject and sentiment intended to be conveyed . . . There is *the ideal* in colouring as well as in forms, which belongs to the perfection of beauty and sentiment, which are chief objects of attainment to the painter, and that to which the philosophic minds of the Greeks aspired.

GEORGE FIELD *Chromatics* 1845, §§277–8

Preface

Turner, like Raphael and Rembrandt, is an artist whose reputation is firmly established, whose work is in the main well known and readily identifiable, but whose artistic personality has remained almost entirely obscure. The understanding of his personality has diminished since his death, as may be quickly appreciated by turning from the five volumes which Ruskin gave to Turner in *Modern Painters* (1843–60), and which are still the most rounded and sympathetic treatment of his art, to the brief essays by Michael Kitson (1964) and Lawrence Gowing (1966), and the notes and articles by Professor Ziff which are, together, the most perceptive modern contributions to this understanding. The most substantial of the recent studies, from Falk (1938) and Finberg (1939/1961) to Lindsay (1966), have concerned themselves almost entirely with Turner the man, and are sadly uneven when dealing with him as an artist. I hope in this book to relate one aspect of Turner's art to his career, to trace some of the characteristics of his style to developments in his activities as student, tourist and teacher, and to set these activities in the context of the art-life of his times, on the Continent as well as in England. In no aspect of his work is this more necessary or more appropriate than in his practice as a colourist, which, though rarely overlooked, has often been misinterpreted.

These studies, which were originally prepared as a doctoral thesis in the Courtauld Institute of Art, University of London, are in many respects premature. Turner left perhaps the bulk of his work, paintings and drawings, to the nation in the Turner Bequest, now divided between the Tate Gallery, the National Gallery and the British Museum; but aids to the study of this Bequest are still very incomplete. The oils in the Tate and National Galleries have never been fully catalogued (catalogues of all the Turner oils, within and without the Bequest, are currently in preparation by Mr Martin Butlin and Mr Evelyn Joll); and Finberg's Inventory of the nearly 20,000 drawings in the British Museum (and a selection on loan to the Tate Gallery and the Victoria and Albert Museum), although the indispensable basis for all Turner studies, becomes increasingly less reliable and complete as it deals with the later period of Turner's activity, where the author's interest and his stamina waned. Most important, perhaps, the Turner manuscripts and manuscript annotations to his books, extensive and difficult to decipher and interpret as they are, have never been comprehensively studied or related to his art, although they have long been placed at the disposal of scholars by the artist's family, and are now lodged mainly in the British Museum. The Turner correspondence,

which promises to be both extensive and fruitful, has never been collected, although this work is now in hand.

The neglect of Turner's writings, until the very recent work of Professor Ziff and Mr Lindsay, is one of the most substantial gaps in the appreciation of the artist's personality, for Turner was essentially an intellectual, even if an intellectual *manqué*. His reading was informal, but wide, and even the misunderstanding of what he read bore rich fruit in his work. His elliptical, essentially synthetic intelligence is revealed most clearly in his literary habits, and the almost obsessive readiness to associate ideas; but it is also, as Ruskin recognized in a brilliant analysis of his sketching methods, one of the most constant characteristics of his art as a painter. This consideration must give a new emphasis to the conceptual aspect of his mind and method, and to the element of teaching in his career. In the case, for example, of the Italian tour of 1819, which has always been regarded as a turning point in his use of colour, a consideration not only of the extraordinary sophistication of the Italian sketches, which can hardly have come entirely unprepared, but also of the development of Turner's ideas in the 1810s, makes it possible to account more convincingly for their revolutionary quality. Here a feeling for the rich and varied qualities of light and atmosphere, which is already clear in the range of Rhineland drawings two years earlier (it is now possible to compare both types of drawing in the excellent plates of Martin Butlin's *Turner Water-colours* [1962]), was developed in relation to the concern with the status of the primary colours of light, which had arisen in Turner's series of Academy lectures in 1818. Theory and practice were directly related. Here Turner's colour was decisively affected by his study of the truths of contemporary science; earlier, and again later, it was shaped by his response to readings in eighteenth-century and contemporary poetry. His was a literate, sometimes a thoroughly literary, artistic intelligence.

Even a very summary survey of nineteenth-century memoirs and published correspondence has shown that the biographical material on Turner so far gathered by scholars is very partial, and that even well-indexed sources like the Library Edition of Ruskin's *Works* or the typescript of Farington's *Diary*, housed in the British Museum Print Room (the *Diary* is to be published unabridged under the editorship of Dr Kenneth Garlick), have been used only in the most piecemeal way. Turner's fame as a painter and his reputation as an eccentric made him a subject of very general interest, and it is likely that much more biographical information remains to be uncovered in letters and diaries. The list of sources at the end of this book is in no sense a complete bibliography, but gives simply the limited material used in the present work.

In spite of the very imperfect historical tools at my disposal I have decided to release these studies now because they do at least demonstrate the very wide front in both English and European art on which Turner's art must be approached. They will, I hope, serve as something of a corrective

to the too exclusively formalistic appreciation of this art characterized by the exhibition, *Turner: Imagination and Reality* held at the Museum of Modern Art in New York in 1966, whose antecedents I have sought to outline in an Epilogue. I have tried to relate Turner's formal inventiveness and his economy of means (which was so exciting to Signac, and remains so to us) to the development of his method and teaching: it has little to do with the aesthetic programme of symbolism and sentiment which he proposed in his writing and conversation and carried into his finished works. To reconcile the two in relation to colour has been the chief object of these studies. I have kept the number of illustrative examples to a minimum: the exploration of the richness of Turner's art is, I believe, only just beginning, and would need a far more generous framework than this. I hope to have indicated some of its range.

In the introductory chapter I have outlined the English and European background to Turner's colour interests, which has been very generally neglected by art-historians and by historians of science. Dr G.E.Finley has recently made the first attempt to relate this background to Turner, but he has limited his scope so much as to make his article (*Journal of the Warburg and Courtauld Institutes*, 1967) incomprehensible, and very far from an appreciation of Turner's real concerns. The general problem of treating colour in the history of painting is aggravated by the lack of a developed language of analysis, and a method based dominantly on the black-and-white photograph. Adequate colour-reproductions are unobtainable photographically, since all colour film tends to exaggerate the warm tones, and block-making often pushes the imbalance in the same direction. Colour perception is often radically affected by the reduction in scale in reproduction. This is not to say that colour-plates do not have a value as reminders of the original. Formal analysis has its own pitfalls, which are multiplied in the case of colour, for colour-memory is fickle and the terms of reference are notoriously vague. Two recent students of Delacroix's *Liberty Leading the People* (Louvre) reached opposite conclusions about its coloration: one saw it as exceptional in the painter's development as a colourist, in its return to the earthy palette of Géricault; the other saw it as a contrast to Géricault's chiaroscuro interests in the chromatic complementaries used in the figures of the dead. In the present book I have kept the description of the colour-organization of specific paintings to the fewest possible cases and to the most general terms. This is perhaps the more excusable in that Turner's work is generally accessible and well known. These studies are in every sense historical rather than critical, although I hope they may provide some of the bases for a more rounded Turner criticism.

My catalogue of indebtedness is a long one, and I have tried to cite specific borrowings in the notes. No Turner student could survive without the continued generosity and kindness of Mr and Mrs C.W.M.Turner, who have made the Turner Library and MSS in their possession available for study. Mr Edward Croft-Murray, Mr R.Williams, Mr R.Ralph and the

9

staff of the British Museum Print Room; Mr Martin Butlin, Professor Lawrence Gowing and Mr Leslie Parris at the Tate Gallery have offered stimulus and every facility for work in their collections; and Mr Evelyn Joll has generously provided access to many works in private hands. Mr Hutchison and Miss Parker of the Royal Academy library have put much MS material at my disposal, and the Academy Council has given permission to quote from it. Mr D.G.C.Allen of the Royal Society of Arts and Miss Dorothy Stroud of Sir John Soane's Museum have helped me to consult and use manuscripts in their collections, and the Syndics of the Fitzwilliam Museum, Cambridge, have allowed me to quote the Turner letters to Miller and other unpublished material in their possession. Messrs Christie, Manson and Wood have given me access to their collection of marked catalogues; and Her Majesty the Queen has graciously permitted the quotation of unpublished portions from the Farington *Diary*. Mr Dudley Snelgrove and the Paul Mellon Foundation have generously supplied information and funds for research, which has also been considerably eased by the Central Research Fund of the University of London and the Elmgrant Trust.

I owe an especial debt of gratitude to Michael Kitson, who watched over these studies with sympathetic criticism from their beginnings. Many of my attitudes to Turner and his background have been shaped by conversations with Conal Shields and Hardy George over several years. They both read sections of the text in draft, and Conal Shields has generously checked my transcriptions from the Turner MSS in the British Museum, although the readings I have adopted from these often debatable texts are my own. Other sections of my MS were read and criticized by Dr Robert Ratcliffe, Mr Stephen Rees Jones, Mr Michael Wilson and Mr Ralph Brocklebank. I have been helped to tighten many slack arguments and expand many oblique references by the sustained curiosity and incredulity of Lynda Price and Flora Dutton, whom I must finally affront with a dedication.

J.S.G.
Mannington, October 1968

Introduction: the setting

During the lifetime of J.M.W.Turner (1775–1851) the study of colour in painting underwent one of the profoundest revolutions in the history of western art. In 1672, Roger de Piles, the chief supporter of Rubens in France, had written, in his *Dialogue on Colouring*:

> During the all-but three hundred years since the revival of painting, we can hardly reckon half-a-dozen painters who have coloured well; and yet one could list at least thirty who have been outstanding draughtsmen. The reason for this is that drawing has rules based on proportion, on anatomy, and on a continual experience of the same data; whereas colouring has as yet hardly any well-known rules, and, since the studies made have differed according to the different subjects they treated, no very precise body of rules has yet been established.[1]

The lament became axiomatic within and without France until about 1800; but by 1830, a pupil of Jacques-Louis David, Merimée, was prepared to question its validity. 'If,' he said, 'mere study could produce an able designer, the same process might equally well produce a fine colourist.'[2] Shortly after Turner's death, Charles Blanc, one of the earliest biographers of Delacroix, asserted confidently the direct contrary of De Piles' view:

> Not only can colour, which is under fixed laws, be taught like music, but it is easier to learn than drawing, whose elaborate principles cannot be taught.[3]

Critics and artists were most vocal in France, the home of academic formulation, but the conditions which allowed this revolution to take place were chiefly established in eighteenth-century England. They rested on a reversal of the traditional aesthetic attitude which regarded colour as a minor element in painting, separable from and opposed to form; a readiness to regard scientific discoveries as relevant to art; and the formulation of a scientific colour-theory accessible to painters. These developments were closely interrelated, and fostered in their turn an approach to the problem of painting, as opposed to drawing, in art-training, that was at once more practical and more theoretical than had been common in the academies of the seventeenth and earlier eighteenth centuries.

The late arrival of painting schools in these academies has often been remarked. In France, although David had developed the general practice of painting in the life-class, there was no agreement among his followers about the relationship of drawing to painting in an artist's study; Gros continued to base his teaching on drawing, while Girodet wanted his

students to paint from the start.[4] In England, the first two Presidents of the Royal Academy had advocated painted studies; but no painting school was instituted there until 1815, when pictures by Old Masters began to be borrowed for copying from the Dulwich Gallery. Turner was appointed as one of the first Visitors to this school.[5] It was not, therefore, until about 1800 that colour-theory began to be a serious issue in the teaching of art; before then it had concerned only a few very exceptional painters like Leonardo da Vinci or Rubens, at moments when their aesthetic seemed to be taking a scientific turn.

Leonardo's remarks on colour, perceptive as they invariably are, do not constitute a complete theory; his approach was empirical rather than theoretical; and his much-publicized preference of chiaroscuro values to chromatic values, of light over colour, and his attack on the bright and barely-modulated pigments of the more old-fashioned colourists, generally had the effect of diverting painters' attention from colour problems until the eighteenth century.[6] He and his contemporaries inherited from Antiquity only a very piecemeal account of the nature of colour, whose complexity, according to the most complete text, the pseudo-Aristotelian *De Coloribus*, defied any clear idea of study or practice:

> We do not see any of the colours pure as they really are, but all are mixed with others; or if not mixed with any other colour they are mixed with rays of light and with shadows, and so they appear different and not as they are. Consequently things appear different according to whether they are seen in shadow or in sunlight, or in a hard or soft light, and according to the angle at which they are seen and in accordance with other differences as well. Those which are seen in the light of the fire or the moon, and by the rays of a lamp differ by reason of the light in each case; and also by the mixture of the colours with each other, for in passing through each other they are coloured; for when a light falls on another colour, being again mixed by it, it takes on still another mixture of colour . . .[7]

On the two questions of primary importance to artists, the number and nature of the basic colours used in mixing, and the harmonious or disharmonious effect of their juxtaposition, classical authors had little to say. Or, rather, they said too much. Aristotle proposed seven *or* eight fundamental colours, including black and white, in his *De Sensu et Sensili*, but in his rainbow he had only three: red, green and blue.[8] Neither Alberti nor Filarete, Leonardo nor Lomazzo among Renaissance theorists followed one scheme consistently, nor were they prepared to justify their choices experimentally.[9] Rubens, it may be assumed, took over the five-colour system of his friend François d'Aquilon; although his own *Treatise on Light and Colour* has disappeared, and on the basis of the surviving eighteenth-century interpretations it is possible to reconstruct only a general idea of some parts of it.[10]

12

How far the general uncertainty about the primary colours affected Renaissance and post-Renaissance views of colour-harmony may be illustrated briefly by the fate of the classical story about the limited number of colours chosen by the best masters—Pliny's account of the four colours used by Apelles and his colleagues:

> When I consider so many colours, and those so variable, as be now adaies in use, I must needs enter into the admiration of those artificers of old time; and namely, of *Apelles, Echion, Melanthius* and *Nicomachus*, most excellent painters, and whose tables were sold for as much apeece, as a good town was worth; & yet none of these used more than four colours in all those rich & durable works: And what might those be? Of all whites, they had the white tripoli of Melos; for yellow ochres, they tooke that of Athens; for reds, they sought no farther than the red ochre or Sinopie ruddle in Pontus; & their black was no other than ordinarie vitrioll or shoemaker's black.[11]

Unlike Pliny's other story of the dark toning varnish used by Apelles, this account seems to have found almost no echo in Renaissance art-theory, because it was irrelevant to artistic practice and was not supported by optics. Only in the nineteenth century was it taken up very widely among painters and scientists (Turner copied the passage from Holland's version of Pliny), in spite of new historical evidence against its authenticity, and interpreted in terms of the three-colour theory of the harmony of the primaries red, yellow and blue.[12]

This harmonic theory was elaborated towards the end of the eighteenth century by the entomologists Ignaz Schiffermüller in Vienna and Moses Harris in London, who demonstrated the 'complementary' nature of the three primaries and three secondaries, red–green, yellow–violet, blue–orange, and sought to make them the basis of harmonic colour relationships in painting.[13] Their conclusions were strengthened in the 1780s and 1790s by the physiological researches into coloured after-images by Robert Waring Darwin, and into coloured shadows by Benjamin Thomson, Count Rumford, which tended to show that the eye 'demanded' a complementary juxtaposition of colours, and induced it automatically when one colour was looked at for some time.[14] The complementary colour-circle of six colours, based on these researches (56) became standard equipment for the painter around 1800: Philipp Otto Runge in Germany, Delacroix in France and Turner in England are only the best-known artists to become interested in the scheme, which was published in many treatises and lectures.[15]

The six-colour harmonic arrangement, in which a primary colour became harmonious when juxtaposed with its complementary, which was made up of a mixture of the two remaining primaries, superseded an older, seven-colour theory, based on the Newtonian spectrum, which had always proved troublesome to artists, who knew empirically that the basic

colours were simply red, yellow and blue.[16] Newton himself had related these seven colours to the harmonies of the seven notes in the musical scale,[17] and the increasing application of musical terminology to colour throughout the eighteenth century implied the greater precision of Newton's discovery of a measurable value for each of the primaries.[18] The theory was given the natural authority of the supposed seven colours in the rainbow, and in the name of 'nature' it was pursued most tenaciously in England by Benjamin West, in the face of the new three-colour doctrine. West sought to show that Raphael in his Cartoons had followed the harmonies of the rainbow in his disposition of colours, and in his dogmatism he appears to have carried with him Henry Fuseli, Professor of Painting at the Royal Academy.[19] Neither painter was a particularly distinguished colourist.

From Newton, colours had acquired fixed values which made them capable of being seen as proportionate among themselves, whether musically or otherwise; and it was this capacity for, as it were, formal relationships which made colour for the first time accessible to aesthetics. Kant, who has generally been described as sensitive only to form, saw that the scientific and musical approach to colour was one which gave possibilities for real aesthetic judgements, since it offered, in effect, '*an estimate of form* in the play of a number of sensations'.[20] The Lockeian distinction between the primary quality of form and the secondary quality of colour was itself eroded early in the eighteenth century, as far as vision was concerned, by Bishop Berkeley, who re-emphasized the mediaeval proposition that the eye sees 'only diversity of colours' and no form.[21] Goethe made this proposition the whole basis of painting:

> We now assert, extraordinary as it may in some degree appear, that the eye sees no form, inasmuch as light, shade and colour together constitute that which to our vision distinguishes object from object, and the parts of an object from each other. From these three, light, shade and colour, we construct the visible world, and thus, at the same time, make painting possible, an art which has the power of producing on a flat surface a much more perfect world than the actual one can be.[22]

Not that the adaptation of optical theory to the needs of artists was ever a simple operation. The physicists studied, in the main, light transmitted through the prism; the painters, light reflected from their pigments; and long before Turner there was an awareness that, in some respects, the colours resulting from the two processes were not the same.[23] But no painter was prepared to accept the conclusions of Wünsch in Germany that the 'primary' colours of light (i.e. the smallest number which would mix to make white light), as opposed to pigments, were not red, yellow and blue, but red, green and violet; nor Thomas Young's proposal that this new triad also constituted the 'primaries' of colour-perception, since the

eye possessed a set of receptors sensitive to each.[24] Even after the validity of these theories had been substantially established about the middle of the nineteenth century by Helmholtz and Maxwell, they did not become relevant to artists. Nor were painters ever with their materials able to match the 'ideal' prismatic colours of the scientist, on which the harmonic theory was based. George Field, the English colourmaker and philosopher who did much to improve the purity and range of pigments in the nineteenth century, confessed that three 'primaries' could never be adequate for the painter anxious to maintain purity in both lights and darks.[25] Even overlooking this practical difficulty, the exact numerical and harmonic proportion of one colour to another, outside the artificial situation of the spectrum and the rainbow, had not been ascertained, and continued to preoccupy some artists.[26] It was, furthermore, remarked that the complementary colour-circles offered by Harris, Goethe and others were misleading, since in coloured after-images the induced colour was very much weaker than that which caused it, whereas their diagrams presented them as of equal strength.[27]

In the face of such theoretical and practical problems many painters turned away from the complexities of colour, claiming that they were a waste of the artist's time.[28] But a growing belief that painting, and especially landscape painting, should not only embody the fruits of a penetrating study of the natural world, but should also present the truths about this world as exposed by science, prevented the discoveries of eighteenth-century optics, which themselves claimed to be so relevant to painting, from being long ignored in art. If they were hardly touched by physical optics, artists were very much concerned with the newer discoveries of physiological optics, for these had a great deal to say about artistic perception and spectator response. Through a study of the workings of the external world on vision, painting could become the 'second nature' of the Kantian aesthetic, even more perfect, as Goethe put it, than the first.[29] On the one hand, paintings were themselves recognized as objects in nature, subject to natural laws of lighting and colour, and to be related very consciously to their surroundings. This was the outlook which passed from the interior decorators to the easel painters in the generation of Reynolds and Gainsborough, David and Delacroix, and Caspar David Friedrich.[30] On the other hand, natural laws could provide the subject-matter of paintings, often through figurative allegories derived from Greek poetry: Girodet in France, himself an enthusiastic student of landscape, and author of some of the freshest French landscape sketches before Corot, turned in this direction; and in Germany, Philipp Otto Runge used the idea specifically in the interests of colour.[31] It is against this background that we must study the work of Turner, for from both traditions he took his fill, and in combining them produced one of the most original contributions to Romantic art.

Part I Practice

'It is the art obtained by the practice in each art that can truly be called Art' [1]

1 Turner's training in watercolour and oil

'The only secret I have got is d—d hard work.' [2]

I

Turner's practice as a colourist in his maturity was so startling to his public, that critics were led to attribute it to an obsession with pigments for their own sakes, or, in an even more positivist vein, to a developing physical defect in his eye.[3] For his professional colleagues the alchemy was at once more deeply mysterious, and more readily to be interpreted as the result of some curious and wholly personal technique. The vacuum left by the breakdown of the apprentice system in painting towards the close of the eighteenth century had been imperfectly filled by a plethora of rumoured 'secrets' from living artists and from the Old Masters;[4] and it is hardly surprising that such mysteries surrounded the virtuosity of Turner from an early date.[5] But if the painter had 'secrets', they have remained so. All that can perhaps be said is that, in a period when the most complicated recipes were given by and expected among artists—Ozias Humphrey's notebooks in the British Museum, and West's and Loutherbourg's lengthy confidences to Farington are only among the most conspicuous examples[6]—Turner's hints, which survive mainly in Farington and in notes by his friend, the young Trimmer, from about 1811, must have seemed ungenerous, not to say obscurantist. Yet the remarks themselves do not give this impression; and they may, I think, be interpreted in a very different light. Turner's confession to Trimmer that 'no one could tell if a method would answer, as he would be dead before it could be proved',[7] and his declared incapacity to understand the procedure of Claude, suggest that his closeness was not the result of general uncommunicativeness, but was an admission of the irreducible nature of the subject itself. As early as 1797, Turner appeared in Gillray's satire, *Titianus Redivivus*, as an opponent of the so-called Venetian Secret, which was ruffling the Academic Grove;[8] and the following year, when Turner for the first time showed as many as four oils at the Academy, a critic wrote that the painter

> seems thoroughly to understand the mode of adjusting and applying his various materials; and while colour and *varnish* are deluding one half of the profession from the path of truth and propriety, he despises these ridiculous superficial expedients and adheres to nature and the original and unerring principles of the art.[9]

Turner's suspicion of colour-theory in a more general sense continued as late as the notes to Goethe's *Theory of Colours*, of the early 1840s.

The second professional assessment of Turner's colour: that it may be

traced to newly available materials, is more apt for study; and it is an attitude of some importance, although it has received almost no attention from later Turner students, with the exception of the two fundamental essays on technique which the late C.F.Bell introduced into his catalogue: *Turner's Exhibited Works*, in 1901.

Just after Turner's death, John Burnet wrote that 'the extreme vividness of his colours, especially when his pictures were fresh from the easel, arose from the chemical changes that took place in the manufacture of the pigments during his career, such as chrome yellow, emerald green, cobalt blue, &c., which none had the courage to venture on but Turner . . .'[10] Although it is fine as far as it goes, the inadequacy of this explanation may be seen if we look at the developing technical brilliance of, say, William Mulready, whom Dr Liebreich associated with Turner in having an ocular disability, but whose work is very different from Turner's, or at the dazzling palette of the Pre-Raphaelites in the early 1850s. Although a detailed examination of Turner's methods and materials is properly the province of the restorer and the chemist, it is possible, on the basis of published and visible information, to comment briefly here on Burnet's remarks.

Of the new pigments he lists, only emerald green has not been identified among those discovered in Turner's studio at the end of his life;[11] and even this colour seems to have been used, at least in mixtures, in watercolours of the early 1830s and later.[12] Cobalt blue survives in two varieties among both the watercolours and the oil pigments; and it may have been in use at least since 1811 or 1813, when it appeared in a drawing connected with the oil now in the Lloyd collection at Wantage, of *Oxford High Street*, and in a sketchbook almost certainly in use on one of the Devonshire tours of these years.[13] Both green and blue form, in range as unmixed pigments, a very minor element in Turner's palette; but it is interesting that the greatest evidence for the use of new materials is in the yellows, which themselves constitute at all periods the largest proportion of colours in his pigment range, as they had always done in the history of pigments, on account of their chemical nature. Among the colours preserved from Turner's studio at the Tate Gallery are a dozen varieties of yellow, four of which were developed during Turner's lifetime; and many others are among recipes in the sketchbooks. In the late watercolour box at the Royal Academy, there are six distinct yellows, as opposed to four reds, four browns, two blues and two greens. In the *Chemistry* sketchbook already mentioned, five pages are given over almost entirely to formulae for yellow pigments. This emphasis is of more than merely technical interest, although it may be explained technically by the need to keep the lightest colours pure and unmixed; for yellow became for Turner, as it became for his critics, the hallmark—almost the objective—of his art as a colourist. It was his favourite colour, he told Trimmer, 'for pictures wanted colour'.[14] Sir George Beaumont had recognized a jaundiced tone in Turner's work

as early as 1806 (Farington *Diary*, 26 April); and in the twenties, when a renewed interest in chemistry is documented in the notebooks,[15] the painter himself took up the theme in the bantering correspondence with James Holworthy and George Jones. On 13 May 1826, the critic of the *Literary Gazette* joked of the *Cologne* (now in the Frick Collection, New York) and the *Forum Romanum* (originally painted for Soane; Tate Gallery 504), that in them Turner

> seems to have sworn fidelity to the *Yellow Dwarf*, if he has not identified himself with that important necromancer. *He* must be the author of gamboge light.

Turner must have scented the critical air, for in a slightly earlier letter to Holworthy, referring to Thomas Phillips's Italian suntan, he wrote, 'the executive, alias hanging committee at the Royal Academy this year has brought him back to his original tone of colour—but I must not say yellow, for I have taken it *all* to my keeping this year, so they say. And so I mean it should be . . .'[16] Four years later, after a moving account of Sir Thomas Lawrence's funeral, Turner concluded a letter to Jones:

> I wish I had you by the button-hole, notwithstanding all your grumbling about Italy and yellow. I could then tell more freely what has occurred since your departure of combinations and concatenations somewhat of the old kind, only more highly coloured, and to my jaundiced eye not a whit more pure . . . Chantrey is as gay and as good as ever, ready to serve; he requests for my benefit, that you bottle up all the yellows which may be found straying out of the right way . . .[17]

Turner's concern for purity of colour was to have an especial resonance in his late work; and his jokes often show a freedom of self-revelation greater than more serious talk. The interrelationship of materials and matter, of technique and conception was typical; and it is in this light that we may see a reason for the painter's remark to William Westall that he 'could not afford' to paint a palm-tree green rather than yellow. Green, as a mixed colour, was one for which, as he got older, Turner found increasingly little use; and it was probably in this context that he told his most sympathetic late follower, J.B.Pyne, that he wished he could do without trees.[18]

By the standards of his time, when studio traditions of craftsmanship had all but ceased to exist, Turner's sketchbooks are remarkably free from technical gossip; and Trimmer records only a single instance of the artist's wish to discover the technical procedure of a contemporary: the oil vehicle of James Ward.[19] In general, Turner seems to have been content to use the preparations of colourmen like Newman, Middleton and Sherborn;[20] and in view of the seven varieties of madder among the pigments at the Tate Gallery, and among the watercolours, it is notable that he was asked by the Society of Arts as early as 1804 to test the qualities of a

madder lake produced by Sir Henry Englefield who, the following year, appeared as a subscriber to Turner's print of *The Shipwreck*.[21] The madder had been prepared in oil by Newman, and it was awarded a gold medal on the attestation of Turner and his friend John Hoppner, as well as West, Trumbull, Daniell and Opie, who tried it in oil, and John Sell Cotman (who, like Turner, had already been connected with the Society as a prizeman), and Paul Sandby Munn, who tested its capacity in water-colours. Turner's tendency to improvise his pigments has almost certainly been exaggerated in the light of his later practice on Varnishing Days; and the recent successful restoration of even some late oils suggests that contemporaries like Ruskin, and later critics, were unduly pessimistic about their *facture*.

That Turner's use of colour became increasingly conceptual towards the end of his career I shall attempt to demonstrate in the course of this book; Burnet's simple technical explanation, however right in its data, is clearly inadequate to the understanding of the painter's principles of choice, and the direction of his feeling. But in dealing at present specifically with his *practice*, it will be necessary to return to the earliest years of his career, and to look again at some of the work usually neglected by students of the colourist, as being too immature and too pre-colouristic to be drawn into the argument. This attitude is unjust; and the traditional separation of the work in watercolour from that in oil, and the tendency to regard the watercolours as more 'advanced' than the oils at any given date, is true neither to the chronology of the work nor to Turner's own scale of values. As a comparison of finished with finished and unfinished with unfinished work in the two media must show, Turner distinguished between them on functional rather than on aesthetic or technical grounds; and, after an initial and very short period of training in each, he managed each with a comparable facility. If we begin our account with the painting in water-colours, it is because of their priority in time, not because of a priority in inventiveness or capacity.

II

One of the chief considerations in the understanding of the young Turner is Edward Dayes's assertion, in the earliest biographical notice, that his artistic development was 'without the assistance of a master'.[22] Dayes, as the master of Girtin and a frequenter of the Monro circle, was in a good position to know; and his statement has at least negative support in the silence of apprenticeship records between 1788 and 1796. How, then, did Turner develop his artistic practice? Dayes stated that it was through copying the work of other draughtsmen, and sometimes pictures in the Exhibition, but so far no work of this type has been identified with certainty, so that it is difficult to assess Turner's direct debt to the work of contemporary landscape artists before the mid-nineties, when he had

already ceased to be, at least technically, a student. Turner's earliest calligraphic technique is rare among watercolourists, with the exception of Francis Grose, and some of the work by Paul Sandby. There is, however, early evidence for the artist's practice of copying and colouring prints; and the first posthumous account of his career, Lovell Reeve's obituary notice, stressed his work for the print-maker, John Raphael Smith.[23] The earliest 'works' to be attributed to Turner with any certainty are the tints of water-colour on some engravings in a copy of Boswell's *Antiquities of England and Wales* (1786), now in the Brentford Public Library. Turner is said to have tinted seventy of the plates for a fee of twopence each,[24] and he has given the rather dull engravings strong effects of lighting and weather, and broad, simple, saturated washes of colour, thoroughly characteristic of what we know of his earliest signed work. One of the Brentford subjects, *Friar Bacon's Study at Oxford* (pl. 14), was that copied on a larger scale from an Oxford Almanack print, in 1787, and of which two versions, with different lighting effects, survive in the British Museum (TB I, A, Aa). This type of artistic activity continued until 1792 at least, for the British Museum has an engraving of an infantry officer after Dayes, dated February 1792, which was, according to a MS note on the back by J.T.Smith, Keeper of Prints and Drawings until 1833 and a friend of Turner, coloured for [Paul] Colnaghi by the artist 'when a boy'.[25] A comparison of this work of Turner's with other tinted copies of the same engraving in the Print Room suggests that he was the surest exponent of a 'house style', whose characteristics were a great purity, breadth and strength of wash, laid on with a vigorous brush-stroke, which are precisely the characteristics of Turner's earliest known independent work.

If Turner worked for both John Raphael Smith and Colnaghi, it seems reasonable to suppose that he had a wider *clientèle*; and we should perhaps look again at those early associations recorded, rather confusedly, by the older biographers, with the architectural drawing-offices of Thomas Hardwick, William Porden and Thomas Malton, as well as considering a possible early connexion with the office of Sir John Soane. Finberg has recently rejected the story that Turner was a 'pupil' of Hardwick, but the drawings he claims as too 'pictorial' for this are certainly not unlike the contemporary products of architect's offices, where there was a movement, fostered by the Royal Academy Exhibitions, in favour of wholly pictorial watercolour drawings of projects, to save the expense of models, and to give the feeling of a site. Later, both Turner and Soane discussed this idea in Academy lectures, and Soane specifically referred to Turner's architectural drawings as dangerous models of excellence in this style.[26] The account of Turner's 'some months' in Hardwick's office, after his training under Malton, and before entering the Academy Schools (i.e. before 1789) is given, independently of Thornbury, by William Sandby in his *History of the Royal Academy*;[27] and in the Royal Institute of British Architects there is a watercolour attributed to Hardwick of the front elevation of a Pavilion,

which suggests that the less purely 'architectural' type of drawing was not foreign to his office practice. It remains true, however, that the only architectural connexion of Turner's youth directly supported by contemporary evidence is that with the younger Thomas Malton, mentioned by Farington in 1795, but not referred by him to any particular period, except the past.[28] In a number of Malton's architectural drawings of the late 1780s and early 1790s, particularly the fine set, after designs by Sir Robert Taylor, now in the Ashmolean Museum, Oxford, there are many signs that Turner's vigorous early method was closely related to architectural conventions. The drawing of *Sir Charles Asquill's Villa at Richmond*, exhibited at the Royal Academy in 1791, is especially close to Turner's work at the end of the 1780s—for example, the Radley Hall drawings, dated 1789 (TB III, C, D), in its flat patches of foliage, briskly drawn with diagonal strokes of bright, saturated colour, and in its dramatic lighting.

Malton himself engraved these drawings for Taylor in aquatint, as was the practice of a number of architects and architectural draughtsmen, including Sir John Soane, whose *Sketches in Architecture*, published in 1793, found their way into Turner's own library. Only some of the plans and elevations for these designs, dated 1791, seem to survive at the Soane Museum, without the intermediate 'picturesque' drawings from which the aquatints were made; but the character of these engravings, especially the foliage and vegetation of several plates,[29] is close to the works of Turner and Malton mentioned above; and other surviving watercolours of the period, produced in Soane's office, allow us to say the same of the style of colouring. Turner's earliest connexions with the architect have usually been placed in the early years of the nineteenth century; but an entry in Soane's notebook of 29 March [?] 1792 has the memorandum: 'to define the profession and qualifications of an Architect (?) [*sic*] Turner, Portland Drawg.',[30] which, if it refers to J.M.W.Turner, may mark the last serious consideration of a profession which he continued to practise as an amateur throughout his life.

Whatever the exact nature and terms of Turner's involvement with architecture as a student, it seems certain that the practice of architectural draughtsmanship allowed, if it did not lead him, to develop a feeling for strong, schematic, non-naturalistic colour masses, hardly to be found in contemporary watercolour painting as such; and which reappeared, transformed, in his practice as a colourist after about 1810. But in 1792, when Turner showed the first and brilliant signs of a wholly painterly approach to colour in the sombre little sketch of the smouldering Pantheon ruins (TB IX, B), 1, he was introduced to a watercolour tradition which induced a very different attitude to colour problems, at once less chromatic and more concerned with form. This new influence was his contact with Thomas Girtin, with Dr Monro and through them, with the Picturesque.

According to Lovell Reeve, Turner and Girtin first met in the employ of John Raphael Smith, which would certainly put the encounter before

1792, when Smith seems to have abandoned printmaking with the closure of the Continental markets.[31] However this may be, it seems clear that, until 1792, the two artists' backgrounds had been very different. Girtin's drawings of mediaeval ruins for the antiquarian James Moore, his small-scale topographical work for engraving and his apprenticeship to Dayes all worked in favour of a small manner and a reticence of colouring quite opposed to Turner's bold scale and palette, adapted as it was to Exhibition drawings such as he had been showing at the Academy since 1790.[32] Girtin was not to exhibit until 1794, the year in which Turner, conversely, produced his first small drawing for engraving in *The Copper Plate Magazine.* 1792–3 is, too, the period when we have the first evidence of Turner's repetitions of drawings based on tour-sketches (*Llantony Abbey* TB XII, F), a practice which during the 1790s was to establish his fortune, with important consequences for the development of his work. In the exhibited works of 1792 (*Malmsbury Abbey*, Norwich Castle; *The Pantheon*, TB IX, A) and in drawings of the following year, for example, *Tom Tower, Oxford* (TB XIV, B) and the *Abingdon Abbey* ('Starvecastle Ruins') in the Ashmolean, there is still no trace of Girtin in the broad and pearly colour and the rather bold drawing; but in the series of four of the *Interior of Tintern Abbey* (TB XXIII, A; British Museum, Lloyd Bequest; Victoria and Albert Museum; Ashmolean), one of which was exhibited in 1794, a sobriety of colour and a smallness of touch has become very clear. Two events in Turner's life which may have affected his contact with Girtin between 1793 and 1794, and certainly influenced the course of his development as an artist, were his winning the prize for landscape drawing at the Society of Arts in March 1793, and his meeting with Dr Thomas Monro.

John Linnell, who was a later protégé of Monro's, recorded that the doctor 'had been in the habit of taking [Turner and Girtin] out to draw from nature for him'.[33] Turner may well have met Monro in Surrey, where he had a country cottage, in 1792, and been encouraged by him to enter for the Society of Arts competition the following spring. He was first mentioned in Monro's diary in 1793, and a drawing of Monro's house at Hadley signed by Turner and dated this year is still in the collection of one of the doctor's descendants;[34] but Monro did not move to the Adelphi until March 1794, and the first record of his 'Academy' does not appear before an entry in Farington's diary of the following December. None of the watermarks on the Monro School Copies in the Turner Bequest are earlier than 1794; others are of three years later (TB CCCLXXV, 28, 29), which seems to support the view that Turner and Girtin were active there between these dates, and that they had ceased to be so by the time of the account given to Farington in November 1798. The distribution of surviving drawings among the original members of the Monro School is almost impossible; and where external evidence is an aid—for example the drawing called *L'Arriccia* in the Girtin Collection, which is on an original Girtin mount of *c.* 1794/5—there seems to be little to be deduced about variations

in style. Farington's account must stand as the most authentic and detailed record of Monro's arrangements. Turner and Girtin told him

> they had been employed by Dr Monro 3 years to draw at his house in the evening. They went at 6 & stayed till Ten. Girtin drew the outlines and Turner washed in the effects. They were chiefly employed in copying the outlines or unfinished drawings of Cozens &c. &c. of which copies they made finished drawings. Dr Monro allowed Turner 3s 6d each night—Girtin did not say what he had.[35]

In his earliest reference to the circle (30 December 1794), Farington says that the outlines—here those of Thomas Hearne and John Henderson—were traced; and this has been accepted by Bell.[36] By far the greater proportion of known Monro School Copies are based on outline sketches by J.R.Cozens, Henderson and, probably, Dayes,[37] so that Girtin would have every reason for the complaint that he was not given 'the same chance of learning to paint' as Turner.[38] He can hardly have had much opportunity even to draw. However, at least twenty-four of the known copies are after watercolours, from which it would have been damaging to make tracings, and in one case, the '*Riquenbac*' (TB CCCLXXIV, 4), **3**, the copy is larger than the original (British Museum 1900-4-11-30, Bell & Girtin 25), **2**. Farington is, in any case, clear about the part played by Turner in Monro's organization; it was that of providing the 'effects', which was a development of what he had already been doing as a tinter of prints. It was essentially a superposition, a transformation. Students of the Monro School have long recognized that its productions were not, properly, copies; and where, in the case of John Robert Cozens, it is possible to compare a watercolour with its derivative, the differences are perhaps more striking than the similarities.[39] The 'copies' have a drama of lighting, an all-over quality of texture, a sparkle and robustness of handling which is very far indeed from Cozens's curious formality, or his poetry and quiet. Nor is there any attempt to reproduce the rich sobriety of Cozens's palette. The Monro School copies are chiefly in simple washes of grey and blue; but there is a group (TB CCCLXXVI), based mainly on tracings, which are coloured, and tend far more to an effect of yellows and browns than comparable work by Cozens.

The available evidence does not allow us to be very confident about the origins of the 'Monro School Style'; but whether it is to be traced ultimately to Girtin, to Dayes or to Hearne, or even to Turner, whose large and assured brushwork is to be seen in many examples, it seems certain that the work of Cozens himself was the least important element in the development. As far as Turner is concerned, there may well have been in these copies already an element of Picturesque 'improvement' which was to characterize his approach to earlier painters throughout his career; and, apart from these products of the School itself, he seems to have shown a strange coolness towards Cozens's drawings. As Oppé has shown, Turner

occasionally drew motifs from them,[40] but, in contrast to Fuseli's and Constable's enthusiasm for the 'enchantment' and 'poetry' of the watercolours, Turner's only recorded reference to a work of Cozens—and he was not ungenerous in his remarks about artists—was about his indebtedness to one of the very rare Historical Landscapes, the lost oil, *Hannibal in his March over the Alps, showing to his army the fertile plains of Italy*.[41] Turner is known to have owned but a single Cozens drawing (he collected, on the other hand, several Wilsons), the *Lake of Lucerne near Altorf* (TB CCCLXXX, 21; Bell & Girtin 32), one of the most colourful type, in its purples, blues and greens; but it was probably a gift from Sir Richard Colt Hoare about 1797.

The impact of the Monro circle on Turner's style, and especially on his colour, was undeniably great; and the move towards a muted palette should perhaps be traced less to the evening work as a copyist, than to the new stimulus towards sketching from nature which the contact almost certainly brought, and which antedates the formation of the Monro Academy as such. Monro himself as a draughtsman rarely strayed outside monochrome, and the few coloured drawings attributable to him (e.g. British Museum 1920-7-16-1) use black chalk as the basis for a very muted and mellow watercolour wash. Among the doctor's friends, however, were Thomas Hearne, a very experienced topographical artist in watercolour; John Laporte, a prolific sketcher, known chiefly for his rather insensitive work in gouache; P.J.de Loutherbourg, a history and landscape-painter, with a very wide Continental background, who was to have a great effect on Turner's development; and Girtin's master, who also combined History painting with landscape, Edward Dayes. All these artists were professional Picturesque tourists; and it is surely no coincidence that Turner's first important tour, as opposed to the expeditions he had made while staying with friends, or around London, was made in 1794, a year or so after meeting Monro (TB XIX *et seq.*); or that in this year he produced his first drawing for a topographical engraving.[42] In these and the immediately following tour sketchbooks Turner developed a style of drawing in broken outlines and a rich, sparkling, if rather sombre key of colouring entirely in the spirit of the Picturesque aesthetic with which he was now in contact. In the *Isle of Wight* sketchbook of 1795 (TB XXIV), **4**, the only drawing which he chose to finish in watercolour, *Alum Bay*, was precisely the subject in the island especially approved by the chief Picturesque writers of the period, Uvedale Price, Richard Payne Knight and William Gilpin; and Turner's treatment of it is entirely in agreement with their views.[43] The Isle of Wight, too, had already in the early 1790s a special connexion with artists in the Monro circle. The tours of the mid-nineties were impregnated with Picturesque feeling, and Turner's involvement helped to produce in his work a handling that was at once less chromatic and more atmospheric than in the earlier stages of his practice. It was a phase which lasted about four years; and it conveniently closes our consideration

of Turner as a young watercolourist, for about 1794 or 1795 he began his first experiments in oils, and from this moment it becomes impossible to treat the drawings in isolation.

III

Seen from the vantage-point of the 1820s, Turner's achievement as a watercolourist in the last decade of the eighteenth century was, according to W.H.Pyne, that he made his drawings, as did Girtin

> on the same principle which had hitherto been confined to painting in oil, namely, laying in the object upon his paper with the local colour, and shadowing the same with the individual tint of its own shadow. Previous to the practice of Turner and Girtin, drawings were shadowed first entirely through, whatever their component parts— houses, castles, trees, mountains, foregrounds, middlegrounds and distances, all with black or grey, and these objects were afterwards stained, or tinted, enriched or finished as is now the custom to colour prints . . .[44]

Turner had raised watercolours to the powerful level of oils, and this and similar attitudes are understandable in the atmosphere after the secession of the watercolourists from the Academy in 1805 to form their own society, when the status and purity of the art was becoming a fetish;[45] but it hardly represents the position in the 1790s, when watercolour was but another medium of expression. Certainly it was regarded as a minor medium by oil-painters. Wright of Derby remarked in 1795 that 'Paper and camel-hair pencils are better adapted to the amusement of ladies than the pursuit of an artist';[46] and the prejudice was reinforced by the practice of the Academy in not allowing full academic honours to artists working alone in watercolour. Drawings were hung at the Exhibition separately from oils, so that it can hardly have been in deliberate rivalry that Turner gave his *Norham Castle*, **33**, exhibited in 1798, 'the force and harmony of oil painting', noticed without insistence by a critic.[47] In the work of Paul Sandby and John Laporte, Turner will have been as familiar with body-colour and mixed techniques as he was with 'stained drawings'; and a surviving anecdote about his purism[48] refers only to the use of body white on white paper, and is partly contradicted by some of the Farnley series and the Rhineland drawings of 1817, made for Walter Fawkes, both of which are in body colour or mixed techniques on white paper toned with a grey wash. Rather than seeing Turner's work in watercolours of the 1790s as aspiring towards the condition of oil, and oils in the 1830s and 1840s as aspiring to that of watercolour, we notice at any one moment that there are common expressive interests developing side by side in each medium.

W.H.Pyne's account of Turner's innovations overlooked the fact that

both grisaille underpainting and dead-colouring were procedures taken over by watercolourists from oil-painting; and the second method seems to have been practised, for example by Francis Towne, well before Turner's day. In Turner's own *œuvre* the process was hardly one of emancipation from the stained manner to full colouring; for in the Radley drawings of 1789 (TB III, C, D) there appears to be no monochrome underpainting, and one is signed boldly *Wm Turner pinxt.*, as if the artist was already fully aware of his status as a painter. In the *Bristol and Malmsbury* sketchbook of 1791 (TB VI) different pages show different methods of beginning: p. 17a seems to have been started in grisaille; but p. 23 has the first washes in yellow and blue. Sometimes, as in TB XVI, G, of 1792 or 1793, the subject seems to have been painted nearly to a complete finish, area by area, as are a number of drawings in the *Isle of Wight* sketchbook already noted. Examples of a monochromatic underpainting in the mid-1790s are in TB XXVII, H, N, W, and the fine, pure monochrome beginning of *Llandowror Mill* (TB XXVIII, B). From the late nineties we may quote the magnificently Claudian and atmospheric *Stourhead* (TB XLIV, f) which, if it were not chiefly grey monochrome, would be called a 'Colour Beginning', and which may be either a rejected first stage of a drawing of which TB XLIV, g, is a later condition, or a different effect of light: sunrise to sunset. The delicate dawn grey is here the vehicle of mood; and colour had become, long since, for Turner, not a system or a method, but subordinate to an expressive idea. Turner felt his way slowly, and invented his procedures as he went.

In a well-known remark of November 1799 to Farington, which has sometimes been associated erroneously with the system of landscape invention developed by Alexander Cozens,[49] Turner 'reprobated the mechanically systematic approach of drawing practised by [John 'Warwick'] Smith, and from him so generally diffused. He thinks it can produce nothing but manner and sameness. The practice of [] is still more vicious. Turner has no settled process but drives the colours about till he has expressed the idea in his mind.'[50] The account does not suggest improvisation, but it does oppose the drawing 'process' of Smith, which in the 1790s had something like the vogue in water colours enjoyed by Ibbetson's *Gumption* or Miss Provis's *Titian Shade* in oils. In 1793, Wright of Derby regretted that he could not pass the secret on to Morland, as his friend, the Rev. Gisborne 'does not think himself at liberty to Divulge Smith's mode of washing with water-colours'; and the following year, Farington noted that John Glover had adopted Smith's system, which, it seems, was also that of William Payne.[51] How simple and 'scientific' the method was is clear from the account of it given by John Landseer in 1808:

Mr John Smith first discovered and taught the junior artists the rationale of tempering their positive colours with the neutral grey formed by a mixture of red, blue and yellow; that this grey, con-

stituted of all the primary colours, could harmonize for all; and that tempered with a little more or less of warm or cool colour, as time, climate or season might require, it became the air tint, or negative colour of the atmosphere which intervened between the eye and the several objects in a landscape. Others may have been the first to teach the minor arts of touching a tree, or granulating a rock or an old wall, but these things, however estimable, are very inferior things to the discovery and promulgation of PRINCIPLE. Others may have taught the existence of aerial prospective [*sic*], Smith shewed on what principles it depended, and to how simple a mode of practice these principles were reducible . . . this practice of Mr Smith . . . is really a scientific development of fundamental principle, such as both the Royal Society and the Royal Academy should honour him for.[52]

Since Turner had little use for this sort of principle, we must ask what there was in his training as an oil-painter which may have influenced his watercolour practice, and *vice-versa*; and here an answer may well be found in the use of grounds. Early oils sometimes resemble watercolours in style. The small oval *Mill* in oil on card (TB XXVIII, a), which must belong to 1794 or even earlier, is close to rather coarse watercolours of the period, like the transparency of a cottage (TB XXVIII, H). But there is one very conspicuous case about 1798 of an attempt to repeat the process of an oil in body-colours, in two small pictures of *Caernarvon Castle*. In the *Academical* sketchbook (TB XLIII, p. 39a), 5, is a bright, yellowish drawing in body-colour of the motif, of which an oil of very similar size and composition is in the Tate Gallery (No. 1867), 6. Like the oil, the drawing has been painted over a prepared red ground, which shows prominently through some of the thinner areas of paint. It is as though Turner was calculating very consciously the effects of two widely differing media.

In his first recorded large oil, the *Fishermen at Sea off the Needles*, 36, exhibited in 1796 and on permanent loan to the Tate Gallery, Turner showed that he was in close touch with a French landscape tradition represented in England by Loutherbourg, to whom, indeed, he may have been directly indebted for the motif.[53] The soundness of handling the paint in this picture, which already, in its dish of light, has some elements of the artist's later compositional preferences, demonstrates a technical lesson well learned; and Turner could hardly have had a better teacher than Loutherbourg, who was well known as one of the soundest technicians of the period.[54] Loutherbourg may well have been the source of Turner's interest in grounds, for in conversation with Farington in 1798, his pupil, Sir Francis Bourgeois, said of the master that 'He prefers light grounds from the Colourmans, as he thinks the dark brown grounds will appear *through the colours* and prevent the effect of air. He uses Fat drying oil with Turpentine—and as much as he can avoids repeating his colours so as to

load the canvass.'[55] In this Loutherbourg was following the tradition of his own master François Casanova, who recommended finely ground colours for transparency, and habitually made his design, according to another pupil, Joseph Vernet, 'sur une toile imprimée d'une couleur apeuprés du ton dont il veut faire son tableau, dorée s'il veut le faire chaud, de couleur grisâtre verd s'il veut le faire argentin . . .'[56] Too few of Turner's early oils survive in an unfinished state for us to be sure how far he was experimenting in this direction; although it is clear in the small *Caernarvon* pair; and a scrap of oil landscape of around 1798 in the British Museum (TB LI, M) seems to be on a red ground. But in large watercolours something of this sort seems to have been happening in the pair of *Stour-head*; and in a group of drawings associated with the Northern and Welsh tours of 1797 and 1798, which have been scattered by Finberg, but which surely belong together, Turner worked out his all-over colour-beginnings almost entirely in terms of delicate blues and pinks, **37**.[57]

The Welsh tour of 1798 was in part, for Turner, a pilgrimage to Wilson,[58] and the Wilsonian tradition of landscape which dominated Turner's oils in the late nineties was, technically, one of opaque impasto which hardly exploited the ground.[59] English landscape grounds seem in any case to have been generally warm and low toned, as opposed to Continental practice, based on Claude, which favoured white. Ozias Humphrey noted that the procedure of the German landscape painter, Hackert —probably J.G.Hackert, the brother of Goethe's friend and teacher, whose work was exhibited in London in the 1770s and 1780s, and who died in Bath in 1773—was to paint 'always upon Canvases or wood prepared with white and never 'till they have been a year prepared because he says he finds from experience that it is necessary the canvas should be well dried to give the utmost value to the colours—and that the preparation should be white to produce brilliancy . . .'. Like Casanova, Hackert also stressed finely-ground colours, 'to give light colours greater lustre and dark strength and clearness'.[60] If Turner's admiration for Wilson led him temporarily away from this method, his continuing interest in the effect of grounds in oil, as well as in watercolour, is demonstrated by the notes on Old Master painting in the Louvre in 1802;[61] and in the first group of oil beginnings which will be discussed below, the grounds are in almost every case white or a pale beige. At the close of his life, when the use of a white or light ground had become general, Turner in his notes to Goethe, commenting on a passage (§583) dealing with brilliant colour over bright grounds, added 'thus paper as the acting-ground in Water Colours, White in Oil Colours', emphasizing not only that the ground has a positive function, but also that oil and watercolours are completely on a par.

I have suggested that the colour-beginnings in watercolour at the end of the 1790s arose from a preoccupation with the emotive colour effect of an overall ground. The more elaborate multi-colour structures, which seem to begin about the same time, can, I think, be associated even more

closely with Turner's experience of oil-painting. On 8 May 1799, Turner, together with West, Farington and Smirke, visited William Beckford's house in Grosvenor Square to see the Altieri Claudes, which Beckford had just acquired. West characteristically ventured a decided opinion on Claude's technique; and Farington reported:

> 'He thinks Claude began his pictures by laying in simple gradations of flat colours from the Horizon to the top of the Sky, and from the Horizon to the background [*sc.* foreground], witht putting clouds into the sky or specific forms into the landscape till he had fully settled those gradations. When he had satisfied himself in this respect, he painted in his forms, by that means securing a due gradation,— from the Horizontal line to the top of the sky—and from the Horizontal line to the foregound . . .[62]

Turner's remark on this occasion was typical of his distrust of systems: 'He was both pleased & unhappy while he viewed it,—it seemed to be beyond the power of imitation'; and we are reminded of George Jones's recollection of another episode of Turner's youth, when, in front of one of the Angerstein Claude Sea Ports, now in the National Gallery in London, the painter burst into tears 'because I shall never be able to paint anything like that picture'.[63]

But West's observations seem to have worked on Turner's mind, for when he next had the opportunity of studying the same Claudes a few months later at Fonthill, he used precisely the type of overall establishment of tonal gradations in horizontal bands, suggested by West, in the upright watercolour sketch of Fonthill Abbey which he prepared for a drawing for Beckford, **7**. Only the smallest sharp lights on the Abbey are left unwashed, and the whole of the deep foreground, which in the more finished drawing, **8**, was to be broken into deep gullies and rich masses of vegetation, is here left an almost unmitigated green.[64] Turner noted a similar broad division into 'three broad strata of (1) the sky distance and Houses. The second the foreground, the third with the figure and the immediate foreground rather lighter . . .' in Poussin's *Diogenes* in the Louvre (TB LXXII, p. 25a). The division of planes into distinct colours had been traditional in seventeenth- and early eighteenth-century Flemish landscape.[65]

Another example of a broad colour-beginning before the well-known Venetian series of 1819 is a *Scarborough* in the Turner Bequest which seems to be the basis for a series of drawings, one of which, dated 1809, is now in the Wallace Collection.[66] Here, the economy of form is not as great as in later examples, but the design is already conceived in broad areas of hardly worked wash. The colour is muted, but dominantly yellow and blue; and just before the Italian visit of 1819, Turner made what seems to be the first example of a fully prismatic colour-composition, in the small beginning for a drawing of *Crichton Castle*, **9**, for Scott's *Provincial Antiquities of Scotland* whose engraving was published in August 1819, and therefore in

hand at least six to nine months earlier. The sketchbook in which this colour rough occurs (TB CLXX) was thought by Finberg to contain Venetian sketches; but it is now known that these are of London subjects,[67] and among them (pp. 12, 13, 40a) are colour-beginnings of buildings and water of a delicacy and lucidity which rivals anything in the *Como and Venice* sketchbook of 1819. The best-known colour-beginnings of the Italian trip are the very summary banded washes of this latter book (TB CLXXXI, pp. 10–13), 38, chiefly in blue, pink and yellow; and the water-colour of the *Campanile and Ducal Palace* (p. 7) shows how readily and naturally a frontal composition of sky, buildings and water could evoke this type of horizontal schematization. Venice certainly sharpened Turner's awareness of this type of fundamental structure as a natural phenomenon; but it had been working in his mind for about twenty years.[68] That it became an important element in the procedure for making watercolour drawings during the latter part of Turner's career is shown by the frequency of this horizontal type of colour-beginning, to which it is almost impossible to give dates, throughout the later sections of the Turner Bequest.[69] But that these are only one type among many watercolours in various stages of completion sorts very well with what we know from documentary sources of the artist's late method, which showed much of the virtuosity of Varnishing Day activities in oils. The collector and painter James Orrock recorded:

> I have been informed, on unimpeachable authority, that each of the matchless drawings which were painted for Mr Windus of Tottenham [who had about fifty drawings by the mid-thirties] was executed there in a day. Turner's method was to float-in his broken colours, while the paper was wet, and my late master [W.L.Leitch], . . . told me that he once saw Turner working, and this was on water-colour drawings, several of which were in progress at the same time! Mr Leitch said he stretched the paper on boards and, after plunging them into water, he dropped the colours onto the paper while it was wet, making *marblings* and gradations throughout the work. His completing process was marvellously rapid, for he indicated his masses and incidents, took out half-lights, scraped out high-lights and dragged, hatched and stippled until the design was finished. This swiftness, grounded on the scale practice in early life, enabled Turner to preserve the purity and luminosity of his work, and to paint at a prodigiously rapid rate . . .[70]

The Fawkes girls also told Leitch that they had seen in Turner's bedroom at Farnley (i.e. before 1826, when Turner visited the house for the last time) 'cords spread across the room as in that of a washer woman, and papers tinted with pink and blue and yellow hanging on them to dry'.[71]

Turner's use of a coloured underpainting to establish from the first his

composition and tonality in watercolour was, then, adapted from the practice of painters in oil. Wilson, for example, is known to have left a good part of these preparatory states to pupils;[72] and through his early contact with one of these pupils, Farington, and later with George Field and W.R.Bigg, Turner was in an excellent position to have an intimate knowledge of Wilson's methods, even though he may not have seen his unfinished works themselves. But there was an earlier and more practical way in which Turner must have been made familiar with this type of colouristic approach: through his close association with the practice and tradition of Sir Joshua Reynolds. Turner's warm references to Reynolds in the Perspective Lectures, and to his study under him as 'the happiest of my days'[73] refer in their context to the last of the *Discourses*; but there is evidence for thinking that he was also active as a student in Reynolds's studio. The President, said C.R.Leslie, 'kindly allowed young artists to call on him early in the morning before he had himself commenced painting. He criticised their works . . .':[74] and he 'most readily lent them his finest works to copy. Turner also told me that he copied many of his pictures when he was a student.'[75] If Leslie's statement can be taken to mean that Turner also visited the President's studio to copy or borrow work, he will almost certainly have seen these works in various stages of completion, including simple dead-colouring, for 'not long before his death, some pictures, which he was in the habit of lending for students to copy, were prepared with indian red, black, white and umber, and purposely left in that unfinished state.'[76]

This contact must have taken place between 1789, when Turner joined the Academy Schools, and 1792, when Reynolds died; but towards the end of the decade he will have developed a new closeness to the Reynolds tradition by his friendship with John Hoppner and the employment of Sebastian Grandi. Hoppner is first recorded as close to Turner in January 1798; and later in the same year, he claimed that Turner had been taking some of his advice on his art.[77] Hoppner was very much the leading pupil of Reynolds, and he is known to have taken over some of his master's more personal methods, like the use of wax, which he may well have passed on to Turner.[78] Hoppner, too, adopted Reynolds's practice of dead-colouring in a variety of colours. John Cawse recorded:

> It was used by his [Reynolds's] scholars also; for in 1802, Mr Hoppner RA employed me to dead colour a large historical picture of Medea &c; and the palettes he gave me to use were, for the flesh, Prussian blue, vermilion and white; for the draperies, black, raw umber and white, with a little Prussian blue. This preparation covered the canvas well in, and left the picture in a state for finishing.[79]

The last sentence suggests that the colours were not used as a grisaille mixture; and Cawse's account allows us to interpret more certainly the precise way in which Turner used the services of Sebastian Grandi, who

had been Reynolds's colour-grinder, and who had developed a reputation for familiarity with sixteenth-century Venetian methods.[80] In February 1802 Farington recorded that Turner 'paints on an absorbing ground prepared by Grandi and afterwards pumissed by himself'; and on a later visit to Turner's, 'Grandi being there laying me some absorbing grounds. He uses white, Yellow Oker, Raw and burnt Terra di Sienna, Venetian red, Vermilion, Umber, prussian blue, blue black, Ultramarine . . .'[81] It is not quite clear from the context whether the user of the colours was Turner or Grandi, but the list includes all those mentioned by Cawse in connexion with Hoppner; and the additional reds, Indian red, light ochre and brown ochre, are among those regarded as necessary for dead-colouring landscapes in a popular treatise of the period.[82] Hence Grandi was probably grounding and dead-colouring Turner's canvases in the studio tradition of Wilson and Reynolds, so that Turner's adaptation of the process to watercolour has its roots very firmly in the eighteenth century. It is thoroughly typical of Turner's artistic personality that a traditional procedure should be given a brilliant and wholly novel direction after he had been experimenting with it for a considerable period of time.

IV

One of the aspects of Turner's approach to painting which is most difficult to assess, but which is critical for the understanding of his colour, is the question of his work from nature, and the relation it bears to his increasing reliance on memory in the later part of his career. The evidence for Turner's colouring on the spot in watercolours during the early part of his career is unambiguous. In 1798 he showed Farington 'two books filled with studies from nature—several of them tinted on the spot, which he found', he said, 'were much the most valuable to him'.[83] In one of these books, the *Hereford Court* sketchbook, there is a drawing of the *Pool on the Summit of Cader Idris* (TB XXXVIII, p. 70), partly finished in watercolour and spotted, it seems, with rain. Turner was also apparently prepared to paint out of doors on a large scale (*c.* 21″ × 30″) about 1799,[84] in a group of watercolours of English Lakes and North Wales subjects, some of which (TB LX(a), G[**39**], J; LXX, Z) show signs of folding down the middle while wet. These magnificent studies are closer in colour and brushing to Constable's work, in the sombre Borrowdale watercolour sketches of 1806 in the Victoria and Albert Museum, than Turner ever came again. That they date from the same time as the large Welsh colour-beginnings noticed above should warn us against seeing any moment in Turner's development in terms of a single method of approach. It is worth noting that at precisely the same time as Turner, Girtin was also working out of doors in watercolour;[85] but by April 1802, in Paris, Girtin found sketching on a large scale, and colouring on the spot a 'very tedious' prospect.[86]

The evidence for Turner's later practice in watercolour is more difficult

to evaluate. The usual inferences from the younger Soane's letter from Italy in 1819, recording the painter's opinion 'that it would take up too much time to colour in the open air—he could make 15 or 16 pencil sketches to one coloured',[87] must at least be modified in the light of two independent accounts of Turner's colouring on the spot on this trip. In Naples, Turner met the architect, T.L.Donaldson, and asked to accompany him and a friend on an expedition up Vesuvius. 'On this occasion Turner made a coloured sketch of the sky, which he did not show to his companions.'[88] However, no coloured sketches made on Vesuvius have been identified among the drawings of the Turner Bequest. Also on the 1819 tour, Turner met the Irish medical student, R.J.Graves, an amateur artist, who sketched together with him:

> At times . . . when they had fixed upon a point of view, to which they returned day after day, Turner would content himself with making one careful outline of the scene, and then, while Graves worked on, Turner would remain apparently doing nothing, till at some particular moment, perhaps on the third day, he would exclaim 'There it is', and seizing his colours, work rapidly until he had noted down the peculiar effect he wished to fix in his memory.[89]

The authenticity of this story is borne out by the fact that several sites, like Tivoli, seem, from the sketchbooks, to have been the subject of protracted visits; and that colour studies, so called by Turner on the covers of his books, of Tivoli, Rome and Naples (TB CLXXXVII, CLXXXIX, CXC) seem to be grouped together, distinct from smaller pencil sketches.

Munro of Novar's account of his sketching-tour with Turner in the Val d'Aosta in 1836 implies that on this occasion the painter worked out of doors in watercolour in Switzerland and Italy; but in the version Munro gave to Thornbury, Turner is said to have complained 'I could have done twice as much with the pencil'.[90] However, as in the case of Vesuvius, there are no coloured sketches in the surviving sketchbooks associated with the tour.

The later sketchbooks themselves do not offer much help to our understanding of this question. The very swift and summary brushwork in the *Thames* sketchbook of about 1825 (TB CCXII) might lead us to suppose that it is from nature; but p. 29 has colour washes over written colour notes, which would seem to imply that this is not the case. Many of the Petworth gouaches of figure subjects, made in the early 1830s (TB CCXLIV), have the appearance of notations from nature; but if so, p. 102, *The Artist and his Admirers*, can hardly depict Turner himself, as has often been thought. The Houses of Parliament watercolours (TB CCLXXXIII, **10**; CCLXXX 45, 49, 79, 83) of 1834 have also been identified, from their blotting on the facing pages, as studies from nature.[91] In general, from the diminishing number of colour studies in tour sketchbooks after about 1810, it would be reasonable to infer that Turner came more and more to rely on his memory, for

whose astounding performances there is considerable documentary evidence. John Burnet recorded that the Turner dealer Woodburn

> told me of an example of this power in Turner. Driving down to his [Woodburn's] house at Hendon, a beautiful sunset burst forth; Turner asked to stop the carriage and remained a long time in silent contemplation. Some weeks afterwards, when he called on him in Queen Anne Street, he saw this identical sky in his gallery, and wished to have a landscape added to it. Turner refused the commission—he would not part with it.[92]

This was surely a tendency which gave freer play to Turner's increasingly conceptual understanding of colour.

The situation with regard to oil-painting is hardly clearer. Turner's turning to oils as a sketching medium was in no sense a novelty, for the practice had been common among English, French and German landscape painters, especially in Rome, at least since the middle of the eighteenth century. Even Wilson, who advised his pupils not to colour from nature, seems occasionally to have waived his own counsel;[93] and it is noteworthy that his *Tivoli*, at Dulwich, of which Turner made a copy (TG 5538), includes a prominent figure sketching the cascades, which Wilson's pupil, Farington, interpreted in 1809 as the artist himself 'with an Easel painting'.[94] Several English landscape painters seem to have turned to sketching on the Thames in oils about 1805/6; and Constable's oil sketches, which began substantially with his Lake tour in 1806, had developed to full maturity by 1811.[95] Turner's first oil sketch that can be readily dated is the view of Tabley House in the first Tabley sketchbook of 1808 (TB CIII, p. 18); but its small size and rather dry manner does not make it easy to compare with other work of the period, and since it is based directly on the pencil drawing on pp. 15a–16, it may well have been made away from the motif. The same consideration applies to the other oil sketch on p. 22 of the same book. Nor is the status of the most comparable oils done in or near Knockholt in Kent, and given by Finberg to about 1806–7, very clear (TB XCV(a)). With the exception of the delicate and liquid small study of a willow (E), these are rather coarse in drawing and muddy in colour; and they have little to compare with the oil sketches on veneer and canvas in the Tate Gallery, which Finberg groups together, rather indiscriminately, as painted about the same time.[96] Turner's great love of Thames and Wey scenery is clear from exhibited pictures after 1806; and it is conspicuously documented by 1809.[97] But this does not seem to be a sufficient reason for attributing all the Thames and Wey sketches to these years, for they differ very considerably among themselves. Specific relationships with pencil or watercolour sketches in the British Museum there are very few; and both the watercolours of the *Hesperides* and *Thames from Reading to Walton* sketchbooks (TB XCIII, XCV), which belong to 1806/8, and the oil studies already noticed, seem to be

more 'archaic' and Wilsonian than any of the Tate sketches. There is, however, in the latter book, a tree-study (p. 37) which is related to one of the large unfinished canvases in the Tate Gallery (2706, R. & B. colour pl. III; cf. also 2699); and a very exceptional watercolour of a frieze of trees and a bridge (p. 46) which is close in subject and treatment to another (2692), **40**. Two drawings (pp. 108a, 128a) in the *Wey, Guildford* sketchbook (TB XCVIII), given by Finberg to 1807 (but possibly two or three years later, since it contains studies for pictures and engraved work, the earliest of which was exhibited or published in 1811), are related to Newark and Windsor oil sketches (TG 2306, 2677). In the *Studies for Pictures, Isleworth* sketchbook (TB XC), which is now thought to have been in use about 1811/12, there are a number of drawings whose tall, attenuated trees recall the type favoured in paintings after about 1811.[98] Even within a single sketchbook, like the *Thames from Reading to Walton* book, the character of the watercolours is various;[99] and it is possible that this book, like many others, was in use at several periods. It would certainly be misleading to make any grouping and dating of the oil sketches very rigid. Before attempting to arrange them in any sort of order, it will be as well to quote the only surviving account of Turner's activities on the Thames that has been traced so far, that given to Thornbury by the young Trimmer:

> He had a boat at Richmond . . . from [which] he painted on a large canvas direct from Nature. Till you have seen these sketches you know nothing of Turner's powers. There are about two score of these large subjects, rolled up, and now national property . . . There is a red sunset (simply the sky) among the rolls: the finest sky, to my mind, ever put on canvas.[100]

Trimmer's record cannot be taken completely at face value. There are less than a score of canvases in the Turner Bequest which fit his description; and the only sunset which would match what he says is a slightly larger than average, heavily varnished study (4665), at present given to the late 1820s, but very possibly earlier. This could, perhaps, be the sunset sky referred to by Woodburn. Not all the large canvas beginnings seem to be of the same sort. *Cleeve Mill* (2074) certainly has the appearance of a sketch from nature, painted as it is thinly, outwards from the centre, as in many watercolour beginnings of the 1790s; but other canvases, like the *Trees beside River* (2692), **40**, which I have already associated with a watercolour of about 1807, has an important *pentimento*, is painted more thickly all over, and is probably a stage towards a finished studio picture. From the nature of the subject, with the water and ships in motion, the *Shipping at the Mouth of the Thames* (2702) can hardly have been painted on the spot. But if Trimmer's story is acceptable in its general outline for most of these large beginnings, we can infer from it that the practice began after Turner's Hammersmith period, when he had moved up-river to Twickenham in

1811 or 1812. A beginning, like the beautiful *House Beside River*,[101] represents a very developed approach to working from nature in oils; and the tree-types, in particular, are closer to the Italianate landscapes after 1811, like *Crossing the Brook* (TG 497, R. & B. colour pl. VII), than to Turner's finished work of Thames subjects between 1806 and 1810.

A similar feeling arises from the small sketches on veneer, if they are compared, for example, with the small oil of *Cliveden on Thames* (1180), **41**, which is identified with the subject exhibited at Turner's own gallery in 1807. These oil sketches may be placed into three broad groups, on the basis of their style and technique. What seems to be the most 'primitive' group is that of subjects on the Wey and at Windsor, whose chief characteristic is a rather coarse, thick impasto with a gritty component and a yellowish tonality. The group comprises three Windsor subjects (2305, 2306, 2308, R. & B. colour pl. II), *St Catherine's Hill, Guildford* (2676), two Newark subjects (2302, 2677), the *Wide Valley*, now identified as *Godalming from the South*,[102] and three smaller unidentified subjects (2303, 2310, 2311). These subjects would fit together easily on a single tour; and two of them I have associated above with a sketchbook which may well belong to 1809 or 1810, where all the sites listed are either referred to in writing or drawn. The second group is the two *Walton* sketches (2680, 2681) which are isolated both in technique (very thin paint on an apparently ungrounded mahogany veneer), and in their subjects, which in composition seem to bear no relationship either to pencil sketches or to the finished paintings of Walton. They seem to be more assured than the first group, and may be given tentatively to a year or two later. The last group belongs, in the identified subjects, entirely to Windsor and Eton, and is characterized by a warm, mealy ground, a fluidity of handling and a far greater emphasis on tonal than on chromatic contrasts. The brushwork is swift and brilliant, and in the *Tree Tops and Sky* (with Windsor Castle? 2309) is close to the handling of the pine foliage in *Crossing the Brook* (R. & B. colour pl. VII). The other sketches in this group are 2312, 2313, 2678; and *The Ford* (2679) may be related, in its generally open texture and handling, to the freedom of the *House Beside River* (2694) to which I referred above. These groupings are offered hesitantly, for Turner was manifestly a chameleon of an artist, and the dating is even more speculative; but they do seem to differ among themselves, and what I have called the latest, in particular, show a command of the medium in advance of the only other coherent group of oil sketches; those made on the Devonshire tour of 1813.

That some at least of the Devonshire oil sketches on uniform small cards,[103] **42**, were made on the spot, we learn from the testimony of Turner's travelling-companion, Charles Lock Eastlake.[104] Cyrus Redding, however, another companion, in his first account of this trip, claimed that the pencil outlines done in front of the subject were filled in with colour a day or two later.[105] The character of the sketches, owing partly, perhaps, to their small size, seems far less spontaneous than that of the Thames and

Wey subjects, and the overall colour is rather brighter and sharper. None of the subjects has yet been identified; and it must be said that their link with this tour is conventional. Certainly Turner, according to Eastlake's account, was not satisfied with these Devonshire oils and none of them appear to have been used in picture-making. All the surviving sketches for *Crossing the Brook*, the chief product of this tour, are in pen or pencil. There is very little evidence indeed for Turner's use of the oil sketch after the Devonshire tour. Lovell Reeve, in his obituary notice of 1851, wrote that Turner made such sketches on his foreign tours, and at least one of a number of small oils on linen over millboard in the Tate Gallery has, after the recent cleaning, been claimed as a study from nature.[106] But there is scarcely more direct evidence than this. Certainly the thirteen oil sketches on paper discovered at the British Museum in 1962 cannot be understood as such; and they have rightly been recognized as closest to the water-colour beginnings after 1820. Turner's complaint of his difficulties in managing oils in the open air, made to Munro of Novar, must date from after the mid-1820s when they met, and possibly arose from conversation on the Aosta tour of 1836; but it is no evidence that he was still sketching in oil at that date.

Why did Turner find so little use for the vogue for working in oils out of doors? His own remarks suggest that it was largely for technical reasons. The Devonshire sketches had deteriorated, he thought, because some defect in the paper had made all the grey tints disappear;[107] and certainly they are warmer and more leathery than the outdoor subjects among the Knockholt studies. Similarly, he explained to Munro of Novar that his reluctance to use oil was because 'he always got his colour too brown',[108] which would aptly apply to the first group of Thames and Wey sketches, but hardly to the more silvery quality of the last. More important, it is probable that Turner found himself unable in the field to use oil colours of sufficient purity to correspond to his late vision. In any case, the painter's perception, not to say his record of that perception, came increasingly to disregard the impact of first impressions. Possibly there was a conflict between conception and perception in oil and watercolour alike, as media of direct record, for in coloured sketches which have the appearance of being done from nature in the last colour sketchbook, of 1845 (TB CCCLX), Turner reverted to a muted grey and yellow palette and a broken brushstroke which goes back to the mid-1790s. However, in a Venetian sketchbook, probably of 1832 (TB CCCXV, cf. p. 5), pp. 18–21 are in a muted range of greens and browns which seems to come from a direct experience of the subject, while pp. 11–14 have a far more complex technique and brilliant colouring; which suggests that perhaps both modes were used interchangeably for indoor work. It is notable that among the late exhibited oils one of the darkest and least chromatic was precisely that *Steamer in a Snowstorm* (R. & B. colour pl. XXI), shown at the Royal Academy in 1842, which Turner, by his caption in the catalogue and in

his well-known conversation recorded by the Rev. William Kingsley, was most anxious to establish as direct *rapportage*.[109]

Just as Picturesque or significant *form* became, for Turner, not simply a pictorial device, but an objective optical phenomenon,[110] so his increasing understanding of basic colour, nourished by his experience as a critic and a lecturer, took on the conviction of refined physical truth. 'Every object he saw, as he himself has told us,' wrote Lady Eastlake in a review of Ruskin's *Modern Painters* in 1856, 'was outlined to his vision in prismatic colour'; and to another lady who questioned the painter's use of touches of blue, red and yellow throughout his work, Turner retorted, 'Well, don't you see that yourself in Nature? Because, if you don't, Heaven help you!'[111] In interpreting the phenomenon of chromatic aberration of the crystalline lens, which, in certain extreme movements of the eye, produces prismatic fringes around the objects seen, Turner had come to regard the lens itself as a prism, throwing over the external world a halo of prismatic light.[112] The brush became useless for recording appearances in the second half of Turner's career because, for him, both art and nature were seen increasingly in terms of process, a dialogue between artist and subject evolving in time. 'When painting,' he wrote in a despairing note on reflections, about 1820, 'art toils after truth in vain.'[113] Art and perception were a process towards refinement, and must therefore have beginnings cruder than their ends.

> '*Water, the image of the mind,*
> *Clears as it runs, and as it runs, refines*',

Turner told his audience at an Academy lecture on reflections.[114] The image is one that applies as well to the development of his own work. The progress towards greater refinement may be plotted with some exactness because of his own conscious dialectic of the series. Hanging as they do, side by side in the Tate Gallery, *Calais Pier* (472, R. & B. colour pl. I) exhibited in 1803, and *The Shipwreck* (476, R. & B. pl. 23), painted by 1805, mark a clear development towards the distillation of an idea, not only in the greater sensitivity of the painting of figures and sea, but also in the way that the lights and darks, scattered over the surface of the *Calais*, have, in *The Shipwreck*, been drawn together into the single dramatic statement of the central sail and foam. The process may be followed in colour over a longer period in the case of favourite motifs like *Norham Castle* and the *Fall of the Clyde*, which exist in various versions throughout Turner's career. The prismatic beginning of *Norham*, possibly of about 1832, in the Tate Gallery (1981), **35**, is but the final stage of a progress through nearly a dozen drawings and engravings, of a design to which Turner acknowledged an especial debt.[115] In the final delicacy and brilliance of the Tate oil we recognize the arrival, after a long metamorphosis, of 'the powerful King of Day, Rejoicing in the East', announced in the passage from Thomson's *Summer* (ll. 81–2) which Turner appended to the title of the blue and brown

Norham drawing at the Exhibition of 1798, **33**. Similarly, *The Fall of the Clyde*, which became, like *Norham*, a *Liber Studiorum* subject, may be traced to the large and dark drawing now in the Walker Art Gallery in Liverpool, exhibited in 1802, **16**, which seems to have been used by Turner as an illustration to one of the Perspective Lectures.[116] The design exists in other early drawings, but it was also the subject of two late prismatic oils, one of which is in the Lady Lever Gallery at Port Sunlight, **17**, which show the naiads to be indeed 'powers of nature, according to the doctrine of the old mythological poets, concerning the generation of the gods, and the rise of things', outlined in Akenside's *Hymn to the Naiads*, to which Turner referred in the 1802 Academy catalogue.[117] A fuller discussion of the implications of this attitude and development belongs to the study of Turner's colour-symbolism later; here it must simply be stressed that it was a thoroughly practical issue. In 1849 Turner made the point of his new vision even more sharply by taking an early marine from the collection of Munro of Novar and transforming it, in six days, into the impermanent prismatic brilliance of *The Wreck Buoy* (Liverpool, Holt Bequest, R. & B. pl. 126) which he then exhibited at the British Institution.[118] Among pencil sketches, it is noticeable that the method of the late drawings—for example the Swiss and Rhine series of 1841—abandoned the slow, uncharged recording which was characteristic of Turner's approach to new places before 1819, no matter how much they were subsequently compressed and concentrated in the process of vision. The same is true of colour: after 1820 the earliest phases of artistic response are increasingly left out, and we are presented with an image which is, from the first, astounding in its purity. But, as Turner's recorded remarks suggest, it was not art, but nature, that led him to the final style.

2 Turner and engraving

Although the literature on Turner's work for engravers—more properly, theirs for him—has long been more comprehensive, more detailed and more exact than that on any other aspect of his art, the light it may throw on his attitude to painting in general has been neglected since C.F.Bell's excellent essay of 1903.[119] Yet it may easily be understood that the instruction of engravers necessarily forced Turner out of his customary reticence about his art in a way that no other occasion could do; and it remains true that the correspondence with Wyatt, Miller and others, and the long series of heavily touched and annotated proofs, especially for Cooke's *Southern Coast*, are the most thoroughgoing and immediate record of the painter's aims that we have, not least with respect to the general problem of light and colour. As such they hardly deserve the oblivion into which they have fallen.[120]

Turner's conscious striving for brightness and clarity of tone may be traced in engravings long before it becomes insistent in paintings or drawings. Bell noted that as early as 1800, in the *Chapel and Hall of Oriel College* in the Oxford Almanack series (R. 39), the young Turner ventured to correct the work of the far more experienced engraver, James Basire, in black and, chiefly, white; and on a proof of *Christ Church Cathedral* of 1811 in the same series (R. 47), the painter not only lightened the clouds, but gave what appear to be the first written instructions to an engraver, outside the *Liber*, on the accurate drawing of architectural detail.[121] The dual preoccupation with light and with significant detail was a constant one in Turner's art, although it has too often been separated by partisan critics. In the letter to the engraver Jack Girtin, written about 1807, Turner asked, 'Let me see how the sky can be made to clear out, like a grain of aquatinta . . . As long as you can maintain clearness, be not timid as to depth; regard only the gradation of the shadows.'[122] Similarly, in a note to Thomas Lupton on a worked-up etching of the unpublished *Liber* plate, *Ploughing, Eton* (R. 79), Turner wrote of the very different mezzotint process, working from dark to light: 'any way would make it better if brighter'.[123] 'You can see the lights,' said Turner delightedly to John Pye, of his first engraving for the painter, *Pope's Villa*, published in 1811 (R. 76), **43**, 'had I known there was a man living could have done that, I would have had it done before.'[124] On a proof of *Gledhow* (1816; R. 87) in the British Museum, noticed by Bell but overlooked by Rawlinson, which offers an early example of extensive scraping on the clouds and foliage, and chalk touches for the more atmospheric lights, Turner wrote to George Cooke: 'Pray make the lights produced by the scraper very brilliant—

every thing depends much upon their clearness the chalk more for general tones', and below he wrote a note on the addition of a window to the house. Sometimes we can see clearly that the need for light was of radical importance in determining the composition of an engraving. In 1825 or 1826, the painter wrote to Cooke on a proof of *Dover from Shakespeare's Cliff* in the *Southern Coast* series (R. 126), 'The sky is so unequal and in streaks that I must propose Clouds by way of Relief from the heavy tone the said lines give it. The whole of the Castle Hill is too dark—keep therefore the lights bright and clear.'

Turner's close control over every stage of an engraving, from the drawing until the final printing, became legendary;[125] and from 1811, with *The Junction of the Severn and Wye* in the *Liber* (R. 28) he himself practised engraving in mezzotint and aquatint. He also seems to have taken an interest in the new technique of lithography from about 1820, although no plates by him in this method are known at present.[126] The first lithograph after his work, by another engraver, appeared in 1823 (R. 833). A capacity and feeling for the mezzotint process, working as it did from the darks to the lights, is not surprising in a painter one of whose most original contributions to watercolour technique had been the extensive wiping out of lights from the fluid mass of rich, dark, wash. A mezzotint by Turner himself, like the *Inverary Pier*, published in the *Liber* in 1811 (R. 35), **12**, offers in its many stages a complete parallel to the production of watercolours and oils, from the first 'rough'; and in the amazing transformation of the lighting in its sixth state, **13**, it becomes as dramatic a subject of atmospheric expression and variation as, say, the first two pages of the *Como and Venice* sketchbook. As John Pye noted, it is wholly inappropriate to talk of 'states' in the normal sense of many of the *Liber* plates, for each one represents a new and independent artistic statement.[127] In the case of the *Liber*, the reserving of most of the proofs and many of the best published impressions of all states for himself, while yet producing new printings as late as 1845 to meet public demand, may be understood as an early example of that development of a representative collection of work which was to lead to the Turner Bequest. Some of the 'states' with erased marginal marks, which have sometimes been cited as a slur on Turner's honesty, never seem to have left his collection until the posthumous sales of the 1870s.[128] When the print-dealer Halsted was reproved by Turner for breaking up some of the *Liber* sets, since some of the plates sold better than others, the artist concluded, 'A pack of geese! a pack of geese! Don't they know what Liber Studiorum means?'[129]

The attitude of mind towards light and shade in art as being in a mutually creative relationship towards each other, and of the artist as virtuoso, demonstrating this relationship—an attitude which we shall later find so marked on Varnishing Days—is present in the process of engraving as early as 1814, in the production of *Lyme Regis* (R. 94) for

Cooke's *Southern Coast*. On a well-known touched proof, the third, in the British Museum, **14**, Cooke made the following note:

> On receiving this proof, Turner expressed himself highly gratified—
> he took a piece of *white chalk* and a piece of *black*, giving me the option
> as to which he should touch it with. I chose the white; he then threw
> the black chalk at some distance from him. When done, I requested
> he would touch another proof *in black*. 'No,' said he, 'you have had
> your choice and must abide by it.' [130]

But perhaps the completest evidence of Turner's conception of the purpose
of his art and style is that contained in the remarkable series of letters and
touched proofs to William Miller, in connexion with the large plate of
Modern Italy (R. 658), **15**, engraved between 1840 and 1842. On an early
proof, formerly in the Rawlinson collection, Turner wrote:

> You will see I have lowered the White Clouds and all the paper
> by Horl lines. If the chalked sky cannot be done I must advise the
> darkening of the left-hand upper corner and gradually down, to get
> more gradation in the whole sky. The whole of the paper excepting
> the Smoke and Road of the Campagna I have done by *Dots* and
> divided most of the light forms into 2 or more, and make it all more
> flat which gives more value to your front and middle work.

Of an area of foliage in the bottom left-hand corner, Turner added, 'Make
this into a bird's nest with eggs'.[131] Shortly before his departure for Switzer-
land, probably in July 1841,[132] Turner sent Miller another proof, now in
the British Museum, with the notes:

> I have sent you back this which you can return again for you have
> not carry'd out all my remarks, and I have touched the sky differently
> from the last one, so that you have two ways for your guidance, this
> being touched with Chalk, the last with pencil. If you cannot do all
> the chalk by burnishing out, for fear of *making* the Sky rotten, then
> [use] the pencil'd one (the last). The whole of the white paper must
> be taken away, but be sure you do not break it up into harsh parts,
> or bits of white or shadow—for it is now too heavy and not quiet
> enough, and takes away the value of your work below. The Horizon
> must be more blended together in fact wholly lost in one tone over the
> Campagna, and you have a marked distinction of line and strength—
> marked 1 and 2, and leave 2 a light spot—perhaps you may be able
> to work these two remarks together for the sky.
> Now for the rest of the Chalk below, viz. the Spray from the water-
> fall below the bridge and small church and wall, and the Rays—they
> will relive [*sc.* relieve] you on this side of the plate, and I agree with
> you that same power [?] &c. strongly would help the foreground, but

your work [is] too equally close to produce any decided markings, but you will find some try'd on the last proof for *touches*, and [on] this proof for breadth.

On other parts of the proof, Turner noted: 'All the white clothes single lines', and in the bottom margin, 'The water in the front close more in by lines and lose nearly all work and form. The Sky make more quiet and less in form so that it melts more into the Sky by the lower side of each cloud.' Turner required greater definition in the right foreground, of which he drew a new diagram, and noted, 'this part I must ASK you to take out particularly any appearance of the Rings at the upper part. I mean it for a bough sliver'd off and the broken part nearly white or only single lines'. And of the crumbling wall in the left foreground, he noted that it should be 'something like the corinthian Capital' with a 'Frieze of little . . .' [diagram of rams' masks], which were introduced into the published version.[133] Immediately on his return from the Continent, Turner wrote to Miller again:

Saturday October 22 1841

My Dear Sir

So much time for I only return'd from Switzerland last night since your letter and the arrival of the proof for Mr Moon has sent me *one*, that I hope you have proceeded with the plate, in which case it is evident you must take off *three* and mark the two for me—if you adopt the same medium of transfer—but I would say send them direct—my remarks would be wholly yours—and some inconvenience to both avoided—if you have not done anything take off one for me so now to business.

It appears to me that you have advanced so far that I do think I could now recollect sufficiently—without the Picture before me but will now will [*sic*] point out—turn over and answer your questions viz. if the sky you could put right you could advance more confidently therefore do not touch the sky at present but work the rest up to it. The distance may be too dark, tho' it wants more fine work, more character of woods down to the very campagna of Rome a base sterile flat much lighter in tone.

The question of a perpendicular line to the water pray do not think of it until after the very last touched proof for it has a beautiful quality of silvery softness what is only checked by the rock which is the most unfortunate in the whole plate—how to advise you here I know not, but think fine work would blend the same with the reflections of it with the water—this is the worst part and I fear will give us some trouble to conquer and if you can make it like the water in the middle of the plate I should like it better. The Houses above and particularly from the Figures, and the parts from and with the boys looking down are what I most fear about, which range all along

the rock and the broken entrance and the shrine want more vigour to detatch from the Town all the corner—figures &c. The foreground will be required to be more spirited and bold open work dashing *Wollett* [*sic.*] *like touches* and bright lights, so do all you can in the middle part and lower [?] part of the Town and leave *it* all for the present in the front. The *Figure* in front would be better with the white cloth over the face done by one line only [*diagram*] and perhaps a child wrapped up in swaddling clothes before him would increase the sentiment [?] of the whole. The ground on which she kneels [*and the . . . to the front wall* struck by T.] break with small pebbles or broken pavement—Now for the good parts—the greatest part of the sky all the *left side* the upper castle and Palace and partly round to the Sybil Temple—*Town* and procession on the right side and the water in the middle particularly good and I hope to keep it untouched if possible.

I am glad to hear you say I can have the picture after the first touched proof and [*trust* struck by T.] this long letter of directions will be equal to *one* and you will be able to proceed with confidence— write if you feel any difficulty and believe me truly yours

J.M.W.Turner

P.S. Very sorry to hear of the loss you have sustained.[134]

The reference in this letter to silvery water makes it likely that Rawlinson's second proof was sent soon after. It was inscribed:

I agree with you all this part [lower left foliage] wants fine lines between, but in the water I doubt it much. I do not think it looks so silvery as at first, therefore beg to let it remain. The little I have done to it, *fill* in the way you propose. In regard to the printing, the Sky looks perhaps better, but the distance and Castle is certainly cleared away too much.

All beyond the front Trees, procession and [] I want the work quieter and not broken into forms. I take away forms and you follow me not, but keep all the forms. Thus the foliage joins not with the [] and remains dotty or into too many parts all alike, and you get no tone or separation of one mass from the other. I do not want the last 3 or 4 figures to be known what they tread on, but a ray of less definite work or tone produced by filling in, but not in the Shadows. Make the Front touches broad and decidedly strong.[135]

Turner continued to instruct his engraver during the following year, and wrote on 24 June 1842 that he had done everything before his summer trip, 'so make all haste possible to get your plate finished *first* and foremost'; on 9 July he wrote asking Miller to see the plate through the press: 'Your proof shall be touched immediately it arrives in Queen Anne Street.'[136]

46

The last surviving communication from Turner to Miller, a letter of 10 December 1842, shows the painter's continued anxiety for the plate, the last proof of which he had touched, 'more especially to meet your wishes expressed in your last letter'. He closed: 'I declare that not having seen your amended proof of my touched proof since that, I consider the Plate of Modern Italy unfinished'.[137] The plate was advertised as ready for sale on 1 January 1843.

I have given the history of this engraving in some detail not because the existing accounts are inaccurate, but because it demonstrates very fully two aspects of Turner's aesthetic interests which have not often been considered together: that he was concerned equally and passionately with the formal content of his work, and with the language of symbolism which was to be embodied in these forms. I shall attempt to show in later chapters that these two aims were of equal value, too, in the history of Turner's colour. What precisely has Turner's engraving, and his attitude towards it, to do with his colour? The relationship of coloured drawings and paintings to monochrome engravings, and the great rarity of coloured engravings after his work, has puzzled some of the painter's critics. Bell surmised that Turner continued to supply his engravers with watercolours after it had become usual to prepare drawings in sepia for engraving, so that he might sell them later,[138] and Rawlinson felt that the almost complete absence of coloured engravings was due to Turner's inability to adapt after his early training for work in black and white.[139] Neither argument is convincing. Although only a small proportion of the drawings for Cooke survives in the Turner Bequest, by far the majority of the drawings of the following decade, for vignettes and for the *French Rivers* series, is to be found there; and we know that Turner was especially anxious about their fate.[140] If we are to believe Thornbury's account of the price paid by Fawkes for the *Rhine* series of 1817, Cooke's more detailed drawings could have been sold elsewhere for far more than Cooke was himself charged.[141] The *Liber Studiorum* enterprise, which occupied Turner from 1806/7 until at least 1823, can hardly have left him unfamiliar with the making of monochrome drawings for prints; nor does his own use and supervision of a whole range of engraved techniques make it likely that he would have been unable to adapt to new processes. Something of an answer may lie hidden in Bell's reference to the 'showily tinted prints', like Ackermann's *Microcosm of London*, which were being produced in the early years of the century, but which Bell relates rather strangely to Turner's rejection of *monochrome* aquatint as a technique for *Liber Studiorum*.[142] More directly comparable, perhaps, to his work was the series of coloured aquatints of English landscape issued in Bowyer's *England* in 1805/6 by Turner's early associate, Loutherbourg. These prints are fine examples of their kind, but they fully justify the epithet 'showy' by comparison with the rich and subtle resonance of the sepia *Liber*. In the case of the handful of colour aquatints and chromo-lithographs produced after Turner's work in his

lifetime, we know of none of the close control of their production characteristic of the line-engravings and mezzotints; and the distinct but related instance of the coloured examples of Charles Turner's large plate of *The Shipwreck* (1806–7; R. 751) shows that the painter's nice feeling for colour would not allow their production to pass out of his hands. According to the agreement with the engraver, who was also the publisher of the print, any tinted impressions were to be 'under the direction of the artist'; and in a note of 1810 to Charles Turner, he rated him for selling some prints apparently not coloured by himself, 'when Mr C.Turner agreed that none should be coloured but by J.M.W.Turner only'.[143]

The production of coloured prints either mechanically or by hand-tinting was fraught with difficulties in the early nineteenth century; and Turner's rejection of it can best be understood, I believe, if we look at something of the tradition which the artist inherited. The crucial question was that of colour-reproduction, with which Turner was directly concerned both as a student and as a teacher. That no engraved technique was adequate to colour-reproduction must have been clear to him from many instances in his youth.

The practical problems of the three-colour theory were first raised in the eighteenth century in connexion with the colour-engraving process of J.C.Le Blon who had firmly established red, yellow and blue as primaries. Le Blon's work, chiefly portraits, was very influential; and it stimulated a long series of rival attempts. His chief French rival, Jacques Gautier d'Agoty, claimed that the theory in its simplest form was unworkable, since a black key-plate was essential, and Le Blon had been obliged to finish much by hand. D'Agoty stressed that in his own work he was printing pictures and not simply producing coloured prints.[144] The chiaroscuro wood-cutter, John Baptist Jackson, who sometimes worked from as many as seven blocks, and who, in the 1730s and 1740s, cut large reproductions of Rembrandt, Titian, Veronese, Tintoretto and Bassano oils, and of gouaches by Marco Ricci, emphasized that his method was the only answer to the fragility and poor wearing qualities of Le Blon's mezzotint plates, which made it almost impossible to produce many identical prints.[145] But his vigorous and handsome blocks, which Horace Walpole found 'barbarous bas-reliefs', were never reproductions in the real sense; and later efforts with metal plates were scarcely more successful in this.

And yet the need for accurate reproductions was constantly felt both by artists and collectors. 'Well coloured pictures,' wrote Sir Joshua Reynolds, 'are more in esteem, and sell for higher prices, than in reason they appear to deserve, as colouring is an excellence, acknowledged to be of a lower rank than the qualities of correctness, grace and greatness of character.'

> But in this instance, [he went on] as in many others, the partial view of reason is corrected by the general practice of the world: and among other reasons which may be brought forward for this conduct,

is the consideration, that colouring is an excellence which cannot be transferred by prints or drawings, and but very faintly by copies. The famous Holy Family of Correggio at Parma, was offered to the late Lord Orford for £300, but judging only from the print, which was shown to him at the time, he declined to purchase, although I, who have seen the picture, am far from thinking the price unreasonable. Yet, Lord Orford cannot be blamed for refusing to give a price for a composition that promised so little from the appearance of the print, though it was engraved by no less a man than Agostino Carracci.[146]

It may well have been this concern which led Reynolds to sponsor one of the later eighteenth-century attempts to establish the manufacture of colour-reproductions on a commercial scale, Joseph Booth's *Polygraphic Society*, founded in 1784. Booth acknowledged Reynolds's help in his pamphlet advertising the Society; the President's *Laughing Girl* was purchased especially for reproduction, and in the exhibition of 1792, his portrait of Fox was advertised as 'painted expressly for the Polygraphic Society'.[147] The quality of the reproductions was such that they still sometimes deceive in the sale-room, although contemporaries attacked them as 'wretched copies of good pictures';[148] but Booth could clearly not solve the problem of mass-production, for, as in the similar case of the earlier picture manufactory of Matthew Boulton in Birmingham, using the process of Francis Eginton, the need for extensive hand-finishing undermined the economics of the project, which was dead by 1800.[149]

Turner may have had direct contact with these enterprises in a number of ways. His work for John Raphael Smith will have brought him into general touch with the problem of colour engraving, for Smith was one of the leading colour-mezzotinters of his period; and in 1794, for example, he issued a *Christmas Gambols*, after Morland, printed in the three primary colours.[150] In 1801, returning to the print trade, he advertised 'a method of making Impressions from his own plates so to resemble OIL PAINTINGS as to be with difficulty distinguished, even by Connoisseurs, possessing that sort of brightness so much admired in Venetian Pictures'. The artists represented were Morland and Westall, and a contemporary writer noted that the invention 'savs the expense of glass, and will stand exactly like paintings in oils'.[151] Among Smith's pupils of the 1790s was Christian Josi, the completer and publisher of perhaps the most successful reproductive enterprise of the period, Ploos van Amstel's *Collection d'Imitations de Dessins d'après les principaux Maîtres Hollandais et Flamands*, issued in London in 1821.[152] It was in fact the reproduction of drawings which made greatest progress in London in the 1790s, from Earlom's *Collection of Prints after the Sketches and Drawings of . . . Cipriani* (1789) to John Chamberlaine's *Imitations of Original Drawings by Hans Holbein*, completed with the help of Turner's engraver, Lewis, a decade later. For all that Josi stressed Ploos's scientific studies with the prism in connexion with the prints after

Jan van Huysum's flower drawings, these appear to have been coloured by hand, as do others of more than two colours in the collection.[153]

Another associate of the young Turner, Loutherbourg, had lent his paintings for reproduction at the Boulton manufactory as early as 1777; and he was represented in the early nineties at the Polygraphic Society.[154] Loutherbourg's studio sale in 1812 shows that he, like Turner later, had been experimenting with lithography, which itself held out the possibility of a more accurate and uniform type of colour-reproduction. Turner's handbook, the *Complete Course of Lithography* published in English by Senefelder in 1819, echoed the advertisement of John Raphael Smith of 'copies so like oil-paintings that it is impossible to discover any difference between these copies and the original pictures'.[155]

Turner must then have been well aware of the many contemporary attempts to overcome the problems of colour engraving for the reproduction of old and modern masters. As a student he was certainly anxious for some sort of guide to colour. The notes on Poussin's *Gathering of the Manna* in the Louvre sketchbook (p. 26a) show that he was accustomed to studying from prints, as Reynolds had encouraged in the Flanders and Holland notes, even using them as a standard; and from the reference to Rembrandt's *Three Trees* etching in the *Backgrounds* lecture of 1811, we can see that Turner felt behind it the presence of an original painting to whose colour he felt perfectly qualified to refer.[156] In a note to a later draft of the same lecture, however, Turner told his students:

> In the subjects I intend to offer, I have only the opportunity of placing before you some of the subjects by Prints which may in some measure point out the general lines, some of the light and shadow of the subject, but the colour must be attempted by description.[157]

This difficulty helps to account for the strong emphasis on the describing of colour in the Louvre notes and in later analyses of pictures; but Turner also seems to have given some thought to the more direct expression of colour values through black and white engraving, during the preparation of the perspective lectures between 1807 and 1810. James Barry, in his lecture on colour, which Turner may have heard as a student at the Academy, and certainly read while preparing his own lectures, was at pains to show that the expression 'colour', used of prints, referred simply to chiaroscuro and not to hues.[158] Turner, however, taking up a seventeenth-century tradition of heraldic engraving,[159] sought in a long and curious passage, under the rubric 'Color' in an early (?) draft of the second lecture, to establish an elaborate system of correspondences between varieties of dotting and hatching and the colours for which they stood. 'Lines, he said, become the language of colors', and the system would allow prints to suggest to the student the colouring of a picture he had never seen.[160] Turner was attempting to offer an alternative to colour-printing, which had recently been attacked for its imperfections in

lectures by John Landseer, the engraver, who presented his old associate with a copy.[161] The attempt to provide an equivalent to colour in monochrome through the use of symbolic lines was not unfamiliar to Turner's contemporaries, like Lawrence, who explained to Thomas Moore in 1829 that an engraver 'can so *meander* his shadows as to convey (to the painter's eye at least) the idea of blue and (I believe) one or two other colours'.[162] George Field, too, was anxious to establish, on behalf of the engraver, a precise scale of colour values in terms of tone.[163] But I have found it impossible to trace examples of these precise colour-hatchings in Turner's engraved works; and it is easy to see that they would have been very constricting to the direction and expression of the line. His remarks may be seen as a passing speculation at a time when, in the increasingly complex instructions to the engravers of the *Liber Studiorum* and in his own activities as an engraver, Turner was becoming aware that the problem of colour must be approached in a very different way. His experience with the management of sepia drawings in engraving was almost certainly transferred to work from watercolours shortly afterwards, in the *Southern Coast* series, begun in 1812, where the painter's capacities as a teacher of engravers first became really conspicuous. This practical didacticism is of crucial importance for the understanding of Turner's career; in his attitude to engraving, as well as to painting, to poetry and to nature, the key concept of Turner's art is *translation*:

> It is inevitably [?] allowed that Engrav[ing] is or ought to be a translation of a Picture, for the nature of each art varies so much in the means of expressing the same objects that lines become the language of colors.

Turner is echoing Reynolds on Rubens and his print-makers, but the increase of experimentation with colour engraving in the Romantic period had made the question an urgent one for his contemporaries, engravers like Landseer and John Pye, and colourists like Delacroix.[165] For Turner himself it meant the foundation not only of a new school of instruction for engravers, but also the development of a new attitude towards his own art.

Bell rightly noted that Turner helped to train a school of landscape engravers in England; his further contention that he drew on a tradition established by John Britton is more open to question.[166] Britton's *Architectural Antiquities* may have contained excellent models for Turner's engravers about 1809; but Britton's best engraver, Le Keux, did not appear in Turner's circle until a decade later (R. 150); and of the rather casual list of suggested engravers for the *Oxford* pictures sent by Turner to Wyatt in the letter approving of Britton's publication, only one, Byrne, had ever worked for Turner before.[167] Turner's favourite engraver, with the possible exception of Pye, seems from his letters to have been the eighteenth-century interpreter of Wilson, Woollett,[168] whose school and

influence had long since faded with the increasing use of an etched rather than a graven line. We know that for the young engravers whom he mainly recruited, it was in working for Turner that they chiefly found their style, rather than the other way about. It is recorded of his most prolific engraver, George Cooke, that he was apprenticed to Basire in 1795, and only recovered from the neglect in which his master left him by the enthusiasm aroused by Turner's *Oxford Almanack* drawings four or five years later.[169] Similarly Thomas Lupton, one of Turner's best engravers in mezzotint, worked independently for the first time on the magnificent *Liber* plate of *Solway Moss* (R. 52) which survives in an exceptional number of proof states; and Lupton worked for Turner far more than did his master, George Clint.[170] That Turner's attitude towards his engravers was essentially that of a teacher we may deduce from the quality and quantity of his touched proofs; and we know from W.B. Cooke's account books of the 1820s that the painter also made corrections to Cooke's engravings after other artists' work than his own. Another young engraver, Edward Goodall, who first worked for Turner about 1821 (R. 198), records what Turner was able to teach of colour in black and white. Goodall asked how he should translate a piece of brilliant red in one of Turner's pictures (possibly the youth's cap in *Caligula's Palace and Bridge* [Tate Gallery 512] which Goodall engraved in the early 1840s [R. 653]); the painter replied:

> 'Sometimes translate it into black, and at another time into white. If a bit of black gives the emphasis, so does red in my picture.' And in the case of translating it into white, he said after brief reflection, 'put a grinning [*sic*] line into it that will make it attractive.[172]

For Turner, tones, like colours, came to have not an absolute but a relative value in terms of their pictorial function; and it is possible, in the nature of the case, to see the evolution of this mode of perception and feeling earlier in engraving than in painting. If we can trace the practical exploitation of tonal play to the *Liber Studiorum* about 1811, when Turner had just begun to lecture at the Academy, we may also find that his concern with colour-theory began far earlier than has usually been imagined; and that perhaps the development of practice and theory were very closely related.

Part II Theory

[W.H.Hunt] had had frequent opportunities of conversing with Turner, but never heard him utter a single rule of colour, though he had frequently heard him, like all great men, talk of 'trying' to do a thing. RUSKIN[1]

As Sir Joshua says, practice must in some cases precede theory. If not, too much time would be lost to obtain that theory, which would arrive too late for practice.[2]

3 Picturesque colour

Turner's artistic personality was essentially an intellectual one, but his earliest contact with the theory of painting, and especially with colour-theory, is not easy to plot. If the younger Malton took a sufficient interest in his pupil to put his father's textbook of perspective into his hands, Turner's lifelong distrust of colour-systems may well be traced to the sceptical and anti-Newtonian treatment of the subject set out there. The theory of colours, said Malton, could hardly be called a theory, 'which is so little known, and nothing of it demonstrable'; and again, 'To give or prescribe Rules, absolutely, for perfecting a Picture, in respect of Light & Shade, is as impossible as in respect of Colour'.[3]

But, whatever the possibility of the early development of these habits of mind, through his contact with the Monro circle and the Picturesque Movement Turner was deeply involved by the mid-1790s in what was, in English terms, a complex and comprehensive body of aesthetic theory. His remarks to Farington about Wales in 1798 and about Switzerland a few years later show that he had absorbed the Picturesque outlook and its terminology; and by 1809, as a passage in his notes to Shee's *Elements of Art* reveals, he had studied—and disputed—the conceptions of the most important Picturesque theorists, Uvedale Price and Richard Payne Knight. This much we are able to deduce from the documents; but the evidence of Turner's work from about 1794–5 shows that he was already in sympathy with, if not positively influenced by, Picturesque ideas of colour and handling which constituted perhaps the most articulate body of colour-theory in English art at the end of the eighteenth century.

Uvedale Price, in a discussion of the Beautiful, the Picturesque and the Sublime in colour, concluded:

> There are many [colours] which, having nothing of the freshness and delicacy of beauty, are generally found in objects and scenes highly picturesque, and admirably accord with them. Among these are to be reckoned the autumnal hues in all their varieties, the weather-stains, and many of the mosses, lichens, and incrustations on bark, and on wood, or stones, old walls, and buildings of every kind; the various gradations in the tints of broken ground, and of the decayed parts in hollow trees.[4]

With this Picturesque ideal of rich sobriety, Knight and Gilpin, who in his own work as a painter was particularly shy of chromatic display, substantially agreed.[5] Turner's contact in 1792/3 with the work of Girtin and ruin-painting, and with that of Dayes and Thomas Hearne, who had

illustrated Knight's Picturesque poem, *The Landscape*, in that year, adequately accounts for his development of a thoroughly Picturesque style of colouring. But a more general light on Turner's Picturesque sympathies as a colourist, and particularly on his use of a far more sombre palette than hitherto for the 'Sublime' subjects of 1799 and after, may be found in what is perhaps the most sustained account of Picturesque colour, the *Letter on Landscape Colouring* by William Gilpin's brother, Sawrey, the animal painter. Turner's direct contact with Sawrey Gilpin cannot be placed definitely before October 1798, when the latter, himself only recently and belatedly elected to the Academy, promised his support for Turner's candidature as Associate.[6] But Gilpin and Turner were soon on very close terms. In 1799 Turner exhibited a drawing entitled *Sunny Morning—the cattle by S. Gilpin R.A.*; and the watercolour which he showed in 1811, *Windsor Park, with horses by the late Sawrey Gilpin, Esq.* (TB LXX, G), seems to belong in style to about this time. Turner owned a number of animal drawings by the artist (TB CCCLXXX, 6–8; cf. TB CXXIX, p. 8); and evidence for an interest in him as early as 1795–6 has recently appeared in the form of some annotated drawings by Turner, copied from *The Passions of the Horse*, appended by Sawrey Gilpin to the second volume of his brother's *Remarks on Forest Scenery*.[7] Thus in the second half of the 1790s, Turner is very likely to have come into contact with the conceptions of Picturesque and Sublime colouring set out in Sawrey Gilpin's *Letter*, which is now among the Gilpin MSS in the Bodleian Library, Oxford.[8]

True to the eighteenth-century tradition to which he belonged, Gilpin distrusted rules for colour: he could give, he said, only 'loose hints'; but he nevertheless divided landscape colouring firmly into two categories, the gay and the modest, the latter of which was more susceptible to rule, and must prepare the ground for the former, in cases where the painter was not certain of his effects.[9] Both gay and modest colouring, for Gilpin, connoted *richness*, 'by which I mean mellow colouring . . . [which] rather points at the tones & degree of strength than at the variety of the tints'; and he asked that colours should be used purely, 'as nearly as possible in their native strength & beauty, whether the tints of the Picture be many or few. It never suffers a third colour to be added, if two can be found which will form the tint, nor will it allow of *any* mixture where a simple colour will answer the end.'[10] This preoccupation with clean, unmuddied colours is one which concerned Turner until the end of his career. But it is in Gilpin's remarks on the emotive content of colouring that we come closest to understanding Turner's darkened palette towards the end of the nineties, and its persistence until about 1811 (*Apollo and Python* TG 488), **44,** in his grandest designs.

> Gay colouring [wrote Gilpin, drawing on Burke on the Sublime] seems better adapted to the Pastoral than the Heroick style of composition; familiar subjects, such as cultivated landscape, Pasture

Lands interspersed with clumps of trees & cottages, and the generality of common view [*sic*] often require the utmost efforts of varyed colouring to form them into Pictures. In these subjects, too, the Painter is often obliged to have recourse to the incidents of smoak, dust, & to soften the unavoidable repetition of hard edges, or to force effect by opposition, or lastly by an artfull management, to give an air of originality which I think should be part of his aim in every performance. The more elevated species of composition (where gloomy woods, vast lakes, stupendous Rocks, thundering Cascades [*and such like*, struck through by Gilpin] are the effects) appears with a more becoming dignity in modest clothing. Salvator Rosa was a rich colourist, yet seldom coloured gayley . . .[11]

The 'gloomy woods' of Turner's *Rizpah Watching the Bodies of her Sons* of about 1802 (TG 464), **46**; the 'vast lake' of *Buttermere* (TG 460; R. & B. pl. 7) exhibited four years earlier; the 'stupendous rocks' of the *Warkworth Castle* watercolour, **45**, shown in 1799 and now in the Victoria and Albert Museum, or the *Dolbadern Castle*, **37**, his *pièce de reception* at the Royal Academy, of 1800, with its gloom and Salvator-like glints of armour; the 'thundering cascades' of the *Reichenbach* watercolour, dated 1804, at Bedford: all these show how much sympathy Turner felt for Gilpin's conception of the Sublime palette; and it was a sympathy soon to be deepened by the experience of Poussin's *Deluge*, and of Rembrandt.

Gilpin's doctrine of harmony, and how it was to be achieved technically, was one which infused Turner's practice of grounding and colour-beginnings from the late 1790s. It would, said Gilpin, 'necessarily bring the whole of a Picture under the regulation of one Master-tint, or key-tone, which in landscape I think should always be taken from the etherial or unclouded part of the sky; whatsoever colour this inclines to, whether greenish, greyish or purplish, the whole of the Picture must partake of it.'[12] Later, he went on:

The *warm* & *grey* tints in each separate ground should not be dappled or spotted over the whole of that ground; on the contrary they should be conformable to the grand rule of massing . . . [and] the consequence of the above method will be that throughout the Picture the greatest part of the surface of each painted object will be of a tint perhaps foreign to the natural colour of that object; thus a tree or perhaps a whole clump of trees may be painted brown, or grey; yet by a few olive green, & yellow tints properly applied as lights, & reflections upon the edges, here a dab, there a dot, a plump or a feathery touch as occasion requires, the whole shall be made to play upon the eye, the absurdity will vanish, the variety introduced pleases and becomes natural.[13]

Gilpin's talk of a key-tone was in almost precisely the same terms as Turner's later discussion of Veronese's colour, and the colour-massing he

advocated can be found under the rich surface texture of many a Farnley gouache or in *England and Wales* drawings as late as the 1820s and 1830s. But the emphasis on modesty, renewed at the close of Gilpin's *Letter*, is what helps us to place Turner's practice between approximately 1795 and 1810 firmly in a Picturesque context, understanding Sublime as a category of the Picturesque in its broadest sense. Not that all of Turner's work of the late nineties falls within this category: some of the *Wilson* and *Fonthill* sketches of 1798–9, and marines like the Wantage *Sheerness*,[14] probably exhibited in 1808, are far from sombre; and, technically, Turner's palette owed as much to Wilson and Poussin as to Picturesque theory. But it was the direction of his interests, and the uses to which he put his colour that surely betray the impetus which Picturesque discussions could have given him; they were his first contact with a rational approach to colour problems, which was to affect his teaching and practice so much after 1807.

Possibly the only element of Picturesque aesthetics which has hitherto been related to Turner's practice as a colourist is that tendency towards abstraction, stated most clearly by Uvedale Price in his *Dialogue on the Distinct Characters of the Picturesque and the Beautiful* of 1801:

> I can imagine, said Mr Howard [Richard Payne Knight], a man of the future, who may be born without the sense of feeling, being able to see nothing but light variously modified, and that such a way of considering nature would be just. For then the eye would see nothing but what in point of harmony was beautiful. But that pure abstract enjoyment of vision, our inveterate habits will not let us partake of.[15]

Price's idea was one which developed contemporaneously in France and Germany, as well as in England, from Berkeley's theory of vision and from the recognition and study of aesthetics as a distinct branch of philosophy; and it contributed towards the early appearance of a doctrine of art for art's sake. Thomas Phillips, Professor of Painting at the Royal Academy and one of Turner's later friends, derived the idea of the Picturesque itself from the principle that blotches of light and shade or colour by themselves 'are often found to produce ideas affecting to the mind; the imagination supplying the form'.[16] Turner, however, remained opposed to this type of thinking: for him the chief values in art continued until the close of his life to be 'sentiment', 'truth to (objective) nature' and the power of the association of ideas through specific imagery. Painting, for Turner, was essentially another word for language.

The idea that he was affected by the compositional aid of blotting, developed in the eighteenth century by Alexander Cozens, has the sanction of Turner's earliest biographer,[17] as well as a charming and perhaps authentic story from Joshua Cristall of the painter among the children of his painter-friend Wells at Knockholt, probably about 1807, when he got them to rub their fingers on cakes of the three primary colours and dabble

them over the foreground of an unfinished drawing, to which he then 'added imaginary landscape forms, suggested by the accidental colouring, and the work was finished'.[18] Certainly, during the period of Turner's early career, Cozens's blot principle of composition was extended to colour, in Mrs Gartside's *Essay on a New Theory of Colours*, which advised that, 'The best way to get over the difficulty [of commencing a picture] after you have made your drawing, and considered what parts you mean to come forward, and which to retire, is, to make a blot, of such colours as your subject allows you to introduce.'[19] Turner's own watercolour sketches often show considerable traces of fingering; and in the later sketchbooks especially there are many drawings which have all the character of blots. Of about the time of the Knockholt story is a luminous little river scene, unpencilled, in the *Finance* sketchbook; and later conspicuous examples are in a *Thames* sketchbook of about 1825, and in a group of notebooks, all containing erotic subjects, which belong together and seem to have been in use about 1830.[20] Yet it is precisely in these books that we are closest to Turner's need to be specific, his care for controlled expression, and the element of improvisation is minimal. The whole structure of Turner's artistic life: the yearly tours, the constant reassessment of long familiar sites, show that he had little desire or need for what Cozens called landscape 'invention'. Cozens's rather confused idea of the relationship between the generation of compositional ideas through accidental conformations of blots, and the traditional schemata which the artist is required to impose on these conformations,[21] may be contrasted with Turner's constantly reiterated belief in the necessity of continued study and application to nature. If Hoppner and Fuseli referred to Turner's 1803 Academy exhibits in the fashionable terminology of abstraction or the blot,[22] as later critics were to cite the Kaleidoscope or the prism, they scarcely intended a compliment; nor can they have seriously understood a large element of improvisation in works which rested, as these did, on a complicated series of sketches and preparatory drawings. Turner's remark that 'I never lose an accident' does not allow us to infer that he cultivated them; and Ruskin located the emphasis correctly when he commented on it:

> It is this not *losing* it, this taking things out of the hands of Fortune, and putting them into those of force and foresight which attest the master. Chance may sometimes help, and sometimes provoke a success; but must never rule, and rarely allure.[23]

In a treatise on fabric-printing which Turner owned—not necessarily as soon as it was published in 1795, but which may be evidence for his early interest in colour-design—the author, so far from advocating an abstract approach to composition and harmony in the manner of Mrs Gartside, recommended that pattern-makers take the best history-paintings as models for floral arrangements, 'by supposing each figure a flower, and

the back ground, the attributes, and other appendages, as leaves or ornamental parts'.[24] Open as he was to the influences of the Picturesque aesthetic, the most peculiarly English form of abstraction, Turner might well have introduced at least a modified form of it into his teaching, or allowed it to colour his approach to his own work. That he did not do so, but rather chose to follow a rival, associationist, school of philosophy (even in some of those very works whose startling economies have invited critics to use the language of abstraction) and to underline the symbolic and literary ends to which his language of colour and form were directed, must profoundly affect our judgement of Turner's achievement as an artist, and not least, as a colourist.

4 The criticism of the Old Masters

How right Turner was in telling me that criticism was useless. RUSKIN [25]

Turner's remarks on the function of reproductive engraving suggest that for him and for his students, the only reliable source for the understanding of colour in painting was the examination and copying of the works of the recognized masters themselves. In the loan exhibitions at the British Institution from 1806, where artists of the standing of West and Constable continued to study as late as 1819, and in the Painting School of the Royal Academy from 1815, the teaching of the techniques of painting was largely conceived in terms of copying. Turner's analyses of Old Master paintings was very much concerned with their *facture*; and it is clear from this, as well as from the not uncommon practice of following a criticism with an 'improved' version of his own,[26] that he regarded the study of earlier art as a primary source of instruction for his own work. Hence his attitude towards the Old Masters is of great importance for our understanding of his colour technique; but it must be said immediately that the recording, even the analysis, of Turner's remarks on earlier painting, and the evidence of his own collection of it, do not, by themselves, allow us to reach firm conclusions about the particular direction of his interests, for, as in the parallel case of an artist like Delacroix, these notes and this collection were thoroughly eclectic. But, as in the case of the Altieri Claudes, some of Turner's remarks on the Old Masters betray attitudes of mind which were influential for his own development.

Turner's first recorded analyses of Old Master paintings are to be found in the *Small Calais Pier* and *Louvre* sketchbooks of 1802 (TB LXXI, LXXII), where he copied and commented upon works by Titian, Poussin, Rubens, Ruisdael, Domenichino, Vandyke, Guercino, Mola, Raphael, Correggio and Rembrandt. The fact that these are the first surviving commentaries, apart from copies, is itself surprising, for by 1802 Turner must have been familiar with a good half-dozen English private collections,[27] which offered him a wide experience of Italian, Flemish and Dutch pictures; and at least as early as 1798 he had begun to make copies from Old Masters, beginning with Poussin. In this year, too, he began to assemble a collection of his own, beginning not, as might have been expected, with English watercolours, but with classical figure sketches by the History Painter, Charles Reuben Ryley, a pupil of J.H.Mortimer.[29] This conjunction of interests was less surprising than it may now seem; Turner's early associate Edward Dayes, for example, had maintained his early interest in heroic landscape and historical subjects throughout his career as a topographical draughtsman;[30] and the Girtin Sketching Club, founded at the end of the 1790s, dealt frequently with figure or historical landscape subjects derived from literary texts. Hence it is less remarkable

that very few of the pictures studied by Turner in Paris in 1802 were purely or even predominantly landscapes; and that in another sketchbook in use immediately before, and during, the French trip (TB LXXXI), there are drawings for a dozen history pictures or historical landscapes, which, in the case of at least the *Hero and Leander* (TB LXXXI, p. 57; oil: TG 521), continued to occupy Turner's attention as late as 1837.

Although they are the first of their kind surviving in Turner's manuscripts, the Louvre notes are remarkably complex and assured. They show that in 1802 he was concerned with colour both as a reflection of nature, as a means of pictorial harmony and as a vehicle of expression. Of the picture then known as *Titian's Mistress* he wrote, (p. 24), 'A wonderful specimen of his abilities as to natural color, for the Bosom of his Mistress is a piece of Nature—in her happiest moments.' Rubens's *Tournament*, on the other hand, was 'one continual glare of colour and absurdities when investigated by [the] scale of Nature, but captivating; so much so that you [are] pleased superficially, but to be deceived [?] in the abstract', (p. 78). Turner seems to be using 'abstract' here to refer to an underlying *rationale* recognizable on closer examination. He adjudged Poussin's *Gathering of the Manna* to be

> The grandest system of light and shadow in the Collection. The figures of equall power ocupy the sides and are color'd alike. They carry severally their satellites of color into the very centre of the picture, where Moses unites them by being in blue and Red. This strikes me to be the soul of the subject, as it creates a harmonious confusion—a confusion of parts so arranged as to fall into the sides and by strong colour meeting in a background to the side figures which are in blue and yellow, so artfully arranged that the art of causing this confusion without distraction is completely hid (p. 26a).

Turner was already aware of colour contrast—the white in Domenichino's *Mars and Venus* 'is highly useful, for it gives the flesh a colour by its own chalkiness' (p. 36); and in Titian's *Christ crowned with Thorns*, 'One small piece of Blue is admitted purely to give value to the warm colour by contrast' (p. 51).

None of these notes are exceptional in terms of their period; Turner's taste seems to have been very much that of contemporaries like West and Farington, Opie and Shee (only the second of whom was, however, a landscape painter) who were with him in Paris. But neither were they the sort of observations that could be a basis for generalizations; and Turner was almost invariably silent in the Paris conversations on art so assiduously recorded by Farington.[31] A more urgent and personal note is struck in Turner's repeated attempts to reconcile the demands of what he, following Reynolds,[32] called 'historical colour'—that is, a more conventionalized, abstract, use of colour, especially in draperies—with those of naturalistic colour, in unifying the sentiment of a picture. Of Guercino's

Raising of Lazarus, Turner noted: 'the sombre tint which reigns thro'out acts forcibly and improves [?] the value of this mode of treatment, that may surely be deem'd Historical coloring; which in my idea only can be applied where nature is not violated but contributes by a high or low tone to demand sympathetical ideas' (p. 54). And of the greatly influential *S.Peter Martyr* of Titian, **61**, of which Turner said 'the landscape, tho' natural, is heroick', he asked:

> Surely the Sublimity of the whole lies in the simplicity of the parts and not in the historical color which modulates [?] sublimity in some pictures where the subject and Nature must accord? Much has been said upon this subject more as an extenuation of an eccentric color than as a Beauty or rule. Tho' a [*sic*] charged with color it should be uniform and accord with the sentiments of Nature (p. 28).

The tendency of Turner's arguments is clear; nature must be the ultimate appeal of art; but natural colour was, for him, also a language of sentiment. This was an attitude of great importance for Turner's History pictures of the following decades. In Turner's own terms, his colour did not become less natural, but changed with his changing conception of the nature and sentiment of nature itself. One of these changes can already be found in germ in the Louvre notes.

In them we find for the first time evidence of Turner's interest in the prismatic principle of colour harmony, so much discussed in the years around 1800. Titian, in the *Entombment*, had, thought Turner, made the figures of Martha and Mary

> the Breadth and the expression of the Picture. Mary is in Blue, which partakes of crimson tone, and by it unites with the Bluer sky. Martha is in striped yellow and some streakes of Red, which thus unites with the warm streak of light in the sky. Thus the Breadth is made by the 3 primitive colours breaking each other . . . (p. 31)

Within a narrower compass, Titian's *Mistress* had her left hand 'granulated with primitive colours';[33] a technique of flesh-painting which echoes the contemporary practice of a Titianist like Washington Allston, who claimed that his method of painting flesh was substantially in agreement with the spectral analysis of George Field.[34] And in his eulogy of Rubens's technique in the *Backgrounds* lecture of 1811, Turner characterized the master's colouring as without shadow, 'obtaining everything by primitive colour, form and execution . . .'[35]

For the eighteenth century it had been Rubens, even more than Titian, who had brought perfection to the techniques of painting. 'He is by all allowed,' said Pilkington's *Dictionary* (1805), 'to have carried the art of colouring to its highest pitch'; and not only had he practised brilliantly but he had based that practice on a sound theory. Rubens's MS treatise on light and colour appears to have survived at least until the end of the century, although it has since been lost;[36] and its existence may perhaps

help to explain why his reputation as a colourist, which could thus be demonstrated both in theory and practice, so much overshadowed that of Leonardo until the early nineteenth century, although Leonardo's *Trattato*, with its detailed and empirical treatment of colour, was repeatedly translated and reprinted between 1651 and 1800. Leonardo's practice, and especially the darkened condition of most of his pictures and of those then given to him, did not support the idea of a great colourist: he was, in Fuseli's phrase, 'Fitter to scatter hints than to teach by example'.[37]

It is no longer possible to reconstruct Rubens's theory of colours on the basis of his writings; but, for the eighteenth century, it was clearly a three-colour system. The painter's biographer, Deschamps, included among the master's 'Maxims' the advice that in painting flesh, the strokes of colour should be placed separately side by side, and only lightly blended into each other; a practice which had been emphasized, probably from the same source, by De Piles.[38] De Piles referred to four colours, including green, but that by the middle of the eighteenth century Rubens's practice had come to be interpreted dogmatically in terms of the new three-colour conception of the primaries red, yellow and blue, is suggested by some remarks of Hogarth in *The Analysis of Beauty*:

> Rubens boldly, and in a masterly manner, kept his bloom tints bright, separate and distinct, but sometimes too much so for easel or cabinet pictures . . . The difficulty . . . lies in bringing *blue*, the third original colour, into flesh, on account of the vast variety introduced thereby; and this omitted, all the difficulty ceases . . .[39]

By the beginning of the nineteenth century, this interpretation of Rubens, reinforced by the newest developments of the three-colour theory, became even more insistent. Delacroix claimed that he had made it the basis of his whole career as a colourist. While he was attempting to render the red, blue and pale yellow of the drops of water on a torso in the *Barque of Dante* he had, he said, studied both Rubens's Medici cycle in the Luxembourg, and the optical principles of the rainbow; and it is very likely that he was stimulated to this, too, by examples of the rainbow in Rubens's series.[40] In England, however, Fuseli complained that Rubens's 'rainbow' principles were not carried out stringently enough in practice: 'he has not always connected the ingredients with a prismatic eye; the balance of the iris is not arbitrary, the balance of his colour often is' (additions to Pilkington's *Dictionary*, 1805). But his was the exceptional view, and in the 1830s, Henry Howard felt bound to modify considerably his account of the purity of Rubens's tints, which, he said:

> exhibit a peculiarity of treatment which we do not find in any other artist, excepting in some of his imitators. I allude to that decided separation of the flesh-tints into distinct stripes, lying side by side (a dissection of the local colour which is so remarkable in many of his works). His high lights are almost yellow; next to those a bright rosy

63

or deep red, as the complexion required; then a strong grey tint, almost blue, running into still warmer reflections. These, when viewed from a sufficient distance, whence they come in a blended state to the eye, acquire the tone and effect of Nature, and gain in brilliance from their crudeness.[41]

Rubens was, too, for Turner, a model of handling, for all his ignorance or wilful neglect of natural effect,[42] and in the small Old Master section of his own collection, which seems to have been chiefly a 'working' one, he had what purported to be a Rubens painting of *The Rape of Phoebe and Hilaria*, probably a copy of the *Rape of the Daughters of Leucyppus* in Munich.[43] I have been unable to isolate specifically Rubensian, or even, in the strictest sense, Titianesque, elements in Turner's early oil technique: so much may have been learned more directly from Reynolds or Lawrence; but the more generalized concentration on the prismatic aspect of their colour was, I believe, to have great resonance in the later stages of Turner's style.

The Louvre notes represent a good cross-section of late eighteenth-century taste in the Old Masters, with the notable absence of Claude, for reasons which I shall discuss later on. Although they do not reflect the whole of Turner's interests in Paris, only one omission will be mentioned at present, as it is important for the earlier stages of Turner's career: Paolo Veronese. Turner was certainly impressed with Veronese's *Marriage at Cana* in the Louvre, for he treated it in some detail in the *Backgrounds* lecture, where the artist was given more attention than any other painter, with the possible exception of Titian. Talking of the use of architecture in paintings, Turner referred to the *Marriage* as an excellent model, continuing:

> The centre is occupied by a sky of pure white and blue; the architecture light ton'd white marble pavement and the front squares of light colour'd ground without the least indication, or intention of shadow across such a space. The figures are wrought in the same high tone as the sky and each figure, single or grouped, relieved from the pure white cloth on the table by the several powers of primitive bright and full-toned colours. The only mass of shade exists in the architectural arrangements and the figures under the portico; without the shadow caused by the architecture, no balance or even shade could have been effected so effectively to show his consummate powers of producing so artful an arrangement of light and colour without the appearance of positive shadow or even of it being his intention.[44]

The passage, which is one of Turner's comparatively rare exercises in colour-analysis in this lecture—indeed in the first course generally—marks a new stage in the development of Turner's colour interests; and, characteristically, it can be matched in his own work. In the earliest surviving attempt to formulate pictorial principles: a long note on light and shade, of about 1808, in the *Greenwich* sketchbook,[45] Turner had drawn on his understanding of Correggio's *Notte*, of Rembrandt's *Mill* and

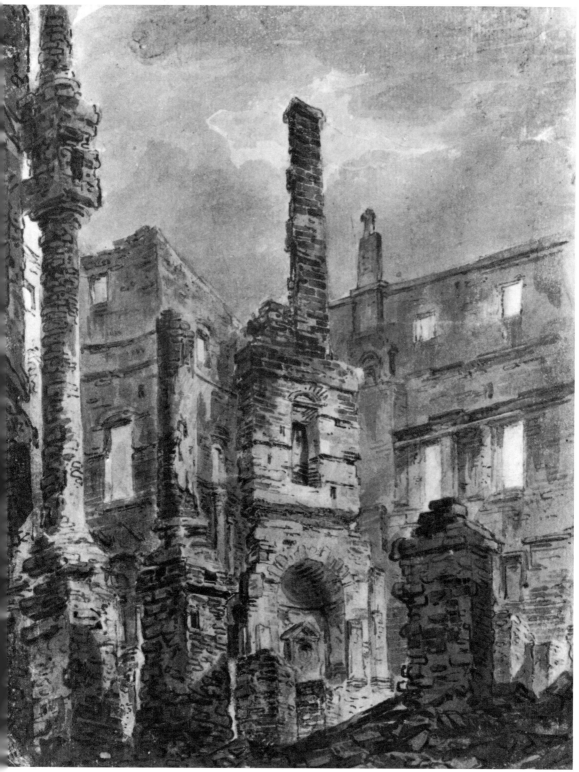

1 J.M.W. TURNER Ruins of the Pantheon, Oxford Street 1792
Watercolour $9\frac{3}{4}'' \times 7\frac{3}{8}''$ *British Museum, London* TB IX B

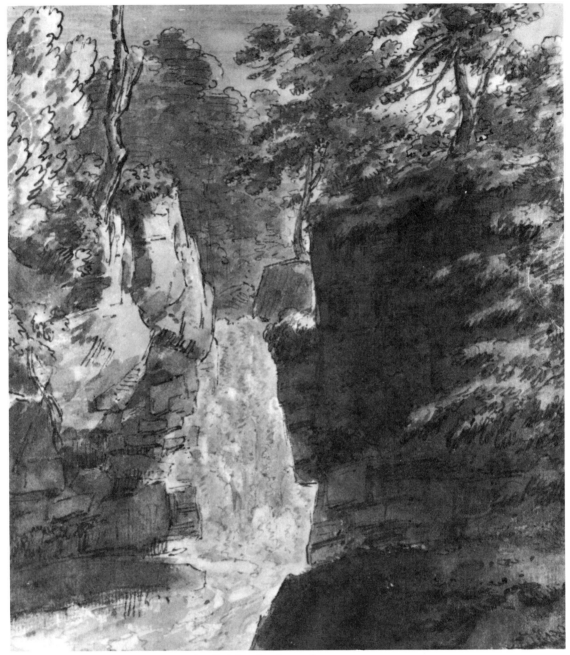

2 J.R.COZENS Eighth View upon the Reichenbach 1776
Watercolour $7\frac{5}{8}'' \times 6\frac{3}{4}''$ *British Museum, London* 1900-4-11-30

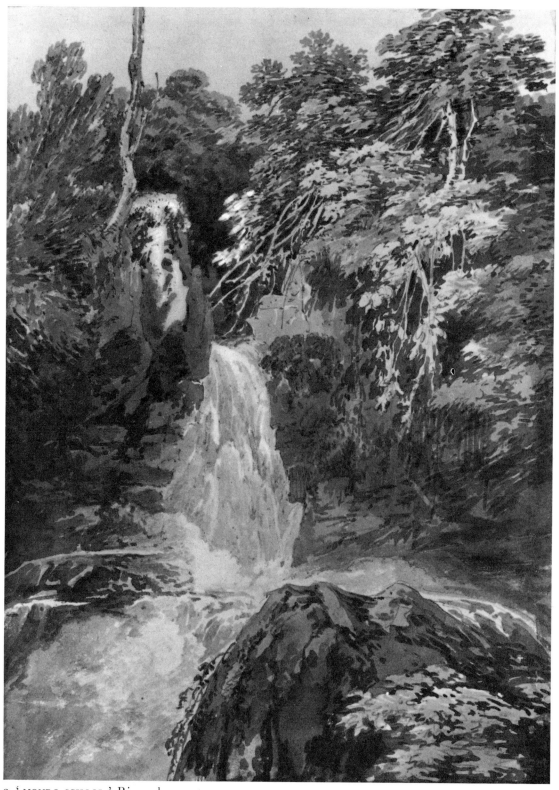

3 'MONRO SCHOOL' Riquenbac *c* 1795
Watercolour $9\frac{3}{4}''$ × $7\frac{3}{16}''$ *British Museum, London* TB CCCLXXIV, 4

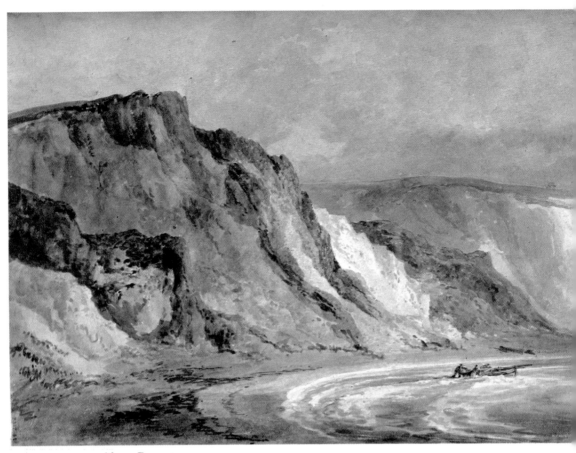

4 J.M.W.TURNER Alum Bay 1795
Watercolour 8″ × 10¾″ *British Museum, London* TB XXIV p 41

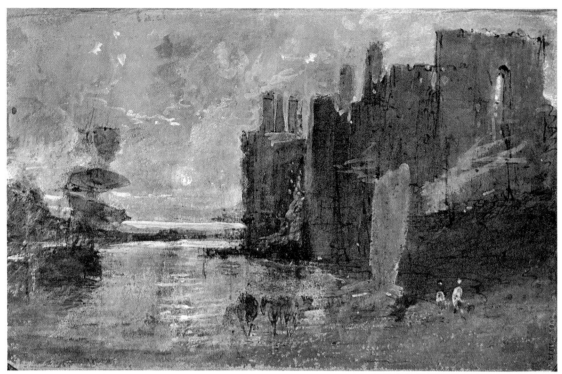

5 J.M.W. TURNER Caernarvon Castle *c* 1798
 Gouache $5\frac{1}{2}'' \times 8\frac{1}{2}''$ *British Museum, London* TB XLIII p 39a

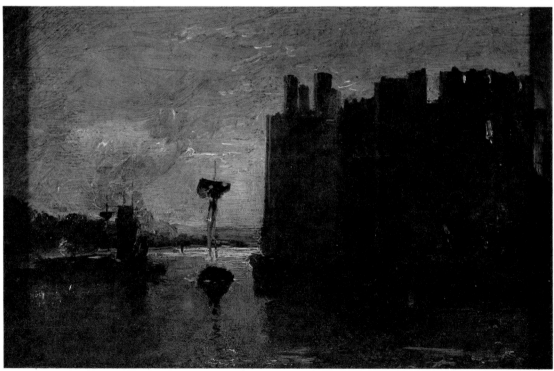

6 J.M.W. TURNER Caernarvon Castle *c* 1798
 Oil on panel $5\frac{1}{2}'' \times 8\frac{3}{4}''$ *Tate Gallery, London* 1867

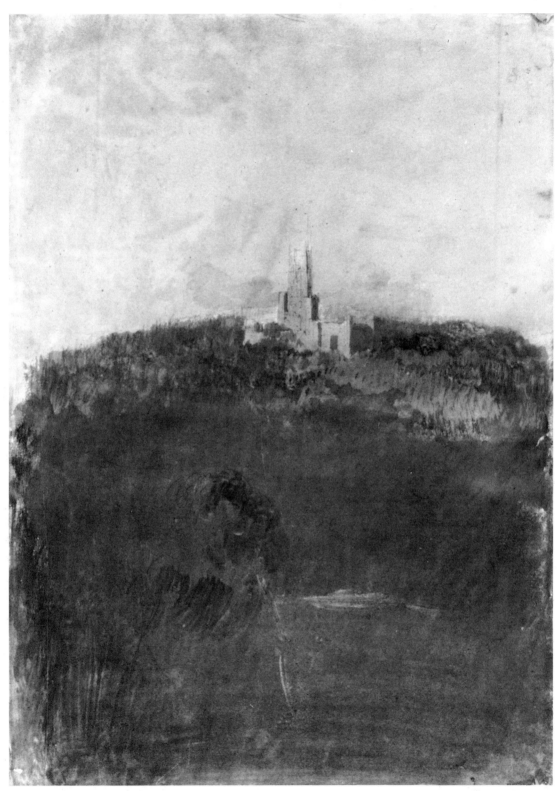

7 J.M.W.TURNER Fonthill Abbey 1799
Watercolour 18⅝″ × 13″ *British Museum, London* TB XLVII p 10

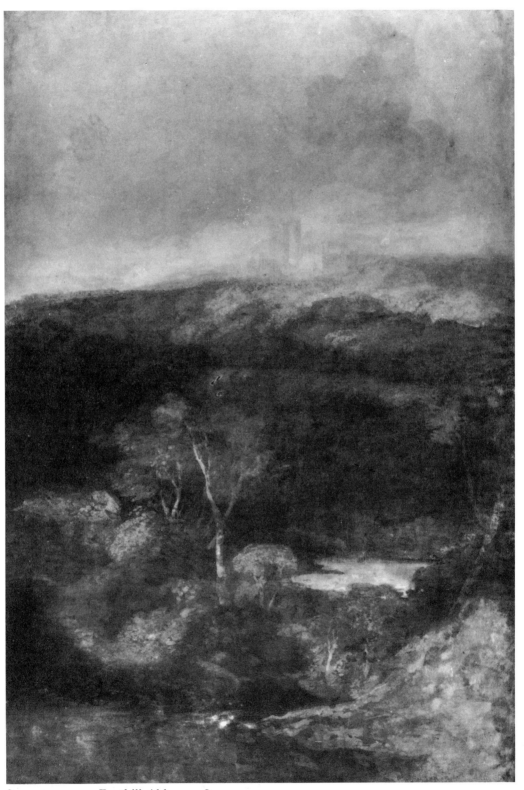

8 J.M.W.TURNER Fonthill Abbey *c* 1800
Watercolour 41½" × 28" *British Museum, London* TB LXX, P

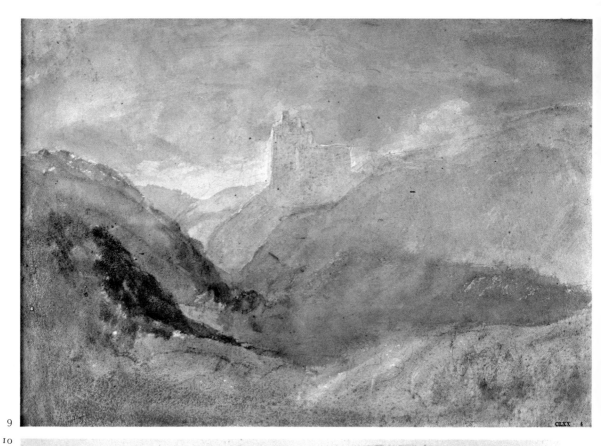

9

CLXX 4

10

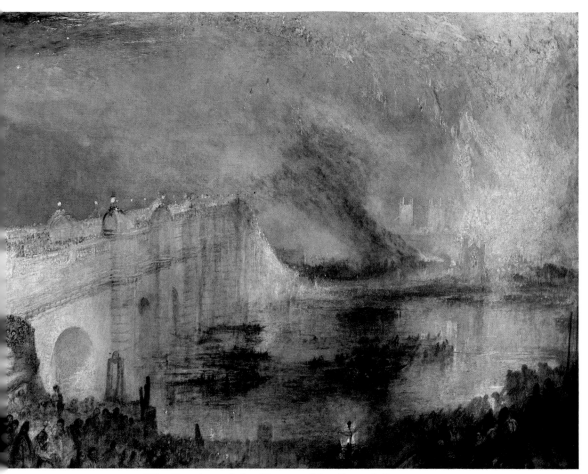

11 J.M.W. TURNER The Burning of the Houses of Lords and Commons
Exh. 1835, oil on canvas 36″ × 48″ *Philadelphia Museum of Art: John H. McFadden Collection*

Opposite
9 J.M.W. TURNER Crichton Castle 1818
Watercolour 7″ × 10⅛″ *British Museum, London* TB CLXX p 4
10 J.M.W. TURNER The Burning of the Houses of Lords and Commons 1834
Watercolour 9¼″ × 12¾″ *British Museum, London* TB CCLXXXIII p 5

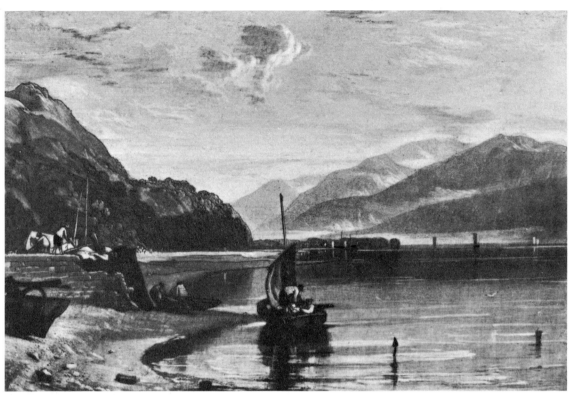

12 J.M.W.TURNER Inverary Pier, Loch Fyne: Morning (Liber Studiorum 35) 1811
Etching, aquatint and mezzotint. 2nd published state *British Museum, London*

13 J.M.W.TURNER Inverary Pier, Loch Fyne: Morning (Liber Studiorum 35) 1811
Etching, aquatint and mezzotint. 6th published state *British Museum, London*

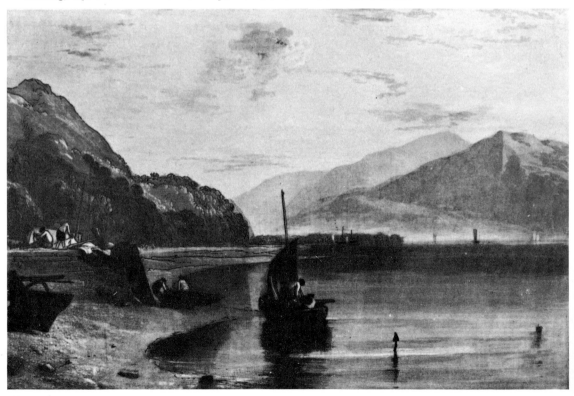

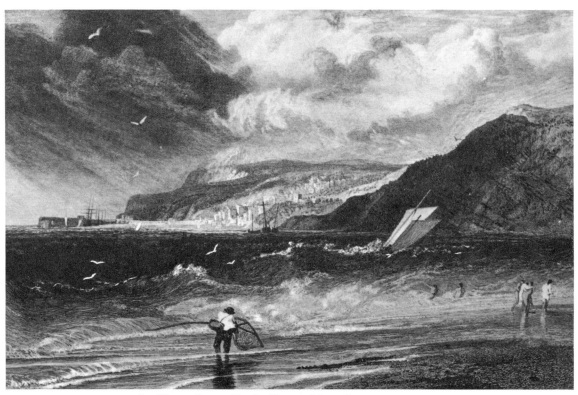

14 W.B.COOKE *after Turner* Lyme Regis, Dorsetshire 1814
 Line engraving, touched proof *British Museum, London*

15 W.MILLER *after Turner* Modern Italy 1842
 Published state *British Museum, London*

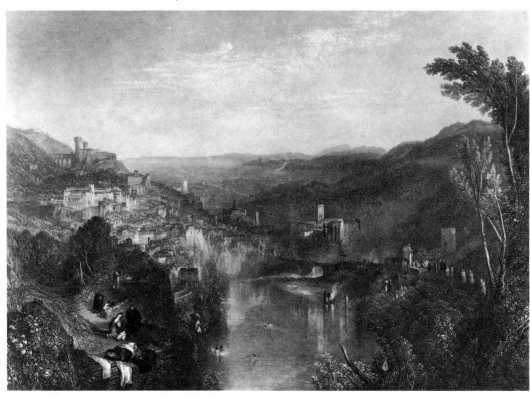

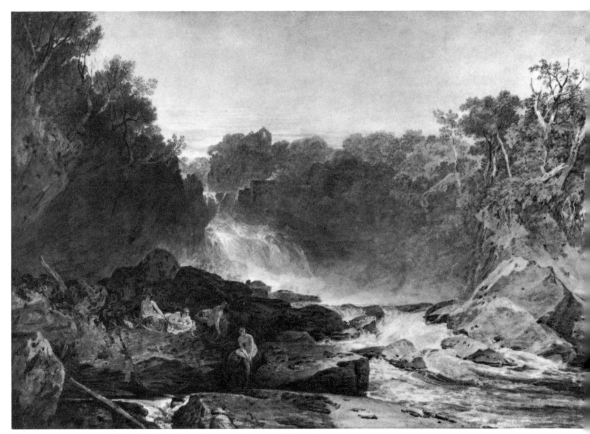

16 J.M.W. TURNER The Fall of the Clyde, Lanarkshire : Noon
Exh. 1802, watercolour $28\frac{3}{4}'' \times 47''$ *Walker Art Gallery, Liverpool*

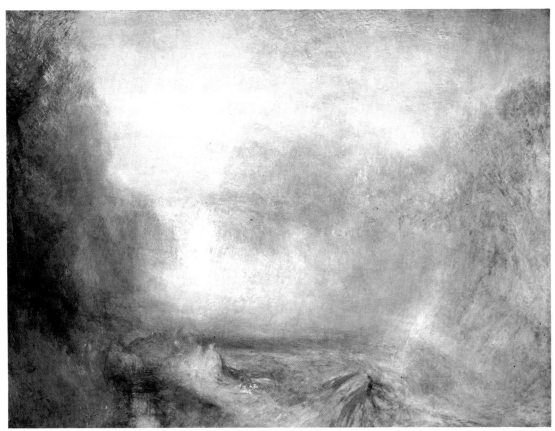

17 J.M.W.TURNER The Fall of the Clyde c 1835
Oil on canvas 35″ × 47″ *Lady Lever Art Gallery, Port Sunlight*

18 P.VERONESE Hermes, Herse and Aglauros *c* 1585
Oil on canvas 91½″ × 68⅛″ *Fitzwilliam Museum, Cambridge*

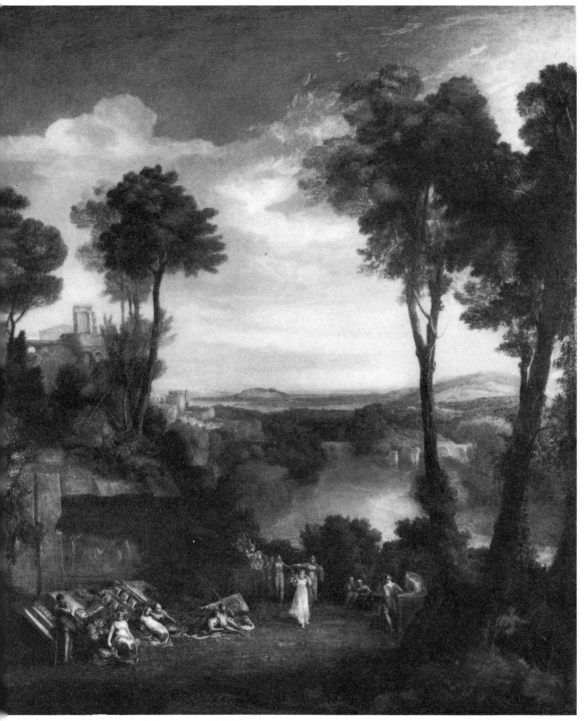

19 J.M.W.TURNER Mercury and Herse
Exh. 1811, oil on canvas *English Private Collection*

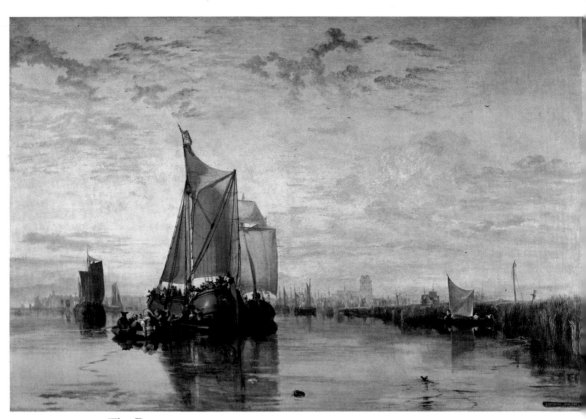

20 J.M.W. TURNER The Dort
 Exh. 1818, oil on canvas 62″ × 92″ *Collection of Mr and Mrs Paul Mellon*

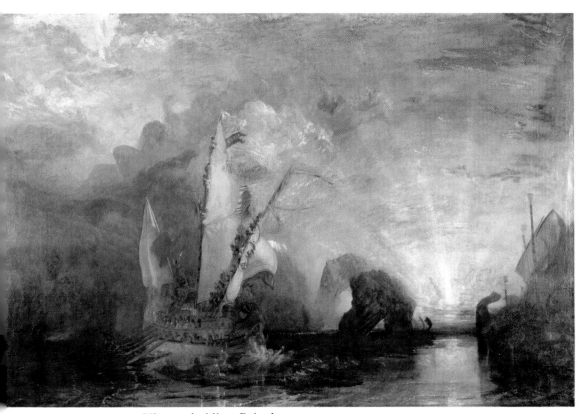

21 J.M.W.TURNER Ulysses deriding Polyphemus
Exh. 1829, oil on canvas 52¼″ × 80″ *National Gallery, London* 508

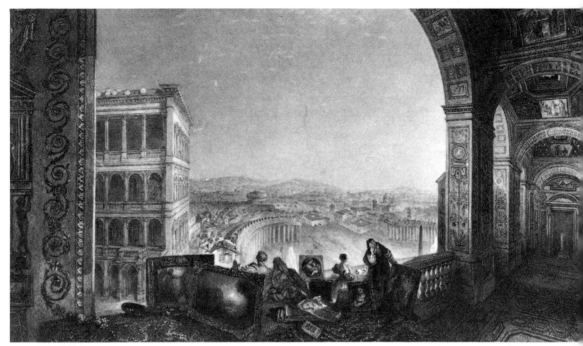

22 A.WILLMORE *after Turner* Rome from the Vatican.Rafaelle, accompanied by La Fornarina, preparing
his pictures for the decoration of the Loggia From the original painting exh. 1820

Tate Gallery, London 503; $69\frac{1}{2}'' \times 131$

23 J.M.W.TURNER Lake of Brienz *c* 1841
Watercolour $14\frac{1}{2}'' \times 21\frac{1}{4}''$ *Victoria and Albert Museum, London*

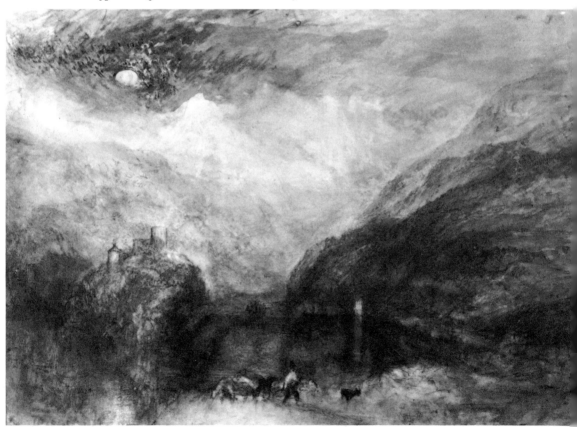

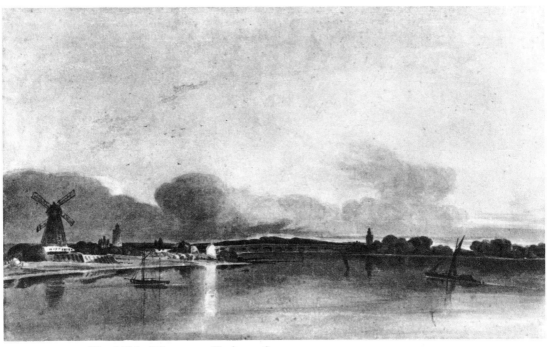

24 T.GIRTIN The White House at Chelsea 1800
 Watercolour $12\frac{1}{4}'' \times 20''$ *Sir Edmund Bacon Collection*

25 J.M.W.TURNER The Contemplative Shepherd *c* 1841
 Watercolour, approx. $12\frac{1}{4}'' \times 20''$ *British Museum, London* TB CCCLXIV, 170

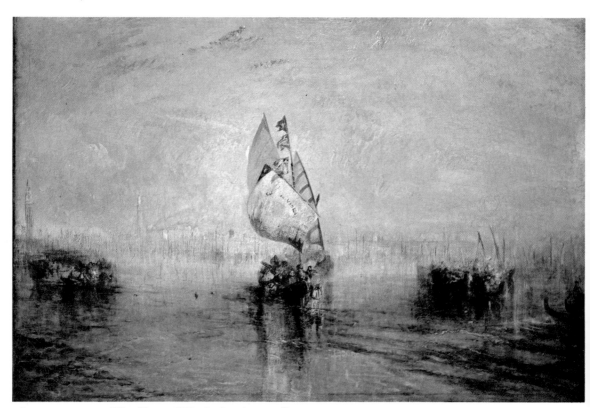

26 J.M.W. TURNER The 'Sun of Venice' going to Sea
 Exh. 1843, oil on convas 24″ × 36″ *Tate Gallery, London* 535

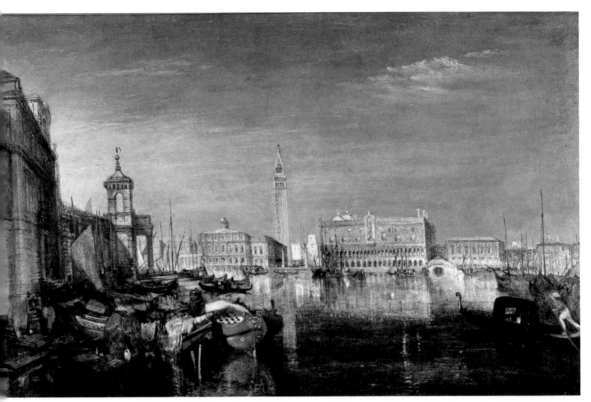

27 J.M.W.TURNER Bridge of Sighs, Ducal Palace and Custom House, Venice: Canaletti Painting
Exh. 1833, oil on panel 20″ × 32″ *Tate Gallery, London* 370

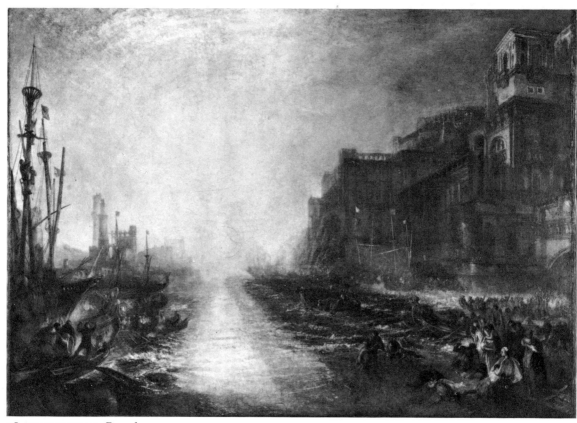

28 J.M.W. TURNER Regulus
 Ext. 1828/1837, oil on canvas 36″ × 48″ *Tate Gallery, London* 519
29 W.B. COOKE *after Turner* Battle Abbey. The Spot where Harold Fell 1819
 Line engraving *British Museum, London*

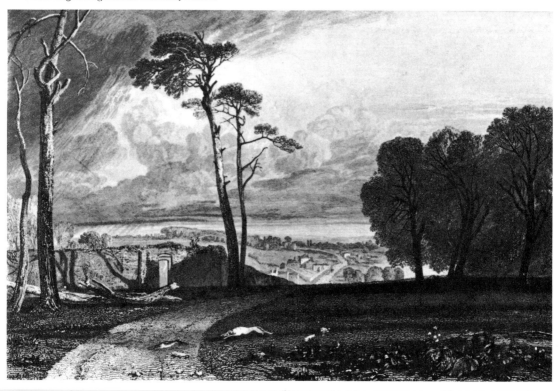

30 T.FEARNLEY Turner Painting Regulus 1837
 Oil on paper on board $9\frac{1}{8}'' \times 9\frac{1}{4}''$ *N.Young Fearnley Collection*
31 J.M.W.TURNER The Artist's Studio 1809
 Watercolour $7\frac{1}{4}'' \times 11\frac{3}{4}''$ *British Museum, London* TB CXXI, B

32 The Library at Harewood House, with J.M.W. TURNER's Plompton Rocks
c 1798 (lower painting)

his *Holy Family* ('*The Cradle*'), to which he was currently painting a pendant, the first of a series of Rembrandtesque pictures.[46] Between 1808 and 1811, Turner had painted a number of pastoral subjects, the *Windsor* (TG 486), the *Abingdon* (TG 485; R. & B. pl. 47), the *Petworth Dewy Morning* at Petworth (R. & B. pl. 46), which show a progressive command of delicate tonal gradations in a high key; and in the magnificent *Teignmouth Harbour* at Petworth, of 1812, **47**, he produced a profoundly original design of astounding economy, and of the reverse order to his earlier *Shipwreck* (TG 476), by raising the overall tone of the composition, and restricting the greatest lights and the greatest darks to the single small area of the girl and cows. It is perhaps the first example of a principle of chiaroscuro which Turner continued to develop in the 1820s and 1830s as peculiarly his own;[47] and it is an early, possibly the earliest, example of an overall spread of light of the type recognized by Turner in Veronese's *Marriage*.

An even more striking instance of the way in which theory and practice nourished each other in Turner's activity is the second colour analysis of Veronese in the *Backgrounds* lecture—that devoted to the Earl Fitzwilliam's *Mercury and Herse*, now in Cambridge, **18**. It was wrought, said Turner

> according [to] the words of a great Master upon the same high pitch in the same high key [as the *Cana*], which keynote is likewise blue, but placed on one side of the picture whereas in the former arrangement [it holds] the centre, forming with the white, the greatest mass of light . . . The centre is occupied exclusively by architecture, sculpture and furniture and constitutes the whole mass of shade, particularly a table cover'd with tapestry, making a square form equal to a quarter of the whole. Tho' of different embossed patterns and colours, yet it is not allowed to hold the least light. Neither can it be called in shade, possessing a peculiar semi-diaphanous yet luminous quality by colours only. On it is a brass Thermae [*sc.* Herm], shadow'd by a rich pink damask curtain hanging from a composite column on the right [*sc.* left] behind Mercury, whose entrance interrupted by Aglauros between his feet occupies one side of the picture composed entirely of light colours relieved only by the dark, rich, olive-toned garment thrown behind him. Opposed to this mass of light and colour is the figure of Herse clad in positive blue and white upon a white and dark colour'd pavement. A low-toned sky seen through an architectural arrangement of the composite order behind in shadow makes the remaining part of the picture. Thus the very furniture, the sculpture and architecture as in the former [*Cana*] *constitute* in a great measure this wonderful production which beyond all doubt weakens Fresnoy's principles of colouring.[48]

It has been suggested that Turner regarded the Veronese as contravening Du Fresnoy's principle that the chief figures should be both the most brightly coloured elements in a composition and comprehend the greatest

contrasts of chiaroscuro; but this rule *is* generally true of *Mercury and Herse*, and it is far more likely that Turner mistook Du Fresnoy for Reynolds, the 'great Master' of the passage, who recorded the high key of the *Marriage at Cana* in a note to these lines of *De Arte Graphica*, but had also, a page earlier, prescribed that the dominant colours of a painting should be red or yellow, and that cold colours should never occupy more than a quarter of its area. This was precisely the proportion which Turner noted was, in Veronese's picture, the province of the warm.[49]

But only a few weeks after the delivery of this colour-analysis, Turner exhibited his own version of the subject, the *Mercury and Herse* formerly in Lord Swaythling's collection, **19**.[50] Although it has nothing to do with Veronese in its interpretation of the theme, it carries into a Claudian landscape his keynote of blue in the vivid sky, mirrored in the lake, tinging delicately the distant hills, and drawn into the foreground by the drapery to the left. Only the square of figures and fallen masonry on the left, veiled in diaphanous shadow, provides a warm middle-tone to the picture; and the distant landscape to the right has a cool grey delicacy that looks forward to *Crossing the Brook* (R. & B. colour pl. VII), which, like it, makes a truly Claudian use of English motifs.[51] In this, Turner has abstracted a principle from Veronese's practice, and used it in his own way.

It was during the late 1810s, in pictures like *The Decline of Carthage* of 1817 (TG 499) and *The Dort*, 1818, **20**, that Turner seems to have shown his first inclination and ability to use a bright chromatic palette, consonant with the light tonality he had developed rather earlier in his practice. Similarly, it was in the course of lectures on perspective delivered in 1818 that colour-theory became a specific topic, although it did not, as one of Turner's jottings has suggested, occupy the whole of one lecture.[52] Turner's tortuous attempt to define colour principles in this version of the *Reflexes* lecture shows at the least his new awareness of their necessary place in his teaching; and he returned there to the theme of the tonality of Veronese's *Marriage at Cana*, which was now introduced as a model for the use of fully saturated colours as tones of shadow, as opposed to the Bolognese principle of using pure colours in light, and darkening them to shade.[53]

Associated with Veronese in this principle was one of Turner's newer and more original allegiances, Tintoretto, who had not appeared in earlier lectures, but whose *S.Mark* [? *The Miracle of S.Mark* in the Accademia in Venice, **48**] was now cited as 'bouyant by [the] apposition of forcible combinations, [just] as comparatively it is the lightest as to degree of *force* and execution'.[54] But in Turner's eyes, Tintoretto's range as a colourist was not restricted to this end of the scale. In a later passage of the same lecture, discussing the defiance of conventional rules in the use of a single overall tonality, he associated 'the sepulchral darkness in the *Raising of Lazarus* by Domenichino [*sc*. Guercino]; the glowing [?] brown sepulchral darkness in the *Cruxifixion* by Tintoretto; [and] the lurid gloom of the

pale gleaming light of Rembrandt upon the cross and dying Saviour, enwrapped with color'd shade as indescribable in tone as evanescent twilight'.[55] A year after this lecture, Turner was able to study Tintoretto's paintings, which he had hitherto known only in prints or, in the case of the *S.Mark*, probably from his memory of the Louvre in 1802. During the first visit to Venice he made thumb-nail copies of the *Crucifixion* in San Rocco, and part of the *Virgin and Child with Saints and Chamberlains* in the Accademia (TB CLXXI, pp. 25, 25a). Sir Thomas Lawrence wrote to Canova that Turner had seen the *S.Mark* again in the Accademia, and had preferred it to Titian's *Assunta*, since 'the colors being all splendid and well chosen, it has an appearance of a general *regulated* Harmony, which the other has not, that having an abruptness of light & dark'.[56] On his return from Italy, Turner, when asked which of the painters whose work he had seen he would have preferred to be, replied, 'Tintoretto', a preference which he apparently shared with his Italian companions, Jackson and Chantrey, and, oddly, with his hero, the Duke of Wellington.[57] The reason is not difficult to imagine, although any precise impact of Tintoretto's style is almost impossible to trace in Turner's work (as it is not, for example, in Stothard and Fuseli). Tintoretto's imagination and method were (for Turner) equally at home with the chromatic sensitivity of more peculiarly 'Venetian' subjects, and with the drama of expressive chiaroscuro; and in Turner's late work, in *Pilate Washing His Hands* (TG 510; R. & B. colour pl. XI) in the *Steamer in a Snowstorm* in the National Gallery (R. & B. colour pl. XXI), and in many brooding marines, shade and darkness were no less an objective than light and colour. A similar reinterpretation of Rembrandt and Titian also characterizes the late works more obviously dependent upon their example. The *Rembrandt's Daughter* of 1827, in the Fogg, the *Pilate* and the *Jessica* at Petworth of 1830 (R. & B. pl. 79) all transform the dark chiaroscurist of the 1800s into a master of jewel-like colour; and pictures like *Medea* (TG 513) or *Woman Reclining on a Couch* (TG 5498; R. & B. pl. 89), both painted in Rome in 1828, take up the studies of Turner's friend and companion C.L.Eastlake, in interpreting Titian similarly in terms of pure colour,[58] no less brilliant in the lights than in the darks. The attempt to co-ordinate colour and light and shade had long determined Turner's approach to engraving, and in the 1820s it dominated the colour-theory which he introduced into his lectures. And if Tintoretto was one Old Master who had indicated a way towards solving the problem, a more recent one was to have a great influence on Turner's subject pictures in the 1820s and 1830s: Watteau.

Turner told the Rev. William Kingsley, late in life, that 'he had learned more from Watteau than from any other painter'.[59] He used the painter's life as a vehicle for his first fully 'theoretical' painting: *Watteau Study by Du Fresnoy's Rules* of 1831 (TG 514, **49**). Turner had made a favourable passing reference to Watteau at the close of the *Backgrounds* lecture in 1811; and his attitude may be seen, generally, as an echo of

Reynolds's merely qualified approval, in the third and sixth *Discourses*, as opposed to the private confession that 'Watteau is a master I adore', which Turner will almost certainly have picked up as a piece of Reynoldsian gossip.[60] Among Turner's contemporaries, Constable was an admirer of the French painter, as was Turner's friend Thomas Phillips, who excepted him from his strictures on the weakness and flutter of the French School.[61] But it was chiefly the example of Thomas Stothard which seems to have directed Turner's attention to the value of Watteau as a model; and his influence first appears, in conjunction, oddly enough, with some of the classical statuary copied on the Italian tour, noticed by Professor Ziff, in *What you Will* of 1822 (R. & B. pl. 78). Stothard may, indeed, have helped earlier to develop Turner's interest in Tintoretto, for his *Diana and her Nymphs* exhibited in 1816 (TG 320) shows the strong influence of Tintoretto in the dramatic landscape. His Boccaccio illustrations of 1825 lie immediately behind Turner's *Boccaccio relating the Tale of the Birdcage* (TG 507), where the idea of using white for foreground and background objects alike directly anticipated *Watteau Study*.[62] In the later picture appear Watteau's *Les Plaisirs du Bal* (in reverse) then, as now, at Dulwich; and *La Lorgneuse*, which was in the collection of Samuel Rogers, who had employed Turner and Stothard in close collaboration on the illustrations of his books of poems. *Watteau*, Turner claimed, would demonstrate that

> *White*, when it shines with unstain'd lustre clear,
> May bear an object back or bring it near.
> Aided by *black*, it to the front aspires;
> That aid withdrawn, it distantly retires;
> But black unmix'd of darkest midnight hue,
> Still calls each object nearer to the view.,

a doctrine which Turner borrowed here from Du Fresnoy, but which he had probably learned first, as I shall show later, from Thomas Girtin.[63] It was a message familiar enough to writers on technique,[64] but a thoroughly original subject for a painting, possibly the earliest example of what I shall discuss in the last part as Turner's 'practical theory'. Turner had long been excited by the dual power of white; and in the 1818 *Reflexes* lecture, where it seems first to have been discussed publicly, Rubens was the painter singled out for his capacity to use white as a *colour*.[65] But, as Reynolds had noted, Watteau was a supreme exponent of the Rubensian mode of painting;[66] and even Turner's uncertain command of historical sequence may have obliged him to recognize that Rubens himself cannot have enjoyed the benefits of Du Fresnoy's instruction. Turner's interest in Watteau, as in Rubens, continued long after he had ceased to provide a direct element in his style.[67]

Watteau Study was Turner's first painting to take an aspect of colour-theory for its subject; but it was not his first art-historical picture. Eleven years earlier he had offered as the most public product of the first

Italian tour, the large and now much deteriorated *Rome from the Vatican. Raffaelle accompanied by la Fornarina, preparing his pictures for the decoration of the Loggia* (TG 503), **22**. The details of the design can be studied rather better in the engraving in Wornum's *Turner Gallery* of 1875 than in a photograph, or even, in some cases, than in the original, and this is perhaps one reason why the picture has received little attention from critics and scholars. Yet it is one of the most crucial paintings for the understanding of Turner's career, representing as it does an autobiographical statement which invites comparison with Courbet's *Atelier du Peintre* of 1855, in the Louvre. A consideration of the earlier French and Anglo-French treatments of the subject of *Raphael and the Fornarina* by Ingres, **50**, and Fradelle should make it clear that Turner's picture is far from being the sentimental anecdote suggested by Finberg.[68] Raphael in Turner's work is presented chiefly as an easel-painter—even a fresco like the *Expulsion from Paradise* has become a canvas[69]—arranging the gallery, of which the plan in the foreground shows him to have been the architect. Turner himself was rebuilding his own gallery in Queen Anne Street at the time of painting and exhibiting this picture.[70] Raphael's range as a painter is shown to comprehend History, portraiture and, conspicuously, landscape, for it can hardly be doubted that the large painting of the 'Casa di Raffaello', for all its Claudian flavour, was intended to represent —as were the anachronistic Bernini colonnades in the Piazza for architecture—Raphael's own activities in this *genre*.[71] Ten years earlier, Turner had built his own 'Casa' in the London 'Campagna' at Twickenham. Raphael's status as a sculptor seems to be alluded to in the figure of a classical River God (?) on the parapet; and Turner in a Roman notebook of 1819 had drawn the statue of *Jonas* in the Chigi chapel, which critical opinion was currently giving entirely to Raphael's hand.[72] The Raphael of Turner's painting was the new, universal artist of J.D.Passavant's eulogy:

> Raphael in his divine serenity is, at the same time, the most universal of artists: no other has succeeded with such ease in making all branches of art his own; all the faculties which enable man to reach perfection are united in him. There is no doubt that we must regard him as the most perfect artist who ever lived.[73]

But that he was an appropriate model, indeed an appropriate forerunner for Turner, may nevertheless seem at first sight surprising; it will be less so if we consider the elements of landscape and colour in the picture.

Raphael as a landscape painter was peculiarly the discovery of the Romantic period. The landscape compartments of the *Loggie*, then attributed to him, were even recognized, by Goethe's friend H.W.Tischbein and by Quatremère de Quincy, as having helped to turn the Vatican into the cradle of the modern landscape school.[74] But it was in the matter of colour that perhaps the most revolutionary developments in Raphael studies had taken place in Rome, about the time of Turner's visit. It may

well be asked how Turner's huge canvas, which was originally far more brilliant than it now appears,[75] can be related in style to its subject, in the way that Ingres's Raphael pictures so conspicuously may. The eighteenth-century tradition of Raphael appreciation to which Turner belonged had stressed his capacity as a draughtsman almost exclusively: whatever little talent as a painter he had shown towards the end of his life, the story went, was due to the study of Michelangelo.[76] Turner seems to have made no colour-notes on the Raphael he copied in the Louvre in 1802; and his public remarks on the artist in the perspective lectures, referring chiefly to the *Transfiguration* and the *Cartoons*, were either confined to their principles of design, or endorsed Reynolds's opinion that Raphael became a colourist only through the lessons learned from other artists.[77] Certainly De Piles had long since compared Raphael as a portraitist to Titian; and it is noteworthy that the Uffizi portrait of 'La Fornarina' which is so prominent in Turner's painting is now given to Sebastiano;[78] but it was not until about 1820 that this appreciation and comparison was generally extended to the whole range of Raphael's *oeuvre*, and particularly to his frescoes in the Vatican.

About 1815, Samuel Rogers in Rome had asked of the *Stanze*, 'surely these frescoes, in colouring, composition & expression, & in every excellence, surpass all the Pictures in the world?'; in the *Mass at Bolsena* particularly, 'The Priest in his crimson vest kneeling at the Altar is rich as Titian himself!'[79] Rogers was almost certainly catching a Roman enthusiasm which by the 1820s had become a firm critical standpoint. Turner himself found the Raphael and Giulio Romano frescoes in the Palazzo Farnese 'Exquisite colored' (TB CLXXI, p. 14a), and Passavant's friend Carl Friedrich von Rumohr, the earliest of modern Raphael scholars, went so far as to claim that the *Mass at Bolsena* anticipated a comparable capacity in Titian's work by several years, and that Giorgione may have introduced his manner into Venice from Rome.[80] Within the Royal Academy, West, in the years just before Turner's Italian journey, had been pressing his 'rainbow' theory of harmony in connexion with Raphael; late in 1817 he

> spoke nearly half an hour and *Extempore*, and with great self-posession, also with a readiness of delivery beyond what had been before heard from him . . . to prove that the *order of colours in a Rainbow* is the true arrangement of colours in an Historical picture—viz. exhibiting the warm and brilliant colours in a picture where the principal light falls & the cool colours in the shade; also that as accompanying reflection, a weaker rainbow [appears], so it may be advisable to repeat the same colours in another part of the picture . . . He remarked that in the picture in the Vatican at *Rome Raphael* had not attended to this principle, but that he first arranged his colours agreeable to it in the *Cartoons*.[81]

Turner's constant attempts at improvements on the works of his predecessors and contemporaries may well lie behind this suggestion in *Raphael and La Fornarina* of what Raphaelesque colour could really be like.

Turner's *Rome from the Vatican* was thus a thoroughly programmatic picture, fully in accordance with the new attitudes towards Raphael which were developing in Rome at the time of his first visit. Raphael was being re-cast in a mould very close to Turner's conception of his own artistic personality. If, as I hope to show in the next chapter, Turner absorbed these ideas, through Eastlake, from the Franco-German artistic and scholarly *milieu*, this same *milieu* may well have stimulated him to study the work of painters whose style had only recently come to be regarded as crowned rather than initiated in the work of the young Raphael: the early Italian masters. Turner's preference had hitherto generally remained within the high Renaissance and the seventeenth century; in the second lecture of 1818, referring to Dürer's hardness, he said, 'it cannot be credited, without [his] being led away by the Giotto taste [*above*: abuse of taste]' into ingenuity; and the German painter had doubtless been misled, too, by 'the splendid baubles of the times arrayd in Blue and Gold, and probably estimated by the weight of precious metal used . . .' [82] Certainly, in the first lecture series in 1811, Turner had defended Holbein against Reynolds's strictures on his 'inlaid' quality; [83] but there is very little evidence of a positive interest in early art before the Italian visit, except as part of the general history of perspective, and a single reference to a Jan van Eyck tempera panel at Bruges in the proposed Rhine itinerary of 1817 (TB CLIX, p. 3). Yet as early as Milan, in 1819, Turner noted the obscure Carlo Crivelli in the Brera; [84] and on the return journey from Rome, in the Uffizi, he was curious enough to study the equally obscure Piero di Cosimo, possibly the most painterly of the earlier Florentine school, and certainly the most fantastic, who, according to Turner's notes 'painted [?] very good'. [85] He noted, too, the work of Alesso Baldovinetti (with the inexplicable date, 1440), who had probably occurred in earlier English criticism only in Hogarth's disparaging satire on the connoisseurs; and he referred to the gold ground and the date of the Simone Martini-Lippo Memmi *Annunciation*, which was regarded by some contemporaries as superior in colour to Giotto. [86]

The precise effect of these interests on Turner's own work on the return from Italy is as obscure as the effect of Tintoretto; but possibly his contact with Thomas Phillips during the mid-twenties, with Samuel Rogers and with William Young Ottley, who were concerned to collect and discuss this type of art, [87] intensified his interest; and on the second Italian visit, of 1828, he applied his study even more in this direction. On a trip to Pisa he made notes at the Campo Santo of frescoes then attributed to Pietro Laurati, Memmi, Orcagna ('Organi'), Giotto, Buffalmacco and Benozzo Gozzoli, whose work there had been especially praised for its landscape qualities by Joseph Anton Koch, with whom Turner had almost certainly

been in contact in Rome in 1819.[88] After 1829, Turner's palette, for example in the paradisaical pinks, purples, yellows and greens of *Ulysses Deriding Polyphemus* (NG 508), **21**, and the hatched technique of many finished watercolours, of which there are several brilliant and fresh examples in the Lloyd Bequest at the British Museum,[89] shows a strong interest in the tempera and fresco work of the Trecento and Quattrocento, whose deliberate patternings may also be felt in the pastel mosaic of the oil sketches on millboard of 1828/9 (TG 5526–8). In 1841, possibly stimulated by the renewed study of early Venetian painting in Vienna the previous year,[90] Turner exhibited a small picture in honour of Giovanni Bellini.[91]

What, in general terms, Turner seems to have learned from his study of the Italian Primitives, was a heightened capacity to use pale but brilliant and delicately balanced masses of colour without dark shadow and without the chalkiness that afflicted, for example, J.B.Pyne's efforts in the same direction. Simone Martini's *Annunciation* is a conspicuous example of the sort of picture lying at the back of, say, the millboard sketches. It was, in a purified degree, what he saw in Veronese, and there was, in general, little real conflict between the techniques of the primitives and the High- and Post-Renaissance painters. Seen through the microscope of technical analysis, the Old Masters appeared far closer to each other than could have been assumed from an assessment of their style at large.[92] Turner's case is close to those of the French architectural theorist Laugier, or of Soufflot and Soane, who admired Gothic architecture for its structural principles, but continued in their work to use predominantly Classical motifs. By the end of Turner's life, and before the Pre-Raphaelite Brotherhood, it had become accepted that so far from distorting natural appearances of light and colour, the early Italian masters had reproduced them far more faithfully than their successors.[93] Turner's concern with them may be understood as being on a technical rather than ideological level.

These remarks on Turner's interest in the colour of the Old Masters are in no sense comprehensive: in particular, they omit the discussion of perhaps the most influential painters for Turner's work, Claude, Correggio, Titian and Cuyp; and of Reynolds and Wilson, whose works represented the greater part of Turner's own collection.[94] Turner's great debt to them is well known. I have been concerned chiefly to note the eclecticism of Turner's interests, to plot the peculiar direction of his studies of the Old Masters who most shaped his *attitude* towards colour. His approach was essentially that of a practical painter anxious to learn new techniques and the means of expressing new types of idea, and these techniques were absorbed into his method often with barely a superficial trace. I have thus given more attention to the less expected models like Raphael and the Primitives than their overall position in the history of Turner's colour would otherwise seem to warrant. The same is true to a more surprising degree of the moderns.

5 Turner
and the art of his contemporaries

Turner left far fewer traces of his contact with contemporary art than with that of the Old Masters. His closest friendships with painters—with W.F. Wells, James Holworthy, A.B.Johns, Thomas Phillips, C.L.Eastlake, A.W.Callcott, and later, with Wilkie and George Jones—all concerned artists from whose style he could have had little to learn; and most of them have survived for us only through their friendship with him.[95] Turner was notoriously shy about passing judgement on the work of his fellow artists;[96] criticism was either oblique, as when he told John Thomson of Duddingston, 'You beat me in frames',[97] or strictly practical, as on Varnishing Days at the Royal Academy. Francis Danby seems to be the only exception to the rule that Turner borrowed little more from his younger contemporaries than a title or a theme for variations. He defended Danby as a 'poetical' painter against the strictures of Kingsley;[98] and the figurative vignettes for Rogers, Campbell and Moore in the 1830s which assimilated allegorically conceived figures into the texture of a naturalistic landscape or marine, in a wholly new way in Turner's work, appear to go back to Danby's subject from *Revelation* exhibited at the Academy in 1829, **53**.[99] Nevertheless, the type of bright colour developed by Danby in this and similar designs, was already clear in Turner's *Ulysses* of the same year, **21**. Apart from some portrait sketches by Owen and Jackson, the only identified modern English picture in Turner's collection was Richard Westall's *Descent from the Cross*, which, if it was comparable with the altarpiece now in All Souls, Langham Place, had something of the sharpness of outline, and strong colour and lighting that Turner was later to admire in the work of Maclise.[100] He was also anxious to purchase Benjamin West's *Cave of Despair*, a picture of rather similar qualities, in 1829.[101]

Turner's attitude to contemporary colour is even more opaque than his view of draughtsmanship, where he evidently preferred the well-defined. From before 1800 he had been the head rather than the follower of a school. The precise quality of his early feelings for the work of Girtin are still mysterious; Thornbury's anecdotes have never been corroborated; and the 'rivalry' noted by the press in the late 1790s is not easy to define, since from about 1795 the styles of the two painters seem to our eyes to have considerably diverged. But it is noticeable that it was Girtin's landscapes alone among the moderns—with a single identified exception for A.W.Callcott (TB CCXVI, p. 19)—that Turner was able to project into the scenes presented to him on his tours, as he did so frequently with Claude or Wilson, Gaspard or Cuyp.[102] Girtin's watercolour of *The White House at*

Chelsea (1800, G. & L. 337) of which he may have known either the version
now in the Tate Gallery (4728), which was in Girtin's own collection until
1803, or the replica in the Bacon collection, **24**, which was owned by
Turner's friend A.B. Johns of Plymouth (with whom he had been in con-
tact since at least 1813),[103] was for Turner possibly the most influential
colour-composition in the work of a contemporary. As a specific motif it is
to be found as late as the watercolour of the *Lake of Brienz* (?1841) in the
Victoria and Albert Museum, **23**, which can be associated with a number of
Swiss sketches of the 1840–1 tours, two of which are inscribed with Girtin's
name and the title of his Chelsea drawing.[104] Expanded into the composi-
tional motif of a white centre, drawing the distance, often the sun and
sunlight, to the surface of the painting, Girtin's idea affected Turner
deeply as late as the four Carthage subjects which he showed as his last
contribution to the Academy Exhibition in 1850.[105] Yet it was Watteau
and not Girtin who seems first to have focused his attention on the
dynamic properties of white, in the years following the first Italian tours.

With the exception of Loutherbourg, no living British artist seems to
have excited Turner to a sustained study or emulation. The case with
French painting, with which Turner first came into contact in Paris in
1802, appears at first sight to be very similar. In a note to Opie's *Lectures*,
discussing the discrepancy between the theory and the practice of Anni-
bale Carracci, Turner observed, about 1809:

> Good drawing must necessarily be the first principle of education, but
> if all the powers are to lead to that alone the student must distrust the
> opinions of his preceptors when he views the works of David and the
> French School, where drawing stands first second and third.
>
> *Without the aid of shade or tone*
> *But indivisible alone*
> *Seems every figure cut like stone.*[106]

About the same time, Turner expanded this criticism in a note in his copy
of Shee's *Elements of Art*:

> Drawing or in other words the outline is the predominant character
> of the French School, Le Sueur, Poussin; and [an] attempt to steer a
> middle course may be exemplified in Vouet, Jouve [net?] and
> Mengs, whose consummate vanity and conceit will live beyond his
> works in the French Raphael;[107] but they have returned with all the
> exquisite productions of ransacked countries [yet] look with cool in-
> difference at all the matchless power of Titian's glowing tones,
> because precision of detail is their sole idol; and it was no small
> wonder to see their choice of study. Nationality with all her littleness
> came upon me, but I could not refrain contrasting ourselves to them
> with advantage. Our endeavour generally [is] to have been able
> without the aid within their power and against the ungenial in-

fluence according to Winckelmann of our northern climate [so that] we may claim justly to be painters [even] if we are deficient as draftsmen. Thus we both stand in contrast [as] the Extremes. The predilection for color follow'd us in our admirations of Beautiful tones and breadth of style; and a trifling anecdote will evince the unconquerable prejudices of extremes. A Portrait of Cardinal Bentivoli [sic] by Vandyke, caught [fraught?] with the amazing power of Breadth, color, freedom and apparent ease and facility of execution to [sic] every Englishman who viewed it, and some pains were taken to obtain an opinion of the French artists what they thought of a picture which seemed to merit such universal suffrage; but all our admiration was their astonishment, [the picture] wanting that detail which could be found in the lace of Rigaud's ruff and points, and Cardinal Bentivolii [sic] seemed to be admired by them with [too much?] an eye of purity, for our taste.[108]

Turner had clearly been very impressed with Vandyke's *Cardinal Bentivoglio* in 1802, for he described it in his notebook as 'a piece of Nature', and made a long note on its technique; and Farington, who was often in Turner's company in Paris, had recorded the opinion of David's best pupils that the English School was contemptible because it had 'nothing but *colouring* and *effect*, which they hold to be very inferior requisites of the Art. They think the picture of Cardinal Bentivoglio by Vandyke to be very inferior to a portrait of General Murat in the French Exhibition painted by Gérard, which they say is much better drawn & finished in every part.'[109] Turner's indignation and his rising nationalism is understandable; yet David's pupils were notoriously more 'Davidian' than their master, who never himself underestimated the value and place of colour in painting. When, in the year of Turner's visit to Paris, Gros exhibited his *Bonaparte Distributing Sabres*, now at Malmaison, David was heard to say publicly at the Salon that it would have a beneficial effect on the French School, where colour was too often neglected.[110]

David's liberalism as a teacher was remarkable, and he was, too, by no means the only important master in Paris. Farington recorded the general opinion of the English visitors in 1802 that Guérin and Gérard were superior to David, and that Gérard's *Belisarius* 'is very near a perfect style both in drawing and expression. Guérin is a little inclining to *the French* (the outré) in his expressions'. Of Guérin's prize-winning *Return of Marcus Sextus* (Louvre) he said that in some parts it approached Guercino, for it had 'form and light and shade':

It is, however, so much more of a picture than those which we have seen by other artists that we readily agree that it merits distinction, but it seems remarkable that the French should give a preference to that which deviated most from their manner—The praise given to Guérin as an Artist superior to his contemporaries is not approved by

99

all. Shee told a person who attended us, a Genteel Man, that Guérin was their best Artist, which he did not appear to like, & mentioned the names of Gérard and Girardet [*sic*] . . . Fuseli thinks it [*Marcus Sextus*] as much above Sir Joshua Reynolds's Ugolino in conception and interest as it is inferior in execution. The Light & Shade He also thinks very fine.[111]

Turner may well have thought so too, for in his *Louvre* sketchbook (p. 47) he made a chiaroscuro note of the picture, with the title, and a description of the subject; although he found the other exhibits in the *Salon*, with the exception of the 'ingenious' sentimental *genre* of Marguérite Gérard, 'very low — all made *up of Art*'.[112] Turner did visit David's studio with Fuseli, Farington and the History Painter J.J.Halls, and saw the *Bonaparte on Horseback* (Versailles), which was adjudged 'good plain painting', but lacking in harmony and effect. Fuseli compared it, curiously, with the work of Northcote among English painters.[113] Turner, however, took away at least the memory of the rearing horse and Napoleon's guesture, as well as the rocks sculpted with the names of Alpine conquerors; for he reproduced them almost to the letter in his *Marengo* vignette for Rogers's *Italy*, many years later.[114]

In 1837, on a hitherto unrecorded visit to Paris and Versailles, Turner was prepared to rely, similarly, on the designs of Gros and Carle Vernet for some of the battle-illustrations for a projected, but never executed, edition of Sir Walter Scott's *Life of Napoleon*.[115]

Unfortunately the identity of the French artist with whom Turner was directly in contact on this trip remains unknown; so far the only other evidence for Turner's later contact with art in Paris is the wholly mysterious and undoubtedly embarrassing interview with Delacroix, which must have taken place, if Delacroix's memory was correct, before 1835.[116] The letter on Napoleonic battles, however, shows that Turner had been looking at French Romantic painting; and was prepared to use it, as he had long used the sketches of English amateurs, as the basis for engraved designs.

Far more interesting light on Turner's attitude to the French neo-classical style of colouring is thrown by the other named modern History Painting, besides the Westall, in his collection: the *Death of Abel*, by the Savoyard Jacques (Giacomo) Berger. Berger had settled in Rome in 1776, and had soon come under the influence of David: but he developed, towards the end of the century at least, an uncharacteristically Flemish feeling for colour, which was remarked on by contemporary critics, and is attested by the two examples of his work that I have been able to discover in the original: the *Joseph's Coat of Many Colours*, signed and dated 1790, in the Church of S.Martin, Thompson, Norfolk, and the *Triumph of Justice*, of 1815, a ceiling of the Sala di Astrea in the Reggia di Caserta, near Naples.[118] It is conceivable that Turner met Berger in 1819 in Naples,

where he taught History Painting at the Academy (1808–22), or, possibly, in Rome.[119] Certainly it is difficult to imagine Turner's acquiring a picture of this sort through the normal channels of the sale-room; and the provenance of the Norfolk painting remains unknown. However this may be, Turner's interest can hardly be doubted; and later, on the Italian tour of 1819, Turner was sufficiently attracted by a work of one of Berger's colleagues, Pietro Benvenuti, a pupil of David and the head of the Florentine Academy, to make a colour-diagram from one of his large historical pictures, the uncharacteristically rich and dramatic night-piece, *Giuramento dei Sàssoni a Napoleone* (1812), now in the Galleria d'Arte Moderna in Florence.[120] The work of Benvenuti and his school was very much an arid development of the Davidian manner, so that Turner's curiosity can be seen to have been far wider than his early declaration of interest would have led us to suspect.

Turner once told the young Trimmer that 'he considered the art at Rome at the lowest ebb'.[121] Again, however, the evidence of his notebooks suggests that he was prepared in his customary way to make it his own. In the *Remarks* sketchbook of 1819 he wrote out a list of a score of Continental landscape painters, French, German, Dutch and Italian, who were active in Rome during his visit.[122] Turner had a reputation for shyness on this trip: Chantrey reported that no one knew his Roman address;[123] and a Rome correspondent of the *London Magazine*, possibly Eastlake, wrote that

> he did nothing for Rome, to our great disappointment. His magic power would have confirmed the enchantment of the Italians. He reserves himself for London; but he has not been idle, having made innumerable sketches of compositions, which he permitted nobody to see—not from illiberality, as some thought, but simply because they were too slight to be understood.[124]

But the evidence of the list of painters, as well as the iconography of *Rome from the Vatican*, which I discussed in the last chapter, show that he must have moved in international circles, for pictures were not readily to be seen in public exhibitions, as they were in London. Turner had just missed the rare possibility of seeing modern Roman art, especially German, together, in the Palazzo Caffarelli exhibition which had been held in the spring of 1819, and had shown works by several of the artists on his list.[125] But, in the course of his visit, in November, a commercial gallery was opened on the Via Condotti, which, later at least, began a register of artists in Rome for the benefit of visitors.[126] The usual Roman practice was for artists to keep open house, but institutions like the Academy of S.Luke's, of which Turner became a member, and the French Academy in the Villa Medici, which Turner knew, also seem to have had exhibition rooms.[127] At the same session of the Academy of S.Luke at which Turner was elected to an honorary seat, one of the landscape painters on his list,

Joseph Rebell of Vienna, was also elected.[128] Much of the assistance which Turner needed in Rome to meet artists and to obtain access to the more private of the private collections may have been provided by Canova; more, especially in connexion with the German and French colonies, was very possibly the responsibility of Charles Lock Eastlake, who was a close friend of Bunsen, the Prussian envoy, and knew Thenévin, the director of the French Academy, well. In 1819 itself, Eastlake wrote a survey of modern art in Rome for the *London Magazine*;[129] and in his current role as chiefly a landscape painter, he shared with Germans like Koch, as with Turner himself, the ideal of painting as a union of History and Landscape.[130]

What can Turner have found, more specifically, in the work of the Roman landscape painters whose names he noted? Certainly it can hardly have been an echo of his own feelings about colour and execution. Koch's and Michallon's well-washed Campagna scenes were not what English artists expected of painting in this *genre*. Eastlake wrote that Rome had little to offer the colourist, and that the German landscape painters, in particular, were 'hard and minute'.[131] It was a common enough opinion, and Turner was one of the sticks used to beat the Continental School:

> 'I feel unwilling to speak of the landscape painters at Rome,' wrote the author of a guidebook, 'for I do not wish to censure, and I find little to praise. Keisermann, a plodding German, laboriously paints very pretty pictures; but above prettiness his works never do, nor will, rise; Gabrielli, a clever and very self-sufficient Italian, sketches remarkably well; but his paintings I can by no means admire. Bassi, a persevering young artist of considerable talent, has lately greatly improved himself. There are many more, but the truth is, there is no great, scarcely a good, landscape painter in Italy.
>
> 'It is wonderful that in a country where the soft lights, the harmonious tints, and the bright aërial hues of the sky shed enchantment over every object, and make every scene a picture, the artist can be *guilty* of colouring so remote from the truth and beauty of Nature. Yet over France, and the whole of the continent, we may search in vain for anything like excellence in landscape painting . . . There is not an artist at present in the world to compare with our own. I only wish that the best works of the best living artists of every foreign country, were placed by the side of those of Turner and Williams of Edinburgh, and I well know to which every judge of painting would at once adjudge the preference.[132]

And yet in Rome and on the Continent in general, landscape painting had achieved a recognition which Turner's own efforts had hardly succeeded in earning for it in England. The artists noted in his list had in common their practice of ideal landscape based on Poussin and Claude, which, like History, they believed capable of expressing ideas. Of the Italians, Bassi

was recognized as a philosophical painter, pointing a moral through his choice of sites very much in the manner of Turner's *Caligula's Palace*.[133] Of the Germans, Koch represented most strongly the conception of landscape as a union of all the *genres*, 55; and his emphasis on the essential character of figures was close to Turner's use of staffage to enhance the sentiment of a picture.[134] Of the French, Chauvin had won a royal medal for his work as early as 1814; Michallon had been the first recipient of the new *Prix de Rome* in landscape in 1817, and Boguet had won a gold medal in 1818.[135] Against this, Turner could only report the Society of Arts medal for landscape sketching which he had won as a very young student in 1793; and his failure in 1814 to secure the British institution prize in landscape with his heroic *Appullus* (TG 495), 54, which had been passed over in favour of a Dutch-type English marine by Hofland, an artist only two years younger and no less established than himself. In 1817, John Glover had shown at the Institution his *Landscape Composition*, painted three years earlier in the Louvre between a Claude and a Poussin on similar principles to Turner's competition piece and awarded a gold medal not in England, but in Paris.[136] These sad facts explain why Turner's curiosity should have been aroused by the activities of an artistic circle whose products in detail he scorned, but where the type of landscape which he advocated had already arrived. They were, too, circles that had given a far wider context than usual to the study of landscape colour.

Koch was both one of the most ambitious landscape artists and one of the most sophisticated craftsmen working in Rome. He had made a protracted study of the techniques of the early Italian masters, aided by the restorer, Pietro Palmaroli.[137] In November 1819, a trip to Perugia, Assisi and Spoleto, made in the company of an unnamed Englishman, renewed the enthusiasm for Primitive fresco-painting which he had felt in the Campo Santo at Pisa in 1810.[138] Of the older techniques with which he had experimented, one was glazing over a gold ground;[139] and in the mid-1820s he took eagerly to painting in fresco with the Nazarenes in the Casino Massimo.[140] Koch was also a friend of Pietro Benvenuti, who had in 1815 rearranged the Florentine Academy collections historically, from Cimabue to Raphael, and who, as I showed above, seems to have had some contact with Turner at the time he was studying early Italian painting in the Uffizi.[141] Koch must certainly be numbered among those 'few German and English artists in Rome', noticed in the early 1830s by the American painter Thomas Cole, who 'paint with more soul than the Italians', and, unlike them, used the glazing techniques of the Old Masters.[142] It is surely remarkable that in the first heroic landscape Turner painted on returning from his Italian tour, the *Bay of Baiae*, exhibited in 1823 (TG 505), a use of delicate glazings combined with a small touch and high finish, close to Continental practice, appears for the first, and almost the last time, in his oils. The Italian watercolours, too, produced about 1820 for Walter Fawkes, and of which the *Colosseum* in the Lloyd Bequest

at the British Museum is a fine example, are closer than any others of Turner's drawings to the minuteness of the Continental manner of a Kaisermann or a Helmsdorff.

The mood of these works, even if it was intended to offer a lesson, did not last long; and when Turner returned to Rome in 1828, the *View of Orvieto* (TG 511), 'finished' for the Roman public, as he put it, 'to stop their gabbling',[143] had in the event precisely the opposite effect. 'The Romans have not yet done talking about the Paesista Inglese,' wrote Eastlake to Maria Callcott, months after Turner had left in 1829;[144] and Thomas Campbell, his sculptor friend, told John Cam Hobhouse during Turner's exhibition 'that the Romans who had seen these pictures were filled with wonder and pity; some of the German artists here talked of trying to outdo these specimens of the low sublime'.[145] Foremost among the Germans was Koch himself, whose *Moderne Kunstchronik*, published in 1834, but written several years earlier, represented something of the combined efforts of his circle, including the second leading German landscape painter J.C. Reinhart.[146] The pamphlet, which purported to be a series of letters written by an artist in Rome to his Mancunian friend in Tartary, has justly been seen as the complaint of a bitter and unsuccessful painter, to be compared, perhaps, with Edward Dayes's splenetic art-biographies in England. Of Turner's show he wrote:

> Notwithstanding the large and vulgar crowd which had collected to see the exhibition of the world-famous painter, Turner, the works were so beneath all criticism and the mediocrity which is admired by the modern world, that it would have been better for poor Turner if he had himself got lost in this 'excellence'. For our modern world has no love at all of these two extremes: it wants the tiresome and sleepy *via media*, where, although you cannot see very far ahead, at least there is little chance of stubbing your toe. This show was much visited, ridiculed and hooted, which is not the case with mediocre and unexceptional things. The old *Caccatum non est pictum* was still a refrain to make you laugh, for you know how little it takes to keep people happy. The pictures were surrounded with ship's cable instead of gilt frames. It is not easy to describe them . . . although the composition purporting to show the *Vision of Medea* was remarkable enough. Suffice it to say that whether you turned the picture on its side, or upside down, you could still recognize as much in it. In sum, it is in the English Mylord-taste of Anglican fantasy, roughly what the French call *tableau foueté* [flogged painting]. The composition was pretty much of the sort that was practised and taught by a Viennese professor called Schmutzer, when he said to his pupils: 'Look, when you want to invent or compose a design, blindfold yourselves and draw what comes into your heads; and when you have done this, and think that it might come to something, take the blind-

fold off. This sort of accident is often better than all pedantic principles. And when you paint, choose the largest brush, and don't reflect too long, but start painting straight off.'[147]

Koch's critique is the only detailed contemporary account of Turner's Rome exhibition to have come to light so far, and he must be allowed at least the credit for having recognized its far from ordinary qualities. But the passage offers, too, early examples of those mistaken critical commonplaces about Turner: the upside-down picture and the dominance of accident; and in general the misunderstanding of his art was complete. There were, however, Germans like Karl Rottman and Karl Blechen, or Dutchmen like Antonie Sminck Pitloo, working in or about Rome in the 1820s, who might well have profited more from an experience of Turner, although attempts to associate them directly with his work have not so far proved successful.[148]

But Turner, for his part, was still open to technical suggestions. He may well have seen the German exhibition at the Palazzo Caffarelli, which was showing during November 1828;[149] and the new experimental landscapes in tempera, which Reinhart had just completed for the Marchese Massimi, had attracted a good deal of public attention, and can hardly have escaped Turner's notice, although the sketchbook material for this trip is far less extensive than that for 1819, and we have little or no indication of his precise movements.[150] Turner's watercolour technique in the early 1830s certainly seems to have been affected by his experience of early Italian tempera painting; and it may well have been through the example of Reinhart that he thought of experimenting with the technique in relation to landscape. Reinhart himself stressed the similarity of approach to that of fresco, referring to the work of Koch, Veit and Schnorr in the Villa Massimi; the tempera method, like the fresco, required a firm and immediate brushstroke.[151] Eastlake spoke of some of Turner's Roman productions in terms of tempera;[152] and although none of the recipes in the notebook of this visit (TB CCXXXVII, pp. 10a, 30a, 31, 35a) seem to refer to this technique, Turner in later life is known to have used dammer varnish in oils, which was a German rather than an English practice.[153]

In spite of Turner's distaste for what he must have seen of the formal qualities of landscape painting in Rome, it seems reasonable to assume that, as in the case of the other foreign art with which he came into contact, he was able to find in it elements which were important and fruitful for his own work. Here, as in every branch of his study, Turner was able to draw profit from the most surprising quarters; and, starting from an idea of the theory of the art of different ages and temperaments, to convert curiosity into emulation, in a way which is most strikingly illustrated in the course of his lectures on perspective.

6 Colour in the perspective lectures

Ariel Perspective is, generally speaking, universal gradation, consisting of parts of light, shade and colour, which is the end, the means of all our toil, and to this every department of the art looks, and labours to attain.[154]

The lectures on perspective at the Royal Academy are central to Turner's conception of his role as an artist. On his own showing, he felt that his task as a painter was essentially a didactic one; and it was a task that became increasingly insistent as he grew older. Into the lectures he heaped the fruits of a wide and often highly detailed reading, of upwards of seventy texts, from Pliny to Hugh Blair's *Lectures on Rhetoric and Belles Lettres*, and from Euclid to the memoirs of the Bishop-Chemist of Llandaff, published in 1817. It was the reading for his courses that provided him with the title, and sometimes with the matter, of his chief and most public poetical theme, *The Fallacies of Hope*.[155] The lectures were delivered over a dozen seasons between 1811 and 1828, covering the period of what has generally been accepted as the transition from a 'mature' to a 'late' style; and, because they are hardly repetitive, but often represent in each year a rethinking of the basis of their teaching, they cast an exceptional light on the development of Turner's attitudes towards art, and not least towards colour.

Before attempting to look at the character and course of the lectures in detail, and at the element of colour in Turner's doctrine, it must be emphasized that until the manuscripts find a sympathetic editor, much must remain obscure, for they present exceptional problems of transcription and interpretation which only a student of perspective who is also an art-historian will be competent to unravel. The readings here, in text and appendices, have been heavily edited. The following outline of the chronology and development of the lectures is based chiefly on the internal evidence of the manuscripts themselves, checked where possible with such newspaper reviews as have been collected by the late W.T. Whitley. Very few newspaper accounts are complete for a whole series, or cover more than a single season, so that a reconstruction of the complete range of courses must at present be tentative and partial. But it is hoped that enough will be shown to indicate that the whole body of the lectures offers material of the first importance for the understanding of Turner as an artist as well as a teacher, and to discountenance the misleading remarks about their status by the editor of the only one of the series that has so far been published.[156]

The teaching of perspective had always presented great practical problems to the Royal Academy. The ill-health of the first Professor, Samuel Wale, had led him to abandon the public lectures laid down by

the Constitution, in favour of private lessons;[157] and the value of the Professorship itself had been questioned during the late 1780s, after Wale's death, when it was found to be very difficult to fill the post. Sir William Chambers thought, according to Reynolds, 'that any one qualified, in all points, to be an Academician, would never condescend to teach an inferior and mechanick branch of the art'.[158] But eventually the sensible proposals of an Associate, Edward Edwards, were accepted, and in 1790 he was given the task of teaching the science in private lessons, which 'regular and sistematic method of tuition', as Turner called it,[159] he continued until his death in 1806. The question of the Professorship, however, continued to be a live one within the Academy; Turner was present in 1804 when Farington remarked on the absence of public lectures on the subject for the last twenty years;[160] and it was a lack particularly felt by architects; for, as Edwards, and Turner after him emphasized in their teaching, the need for perspective drawings to offset the expense, space, and limitations of architectural models, was a very real preoccupation of Academicians. It was thus the architect, John Soane, who, early in 1807, complained in the Academy of this conspicuous gap among the Professors; and it was Soane's assistant, Joseph Gandy, hoping, no doubt, to be sponsored as a full Academician in the course of time, who offered at the Council of 26 February to fill the late teacher of perspective's place.[161] The Council, however, at last, decided to advertise the vacant Professorship among the existing Academicians. By May, only Turner had volunteered his services, and his was the sole response throughout the summer and autumn, so that he was elected to the office in December with only a single dissenting voice.

Turner's elaborate and thorough preparations for his first course took two years. On 17 October 1809, he announced that he would be ready to lecture in the new year; and early in January 1810 this was clearly still his intention, for his plans for the improved lighting of the lecture room were then being completed.[162] But he had almost certainly over-estimated his capacity to bring all the material together in time. On 10 February he begged to be allowed to postpone his course until the following year;[163] and the dictation of the first, uncorrected, versions of the scripts was not complete until several days after this. Turner did not deliver his first lecture until January 1811. The first course seems to have been well received, but the following year, when he revised the course extensively, criticism began to develop within and without the Academy. Soane noted of the fourth lecture of 1812 that it 'seemed a lecture for the Professors of Painting and Architecture, the word Perspective hardly mentioned';[164] and later the sculptor, Rossi, remarked that the series was 'much laughed at, as being ignorant and ill-written'.[165] Turner seems to have been particularly sensitive to Soane's reaction, for on the next occasion when he was able to lecture, in 1814, he delivered a completely new course, with a long preamble contrasting the dryness of his material with the needs of a

public lecture, but claiming that to be useful to students, it must be so. He seems to have reverted to the procedure of Wale and Edwards, and given private lessons to his pupils during 1813, as he spoke of doing again five years later. More important, the 1814 series of lectures were to be accompanied by the *demonstration* of theorems, rather than illustrated with prepared drawings and diagrams; and the scope of the course was wholly restricted to linear perspective. The topic of coloured light and reflections, Turner noted, 'belongs more properly to the professor of painting than to me'.[166] This new scheme, however, was clearly not well received: John Burnet later complained that Turner threw no light in his teaching on the problems of aerial perspective, and his remark may well be an echo of the public response to this series.[167] In 1815 Turner restored a course closer to the original syllabus, but apparently concluding not with *Backgrounds*, or *Poetry and Painting*, but with a lecture on *Light, Shade and Reflexes* (Lecture V).[168] This plan was continued, although slightly rearranged, in 1816; but again an outbreak of violent criticism in the Academy and in the press seems to have been the cause of a complete revision of plan for the next series, in 1818. Turner seems to have intended to open this series with a bitter preamble underlining the need for his audience to make some effort themselves at understanding the intractable material.[169] Similarly, public or private criticisms may well lie behind the revision of the course in 1819 and 1821, to make it closer to the economy of the 1814 series, although these lectures seem to have incorporated more material from earlier ones. 1824 saw a further revision—a more diagrammatic approach; and after 1825 completely new material on vision and light, shade and colour formed part of the last series.[170]

This outline of the vicissitudes of Turner's lecture series may serve to emphasize how much thought and care he put into preparing both the matter and the method of presentation. It suggests, too, that the rather unpromising subject of perspective is capable of yielding a development in Turner's thought and thus the possibility of understanding more of his work as a painter. It was clear from early on, as Soane's remarks suggest, that the lectures were not quite what was expected of a Professor of Perspective;[171] and Turner does in fact seem to have looked chiefly to Reynolds and to the Professors of Painting, Fuseli and Opie, for his models and much of his material.[172] Without analysing in detail the whole of the extant manuscripts, we may observe that Turner returned again and again to a number of fundamental problems not directly connected with his subject in its narrowest sense: the development of habits of perception, and the relationship, often contradictory, between vision and measurable truth; the elemental nature of geometrical forms and of the 'will to form' in art; the important distinction between science and rules. All these problems have a particular bearing on colour; and it was especially in his increasing and more specific interest in colour in the lectures, that Turner left the province of perspective as it was normally conceived, and went

beyond even the Professors of Painting, to whom he was chiefly indebted.

Turner was from the first very conscious of his contribution to the study of reflections; and some reference to the effects of reflection on water and glass, and coloured metals was introduced into Lecture V in 1811.[173] But it was not until the final lecture of the following series that he discussed colour in its own right, in a long argument on the status of colouring in painting and of its use for expressive purposes. Colour, he said, was a decisive element in an artist's style, and still more so in the style of a school; and in this he seemed to run counter to an idea developing in the eighteenth century of colour as the vehicle of the most personal expression.[174] Turner contrasted the crude, emblematic use of quasi-symbolic colour-schemes by Carlo Dolci, with the more sensitive, expressive colour-keys of Poussin, modified for every type of picture, and exemplified supremely in *The Deluge (Winter)*, (Louvre), of which Turner gave a long analysis in terms of expressive colour. Quoting from Félibien's *Conferences*, he rejected the idea that Poussin's varying colour-schemes were classifiable according to the classical modes of music (by a happy misreading of his source, he added to the stock of these modes by distinguishing the 'Bacchanal').[175] Turner denied the possibility of reducing this use of colour to rules, even to the 'last faint and trembling ray of restrictive rule' in aerial perspective, referring to Claude, Cuyp and Wilson: here rules might at most be an aid to excluding impossible combinations of effect. He concluded with an attempt to distinguish the capacity of the poet and the painter to deal with colour: Milton, in his 'twilight grey', was able to suggest colour without reproducing the monotony to which such a subject would be condemned in painting.[176] ''Tis there,' he said, paraphrasing Akenside, 'the High-born soul is told to *seek* Nature, and not pursue any humbler *Quarry*.'[177]

This account by Turner of the use of colour in painting is of some importance for understanding why Turner would never use conventional colour symbols, save in the black sails of his late homage to Wilkie: *Peace, Buriel at Sea* (TG 528, R. & B. pl. 120); and why he never became convinced of the importance of theory: 'all the splendid Theory of art', as he called it scathingly in his notes to Shee (p. 30). But the discussion does not tell us what his conception of colour-theory was. Among the preparatory notes for the lectures in sketchbooks of the Turner Bequest there is, with the exception of some quotations from Lomazzo, very little on colour at all; the most important passage is that on the lighting of Rembrandt and Correggio (see Appendix IIA), which was never, apparently, incorporated into a lecture as such. On the chromatic aspect of colour there seems to be nothing of Turner's own.[178] In his extensive notes from Lomazzo, he quoted both the philosophical definition of colour as adventitious to form and expressing only the '7 qualities of substantiall accidents' which characterize actual forms, and Richard Haydocke's antidote to this abstraction: 'Color is a matterial substance, indued with a quality of diversely affecting

the eye according to the matter wherein it is found.'[179] But in the first lecture of the 1814 series, Turner referred his students to the Newtonian account of the formation of colours given by Joshua Kirby in his handbook on perspective, and he showed a copy of Kirby's diagram of the formation of the spectrum through the prism.[180] This was only a cursory glance at the problem, and ill fitted the nature of the series; but in the new course for 1818, Turner extended his terms of reference in two directions: towards an examination of the functioning of the eye, which had also been referred to in passing in 1814, and towards an account of the number and characteristics of the primary colours. The conjunction was an important one, because it introduced for the first time an extended consideration of how the mind, through the eye, contributes to the shaping of the artist's external world, and of the type of data on which the artist was to base his selection of visual facts. It was an essential prelude to what we may call Turner's 'natural idealism', that is, an idealism firmly based on an analysis of the functions of the natural world.

Turner had become interested in the nature of vision during the early stages of his work on the perspective lectures. He had taken notes on the structure of the eye, and on the mind as the seat of perception from Sir Anthony Carlisle's lectures on anatomy at the Academy, probably in 1809.[181] The topic of vision was listed at the beginning of Lecture II, in what appears to be the first syllabus of perspective teaching;[182] but if this lecture can be identified with MS L in the British Museum, Turner dismissed the subject in a few words as irrelevant to the artist, and this was certainly the impression left with a reviewer who heard the same lecture in 1815.[183] But in the new series of 1818, Turner had clearly planned to devote the whole of Lecture II to vision, and although this plan was not carried out, he did expand on the rôle of vision in art, in the fourth lecture of this course: on light, shade and reflections. Theory, he said, looked to vision for a clarification of the geometrical rules of perspective: the eye was less fallible, in some situations, than mathematical rules:

Vision therefore, whether natural or educated, becomes the judge and arbiter of imitation, whether it is of the greater or lesser truth, by or through lines, the appearance or occupation of space, of any known form; whereas the Science becomes the corrector upon the union of theoretical inductions, which vision, that is the power of seeing with nature['s] pictorial means, creates for itself a power or capacity of so doing. And whether intuitive or acquired [it] is so enwrapt in its method of viewing objects—call it selection [or] choice of nature; it is the foundation of style—as to make them within the sphere of its investigation, amenable to the possibility of representation. The practical part must be self-created; and whether futile, capable or deficient, [it] proceeds to measure causes by effects, and in the examination of those effects recalls to vision the cause . . .[184]

The passage shows Turner's preoccupation with science as the informant of perception, and with perception at the same time as a corrective to theoretical information: what, in an addition of 1827 to MS N, Turner called 'a natural kind of Trigonometry in vision'.[185] It also shows an interest, long felt in his jottings,[186] in the induction of causes from effects; and it prepares us for the reduction of Newton's seven-colour spectrum to three primary colours in the first treatment of chromatics *per se* in the final lecture of the 1818 series. After rejecting again the possibility of absolute symbolic values for colours, such as he had found in Gerard Lairesse— 'they must be left with those who framed them'[187]—Turner classified the three pigment primaries, red, yellow and blue, according to their tonal relationships, and their physiological impact. Red was the most commanding colour, but the mediating colour in respect of tone; in aerial perspective, red seems to be regarded as the colour of matter itself, yellow as the light ('medium') and blue the colour of distance. White Turner regarded as the union of the colours as lights, black (darkness) as the union of material pigments. The three primaries were, in the manner of the German Romantics Runge and Steffens, seen to be woven into the texture of natural time:

> Light is therefore color, and shadow the privation of it by the removal of these rays of color, or subduction of power; and these are to be found throughout nature in the ruling principles of diurnal variations. The grey dawn, the yellow morning and red departing ray, in ever changing combination, are constantly found to be by subduction or inversion [?] of [the] ray[s] or their tangents.[188]

Taken in conjunction with the first 'prismatic' colour beginning of Crichton Castle (TB CLXX, p. 4), **9**, which must belong to 1818, and the curiously prismatic touches on a drawing of Raby Castle a year earlier,[189] the passage represents an important step in the direction of Turner's later philosophy of colour. But, as if to underline the fact that these designs are far from being purely prismatic, Turner, after an account of white as representing light in terms of pigment, observed that colour *per se* was distinct from colouring in art: 'And here we are left by theory, and where we ought to be left, for the working of genius or the excercise of talent.' In an earlier section of the same lecture, Turner had already expressed his perplexity at the inadequacy of verbal categories to analyse the qualities of light and shade in works of art themselves: Rembrandt and Van Goyen may be seen as working according to similar principles, and yet how different do their works appear to the observer. Turner invites a similar reservation in the analysis of his own work; and yet the prismatic conceptions outlined in his lectures *were* fruitful in the development of his late palette, because he saw them not simply in terms of art, but as an expression of the facts of nature. This becomes even clearer in the additions he made to the lecture series of the 1820s.

In the opening lecture of the 1818 course, Turner had re-stated the traditional philosophical case, which he had found particularly clearly in Lomazzo and Francesco Algarotti, for regarding form as more fundamental than colour in nature and art. He claimed:

> That a picture designed according to the rules of Perspective, and the principle of anatomy will ever be held higher in esteem by good judges, than a Picture ill drawn, be it ever so well colord; for nature, though she forms men of various colors and complexions, never operates upon their motions, contrary to the mechanical principles of anatomy, nor in exhibiting those motions to the Eye, against the Geometric laws of Perspective.[190]

Turner was anxious to arrange that his course should follow that of the Professor of Anatomy;[191] because, as he explained in the same lecture:

> we cannot evade those Geometric forms in the Bone, the *machinery of all form*, and therefore why [is it] *degrading* to allow *that* to accompany art which pervaded through Nature, the component parts of which Geological research maintains; the vegetable and mineral evade not, but conform [to]; the cell of the Bee and the Bysaltic mass display the like Geometric form, of whose elementary principles all nature partakes.[192]

In art, the equally natural 'primitive' priority of form was demonstrated by

> the modest carved attempts of the inhabitants of the South Sea Islands [where] some idea of proportionate form appears under every difficulty and impediment; the same appears [among the] coeval ancient Britons [who] painted [their] bodies with circles, stars and moons. The American savage lacerated his flesh according to his notions of form, to appear terrific, while under the warmth of civilisation the germ burst forth shoots [?] proportionate to the natural acquirements of the mind.[193]

The case against the significance of colour in nature, and *a fortiori* in painting, was a formidable one; but Turner had already indicated a direction from which it might be answered at the beginning of his fourth lecture of 1811:

> Dryden says that art reflecting upon Nature endeavours to represent it as it was first created without fault. This idea becomes the original of art, and being measured by the compass of the intellect is itself the measure of the Performing hand, by imitation of which imagin'd form all things are represented which [fall] under human sight.[194]

Turner's source is not ultimately Dryden himself, but Dryden translating freely from the opening of Giovanni Pietro Bellori's *Idea*, in the preface of his translation of Du Fresnoy, which Turner will have found appended to

Reynolds's *Works*.[195] Bellori had said, and Dryden in his version had emphasized, that it was the artist's task to represent nature as it was first created, 'without fault, either in colour or in lineament'. The Platonic idealism was clearly, if only fleetingly, referred to colour as well as to form. Among Turner's predecessors at the Academy, only Opie had allowed colouring in painting to be considered as potentially ideal;[196] and his distaste for scientific optics, to which I referred in the introduction, prevented him from developing this possibility along the naturalistic lines which might have made it fruitful. For Turner, however, the ideal, the scientifically 'primary' and the 'primitive' came to be identified. Bellori's vision of the perfect world of the Creation was echoed, as I shall try to show in a later chapter, in Turner's painting of *Light and Colour, (Goethe's Theory)*, **52**, of 1843. Before then, throughout the 1810s and early 1820s Turner's interest in, and contact with, contemporary activities in the sciences increased. Science was a matter of national pride. In 1814 he expressed, indeed, in his opening and concluding lectures the expectancy that the British would 'rise superior to the rest of the world in the polite Arts, as they have already in the Sciences'.[197]

For all his opposition to the exaggerated claims of theory, Turner seems to have wanted to make a distinction between *rules*, about which he had severe reservations, and *science*, of which he fully approved.[198] A developing concern with science is fully reflected in the two substantial additions to the lectures on light and shade, and on colour, which he added, possibly in 1825, but almost certainly in 1827. Their form suggests that they were originally conceived as separate lectures, though short ones; but in the event they seem to have been given in conjunction with some of the later material in Lectures V and VI of 1818.[199] The two lectures were written in an even more compressed and elliptical language than was customary with Turner, and this reflects the complex and abstract topics with which they had to deal. The handwriting is clearer than usual, but the meaning will probably be disputed for some time to come; these lectures help to account for the breakdown in communication of Turner's courses at the end of the 1820s. Since both manuscripts are transcribed in an appendix, I shall not dwell on the lecture on chiaroscuro, save to notice that in it Turner was more than usually concerned to trace effects to their causes, and this helps us to understand the state of mind which produced the lecture on colour. Daylight, for example, said Turner, is not a cause but an effect, since it is the reflection and diffusion of sunlight from cloud. A similar concern with fundamentals marks the other lecture, which demands some more detailed attempt at analysis and commentary.

Turner first lists the primaries and secondaries, adding that they have each a light value or strength as well as a chromatic strength, in constant relation to each other. He then reviews the manifestations of the spectrum, in a prism or lens (*glass*); and in the rainbow, where he makes a contrast between the way in which light is refracted or divided in rain, and the

way the sun's orb is reflected as a collectivity from the surface of water. Turner goes on to human vision, and the colours formed within the eye itself by the light's being refracted through the crystalline lens, to which he had referred as a refracting lens in a passage on vision in an earlier lecture.[200] Passing to the problem of reproducing colours in painting, Turner looks for a scale to represent their relationships and their individual powers. He seems to have considered that the conversion of primaries to secondaries takes place by reflection and refraction, when the reflecting surfaces and the media of refraction lend their own colours to the original ray, as he had remarked of metals in the *Reflexes* lecture, and of light refracting through the stained-glass dome of the Brocklesby Mausoleum, 57.[201] Here the argument becomes particularly confused. The prismatics, Turner seems to be saying, will light up objects in shade, but darken those in light. He goes on to arrange and discuss colours in the colour-circle, or perhaps sphere, (*Cycloid of light*), which he appears to want to co-ordinate tonally, and according to warm and cool poles [see diagram]. No simple colour-circle has survived among the perspective diagrams, so that it is not easy to check what Turner states in his text, or to know if and when he is making a slip of the pen. He seems to be explaining that primaries and compounds, i.e. the direct and the refracted or reflected rays, lie side by side on the chord of the colour-circle, with the compounds at right angles to the primaries on which they depend. This is, of course, mathematically impossible The cool primary Turner opposes to the warm compounds, and *vice versa*. Dividing his circle up into chords rather than sectors, Turner says that green is the weakest colour (? by opposition to red, the strongest) although of the compounds in the rainbow it is the strongest, i.e. the most extensive, and 'disputes the ray and place of the primitive blue'. But purple and yellow, at the extremes of the same chord, approach each other through red, the strongest colour, which combines with and supports yellow, the next strongest, to divide the circle firmly into warm and cool areas. The diagrams and cancellations which follow seem to support this interpretation, for in them Turner moves from a chordal disposition: orange-green; red-blue; yellow-purple, to a spectral sequence from warm to cool: red, orange, yellow, green, blue, purple.

At this point Turner introduces two colour-circles to illustrate a rather different aspect of colour; the distinction between 'aerial' or light colours, as in the spectrum, and material colours, as in pigments [see diagram]. The one mix to produce white, the other to produce black. The three primaries are here arranged according to their tonal values, although red and blue are placed on the same level as shade colours. Again the audience is invited to consider the colour-symbolism of the times of day, although the hour has somewhat advanced since 1818; grey becomes morning, yellow, midday and crimson, evening. The upper and lower portions of *Diagram I* symbolize simply the light and dark of day and night. As primaries the colours are able to show light and darkness by themselves; in compounds

the combinations of greys, browns and neutrals is infinite, in the progression towards black. Turner seems to be saying that only in the light primaries could the antithesis between light and darkness be fully and fundamentally expressed, and that it was only in these same primaries that light and matter have anything in common.[202] The pre-eminence and the priority of red, blue and yellow is firmly established.

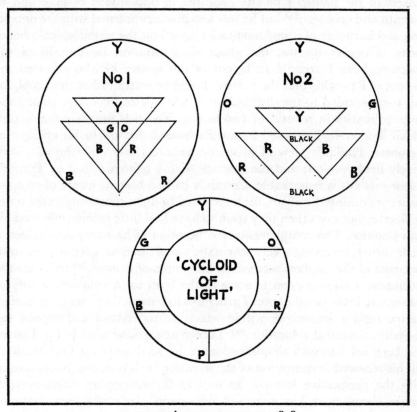

TURNER'S COLOUR-CIRCLES, 1818

Turner's second diagram in this pair was not entirely his own, but was derived from the prismatic circle introduced by Moses Harris into his *Natural System of Colours* in the eighteenth century, 56. Harris and Turner were, however, concerned with colour in very different ways; and Turner completely reinterprets his source. Harris had been dealing chiefly with complementaries, Turner with tonal oppositions, so that he turns Harris's triad of primary triangles on its side to place yellow at the top; and he replaces the purple which would normally fall opposite the yellow at the bottom of the circle with a mud-coloured mixture of all the primaries together, showing the material negation of colour in darkness. Both in their relationships with each other and within themselves, Turner's circles demonstrate light and shade as a function of colour; and the whole lecture seems to be concerned with the coordination of light

and shade, warmth and coolness in the colour-circle. He seems to have been unconcerned with, even unaware of, the idea of complementaries. Turner had almost certainly learned of Harris from Thomas Phillips, who had been preparing his own course of lectures on painting during 1826, and was to use *The Natural System* in the lecture on colour which he delivered three years later.[203] Phillips, like Turner, recognized that the chief powers of the painter's palette consisted in oppositions of tone and of warmth and coolness;[204] but he was also much concerned with the opposition and harmony of complementaries, based on the physiological phenomena of ocular spectra, for whose demonstration he introduced the diagrams from Harris.[205] In favour of this system he also adduced the dictum of Reynolds that the palette should be warm rather than cool, for this corresponded to the distribution of warmth and coolness among the three primaries in a ratio of two to one. This was precisely the dictum which Turner had opposed in the *Backgrounds* lecture in his critique of Veronese. Phillips's view of prismatic harmony was the echo of a very widely held opinion; and the absence of any reference to it in Turner's colour-analysis is remarkable. Certainly he had become aware of complementaries during the 1830s, for he referred to them constantly in the notes to Goethe, but even then they seem to have had little specific effect on his own practice. The complementary conception of harmony was indeed a facile theory, involving a very schematic visual analysis; even the 'natural' spectrum of the rainbow seemed, as his studies of it show,[206] to be far too inconstant a phenomenon to serve as the basis for a complete theory of colour, and in the Goethe notes Turner was to remark that it was nonetheless far too rigid a framework within which to understand and express the diversity of natural coloration.[207] Turner as a young man in the Louvre had been led into such simplifications in his analysis of the Old Masters; but his renewed investigation of the scientific basis of colour in connexion with the perspective lectures, as well as his developing intimacy with nature, clearly made him more and more sceptical of such schematizations. If Turner came to use the three primaries more and more purely in some of his late works, this was not because he thought them more harmonic in pictures, but because he wanted in those pictures to express an idea of light and matter, and he regarded these three colours as symbolic of them.

The years in which Turner delivered his lectures saw an increasing discussion of the theory of colour in England. Harris had been rediscovered, and his treatise had been reissued in a revised edition, dedicated to West, in 1811, the year of Turner's first course. West himself made the most energetic defence of his own rainbow theory of colour in the Academy in 1817, and in this year appeared Henry Richter's landscape treatise: *Day-Light: a Recent Discovery in the Art of Painting*, symptomatic of the new preoccupations.[208] Fuseli, on whom Turner relied so much, and who often chaired his lectures, had incorporated a passage on prismatic colour into his course on painting after 1810;[209] and on the fringes of the

Academy, George Field began to discuss the first fruits of his life-work on chromatics about 1811.[210] Charles Hayter published rather similar ideas on harmony in 1814 in his *Introduction to Perspective*, the second (1815) edition of which was in Turner's library. Turner can thus have hardly escaped the discussion completely; and I believe that his silence on the topic of prismatic harmony, and his modification of Harris's diagram may be interpreted, as is usual in the lectures and marginalia, as a negative commentary upon the current fashion.

The study of painting and engraving alike had shown Turner that tonal relationships were of fundamental importance to the artist; and it was a scale of tonal values from white to black, through yellow, red and blue, that he chose as his basic progression.[211] He would have agreed with Phillips about the amazing power of chiaroscuro to generate a feeling of nature and to excite the imagination, without the aid of colour;[212] and in Lecture V of 1818, the great authority of Titian's late style, as well as that of Rembrandt and Tintoretto, was invoked in favour of an almost monochrome palette.[213] Light, as the notes on Rembrandt and Correggio and those from Lomazzo showed, was, as a theoretical study, an earlier and more urgent concern to Turner than colour itself; it was, indeed, the condition of colour: 'color cannot be seen without light', he quoted from Lomazzo, 'Philosophically the *extreme superficies of a dark untransparent body lightened.*'[214] Similarly, when in his late work, Turner raised his key so remarkably, he achieved contrast through the opposition not of complementaries, but of warm and cool colours, as, for example, in the colour virtuosity of *The Dort* of 1818, **20**, and the two versions of *The Burning of the Houses of Lords and Commons*, **11**.[215]

These preferences, as I hope to show, were not simply the result of Turner's artistic background, but also, and I believe chiefly, of his deep and growing sense of the symbolic function of colour and light. But it was not the conventional colour-symbolism that he had found, and rejected, in the Baroque theorists, but a natural symbolism based on the role of colour in his vision of the natural order. Turner was concerned with the three primary colours because he believed that they were of the essence of natural structure, of the same order as the basic geometrical forms, and that the eye itself was fulfilling a natural function in producing and revealing them. But he reduced these colours to functions of light and dark because light and its negation was more fundamental even than they. For Turner's contemporaries, the complementaries were chiefly valuable as a key to colour-harmony. Turner in his art was less and less concerned to express chromatic harmony, but rather the conflict of light and dark; for him the primaries were emblematic not of harmony but of disharmony. In this he was far closer to the essential system of Goethe than he could ever have imagined; but to see how he achieved it within his chosen framework of naturalism, we must understand a little more of Turner's contact with contemporary British science.

7 Turner
and the colour-science of his time

In his discussions of colour-theory in the perspective lectures, Turner had drawn chiefly on the scientific experience of the Renaissance and of the eighteenth century. Even the harmonic ideas of his contemporaries, which he seems to have rejected, were based on phenomena which had been discovered well before 1800. But the science of optics, and especially the chromatic aspect of it, underwent considerable changes during Turner's lifetime, and, as Thornbury showed, Turner maintained a direct and lively interest in some of these developments right until the close of his life. Did this interest prove fruitful for his work as an artist? I believe it did, for it tended to reinforce, to justify perhaps, some of the professional and personal prejudices which I noticed in passing in the last chapter. Coming to him, as they did, after 1830, the complex optical phenomena with which his scientific contacts and reading were making him familiar may well have helped to confirm the feelings which had surely been developing towards the end of his career as a lecturer: that he could teach colour only by example, not by precept; for the data were too complicated, and too wide in their implications, to be comprehended within the vocabulary and the lecture programme he had at his command.

It would be quite misleading to suggest that because Turner rejected some of the contemporary attempts to use science in painting, his conception of the art was an unscientific one. Quite the reverse. Indeed, Turner seems on occasion to have confused the two activities, as Constable was to do late in life, in his landscape lectures at the Royal Institution.[216] In a long statement on reflections and landscape, which does not seem to have been incorporated into the lectures as delivered, but which may possibly be given to 1810, when Turner was still very much engaged with painting English Pastoral subjects, Turner spoke of the art of landscape almost entirely as if it were a field for quasi-scientific investigation:

> Among the mutable and infinite contrasts of light and shade, none is so difficult either to define or deductable [*sic*] to common vision as reflexies. They enter into every effect in nature, oppose even themselves in theory and evade every attempt to reduce them to any thing like rule or practicability. What seems one day to be equally governed by one cause is destroyed the next by a different atmosphere. In our variable climate where [all] the seasons are recognizable in one day, where all the vapoury turbulence involve[s] the face of things, where nature seems to sport in all her dignity, [] dispensing incidents for

118

the artist's study and deep revealing [?] more than any other [climate] . . . how happily is the landscape painter situated, how roused by every change of nature in every moment, that allows of no langour even in her effects, which she places before him and demands most peremptorily every moment his admiration and investigation, to store his mind with every change of time and place . . .[217]

'Every glance is a glance for study,' as Turner wrote in his notes to Opie's *Lectures*, 'contemplating and defining qualities and causes, effects and incidents, and develops by practice the possibility of attaining what appears mysterious upon principle.'[218] This habit of mind, borne out in Turner's case by so many sketchbooks and the accounts by eye-witnesses of him at work, is fundamentally an exploratory and an experimental one. It was unscientific only in that it could, in Turner's view, lead to no formulation of general laws. It is hardly surprising that a scientist such as the geologist McCulloch was able to see in Turner a potential for greatness in any intellectual pursuit.[219]

Turner's rather generalized scientific attitudes, expressed, for example, in the lecture passage on the geometry of nature, which I quoted in the last chapter, were very much those of his age; although they have been recognized and investigated more thoroughly in German than in English thought. As a youth, he may well have been excited by the rhapsody on universal science buried in that most unpromising of colour handbooks, O'Brien's *British Manufacturer's Companion and Callico Printer's Assistant*:

> The more this great arcana [of Theory] is invaded, the more we discover of that wonderful connection of the whole; what rotation of effects, where nothing is displaced but its room is supplied; and . . . what is called destruction is only a preparative to new combinations and forms . . . may it be exhibited as a respectful, and from the sublimity of the circumstance introduced, an aweful testimony that the present glorious epoch of knowledge transcends all previous human efforts; as taking all nature, as it were, into its grasp, and collapsing the extremes of creation. For, while philosophy on one hand, bursting through the elementary barriers of nature, pursues her to her inmost recesses and analyzes those objects, whose minuteness confounds the imagination, and which are only perceptible by their effects; on the other hand; it not only adds new orbs to our solar system, but darts into the immeasurable expanse and scrutinises objects that as equally confound by their magnitude, and the spaces they possess; in short, it can be said, it exposes immensity itself, gages the very Empyreum, and exhibits its construction!!!![220]

This surprising outburst in Turner's manual gives a sense of scale and amazement which is close in tone and phrasing to his caption, however

disenchanted, to the (untraced) *Fountain of Fallacy*, which was exhibited in 1839:

Its rainbow-dew diffused fell on each anxious lip,
Working wild fantasy, imagining;
First science in the immeasurable abyss of thought
Measured her orbits slumbering.[221]

It was this order of thought, too, which must have attracted Turner at first to the world system of George Field, which attempted to unite all branches of knowledge in a scheme of universal analogy, based on the unity of nature. Turner's taste in cosmology was probably as 'classical' as his taste in art. 'What human breast,' he asked his audience in 1818, quoting Akenside,

E'er doubts, before the transient and minute.
To prize the vast, the stable, the sublime?[222]

In 1847 he drew Galileo's enclosed, concentric system into Solomon Hart's painting of Milton's visit to the astronomer; and in the 1820s he had proposed to introduce it prominently into the vignette of *Galileo's Villa* for Rogers's *Italy*.[223] Turner's textbook of astronomy was Mrs Mary Somerville's rationalistic *Mechanism of the Heavens*, which witnessed, very much in Turner's way, to the underlying unity of principle in natural phenomena, of light and heat, of sound and the movement of water. Even the stars had their colours which were not the deceptive products of 'ocular spectra', as some investigators had thought.[224]

Mrs Somerville was herself an amateur painter and had long admired Turner's work. They seem to have met, probably through mutual friendship with Sir Francis Chantrey, in the late 1820s or early 1830s, and she recalled many welcomings at Turner's studio of a decade later.[225] They certainly had much to discuss, for some years later Turner referred to an early experiment of hers on the magnetizing properties of colours.[226] Violet and indigo, she had shown, and, less conspicuously, blue and green, could magnetize a needle. For Turner it was a further confirmation of the influence of light; a demonstration of polarities, dividing the spectrum even more definitively into warm and cool, and showing that even the cool, the negative pole, had a hidden power.

It seems, too, to have been effects of polarity and contrast in light which attracted Turner to the work of the young American photographer, J.J.E.Mayall, with whom he discussed Mrs Somerville's experiment at the end of his life. Mayall had set up a Daguerreotype studio in London early in 1847, when Turner visited him, and was sufficiently concerned about his work to lend him several hundred pounds to help meet the cost of litigation over patent rights.[227] At first, Mayall told Thornbury, Turner, whose identity was still unknown to him, 'was very desirous of trying curious effects of light let in on the figures from a high position, and he himself sat for the studies'. Later, in the winter of 1847,

He stayed with me some three hours, talking about light and its curious effects on films of prepared silver. He expressed a wish to see the spectral image copied, and asked me if I had ever repeated Mrs Somerville's experiment of magnetising a needle in the rays of a spectrum. I told him I had . . . I was much impressed with his inquisitive disposition, and I carefully explained to him all that I then knew of the operation of light on iodised silver plates. He came again and again, always with some new notion about light. He wished me to copy my views of Niagara—then a novelty in London—and enquired of me about the effect of the rainbow spanning the great falls. I was fortunate in having seized one of these fleeting shadows when I was there, and I showed it to him. He wished to buy the plate . . . He told me he should like to see Niagara, as it was the greatest wonder in Nature; he never tired of my description of it.

When at a soirée of the Royal Society in the spring of 1849, Turner and Mayall met again, and for the last time, Turner 'fell into his old topic of the spectrum'.[228] He had already been familiar with the fact, even the principle, of the Daguerreotype for some years, noting the word in the margin of Goethe's *Theory of Colours* against a paragraph on the effect of different coloured lights on muriate of silver (p. 269); and one of his engravers, John Pye, had been concerned with the development of the invention in England from the earliest days, in 1839.[229] It may well have been, indeed, for the future of engraving rather than of painting that Turner feared, when, if we are to believe the story told by W.B.Richmond, he was first shown a Daguerreotype and exclaimed, 'This is the end of Art. I am glad I have had my day'.[230] Yet, ironically enough, photography at first gave a boost to engravers, who now worked from photographs as well as from drawings, since the Daguerreotype provided a single, unique image without a 'negative', and among them was Turner's own protégé, Mrs Booth's son, D.J.Pound, who engraved Daguerreotype portraits for Mayall himself.[231] But these productions are, as Turner doubtless feared, of a very mechanical quality, partly because they were not translations from colour, but from black and white.

Mayall's work as a photographer had, for his contemporaries, the quality of the best mezzotints. He eschewed colouring, for the same reasons that Turner had avoided it in engraving, as something adventitious, not of the essence of the art. Mayall, wrote a critic in 1847, in contrast with the photographers who tinted their work by hand, 'hopes to do everything by the means of photographic agency alone . . . He conceives the proper exercise of the powers of his art to consist in their application . . . to chiar-oscuri transcripts . . .'

One peculiarity is remarkable in the specimens of his art coming from [Mayall's] hands—Generally, it has been observed that the figures, accessories and background, if possessing colour in themselves,

have been rendered by the Daguérrotype of such a uniform strength that gradation of keeping has been given up as an almost hopeless condition. In most of the American Professor's specimens the varieties of tinting in chiaroscuro are exhibited as in a mezzotint by Cousins or any other engraver of celebrity . . . [Mayall] undertakes to produce effect by the agency of the sun alone (giving up the idea of producing colour), having first made such a combination of elements as shall achieve that purpose in submission to the photographic power . . . By bringing the resources of analytical chemistry to bear on the subject, [he] has reduced the hitherto uncertain action of the Daguérrotype to almost mathematical certainty.[232]

The review may help us both to feel the excitement at the novelty of Mayall's process, and to understand how Turner must have been fascinated by the photographer's skill in translating colour into light and shade by the action of the sun alone. He could see his own early attempts at similar translations in engraving now carried through in terms of natural forces, light generating dark and dark light in a way which had hitherto been the objective of the painter.[233]

Photography could only be a late interest in Turner's life; but it was not the only way in which he found scientific developments encroaching on his province as an artist. In another marginal note to Goethe (p. 87), against a passage on the 'splendid appearance' of light displaced into colours in the prism, Turner wrote 'Kaleidoscope'; and other references scattered through the lectures of 1818 and later, suggest a recurring preoccupation with the instrument.[234] The Kaleidoscope, invented by Sir David Brewster about 1814, has every qualification of the perfect Romantic toy. In it, Nature was taught directly to make art; to transform herself into the colourful and the strange. When it was first brought on to the London and Paris markets in 1816, two hundred thousand instruments were claimed to have been sold within three months,[235] and imitations soon multiplied. Brewster himself saw in his invention the realization of Louis-Bertrand Castel's eighteenth-century attempt at co-ordinating colour and movement in the ocular clavecin:

Those who have been in the habit of using a correct Kaleidoscope, furnished with proper objects, will have no hesitation in admitting, that this instrument realises, in the fullest manner, the formerly chimerical idea of an ocular harpsichord. The combination of true forms, and ever varying tints, which it presents in succession, to the eye, have already been found by experience, to communicate to those who have a taste for this kind of beauty, a pleasure as intense and as permanent as that which the finest ear derives from musical sounds . . . we may venture to predict, because we see the steps by which the prediction is to be fulfilled, that combinations of forms and colours may be made to succeed [each] other in such a manner as to excite

sentiments and ideas with as much vivacity as those which are excited by musical composition. If it be that there are harmonic colours which inspire more pleasure by their combination than others; that dull and gloomy masses, moving slowly before the eye, excite feelings of sadness and distress; and that the aerial tracery of light and evanescent forms, enriched with lively colours, are capable of inspiring us with cheerfulness and gaiety; then it is unquestionable that, by a skilful combination of these passing visions, the mind may derive a degree of pleasure far superior to that which arises from the immediate impression which they make upon the organ of vision.[236]

It was to be predicted, too, that the Kaleidoscope would in the course of time become part of the vocabulary of criticism, no less than that it would be used in reference to the work of Turner:

'If the French fail in want of colour,' wrote a critic of *Ulysses deriding Polyphemus* (NG 508), **21**, in 1829, 'this artist equally departs from nature in the opposite extreme. He has for some time been getting worse and worse, and in this picture he has reached the perfection of unnatural tawdriness. In fact it may be taken as a specimen of colouring run mad—positive vermilion, positive indigo, and all the most glaring tints of green, yellow and purple contend for mastery on the canvas with all the vehement contrasts of a Kaleidoscope or a Persian carpet.[237]

Turner, it could be thought, with his interest in the instrument, might well have accepted this comparison as a compliment; but all his remarks in the lectures refer to its capacity to modify and multiply *forms*, and were not at all concerned with Brewster's intentions for its use as an aid to colour-design. The inventor had himself remarked that the instrument was of least use to the landscape painter, who was not concerned with symmetry, even in forms;[238] and he was very far from sanctioning a belief in the independent value of colour, for all his musical analogies:

It must be obvious, indeed, to any person who considers the subject, that colour, independent of form, is incapable of yielding a continued pleasure.—Masses of rich and harmonious tints, following one another in succession, or combined according to certain laws, would no doubt give satisfaction to a person who had not been familiar with the contemplation of colours; but this satisfaction would not be permanent, and he would cease to admire them as soon as they ceased to be new. Colour is a mere accident of light, which communicates richness and variety to objects that are otherwise beautiful; but perfection of form is a source of beauty, independent of all colours; and it is therefore only from a combination of these two sources of beauty that a sensation of pleasure can be excited.[239]

Brewster's feelings on the supplementary function of colour coincided very much with Turner's; and it was probably for this reason that Turner thought of the Kaleidoscope as more for amusement than for the use of the artist. In this he was not alone. So far from being welcomed as an artistic aid like the Camera Obscura or the Claude Glass, the Kaleidoscope was thought by one writer on colour in landscape to have wasted the time of its inventor, which might so easily have been devoted to answering some real artistic needs: the practical investigation of methods and materials.[240]

It is conceivable that Turner discussed the discoveries of Brewster when he met a friend of the scientist's in Scotland in 1818. Turner was to collaborate with the amateur landscape painter, John Thomson of Duddingston, on the illustrations for Scott's *Provincial Antiquities*; and although the two artists do not seem to have become close friends,[241] they were often in each other's company. Thomson, a friend of Brewster's, was himself something of a scientist, and was thought to have written articles on optics for the *Edinburgh Review*.[242]. Thornbury was told that Turner in Edinburgh had tried to interrogate Brewster during sketching expeditions, on the constituent colours of light, but Brewster denied this; and it may well be that Thomson was the *savan* to whom the biographer's informant was referring; or, alternatively, that the discussions took place during Turner's Edinburgh visit of 1831, when he and the scientist did meet briefly at a dinner.[243] Certainly Brewster's conceptions of light will have been of the greatest concern to Turner, however he heard of them, for they were both anti-Newtonian, and ran counter to the most recent discoveries of his own time, represented by the red–green–violet theory of Wünsch and Thomas Young. Brewster was unable to accept the seven-colour theory of Newton —he spoke of the 'irrationality of the spectrum'[244]—and from his experiments with the production of white light by the absorption of colours, he concluded that he had established the red–yellow–blue theory on an unshakable basis. The first work of Turner's we have discovered to be wholly based on a structure of red, yellow and blue was the *Crichton Castle*, for Scott's *Provincial Antiquities* (TB CLXX, p. 4), **9**, which was prepared on or immediately after the Scottish trip of 1818. But what will have aroused perhaps a particularly enthusiastic response in Turner was Brewster's view that the maximum intensity of yellow was the last stage of colour towards the production of a white light incapable of decomposition in the prism; and he produced a graph to illustrate this in his popular *Treatise on Optics* of 1831.[245] Yellow was thus placed scientifically at the apex of the fundamental three-colour triad, closest to the still more fundamental white light; and in the passage from the fifth lecture of 1818 (Appendix IIc) Turner had placed yellow and white on a par at the head of his warm and cool scales.

Brewster, for his part, may well have been persuaded of the validity of his triad, as had Thomas Young in the early stages of his own work, because it both nourished and was supported by the old theory of the

harmony of complementaries, which had long ceased to be current except in artistic circles. The scientist's daughter recalled that, in spite of the experiments of Clark Maxwell and Helmholtz about the middle of the century, which finally sanctioned Young's three-colour theory,

> Brewster's mind clung . . . to his own Trinity of colour, which he never gave up. A pretty experiment showing the tremulous movement of a red spot upon a green ground, or blue upon orange, was a great favourite; he exhibited it as shown by a mat of worsted work at a meeting of the British Association, explaining the phenomenon by his favourite theory of colours . . . upon one occasion he resolved to bring home a present which should be at the same time a scientific lesson. The result was a dress in which red has its sufficient complement of green, and blue its proper companion, orange. Unscientific eyes were compelled to grieve that it appeared also to possess the uncommon quality of never wearing out! He carried his theory into the study of pictures, criticising severely some of the ancient masters and their disciples for their utter neglect of what he considered the scientific harmony of colouring.

Brewster's friend, the historical genre-painter, William Salter Herrick, recorded the application of such criteria to the work in modern exhibitions:

> Sir David often deplored the want of scientific knowledge in the whole English school. He seemed to me to regard the few pictures that show real harmony of colour in each Exhibition rather as the result of a *feeling* for colour than the result of knowledge. He would take an instrument from his pocket, about two inches long, with two holes in it, which allowed of shifting glasses to show the complementary colours, by which he would demonstrate that, even when a picture appeared to be true in colour, the disproportion of the *hues* of the reds and yellows, with their complementaries, showed how much further a little real knowledge of the principles would have carried the artist. It seemed also to me from the manner he passed from picture to picture, in the Royal Academy, as if when he found one out of harmony it struck him painfully, as a false note in music. The pre-Raphael pictures I believe he regarded as a mistake. When I pointed out pictures by the leading pre-Raphaelites, he would simply exclaim, 'Hideous!' Sometimes on such occasions he illustrated the extreme delicacy of hues by the prismatic colours in pieces of decayed glass, which he carried in his waistcoat pocket.[246]

Such was the grotesque scientism of Turner's later *milieu*. Whether his own work escaped this alarming machinery of criticism is not clear; in Edinburgh Brewster simply remarked that Turner 'exhibited none of his peculiarities' at dinner. But if he will have recoiled at the sort of schema

offered in Brewster's colour-harmonics, which were hardly unfamiliar to him, the attitude to nature and particularly to the nature of light represented by the scientist's work, as surely found a sympathetic audience. On his return from the Scottish visit of 1831 Turner painted his magnificent *Staffa Fingal's Cave* (Astor Collection, R. & B. colour pl. XV), introducing the rare landscape phenomenon of the haloed sun, which had been of particular interest to Brewster.[247] In the chapter on haloes and related phenomena, in the *Treatise* of 1831, Brewster had described the sun in terms which seem almost like an echo of Turner himself:

> When the air is charged with dry exhalations, the sun is sometimes as red as blood. When seen through watery vapours, he is shorn of his beams, but preserves his disc white and colourless.[248]

More important, Brewster's three-colour theory of light, empirical and mathematical as it seemed to be, would carry far more weight with Turner than the looser speculations of his fellow artists at the Academy, with their emphasis on a dubious theory of pictorial harmony. From the middle of the 1830s at least, when he was concerned to show in painting the nature of light, it was in terms of Brewster's three primaries (not strictly 'prismatic' colours, for these included the secondaries) that he chose to do so. 'Red, blue and yellow' was the laconic, but lucid account which Turner gave Ruskin of *Light and Colour, (Goethe's Theory)*, 52, in 1844.[249] It is surely more than a coincidence, that the most conspicuous cases of the late revision of subjects about light itself, *Norham Castle* and *The Fall of the Clyde*, were revisited and reassessed on the same visit to Scotland in 1831 when Turner had been again in contact with Brewster, Thomson and their circle.[250] How Turner came to incorporate and develop in his work a peculiar and only partly naturalistic *iconography* of light and colour must be the subject of the final section.

Part III Turner as a practical theorist

He that impresses the observation or stimulates the Associate idea of a color individually is the great artist.[1]

8 The mythology of colour*

We cannot make good painters without some aid from poesy.[2]

I

The years 1828–30 were perhaps the most critical period in Turner's life, both personally and for his career. The death of his father, following closely on those of two of his most appreciative patrons, Walter Fawkes and Sir John Leicester, must have given great impetus to the sense of isolation which characterizes his later life and work. The years between 1827 and 1833 saw Turner attempting a range of styles and subjects comparable only with the period immediately following 1800, and witness a comparable spiritual upheaval. These years also saw the end of Turner's career as a lecturer, into which he had put so much of his energy and resources. The perspective lectures had been, it seems, at least before 1820, well attended, and even understood, by students and the public.[3] But with the increasing complexity of the courses as they developed in the 1820s, Turner's following fell off, and Henry Cole, who went to the last series in 1828, found himself almost alone. Turner was, he noted in his diary, 'almost perfection in mumbling and unintelligibility'; and at the fourth lecture of the course, 'no attendance but me'.[4] It was some years before Turner found an alternative outlet for his most immediate didactic intentions, on Varnishing Days at the Academy or British Institution; but at the Exhibition of 1829 he showed a picture which by its apparent conservatism of subject no less than by its novelty of treatment, should lead us to reconsider the nature of Turner's methods of communication in colour; and their development from an 'early' to a 'late' style: *Ulysses Deriding Polyphemus* (NG 508), **21**, which Ruskin rightly regarded as 'the *central picture* in Turner's career'.[5]

Ruskin was not alone in appreciating the originality of the painting, although his enthusiasm for its colour had not been widely shared. It was, observed one critic, a 'violent departure from [Turner's] former style', in that it had abandoned 'sober, effective and magical tints'.[6] One of the sources for this change was Turner's developing appreciation of early Italian painting, especially during the Italian visit of 1828–9; but there is in the picture, too, a conception of the subject which suggests a development in Turner's artistic attitudes of far wider implication than this, and which demands a more detailed analysis.

Ruskin noted Turner's accuracy of detail in following his text from Pope's version of Homer, and painting the smoke rising from the Cyclops'

* I have adapted this phrase from Adrian Stokes, *Colour and Form*, 1937, p. 168, an essay which I have found most stimulating.

mountain;[7] and the picture also gives the feeling of the giant as the 'lone mountain's monstrous growth' of Pope's rendering. The painter likewise followed his source in showing Ulysses hailing Polyphemus 'from the shallows clear'; although this detail gave Ruskin some apprehension 'that Leucothea is taking Ulysses right on the Goodwin Sands'. Turner went, however, beyond his source in other ways which suggest that the picture was, for him, far from being a simple illustration of the Homeric Story.

The smoke which Ruskin noticed comes not, as its context in the poem would imply, from the shepherds' fires, but from the crater of a volcano, which is shown even more clearly in the brooding and gloomy oil sketch for the picture in the Tate Gallery (No. 2958). Polyphemus's island is volcanic; and he, as organically part of it, is directly associated with the idea of natural forces given by Hesiod to his brother Cyclops: Brontes, Steropes and Arges, emblems of thunder and lightning.[8] Even if he did not consult Hesiod's *Theogony* in his copy of Anderson's *British Poets*, Turner will have found this association, with a reference to Hesiod, in Lairesse's *Art of Painting* which he had certainly read and discussed extensively in connexion with the lectures, and where Polyphemus is explicitly made the subject of a suggested story.[9] Neither Hesiod nor Lairesse had related Polyphemus to any particular natural force, so that his role was still to be determined; and during the later eighteenth century it had been suggested by scientists that volcanic dust and lightning were closely associated, electrically, in the formation of falling stones (meteorites), themselves often accompanied by thunder. The sea-cavern to the left, with its fire in the depths, is, from its scale, clearly not the cave of the Cyclops himself, as Ruskin supposed, and it may well be Turner's visualization of an idea of Erasmus Darwin, that volcanoes were originally created by the rush of sea-water into the burning caverns of the earth.[10]

Similarly, the conception of natural forces may help us to understand some of the stranger aspects in this picture of colour and light. Neither Pope's Homer nor the modern pantomime to which Turner once teasingly traced his subject[11] gave any indication of the shoal of iridescent Nereids sporting round Ulysses' ship, some of Turner's most original creations, and having for their sisters only perhaps Girodet's Ossianic nymphs greeting the *Shades of the French Warriors* at Malmaison, 58. Lairesse, in his discussion of the subject of *Polyphemus and Galatea*, had referred, again with reference to Hesiod, to the Nereids as signifying 'the different qualities and various effects of the water';[12] but one effect certainly unknown to the Greek poet, and hardly in Lairesse's mind, was the phenomenon of phosphorescence, which had become increasingly interesting to eighteenth-century scientists and which, in the Romantic period, fed the poetic imaginations of Erasmus Darwin, Coleridge and Shelley. It likewise illuminated Turner; and the natural data, which lie behind his shining sea-creatures with stars at their foreheads, were summarized in a compilation which had attracted Coleridge, and which Turner had used in the preparation of his perspective

lectures: Joseph Priestley's *History and Present State of Discoveries Relating to Vision, Light and Colours* (1772).[13] Of light emitted by putrescent substances, Priestley had written:

> That the *sea* is sometimes luminous, especially when it is put in motion, by the dashing of oars, or the beating of it against a ship, has been observed with admiration by a great number of persons ... Father Bourzes, in his voyage to the Indies, in 1704, took particular notice of the luminous appearance of the sea; but though many of the circumstances which he mentions seemed to point to the true cause of it, viz. the putrescent matter in the sea, he does not seem to have been aware of it. The light was sometimes so great, that he could easily distinguish, in the wake of the ship, the particles that were luminous from those that were not: and they appeared not to be all of the same figure. Some of them were like points of Light, and others such as stars appear to the naked eye. Some of them were like globes, of a line or two in diameter, and others as big as one's hand ... Nor only did the wake of the ship produce this light, but fishes also swimming, left so luminous a track behind them, that both their size and species might be distinguished by it ... M. le Roi, making a voyage on the Mediterranean, took notice that, in the day time, the prow of the ship in motion threw up many small particles, which, falling upon the water, rolled upon the surface of the sea, for a few seconds, before they mixed with it; and in the night, the same particles, as he concluded, had the appearance of fire.[14]

The introduction of the stars, the fish, the oars and the ship's prow leaves little doubt that this account was the origin of Turner's idea; and in using it in *Ulysses* he was adding a new, pictorial, dimension to what had for some time been a poetic conceit. In his versified textbook, *The Botanic Garden*, Erasmus Darwin had addressed the Nymphs, Sylphs and Salamanders which he imagined were invested with the electric and phosphorescent phenomena of nature:

> *Effulgent Maids! You round deciduous day,*
> *Tressed with soft beams, your glittering bands array;*
> *On Earth's cold bosom, as the Sun retires,*
> *Confine with folds of air the lingering fires;*
> *O'er Eve's pale forms diffuse phosphoric light,*
> *And deck with lambent flames the shrine of Night ...*
> *From leaf to leaf conduct the virgin light,*
> *Star of the earth, and diamond of the night ...*
> *Or gild the surge with insect sparks, that swarm*
> *Round the bright oar, the kindling prow alarm ...*

In a note on this passage, Darwin explained the last images by drawing on experiences similar to those recounted by his friend, Priestley:

In some seas, as particularly about the coast of Malabar, as a ship floats along, it seems during the night to be surrounded with fire, and to leave a long track of light behind it. Whenever the sea is gently agitated, it seems converted into little stars, every drop as it breaks emits light, like bodies electrified in the dark.[15]

'Dr Darwin's Poetry,' noted Coleridge, 'a succession of Landscapes or Paintings—*it arrests the attention too often*':[16] and although Darwin's most direct contacts among artists had been with Joseph Wright of Derby, a painter who in some ways was Turner's closest precursor in England, his poems, which had been illustrated by Fuseli, were widely discussed in Academic circles, and will certainly have come to the notice of Turner.[17]

Turner's preoccupation with volcanoes has often been noticed; on the visit to Vesuvius in 1819, he offered up his sketchbook to receive the mountain's signature, which came as a shower of hot ash (TB CLXXIV, pp. 78a–79). Similarly, he had always been interested in the colour and luminosity of fish: there are numerous watercolour studies of fish within and without the Turner Bequest; and, according to an episode recorded by Ruskin, Turner made his treatment of the foreground fish in *Calais Pier* (TG 472; R. & B. colour pl. I) a touchstone of his skill as a colourist.[18] Against two passages on the iridescence and incipient putrescence of fish in Goethe's *Theory of Colours* (p. 256), Turner noted the 'Ceylon [?] fish' and 'macker[e]l'; which may itself be a reminiscence of an experiment with boiled mackerel, producing luminous water, discussed in the same chapter of Priestley's treatise which recounted stories of a phosphorescent sea.[19]

But it is another of Turner's own glosses on the Ulysses story which shows most clearly the way in which he was anxious to assimilate science and observation to ancient mythology: in the treatment of the dawn light itself. At first sight, the sky in *Ulysses* seems to be simply the clearest beginning to what we recognize as 'late' Turner: a miraculous splendour contained within a framework of delicate naturalism. But, on closer inspection, we see that out of the sunrise come a fan of rearing, snorting horses, 'drawn in fiery outline', in Ruskin's words, 'leaping up into the sky and shaking their crests out into flashes of scarlet cloud', which were once, it seems, far more prominent than they are now.[20] These horses of the Morning were adapted directly from Stuart and Revett's presentation of the east pediment of the Parthenon, in the *Antiquities of Athens*, which Turner had used in his lectures;[21] and they confirm the feeling evoked by the subject and by the Greek inscription on the banner at the mast-head, that *Ulysses* is Turner's first truly 'Greek' picture. His close interest in the arrival of the Elgin Marbles is shown both in the lectures and by his decorating the entrance hall of his house in Queen Anne Street with casts from the frieze of Centaurs and Lapithae.[22] The introduction of the Horses of the Sun into this scene, although it was not sanctioned by Pope's *Odyssey*, might be thought a conventional Baroque personification. But a

comparison of his treatment of them with, for example, that of Poussin in *Cephalus and Aurora* in the National Gallery (No. 65) (which Turner will certainly have known since its exhibition at the British Institution in 1816) shows that, as in the case of the Nereids and Polyphemus himself, Turner has identified his allegorical figures completely with the natural appearances for which they stand. Poussin's horses, on the other hand, represent the dawn but are not part of it. In *Ulysses*, Turner was attempting to harmonize idealism and naturalism with a clarity which was quite new: to fuse history completely with landscape, in a way paralleled perhaps only in the tentative and uncompleted efforts of Philipp Otto Runge.

The idea of painting pictures about natural forces, using as a vocabulary the representation of these forces themselves, was not itself new. Rubens, in the *Mercury and Argus* in Cologne, and in an early candlelight picture (formerly Francis Collection), to which he gave a caption very much in the spirit of Turner's *Watteau Study* or *Light and Colour, (Goethe's Theory)*,[23] had been concerned, either allegorically or realistically, with light and colour phenomena themselves. But the practice is rare with Rubens, and rarer outside his work; nor did he articulate his conception as widely or as complexly as Turner was to do. In the study of Turner's career as a colourist, *Ulysses Deriding Polyphemus* is a central picture because it is as much about light and colour as it is about the Homeric story; and because it invites us both to look for a conception of natural forces underlying some of the earlier subject-pictures, which have often been considered as merely conventional, and to look forward to a mythology of colour infusing some of the later landscapes, which has generally escaped notice precisely because it is expressed in such purely naturalistic terms. But because Turner's deep feeling for symbolism has received little attention since Ruskin, it will be helpful to digress into some discussion of the more general qualities of his aesthetic response.

II

The association of ideas was, for Turner, not merely a philosophical doctrine helpful to his teaching;[24] it was one of his most constant and deeply rooted habits of mind. At about the time that he was attacking the restrictive categorization of the Picturesque by Price and Knight, in his notes to Shee (p. 7), and introducing into the argument the key-word, 'sentiment', which the artist must extract from his subject, Turner will have read in a critical review of Price's *Essays*, a passage which, I believe, surely struck a very responsive chord in his mind:

> The inexperienced eye may be caught, and even the judgement of the connoisseur gratified, by some pleasing harmony of tints, or happy disposition of light and shade; but a painting of real excellence, in addition to these qualities, must be impressed with some decided character having the power of awakening the imagination, and lead-

ing it to associate a thousand ideas with the objects actually represented. Of eminent landscape painters, Salvator and Claude are the most successful in this reach of the art; Gaspar Poussin perhaps the least so, from his weakness in figures, which are commonly so essential to the completion of character. Gaspar's paintings please by their skilful combination of objects, rather than by any remarkable appearance of nature which they represent, or train of ideas which they excite, excepting, indeed his land storms and hurricanes, while Claude marks the very hour of the day, and the whole character of the scene; and Salvator never fails to interest the imagination, by communicating to the spectator the peculiar idea which was present to his own mind.[25]

Turner was to refer specifically to a Gaspar storm scene, *Dido and Aeneas*, in the passage on English landscape in which he dealt with expressive character (below, p. 213); and his preference for Salvator rather than Claude as a model for English landscape painters was broadly similar.

At its lowest level, Turner's devotion to mental associations showed itself in his weakness for punning; but it also permeated his work as an artist and as a poet. A thoroughly naturalistic account of the colours and shadows of dawn light would suggest Socrates' explanation of the sun as a heated iron plate;[26] Newton's analysis of light rays would call up Joseph's coat of many colours;[27] Sir Edwin Landseer's picture of stags fighting, shown at the Academy in 1844, with the title *Coming Events Cast their Shadows before Them*, provoked in Turner the *riposte* on a night watercolour of a Swiss lake, with bursting rockets—*Coming Events Cast their Lights before Them*, conveying the idea of the 'Sky struggling over the Stars [?]' (TB cccxv, p. 14). A simple Swiss [?] landscape could suggest 'the contemplative shepherd', and some verses (unhappily illegible: TB ccclxiv, 170); and another hilly landscape which Finberg misread as referring to the *Loire*, could serve as the setting for 'Love and . . . Lovers' (*ib.* 357). We saw in Turner's correspondence with Miller (above, p. 46) how Turner was anxious to define the 'sentiment' of his landscapes by the use of staffage; and the tendency to convert landscape into history, even to see the one in terms of the other, did not escape some of the painter's contemporaries. John Burnet wrote in his obituary notice:

Nor was [Turner] less careful in choosing the characters of his figures to embellish the several scenes, for even the most trifling incident was pressed into the service that could excite or heighten the association of ideas; this it is that gives an imaginative or poetical stamp to his works.[28]

Ruskin's elaborate interpretations of Turner's symbolism have sometimes been attacked by reference to a single and thoroughly understandable bantering remark of Turner's that the critic saw more in his pictures than he saw himself.[29] But, although in the letter there is much that must

remain debatable, the spirit of Ruskin's emphasis shows an awareness of the nature of Turner's imagination that is absolutely right.[30] The accuracy of his instinct can be tested in the case of Turner's design for *Battle Abbey: The Spot where Harold Fell*, engraved by Cooke for *Views in Sussex* in 1819 (R. 129), **29**. 'The blasted trunk on the left,' wrote Ruskin in a chapter in *Modern Painters* on the contemplative imagination, 'takes, where its boughs first separate, the shape of the head of an arrow; this, which is mere fancy in itself, is imagination, as it supposes in the spectator an excited condition of feeling dependent on the history of the spot.'[31] Far earlier than Ruskin, the engraved plate had been the subject of an excellent, balanced analysis by the landscape painter, R.R.Reinagle, who had provided the text to Cooke's publication:

> A violent storm is just passing away, having burst its fury at no great distance; this we gather not so much from the mere effect of light and shade, as by an accurate attention to the formation of clouds. 'Thus a commotion or contention and strife of the elements help to give a feeling necessary to the purpose of this design.'
> The direction of the lines of the clouds in their convolutions calls attention to the spot the Artist has to depict; the decline of the day, expressed by a low light, and long sloping shadows, together with the beautiful circumstance of a fallen tree, add an unexpected strength to the conception. The decay of the few straggling yet standing firs, united with the above circumstances, gives a powerful impression of melancholy and sadness to the scene. To add to all this admirable feeling and exquisite sensibility of combination, both in form and effect, Mr Turner has given us an episode, a hare, just on the point of being run down by a grey-hound, which fills the mind of the observer with only one sentiment, that of death, as no other living objects interpose to divert the mind from it ... Independently of this Shakespeare-like poetic treatment, those who only look at the art as a mere vehicle of imitation, will find a most scrupulous attention to nature in all the parts.[32]

Possibly Reinagle took his cue for the exposition of the 'episode' from Turner himself, for the justness of his interpretation, and incidentally, that of Ruskin's, is borne out by a rare and entertaining pronouncement of the artist himself, which was retailed as an anti-Cockney joke in Thomson of Duddingston's Edinburgh circle. When Thomson was admiring the drawing for *Battle* (at present untraced), presumably in 1822 or 1831, Turner is said to have called out, 'Ah, I see you want to know why I have introduced that 'are. It is a bit of sentiment, sir! for that's the spot where 'Arold 'Arefoot fell, and you see I have made an 'ound a-chasing an 'are.'[32]
 In a similar vein, Turner pointed out to the young G.D.Leslie the hare running before the engine which he had painted into *Rain Steam and Speed* on Varnishing Day in 1844; and Leslie conjectured with some justification

that the ploughman in the distant landscape to the right of this picture was suggested to Turner's mind by the tag, 'Speed the Plough'.[34]

If these examples are really characteristic of Turner's mode of feeling, it is clear that far more weight than is usual must be given to the meaning of the verses and inscriptions which he appended to some of his pictures when they were exhibited. In this sense, Mr Lindsay's recent publication of some of the captions in an anthology of Turner's poetry has done a disservice to the artist, since they were neither written, nor intended to be considered, separately from the pictures to which they belong. The longest and most ambitious poem which Turner meant for publication, *The Southern Coast*, was to accompany a series of engravings; and it is evident even from the fragments so far published by Thornbury and Mr Lindsay, that its character is not to present purely descriptive landscape pictures, but rather Thomsonian historical *tableaux* and moral allusions.[35]

Turner's earliest use of poetical quotations is hardly very illuminating. Those from Thomson and Milton which he took in 1798 seem to have been afterthoughts to meet a general demand in the year when quotation was first permitted in the Academy catalogue. Certainly the extract from Thomson's *Spring* appended to *Buttermere Lake* (TG 460; R. & B. pl. 7), with its dazzling references to the rainbow of 'every hue', is wholly inappropriate to the picture, whose low key has only the 'yellow mist' in common with the verses.[36] Professor Ziff has pointed to the captions, from Thomson, to the watercolour of *Norham Castle*, **34**, this year, and from Milton to the oil, *Harlech Castle* (Richmond, Virginia, Mellon Collection) of 1799, as being those which Turner discussed together in the 'poetry and painting' lecture of 1812;[37] but he does not state that Turner then demonstrated their unsuitableness to pictorial representation; and 1812 was the year when Turner began overtly to fashion his own store of poetic captions: *The Fallacies of Hope*. Turner was, too, in these early years, able to conceive a single design as appropriate to several, very different subjects; but in cases of this sort the figure element seems to have been very much subordinate to landscape and architecture; and we have little evidence about the function of colour as a determinant in the designs.[38]

These instances of comparative indifference to the character of a composition are, I believe, exceptional after the early 1800s; Turner's style, including his reminiscences of other artists, generally tells us much about the conception of a subject; and, conversely, the subject itself may help us to understand the development of a particular style. With this in mind, it will be appropriate to look at a number of the early subject-pictures, for it is here that we shall find the beginnings of that process of thought and feeling which leads to Turner's mature conception of colour.

III

With the virtual closing of the traditional channels of patronage and commission during the eighteenth century, and the parallel rise of the

Exhibition as the mainspring of public art, it becomes clear that increasing importance must be given to the artist's choice as well as to his treatment of a subject. Turner's history pictures were soon recognized as being 'singular' in their themes;[39] and a perusal of Academy catalogues during the first decade of the nineteenth century generally confirms this impression. In some cases there is a possibility that work was commissioned: for example Beckford's *Fifth Plague of Egypt*, which Turner mentioned in a note of possibly 1796 or 1797, but which was not painted (at the earliest) until 1799.[40] *The Unpaid Bill* of 1808 (Kincaid–Lennox Collection) we know to have been painted especially for Richard Payne Knight, and probably to his directions.[41] But many of the subject-pictures have no such origins, and remained in Turner's hands; which makes them of the greatest interest in establishing the tendencies of his mind. A number of important clues to this state of mind is contained in a remarkable drawing, *The Artist's Studio* (TB CXXI, B), **31**, which Turner made about 1809.

The drawing is the ridiculous element in a pair designed to point the affinities of the ridiculous and the sublime; and, like its sublime pendant, *The Garetteer's Petition* (TG 482; drawing TB CXXI, A), it was cast in a Rembrandtesque style because Rembrandt was, for Turner and his contemporaries, that Old Master most capable of comprehending the sublime and the ridiculous alike.[42] A portly painter is shown gloating over the picture on his easel, which, according to the caption, must be *The Judgement of Paris*; another painting, visible to the left, shows Adam and Eve divided by the Serpent, and is entitled, *Forbidden Fruit*. Other items in the studio, listed in the inscription, are Old Masters stacked on the floor, 'stolen hints from celebrated pictures', crucibles, retorts, labelled bottles, 'mystery varnish'. In the background, an assistant toasts rolls over the fire, pointing the bathetic message recorded in verses on the back:

> Pleas'd with his work he views it o'er & o'er,
> And finds fresh Beauties never seen before.
> The Tyro's mind another feast controuls
> Nor cares for taste beyond a butter'd roll.

As Professor Ziff has recognized, this drawing has much to do with the fashion for technical *nostrums*, which Turner had witnessed in his youth:[43] the 'stolen hints' may even be a reminiscence of the 'Filchings from Wilson' which Gillray had put into Farington's hands in his caricature of *Titianus Redivivus* in 1797. But the chemical imagery, with which Turner was much occupied about this time (e.g. *The Unpaid Bill*; TB XCIX, p. 77a, now followed by CXCV(a)1; CXXXIII, p. 83a) goes, I believe, far deeper than this, and takes us into the mythological world of traditional science.

The Rembrandtesque picture which bears perhaps most relationship to Turner's drawing is Adrian van Ostade's brilliant *Alchemist*, now in the National Gallery (No. 846), **59**. This painting, which is, similarly, a satire, may have been that in the collection of Sir Francis Bourgeois in the 1790s;

and Bourgeois was not only, it seems, a friend of Turner's,[44] but also a pupil of Loutherbourg, whose concern with practical chemistry we noticed in an earlier chapter. Loutherbourg's preoccupation with the science went, however, far beyond its application in painting; and his early theological studies at Strasbourg seem, too, to have been revived and assimilated to his scientific interests in the 1780s, when he was associated with the London Boehmist sect of the Rev. Richard Clarke.[45] Clarke was a speculative, though not a practising alchemist;[46] and Loutherbourg's known interest in Cagliostro may, too, have been stimulated by his reputation as an authority on pigments as well as on the more hermetic or theoretical aspects of the art.[47] However this may be, Loutherbourg built up a considerable library of occult and alchemical literature; and the traditional symbolism which this literature offered seems to have entered into his work as a painter. Most of Loutherbourg's subject-pictures have yet to be rescued from oblivion; but at his posthumous Sale in 1812 (3rd Day), lot 74 was a painting of *Cadmus Destroying the Dragon:—The Story Related in a Grand and Romantic Landscape*. In a French eighteenth-century attempt to reduce Classical and Egyptian mythology to terms of primitive chemistry, the name Cadmus was related to *Cadmia*, zinc oxide and other zinc compounds, and Cadmus himself was associated with alchemy through his invention of mining and working gold.[48] The same author, A.-J.Pernety, also tried to identify the Cadmus myths with those of Jason; and we know that Loutherbourg painted a *Jason Enchanting the Dragon*, which was in the Bryan collection until 1798.[49] This alchemical gloss on ancient mythology has a direct bearing on Turner's drawing of the *Artist's Studio*, for the *Judgement of Paris* was directly linked in a chain of alchemical symbolic association with *Forbidden Fruit*.

That there was a relationship in Turner's mind between the Apples of the Hesperides and those of the Tree of Knowledge is clear not only from the drawing, but also from the *Ode to Discord* which he prepared, but did not use, as the caption for his *Goddess of Discord Choosing the Apple of Contention in the Garden of the Hesperides*, exhibited at the British Institution in 1806 (TG 477, **60**). The closing verses:

> *The shiny mischief to herself she took;*
> *Love felt the wound, and Troy's foundations shook.*[50]

are clearly a reminiscence of that fatal moment in Book IX of *Paradise Lost*, when Eve

> *her rash hand in evil hour*
> *Forth reaching to the fruit, she pluck'd, she eat:*
> *Earth felt the wound, and Nature from her seat*
> *Sighing through all her works gave signs of woe,*
> *that all was lost.*

In an early eighteenth-century compendium in Loutherbourg's library, the story of Adam and Eve and the temptation was given an alchemical meaning; Adam was the (black) *prima materia*; Eve the white mixture of all the elements deriving from him; the Serpent the acid (*Resovier Wasser*); and the apple, the tinting agent.[51] Similarly, Pernety interpreted Paris in the Greek myth as hermetic sulphur, probably by analogy with the sulphur-golden fleece of the Jason story; and the golden fruit itself as the goal of the alchemical quest hardly needs elaboration.[52] The attempt to force the ancient myths into an alchemical framework was crude and simplistic; but it did give a new impetus to their interpretation in terms of the forces of nature: it gave a *rationale*, thoroughly characteristic of the Enlightenment, to a body of stories which might otherwise have seemed to be arbitrary, to have no common bond. They had been treated in this way by Akenside for precisely similar reasons.

Turner's attitude to alchemy itself is not clear. His drawing of *The Artist's Studio* is unambiguously satirical; and I believe it to be a satire on Loutherbourg himself, for the figure of the painter is very close to Loutherbourg's self-portrait in the National Portrait Gallery. We know that while the two artists were neighbours at Hammersmith between 1807 and 1811, Turner visited Loutherbourg so regularly that his wife was afraid for her husband's secrets, and turned him roughly away.[53] It may well have been a slight of this kind which provoked the form of Turner's drawing; but perhaps he felt it too unkind to execute and exhibit, like the *Garetteer*, in oils. If he pursued his study of Shaftsbury's *Characteristicks*, in which he had been interested by his study of literary style for the perspective lectures,[54] he will have found a scathing comparison of the alchemists with the *virtuosi* of art, thoroughly in the spirit of his satire. Shaftsbury mentioned, too, that the alchemists were concerned to make man (i.e. Adam) 'by other mediums than Nature has hitherto provided'.[55] But of the three chemical treatises which we know Turner used in his practice, only one was anti-alchemical; and the others, especially William Salmon's *Polygraphice* (3rd ed., 1675), gave more or less space to alchemical recipes.[56] Whatever the truth about Turner's practical scepticism, alchemy brought him into contact with a body of mythological doctrine on which he was to draw constantly during his early years as a history-painter. It was, in particular, a doctrine which helped him to concentrate and conceptualize his feeling for the elemental significance of light, shade and colour.

In 1802, Turner showed at the Academy his first painting in which the figure plays a dominant rôle: *Jason* (TG 417), a rare subject, for which the closest precedent I have been able to discover is the Loutherbourg picture referred to above. In an alchemical treatise attributed to Paracelsus, in Loutherbourg's collection, the whole story of the Golden Fleece was considered as an allegory of the alchemical quest for precious metals; and it was similarly treated by Pernety, who quoted Ramon Lull on the dragon composed of the four elements.[57] Turner, who seems to have used not the

very brief account of the episode in Ovid's *Metamorphoses* (Bk. VII), but the more circumstantial version of Apollonius Rhodius,[58] nevertheless placed the greatest emphasis on Jason's encounter with the dragon itself: there is no fleece either in the painting or in the *Liber Studiorum* plate after it (R. 6); and Turner departs from Apollonius, to give a more elemental interpretation to the subject, by placing his dragon not in an open grove, but in the bowels of the earth. Similarly, Turner's dragon of the Hesperides in *The Goddess of Discord*, far from guarding the fruit, has gone off to air himself in the mountains, of which he has become almost a part. As Pernety noted, he was Ladon, the son of Typhon and Echidna: fire and tempest, earth and water, and the brother of Jason's dragon.[59] Turner's curious substitution of Psyche for Thetis in the *Ode to Discord* (who was, according to his poem, '*Unasked at Psyche's bridal feast to share*') may well have been a transference of ideas from Vesta, the fourth Hesperid, whom he has added to the original triad in the Garden, for both Vesta and Psyche, according to Pernety, were symbolic of mercurial water.[60]

Fawkes's version of Apollonius Rhodius (*Argonautics*, Bk. IV, 1647 f) which was the translation Turner is most likely to have consulted, described the Hesperidean dragon as a 'serpent', which may well have established for him his relationship with the Python slain by Apollo, a subject which he conceived about the same time as *Jason* (cf. TB LXXXI, p. 68; XC, p. 3), but which he did not exhibit as a painting until 1811 (TG 488), **44**. Turner took exceptional care over the caption to this picture, studying eighteenth-century versions of Calimacchus's *Hymn to Apollo* while he was composing his own.[61] In his two most complete paraphrases of the poem, one of which was published in the Academy catalogue, Turner stressed the contrast between Apollo's 'golden arms' and the 'gloomy' mountain setting of the episode, blackened with Python's gore, a contrast precisely rendered by the dramatic chiaroscuro of the painting. Apollo had been in a more general classical tradition, as well as in the language of the alchemists, the emblem of solar light; and Python, according to Pernety's etymology, signified *putrefactio*; he was born of slime, just as Turner's monster slithers glistening from among the rocks.[62] Girodet, among artists of the period, had made a similar contrast to Turner's in his definition of Apollo as 'Le radieux vainqueur du ténébreux Python'.[63] In this subject the painter's light and shade were themselves conspicuously the vehicle for representing an analogous struggle of the elements.

This antithesis of light and dark was not offered to Turner in the eighteenth-century English versions of Callimachus; but if he consulted the 1755 translation of William Dodds, he will have found in a long note on the Python story that 'The ascribing of this exploit to *Apollo* seems evidently to have arisen from a corrupt tradition of what the Redeemer *was to do*, a tradition founded on the promise of God that "the seed of the *woman* should bruise the *serpent's* head"'.[64] In the same sketchbook as the

first project for the *Death of Python*, Turner drew a *Holy Family* (TB LXXXI, p. 63), **63**, the first surviving study for the painting he exhibited at the Academy in 1803 (TG 473), **64**. To the right of the composition of the oil version, which is set in a landscape, a serpent slithers away up a rock; and the serpent was, as Ruskin rightly noted, Turner's emblem of evil throughout his life. The conjunction of the Christ-Child and the serpent was not only a parallel to the confrontation of the boy-Apollo and the serpent Python; it was also very much a part of Boehmist nature-symbolism. In *De Signatura Rerum*, Jacob Boehme had written of the Nativity and the Serpent in the same context:

> The Seed of the woman, *viz.* of the heavenly Virginity, which disappeared in *Adam*, and also the corrupted Man's seed in the Anger, *viz.* Mary's seed, were formed into one person, which was Christ; and the Seed of the Woman, *viz.* of the Virgin of God, understand the heavenly Essentiality, should bruise the Head of the Serpent, understand the Wrath of God in the corrupted Man; the Head is the might of God's Anger; the divine Man, understand the divine Property, should change the earthly into itself, and turn the earth to Heaven.

Earlier, Boehme had explained that Christ's life and death is an analogy for the Alchemical Work; and later on he placed the image of darkness and light in this process quite clearly:

> As Adam changed the likeness of God into the dark Death's form, so God did again change the likeness through his fire-wrath out of Death into the Light.[65]

Turner's conception of *The Holy Family* is curiously close to *The Rest on the Flight*, by Philipp Otto Runge, in the Hamburg Kunsthalle, **65**, which has the Infant Christ similarly posed to receive the light. Runge's Boehmist reading may well have lead him to similar symbols in this picture, which he described as a *Dawn*, showing how 'das Kind aus dem Schatten heraus mit der Hand in den ersten Sonnenstrahlen spielte . . .'[66] For Runge as for Turner, the distinction between the scope of landscape and figure painting was difficult—and unnecessary—to define.

Fuseli called Turner's *Holy Family* 'The blot of a great master of colouring', and certainly in style and handling it is by Reynolds out of Titian. Titian was even more directly behind his original idea, for the earliest sketch (TB LXXXI, p. 63), **63**, was based on the *St Peter Martyr*, **61**, which Turner had seen and studied in the Louvre in 1802. This picture was perhaps Turner's most constant inspiration among the Old Masters, both for its more purely pictorial qualities, and for the drama of the action. It showed, he had noted in the *Louvre* sketchbook:

> great power as to conception and sublimity of intelect—the characters are finely contrived, the composition is beyond all system, the landscape, tho' natural is heroic, the figure wonderfully expressive of

surprize and concomitant fear. The sanguinary assassin (is) striding over the prostrate martyr who with uplifted arms exults in being acknowledged by Heaven. The affrighted Saint has a dignity even in his fear . . . (p. 28a)

In an addition to the *Reflexes* lecture of 1818, Turner conceived of the shower of putti in the picture as sparks from a bursting rocket, 'struggling with the elements'; [67] and he is unlikely ever to have thought of Titian's work in terms of its design and handling alone. In the process of invention and composition in his notebook, Turner transposed the martyrdom of St Peter into the martyrdom of Christ; for in the passage of Boehme which showed the relationship between the Nativity and the Serpent, Christ's triumph over it was expressed in terms of the Crucifixion. [68]

Likewise, I believe we must look for a darker and more complex theme beneath the apparently Rococo subject of *Venus and Adonis* (New York, Huntington Hartford Coll.), **62**, painted about 1803, but not exhibited until 1849; for this, too, was based directly on the *St Peter Martyr*. The first study (TB LXXXI, p. 50), which did not derive from the Titian, appears only a few pages before those for the *Holy Family* and the *Death of Python*; and Turner planned a sequel to the Venus and Adonis episode (*ib.* p. 52), which reminds us that, in quitting her, the god is going to his death. According to Pernety, Adonis represented the same natural principle as Apollo and Osiris, the emblems of the sun, and his escapade with Venus (Saffron colour) led to his alchemical death in transmutation. The red roses which Turner, following Ovid, has painted round the goddess's couch, foreshadow those she tinged with her blood as she ran through the briar thickets in search of her dying love. [69]

These notes on some of Turner's early subject-pictures are in no way exhaustive; Jason, for example, later assumed a political significance for Turner with which I have not here been concerned. [70] But I have tried to show that there is among most of the subjects which he chose to execute, and which were all projected about the same time, in 1802 or 1803, a consistency of theme which makes their choice less arbitrary than it might otherwise seem; and that this connexion is to be found in the imagery of traditional science for the clash and metamorphosis of the elements, and, especially, for the conflict of light and shade. This imagery was revived and transmitted in the eighteenth century most conspicuously in the symbolic language of alchemy; and, through his early connexions with Louther-bourg, Turner was put in direct touch with the alchemical tradition. But alchemy was not the only source of these ideas; philosophers and critics with scientific interests were quite able to make their own analogies. Turner's *Narcissus and Echo* at Petworth, exhibited in 1804, may well have suggested itself as a subject from an idea of George Field's, that reflection in colour might be compared to echo in sound, and 'it is agreeable to this analogy, that *Echo* was feigned to have pined for *Narcissus*'. [71] Turner had

long been fascinated by reflections in water (e.g. TB XXIII, a; XXXV, p. 25);
and he had in the *Swans* sketchbook of about 1798 drafted a love-song in
which he asked 'Babbling Echo' why his love had left him.[72]

Just as the Old Masters had been enrolled by eighteenth-century colour
theorists in support of their systems, so they were pressed into service by
Romantic critics as exponents of natural symbolism. J.-B.Deperthes, in
his *Théorie du Paysage*, one of the most important documents of the growing
concern for the status of landscape on the Continent, gave a symbolic gloss
to Poussin's *Deluge*, a landscape which had especially excited Turner in
the Louvre in 1802:

> Towards the right, a huge serpent slithers over the rocks, trying to
> reach the higher ones. If, by this image of a reptile seeking refuge on
> higher ground, the painter wanted to show that the surface of the
> earth was already submerged, one can only applaud his choice of
> means, which reinforces the idea of the Flood; but whoever has
> fathomed the depths of Poussin's genius will readily imagine that the
> serpent is rather an emblem conceived by the artist to recall to the
> spectator's mind the memory of the Temptor, whose infernal wiles in
> misleading Adam and Eve was the chief cause of ruin to their
> posterity.[72]

This type of emblematic vision was very much Turner's, although his
analysis of this painting in particular (cf. p. 200 below) was rather in terms
of the more generalized symbolism of the colour; and it seems entirely
possible that Poussin's serpent of the *Deluge* was transferred to a similar
position and function in Turner's *Holy Family*.

IV

Neither Turner's imagination, nor his developing powers of observation
could long remain content with this type of neo-Baroque allegory. Like
Seurat, who in *La Baignade* in the Tate Gallery, was to denude the theme
of Narcissus and Echo of its mythological content, Turner became con-
cerned to express the ancient ideas of elemental drama by more purely
naturalistic means. Between 1811, with *Apollo and Python*, and the *Ulysses
Deriding Polyphemus* of 1829, a period when Turner was especially de-
veloping a vocabulary of naturalism in the oil sketches, and was becoming
more absorbed, through the demands of the lectures, in the problems of
the observation and representation of nature, he painted, it seems, no
subject-pictures of the type we have just been considering. This dissatis-
faction with the traditional language of mythology in the expression of
'landscape' ideas may be well understood from his criticism, in 1819, of
Guido Reni's *Aurora*, in the Palazzo Rospigliosi, in Rome, **66**. Reni's
ceiling design had been recognized by Runge, who knew it only from
copies or prints, as an example of the tendency of all post-Raphaelite

painting to become landscape;[74] but Turner found that the aerial qualities of landscape were lacking in the sky, while the sea was itself too ariel [?], although he admired the drawing and colour-harmony of the draperies.[75] Natural effects could not be expressed in mythological, figurative, language alone; and *Ulysses* represents, as I have suggested, an important stage towards the fusion of nature, vision and story.

Turner made a further step in this direction in *Regulus* (TG 519), **28,** which seems to have been begun in Rome in 1828, but not completed until it was exhibited at the British Institution a decade later. The character of Regulus seems long to have interested Turner as a type of Roman virtue and courage, who died for love of his country. As such, the subject of his *Departure for Carthage* had been a common eighteenth-century motif, which Turner may have found, for example in Wilson; the Roman's selfless patriotism was the subject of a passage in Turner's *Southern Coast* poem of 1811 (TB CXXIII, p. 90a); and he made a note of *Regulus Returning* [to Carthage ?] in his copy of Goldsmith's *Roman History*, probably about the same time, since another subject listed was *Hannibal Crossing the Alps*.[76] But in the painting of 1828–37, the figure of Regulus himself has completely disappeared; Turner shows not the valour of the man, but the means of his terrible torture by the Carthaginians. Regulus, like Apollo, Jason and Christ, a slayer of serpents,[77] was himself tortured and blinded by Apollo's power. 'Dionysius, the tyrant of Sicily', Turner will have read, in preparation for his lectures:

> among other means which he used to gratify his revenge, and satiate the cruelty of his temper, was accustomed to bring forth his miserable captives from the deep recesses of the darkest dungeons, into white and well lighted rooms, that he might blind them by the sudden transition from the one extreme to the other. Actuated by principles equally cruel, the Carthaginians cut off the eye-lids of Regulus, and then exposed him to the bright rays of the sun, by which he was soon blinded.[78]

The effect of the sun in Turner's picture, advancing from the horizon like 'the powerful king of day' he was, consuming the port of Carthage and lapping the water greedily with his rays, so that the foreground bathers cower and fly before him, makes the otherwise laconic and enigmatic title perfectly clear; although the real subject of the painting does not seem hitherto to have been understood.

Similarly, where the earlier, watercolour version of the *Fall of the Clyde* in Liverpool, **16,** was scarcely able to show that it was about the elemental forces of nature, the effect of sun on water, without a reference to Akenside's *Hymn to the Naiads*; in the prismatic colour of the later oil version at Port Sunlight, **17,** this content is immediately clear, once we recognize the direction of Turner's mind. The origin of the Naiads, Akenside had said, 'is deduced from the first allegorical deities, or powers of nature, according

to the doctrine of the old mythological poets, concerning the generation of the gods and the rise of things. They are then . . . considered as giving motion to the air and exciting summer breezes.' [79] Noon, Turner's chosen moment in the early drawing, was the time of day

> *when the might*
> *Of Hyperion, from his noontide throne*
> *Unbends their languid pinions, and from you*
> *They ask; Favonius and the mild south-west*
> *From you relief implore. Your sallying streams*
> *Fresh vigour to their weary wings impart.* (45–50)

And in a long note to the passage, Akenside explained:

> The state of the atmosphere with respect to rest and motion is, in several ways, affected by rivers and running streams; and that more especially in hot seasons: first, they destroy its equilibrium, by cooling those parts of it with which they are in contact; and secondly, they communicate their own motion; and the air which is thus moved by them, being less heated, is of consequence more elastic than other parts of the atmosphere, and therefore fitter to preserve and propagate that motion. [80]

Turner surely had in mind this poem and its note in 1818, when he used the *Clyde* drawing to illustrate a passage in his *Reflexes* lecture, where reflections were shown as influenced by 'the gentle breeze that on the surface of the water sleeps'. [81]

Light was expressed in these late works in terms of a three-colour theory; but the idea of the contrast of light and dark, so marked in *Apollo and Python*, also persisted in a subtler form into this period of greater naturalism. In a poem of about 1830 on the Evening Star (TB CCXXXIX, p. 70) which may possibly, although hardly obviously, be connected with the warm and gentle unfinished picture in the National Gallery (No. 1991), Turner wrote that

> *The first pale Star of Eve e'er Twylight comes*
> *Struggles with the little life of day.*

'Mythologically,' said George Field, in the second edition of *Chromatography*, 'the antient poets and painters truly represent Hesperus, or evening, as of double investiture, with relation to *light* and *shade*: as Lucifer and Phosphorus, they give him a *white* horse; and as Hesperus, a *black* one.' [82] Turner likewise conceived of Hesperus, the Evening Star, as having first to combat daylight and then the darkness of night; but it was a struggle he would no longer express in terms of the mythological tradition.

Not that myth-making was ever entirely abandoned in Turner's *œuvre*. His rendering in mythological terms of *Light and Colour (Goethe's Theory)* I

shall discuss in the final chapter, but even later than this, in a painting like *The Angel Standing in the Sun* (TG 550), **70,** Turner was concerned to convey in a figurative language, as well as through his colour, the antithesis of darkness and light. Not all the details of the picture are easy to interpret. The chained serpent in the foreground is derived from *Revelation* XX, 1–2; and the decapitated Holofernes may be one of the captains whose flesh was to be devoured by the fowls in the eighteenth verse of chapter XIX of *Revelation,* which Turner quoted in his caption. In Turner's imagination, the Angel of the Apocalypse had become conflated with the Cherubim with the flaming sword at the Gate of Paradise, on the expulsion of Adam and Eve (*Genesis* III, 24), who are here propelled by the light towards a violent future symbolized in the dead Abel. But the passage in Samuel Rogers's fragmentary *Voyage of Columbus,* from which Turner derived the second part of his caption:

> *The morning-march that flashes to the sun,*
> *The feast of vultures when the day is done,*

has the superscription, 'The flight of an Angel of Darkness'.[83] The dazzle implies its own dark; and if Turner exclaimed, a few weeks before he died that 'The sun is God',[84] He was, as the *Angel* and *Regulus* show, a terrible and avenging God, a true source of Turner's growing pessimism which expressed itself not alone in darkness but also in the more awful sublimity of light.

Already in Akenside, Turner will have found the naturalistic interpretation of mythology which he sought. 'As the mere genealogy or the personal adventures of the heathen gods, could have been but little interesting to a modern reader,' wrote the poet in a closing note to his *Hymn to the Naiads,*

> It was . . . thought proper to select some convenient part of the history of nature, and to employ these ancient divinities as it is probable that were first employed: to wit, in personifying natural causes, and representing the mutual agreement or opposition of the corporeal and moral powers of the world; which hath been accounted the very highest office of poetry.[85]

But even the personifications of Akenside and Thomson, whose 'powerful king of day' had appeared in one of Turner's first captions in 1798, and whose example surely lies behind the painter's own magnificent 'fierce archer of the downward year' (i.e. Sagittarius, entering the heavens in November), in the verses for *Hannibal Crossing the Alps* of 1812, ceased to have the immediacy of observed phenomena during the second half of Turner's career.[86] He quoted them less; and the mature Turner was, I believe, far closer to the more purely scientific mythography of Shelley. *Ulysses Deriding Polyphemus,* Turner's most Hellenic picture, is an equivalent, in its scientific spirit, to *Prometheus Unbound.*

Turner seems to have discovered Shelley late in life, in the anthology of

modern English poets published by S.C.Hall in 1838 as his last *Books of Gems*. Turner's curious, crabbed caption to the *Sun of Venice* of 1843 (TG 535), **26,** a picture which itself had much to do with the tragedy of light and darkness, and which was, with its painted sail, a sort of *Ulysses* in modern dress, ran, in the less awkward version:

> *Fair shines the morn, and soft the zephyrs blow*
> *Venecia's fisher spreads his painted sail so gay*
> *Nor heeds the demon that in grim repose*
> *Expects his evening prey.*

The verses begin and end with a borrowing from Gray's *Bard*, but its mood, its Venetian context and some of the images are taken from a passage of Shelley's *Lines Written Among the Eugenean Hills*, which Hall had published separately as *Venice*:

> *Sun-girt city, thou hast been* *And all is in its ancient state,*
> *Ocean's child, and then his queen;* *Save where many a palace gate*
> *Now is come a darker day,* *With green sea-flowers overgrown*
> *And thou soon must be his prey,* *Like a rock of Ocean's own,*
> *If the power that raised thee here* *Topples o'er the abandoned sea*
> *Hallow so thy watery bier.* *As the tides change sullenly.*
> *A less drear ruin then than now,* *The fisher on his watery way,*
> *With thy conquest-branded brow* *Wandering at the close of day,*
> *Stooping to the slave of slaves* *Will spread his sail and seize his oar*
> *From thy throne above the waves* *Till he pass the gloomy shore,*
> *Wilt thou be, when the sea-mew* *Lest the dead should, from their sleep,*
> *Flies, as once before it flew,* *Lead a rapid dance of death*
> *O'er thine isles depopulate,* *O'er the waters of his path.*[87]

I do not propose to enter here into a detailed comparison of Turner and Shelley; but it is noteworthy how close, in other sections of the *Lines Written Among the Eugenean Hills* and elsewhere, Shelley's incandescent vision of Venice is to Turner's own; and they shared a common interest in science and religion. Turner's God behind *The Angel Standing in the Sun* is the God of Ahasuerus in Shelley's *Queen Mab*, 'revengeful as almighty' (VII, 85); and it is surely this poem that stimulated Turner's painting *Queen Mab's Cave* of 1846 (TG 548). Mr Martin Davies has rightly emended the caption of this picture to read continuously:

> *Frisk it, frisk it, by the moonlight beam*
> *Midsummer night's dream,*[88]

and Shelley's poem too arises from a dream in moonlight, which is not itself, as Turner's vision is not, moonlit. Although Turner's imagery is unlikely to be traced to a single source, the elements and feeling of his treatment are very close to Shelley:

146

Yet not the golden islands
Gleaming in yon flood of light,
Nor the feathery curtains
Stretching o'er the sun's bright couch,
Nor the burnished Ocean waves
Paving that gorgeous dome,
So fair, so wonderful a sight
As Mab's aethereal palace could afford.
Yet likest evening's vault, that faery Hall!
As Heaven, low resting on the wave, it spread
Its floors of flashing light,
Its vast and azure dome,
Its fertile golden islands
Floating on a silver sea;
Whilst suns their mingling beamings darted
Through clouds of circumambient darkness
And pearly battlements around
Look'd o'er the immense of Heaven. (II, 22–39)

'Evening's vault', indicated by Turner's low crescent moon; the 'golden islands floating on a silver sea'; the 'pearly battlements' of the distant castle, are details from a word-picture which seems to be an exact equivalent of Turner's work.[89] His borrowing from *Prometheus Unbound* in the caption to *Light and Colour (Goethe's Theory)* I shall treat in the final chapter; here it is appropriate only to underline that both poet and painter were concerned to evolve a poetic language out of the most intimate understanding of the workings of nature, to reveal causes through the representation of effects without resorting to the 'splendid puerilities' of conventional emblems which Turner had found even in Raphael and Michelangelo.[90] For Turner, concerned with the visible, the problem was chiefly one of light and colour; but it was a problem he could see not only in the activities of nature, but also in his own activities as a painter: his work was, no less than any natural object, a product and a subject of natural laws. From an almost exclusive attention to Turner's view of the external world, we must now turn to the art he made out of it, for it was the gulf he found fixed between observation and representation, which produced some of the most original elements in Turner's work.

9 The Turner galleries

Turner is an artist who was always supremely conscious of the environment, of the destination of his art. He had, from his early period as a watercolourist, been a painter for exhibitions; and in his first major commission in oils, the *Plompton Rocks* and *Plompton*, which he painted for the Earl of Harewood in 1798, and which are still, happily, *in situ* in the library at Harewood House, **32**, he showed himself a master of the decorative landscape, taking up into his delicate clouds the pastel pink of the Adam interior. The paintings have, too, a viewing distance which is wholly calculated in relation to the scale of the setting, and an ugliness of handling when examined closely which is also noticeable in that exceptional series of long panels of about 1830 at Petworth, which was originally conceived as furnishing for the dining-room, and would surely gain in substance and resonance if it was restored to the dark surround of the Grinling Gibbons carving.[91] Turner's eye and his early training thus united in an extreme sensitivity to the physical context of a work, for the conditions of exhibition; and it is not surprising to find that very soon after he had achieved the status of full Academician, he built his own gallery so that he could keep these conditions more firmly under control.

Although some exceptionally aware and 'scientific' artists like Leonardo had sometimes studied the lighting conditions surrounding their easel pictures, and painted on them *in situ* in church or gallery, in the new conditions of eighteenth-century exhibitions there are many indications that the modifying effects of lighting and background on paintings came to artists as something of a surprise. Within a decade of the establishment of regular *Salons* in Paris in 1737, we already find the elements of a debate on exhibition settings that was to develop into a great controversy in the Romantic period. One party praised the hangings for providing a favourable background to the pictures; and the opposition complained that the pictures were so crowded together that there was little background to show them off at all.[92] Soon we hear of the rearrangement of pictures during the course of the exhibition, possibly on account of the lighting.[93] In England, the exhibition rooms at the newly founded Royal Academy seem to have come as a shock to Reynolds, who told William Mason, when he saw his *Venus* on their walls, 'he felt much surprised, and a little temporary chagrin, to see its effect so much lessened from that which it had on its easel. But on reflection he said: "I was soon reconciled with my work; I concluded, that the more fiercely colored paintings, which surrounded it, made it appear so faint as it seemed to do; for I know . . . that it was the precise hue of nature." '[94] In the 1780s, Gainsborough withdrew

works from the Exhibition because the Council would not hang them in a favourable light, and, like Turner twenty years later, he took to exhibiting in his own private gallery, which, he felt, was more suitably lit to show off 'tender' effects.[95] Like Turner, too, although, less generously, because they interfered with, rather than assisted, other artists' works, the Hanging Committees sometimes took drastic steps to modify the effect of paintings on the spot. Thus Wilson in the 1760s at Spring Gardens is recorded as having toned down 'nearly half the pictures in the exhibition' with a wash of Indian Ink and Spanish Liquorice.[96] It was such conditions that led, towards the end of the eighteenth century, to the opportunities given to Academicians and Associates to do their own retouching; and to the establishment of regular Varnishing Days in the Royal Academy in 1809.

During the first two decades of the nineteenth century, which saw the building of a number of important new galleries in London, including the British Institution and Soane's Dulwich, as well as Turner's two galleries, the discussion of the problems involved in exhibiting pictures effectively reached a pitch. Their problems were summarized by a writer in a London review, *Le Beau Monde*, in 1807:

> The object of all exhibitions of works of art is to make known the particular species of merit, or talent which characterises each performance; and three points of deliberation are seriously to be weighed as conducing to this object: 1st the colour of the apartment, 2nd the nature of the light; and 3rd, the elevation of the performances. As colours are almost entirely a matter of contrast, it is obvious that if pictures be hung on a ground of any colour whatever, that ground will enhance, in such pictures, the colours that differ from it, and will reduce the effect of those that are of its own kind. The painting-room of Rubens is known to have been hung with crimson, and, though somewhat subdued by a dark pattern of flocks, it certainly may be considered as one cause of the excessive redness to be found in all his pictures. The picture-gallery at Powis castle was, lately, a bright green, coloured, no doubt, by the upholsterer, as a matter of furniture. The gallery at Cleveland-house, where so many fine pictures are displayed, is a fleshy kind of brown, judiciously chosen for a collection of the Old Masters, to correct the brownness which all pictures in oil acquire by time. The colour of the British Gallery, when last open to the public, was a bright scarlet! A circumstance so extraordinary, that we can no way account for it, but by supposing it meant as a precaution against the too vivid colouring, which a desire of attracting notice has introduced into our school of painting . . .
>
> The light of an exhibition-room for pictures should be just so large, and so far distant, that the performances which must necessarily be placed at the greatest distance from the spectator shall receive an

accession of light in the same proportion, to give them perfect distinctness. In this point the British Gallery has very superior advantages.

The consideration of this principle will determine the third point we have proposed to examine. If any picture be placed so high in the room, that the increase of light which we have recommended, on the increase of distance, will not make it perfectly discernible, the artist is rather injured than benefitted by the admission of his works.[97]

As these exhibition conditions were very general, so the sensitivity of painters to them can be traced throughout Europe. In Germany, Caspar David Friedrich at first refused to finish his first major oil, the *Tetschener Altar* of 1807, in his Dresden studio, because he knew that the setting of the Bohemian chapel for which it destined was quite different; and when the pleas of friends finally persuaded him to do so, he modified his studio lighting and backgrounds specially for the purpose.[98] Delacroix's well-known re-painting of the *Massacres de Scio* in 1824 was probably carried out in the Louvre for similar reasons, rather than as a result of the immediate impact of Constable.[99]

Contrary to the rather confused assumptions of the writer in *Le Beau Monde*, it seemed to some observers of English painting that the new high key was a response to the demands of the Exhibition environment rather than their cause. As early as 1806, that is, three years before the institution of official Varnishing Days at the Academy, a critic noted that the practice of retouching in the Exhibition itself was having a decisive effect on style,[100] and at the end of the 1820s, Turner's friend, Charles Lock Eastlake, wrote to Thomas Uwins:

A man is surely padrone to paint more cooly [than Titian] if he likes, and most of the painters now living do so paint: added to which *the silvery picture kills the golden one in Somerset House* . . . When the modern picture were exhibited at Pall Mall, where their whiteness was revealed, Wilkie's expression was, 'we are all wrong together'; but after all, if, as Sir Joshua says, the golden manner is the highest (it is certainly the most difficult), there remains praise and glory enough for a successful silvery picture *at all times*, but now more especially because it is the predominant taste of the English School, owing to the frosted windows of Somerset House and the taste of some of our principal living artists.[101]

In the same year in which he succeeded in having three Academy Varnishing Days formally established, Martin Archer Shee put the aesthetic case against the influence of exhibitions in its most forceful terms:

He who passes the first hour of exhibition without hearing from all sides the echoes of his brilliancy and his force, considers the present

opportunity as lost, and at once transfers his hopes to that returning period of publicity when he can try more dazzling splendours of effect, and more ingenious devices of allurement . . . The emulation excited by an exhibition is rarely influenced by general and comprehensive views; occupied with local and partial objects, it becomes a rivalry not of positive, but of comparative eccellences; not of the merits of the art, but of the manner of the school. Instead of contending with the great masters, we are obliged to contend with each other; and to be the hero of the day is the summit of ambition. The painter who is not engaged in this kind of conflict, may enter the lists with Raphael or Rubens, with Titian or Correggio; he consults his own taste, and chooses his combatant; but he who suspends his picture in a public exhibition, must contend with those around him, and conform to the fashions of the scene in which he hopes to shine . . . The study of an exhibition effect is now indeed an Art in itself, an art also, which occupies the attention to the prejudice of nobler objects. It is a kind of scene painting, in which, at a given distance, Carver would surpass Claude; in which every thing to be forcible must be violent—to be great must be exaggerated—in which all delicacy of expression, detail of parts, and discrimination of hues, are laid aside as useless particulars, or lost in the formless void of general masses . . .[102]

Not that hanging conditions alone will have dictated Turner's decision to hazard the cost of a private gallery; the atmosphere of London in the early 1800s was full of projects for the more or less permanent one-man show; and Turner will almost certainly have recalled Fuseli's *Milton Gallery* of 1799–1800, which the artist had described as 'a monument to myself, whatever I may be', and which had been generally well received as the virtuoso performance of a single painter.[103] But it seems likely that the immediate occasion for Turner's own enterprise was chiefly a concern for the lighting and setting of pictures, for he must, in the Louvre in 1802, have become critically aware of the very damaging effect of a negligently mounted exhibition. The plans for the top-lighting of the *Grande Galerie* of the Louvre, which had been projected since the 1780s, had not yet been carried out; and visitors were universally critical of the illumination which, in contrast with that in the neighbouring *Salon Carré*, made the exhibits impossible to see:

The great Gallery of the Louvre is not well adapted for the exhibition of pictures; it is too narrow in proportion to its length, and the windows, which look out towards the Seine, defeat the effect of those which look towards the Place du Carrousel. A great number of paintings thus appear to be covered with a continual mist, and others are scarcely discernible, so that the principal effect of light and shade is destroyed . . . [The French restorers] have . . . injured a multitude

of exquisite performances with a species of varnish by which, when I have approached them in search of the beauties of the artist, I have been mortified by a vision of my own homely features.[104]

Amelia Opie records that at first she completely overlooked Raphael's *Transfiguration* because it was so poorly lit in this gallery;[105] and this may well give us a clue to Turner's otherwise curious neglect of Claude on this visit, although there seem to have been at least seven of his works hung in the room; for his delicate effects may have been barely visible, while most of the paintings, by Rubens, Poussin, Titian, Ruisdael, Correggio, Guercino and Mola, which Turner did copy there, were larger, and characterized by stronger colour and more dramatic lighting.[106] Certain it is that the colour of Veronese's *Marriage at Cana*, more delicate than most, remained strongly in Turner's mind at the time he delivered his lectures a decade later, although he does not seem in 1802 to have made a copy or notes; and the Veronese hung in a far better position in the *Salon Carré*. Turner's *Festival of the Vintage at Macon* (Sheffield, Graves Art Gallery; R & B. pl. 22), exhibited in 1803, is Claudian in all but the relative crudity of its effects and the toughness of its handling, which hardly suggests a flagging taste for Claude in Turner at this time. When he made a second visit to the Louvre, in 1821, the *Grande Galerie* having been converted to top lighting, he copied at least five of the Claudes he had overlooked in 1802, with possibly another, and specifically recorded the new lighting arrangements in a number of drawings, **67**.[107]

In the year following his Paris trip, Turner visited in London the new Truchsessian Gallery, which was top-lit throughout, and especially praised for the high quality of the display.[108] Although no details of the nature of Turner's first gallery have so far come to light—he himself called it 'Alladin's palace' in 1820, but this may well refer to his view of the contents[109]—we may assume that it was built to the most modern specifications, of which the Truchsessian Gallery provided a good example. It is even possible that Turner consulted his friend Sir John Soane, who was to be one of the earliest purchasers from the gallery, for with a letter of 4 July 1804, Turner returned to Soane some drawings he had borrowed, and Soane was a leading designer of picture galleries, with whose work in this field Turner will have been long familiar at Fonthill.[110]

Turner's gallery can be seen as a protest against hanging conditions at the Royal Academy; for, in contrast to the ten or a dozen works which he had been showing there regularly since the mid-nineties, in 1804, the season of his own opening, he sent only three,[111] and in 1805 none at all. Likewise, when in the following year, the British Institution opened its exhibition rooms for the first time, offering hanging conditions which were thought to be much superior to those at the Academy, Turner sent two pictures there, as many as he sent to the Academy; and in 1808 he had twice as many pictures at the Institution (but only two in all). It was

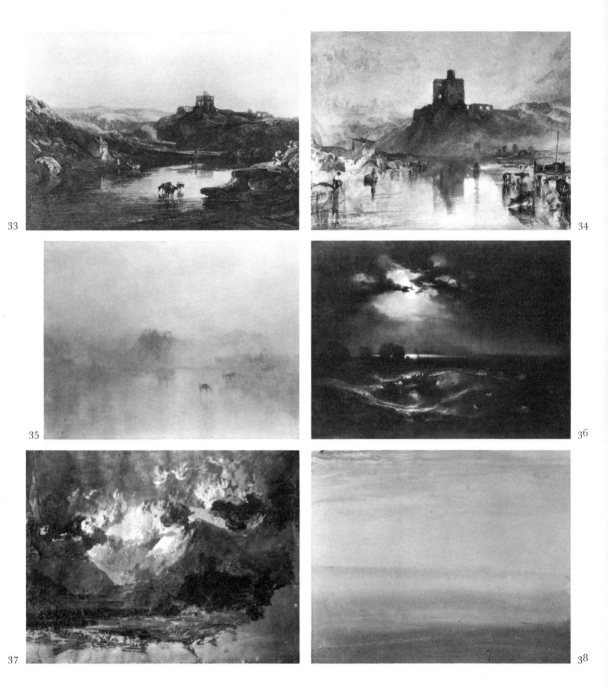

33 J.M.W.TURNER Norham Castle on the Tweed:Summer's Morn
 Exh. 1798, watercolour 19¾″ × 27¾″ *English private collection*
34 J.M.W.TURNER Norham Castle on the Tweed *c* 1823
 Watercolour 6⅛″ × 8½″ *British Museum, London* TB CCVIII, O
35 J.M.W.TURNER Norham Castle:Sunrise *c* 1835
 Oil on canvas 35½″ × 47½″ *Tate Gallery, London* 1981
36 J.M.W.TURNER Fishermen at Sea off the Needles
 Exh. 1796, oil on canvas 36″ × 48″ *F.W.A.Fairfax-Cholmeley on loan to Tate Gallery, London*
37 J.M.W.TURNER Dolbadern Castle *c* 1800
 Watercolour 26″ × 36″ *British Museum, London* TB LXX, O
38 J.M.W.TURNER Como and Venice Colour Beginning 1819
 Watercolour 8⅞″ × 11¾″ *British Museum, London* TB CLXXXI p 10

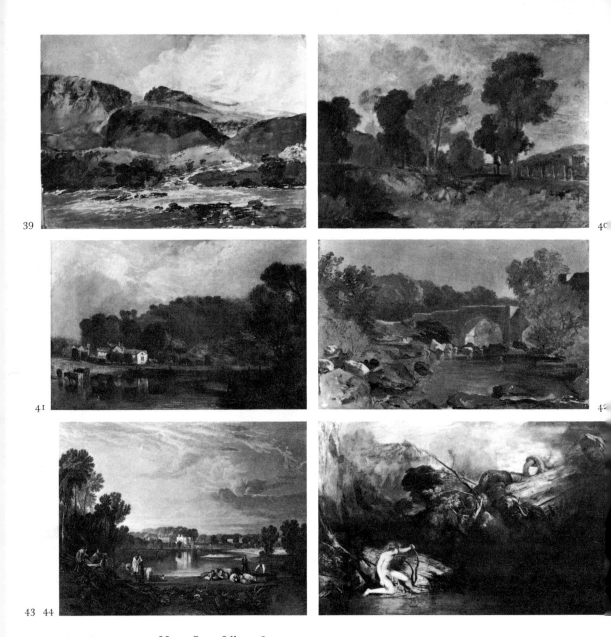

39 J.M.W.TURNER Near Scawfell *c* 1800
 Watercolour 21½″ × 30″ *British Museum, London* TB LX(a)G
40 J.M.W.TURNER Trees beside river with Bridge in Middle Distance *c* 1812
 Oil on canvas 33″ × 47″ *Tate Gallery, London* 2692
41 J.M.W.TURNER Cliveden on Thames *c* 1807
 Oil on canvas 15″ × 22¾″ *Tate Gallery, London* 1180
42 J.M.W.TURNER Bridge in Devonshire *c* 1813
 5⅞″ × 9¼″ *British Museum, London* CXXX,K
43 J.PYE and J.HEATH *after Turner* Pope's Villa 1810
 Line engraving *British Museum, London*
44 J.M.W.TURNER Apollo and Python
 Exh. 1811, 57¼″ × 93½″ *Tate Gallery, London* 488

45 46

47 48

49

45 J.M.W.TURNER Warkworth Castle, Northumber-
land; Thunderstorm approaching at Sunset
Exh. 1799, 20½″ × 29½″ *Victoria and Albert Museum*
547

46 J.M.W.TURNER Rizpah watching the Bodies of
her Sons *c* 1802
Oil on canvas 36″ × 48″ *Tate Gallery, London* 464

47 J.M.W.TURNER Teignmouth Harbour
Exh. 1820, oil on canvas 35½″ × 47½″ *The Petworth
Collection, National Trust*

48 J.TINTORETTO The Miracle of the Slave 1548
Oil on canvas 163½″ × 214¼″ *Accademia, Venice*

49 J.M.W.TURNER Watteau Study by Du Fresnoy's Rules
Exh. 1831, oil on panel 15½″ × 27½″ *Tate Gallery, London* 514

50 J.A.D.INGRES Raphael and La Fornarina 1814
Oil on canvas, 26″ × 21½″ *Fogg Art Museum, Harvard, Bequest of Grenville L. Winthrop*

50

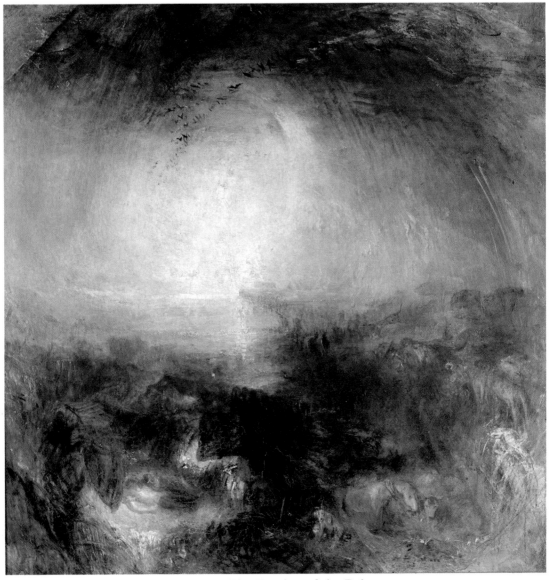

51 J.M.W.TURNER Shade and Darkness: The Evening of the Deluge
Exh. 1843, oil on canvas, octagonal: $30\frac{1}{2}''$ *Tate Gallery, London* 531

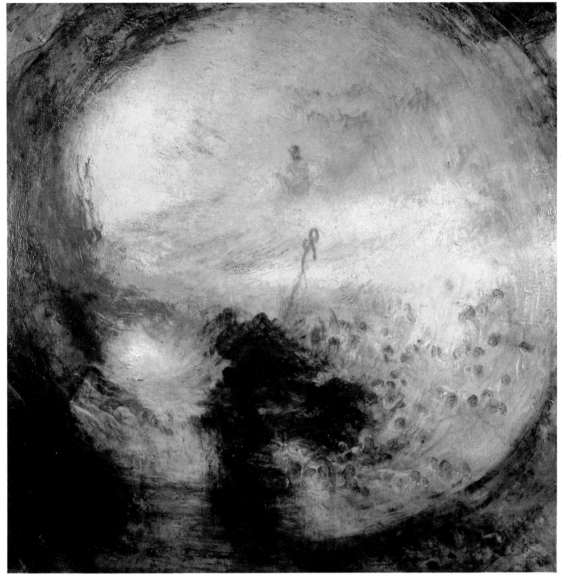

52 J.M.W.TURNER Light and Colour (Goethe's Theory): The Morning after the
Deluge Moses writing the Book of Genesis
Exh. 1843, oil on canvas, octagonal: $30\frac{1}{2}''$ *Tate Gallery, London* 532

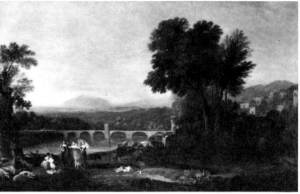

53

54

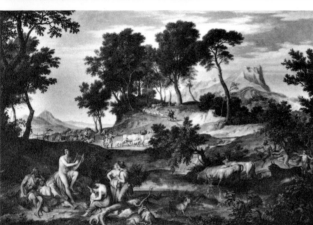
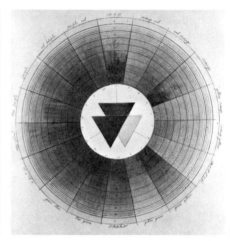

55

56

57

58

53 F.DANBY Illustration for the Revelation of St John ch 10 v i-ii
 Exh. 1829, oil on canvas 24¼″ × 30¼″ *Collection of Robert Rosenblum*
54 J.M.W.TURNER Apullia in Search of Appullus Exh. 1814, oil on canvas 57″ × 93″ *Tate Gallery* 495
55 J.A.KOCH Landscape with Apollo among the Shepherds 1834
 Oil on canvas 31″ × 44⅛″ *Schäfer Collection, Nürnberg*
56 M.HARRIS Prismatic Colour Circle 1811 *British Museum, London*
57 J.M.W.TURNER The Brocklesby Mausoleum *c* 1811
 Watercolour 24″ × 19″ *British Museum, London* TBCXCV, 130
58 A.L.GIRODET DE ROUCY The Shades of the French Warriors led by Victory to the Palace of Odin
 Exh. 1802, oil on canvas 75½″ × 71¾″ *Musée de Malmaison, France* MM 6955

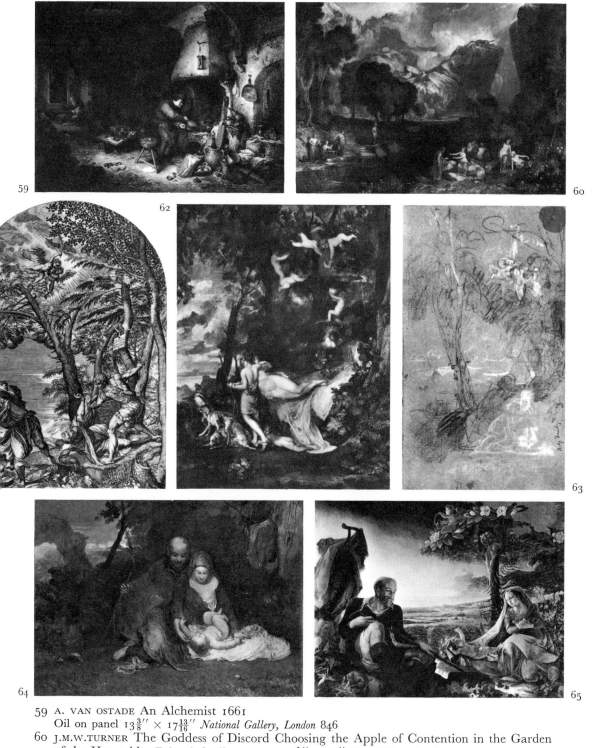

59 A. VAN OSTADE An Alchemist 1661
 Oil on panel 13⅜″ × 17¹³⁄₁₆″ *National Gallery, London* 846
60 J.M.W.TURNER The Goddess of Discord Choosing the Apple of Contention in the Garden
 of the Hesperides Exh. 1806, oil on canvas 59½″ × 84″ *Tate Gallery, London* 477
61 M.ROTA *after Titian* The Martyrdom of St Peter Martyr Etching *British Museum, London*
62 J.M.W.TURNER Venus and Adonis *c* 1803
 Oil on canvas 59″ × 47″ *Huntingdon Hartford Collection, New York*
63 J.M.W.TURNER The Holy Family *c* 1802
 Black and white chalk 17⅛″ × 10¾″ *British Museum, London* TB LXXXI p 63
64 J.M.W.TURNER The Holy Family Exh. 1803, 40″ × 56″ *Tate Gallery, London* 473
65 P.O.RUNGE Rest on the Flight into Egypt 1805-1806 38″ × 52″ *Kunstalle, Hamburg*

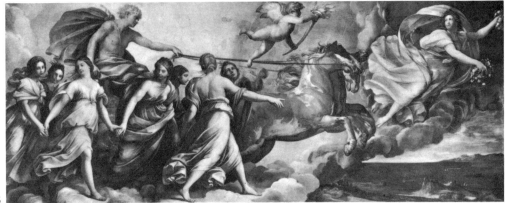

66

68

67

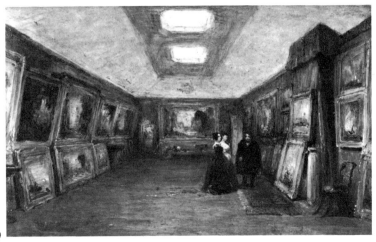

69

70

66 G.RENI Aurora 1614
Ceiling fresco *Palazzo Rospigliosi, Rome*
67 J.M.W.TURNER The Skylight of the Grand Gallery of the Louvre *c* 1821
Pencil 6″ × 4″ *British Museum, London* TB CCXLIX p 43a
68 J.M.W.TURNER Toplights and plans of Turner's Second Gallery 1820
4¼″ × 7¼″ *British Museum, London* TB CV p 44
69 G.JONES Interior of Turner's Gallery *c* 1852
5½″ × 9″ *Ashmolean Museum, Oxford* 224
70 J.M.W.TURNER The Angel Standing in the Sun
Exh. 1846, oil on canvas 30½″ × 30½″ *Tate Gallery, London* 550

probably the presence of his enemy, Sir George Beaumont, on the board of directors that prevented Turner from giving more than intermittent support to the Institution later.

Even from the scanty records which we have of the exhibitions at Turner's Gallery, it seems certain that until 1811 he showed far more works there than at the more public exhibitions; and it is notable that it was only in 1811, the year in which he modified the lighting of the Academy Lecture Room (also the main exhibition room), ostensibly for the benefit of his and Soane's lecture diagrams,[110] that he returned to its walls in strength at the Exhibition, with eight works. Turner continued to be very sensitive to the way his exhibits were hung. At the British Institution in 1806, his first contributions had been dimly lit, so as to 'look like old Tapestries as to general colour and effect'; and he had threatened a few weeks later to withdraw *The Falls of the Rhine* from the Academy unless it were given a good position.[113] In 1812 he would have preferred to remove Wyatt's two Oxford oils because they were in bad company; and he had endless trouble over the hanging of *Hannibal Crossing the Alps* (R. & B. pl. 49), which he insisted should be placed below the line and, again, threatened to withdraw if it were not.[114] Certainly the sweep of the composition, suspended, as it were from the sun, is only really appreciable when the picture is viewed from slightly below the level of the eye, and Turner was clearly concerned to enclose his spectators as the storm at Farnley had enclosed him two years earlier. Later in his career, he was to have a further reason for keeping his pictures near floor-level, when he came to work more thoroughly on them in the Exhibition itself. In 1819, as one of the hangmen, he completely reorganized Shee's arrangement of the rooms, possibly in response to the brilliant gas-lighting which had been introduced two years earlier, and completed the previous year.[115] The year 1828, when Turner was paid £29 8s 0d by the Academy for 'attendance and arrangement of the performances for the exhibition', may have been the occasion referred to in an anecdote recorded by Thomas Miller, of Turner's having the seating of an exhibition room covered with red cloth to act as a foil to a picture; but it seems that the gallery upholstery was regularly renewed, and the story more probably refers to a Varnishing Day episode of a year earlier.[116]

In May 1814, Turner announced that his Gallery would close after the 1816 season,[117] and this may help to account for his return in greater strength to the Academy in 1815, so that his image as a painter might be renewed before a wider public. He was probably already thinking of building a new gallery, a decision influenced perhaps by Soane's thoroughly modern work at Dulwich, which had been opened in 1811; for Turner's second gallery, about which we are far better informed, had much in common with the designs of Soane. On the other hand, Turner may have been thinking of a new gallery as early as 1809, for in the *River and Margate* sketchbook of about that year, there is a drawing of a top-lit

studio in a town house.[118] Turner's activities at Sandycombe Lodge, Twickenham, between 1810 and 1812 will, however, hardly have made a second architectural enterprise feasible; and the first certain notice of his new plans, apart from the implication of his exhibition card of 1814, is in Soane's diary of the following year, when, on 13 September, Turner is recorded as having called on his neighbour in Harley Street, Mr Benjamin Young, 'and survey'd premises'. In November of the following year, Turner consulted Soane on 'the repairs to his House occupied by Mr Young. I wrote to him on the subject in the morning':[119] and in a Yorkshire sketchbook of the same year appears what seems to be the first plan of the transformed premises with the new gallery, and a room inscribed 'painting room' (TB CXLVIII, p. 17). Soane thus seems to have been associated with the new gallery from the start. A plan of a skylight (TB CLXIII, p. 28) and a note of insurance, dated 1817 (p. 24), may refer to this project; and other architectural drawings in the *Guards* sketchbook (TB CLXIV, pp. 9, 9a, 59, 59a, 61, 61a) seem also to record its progress.

Building operations themselves appear to have begun in 1819; and a note on the cover of the *St Peter's* sketchbook, probably of the following year (TB CLXXXVIII) shows that Turner took as much care over the details of this as of his earlier architectural projects. The building was continued through 1820 and 1821; details of the skylight and furnishings are in the *Tabley No. 3* sketchbook, together with some observations on the Tabley gallery, with which Turner's had something in common (TB CV, pp. 19a, 42a–44a, [68], 49, 67a, 68). After an interval of six years, Turner's Gallery reopened in 1822; and this may again have been the reason why his Academy contribution this year was so small, although he had had the winter free to prepare for it, after the disruptive presence of the builders.[120]

Of the appearance of Turner's second gallery considerable details have survived. Two small oils by George Jones, in the Ashmolean, painted soon after Turner's death, **69**, show that it was long and narrow, lit by octagonal skylights, and with the walls covered in dull red drapery, like the British Institution, Soane's Dulwich and the rebuilt *Grande Galerie* of the Louvre, which Turner had seen in 1821.[121] Of the furnishings and lighting, the Rev. William Kingsley recorded:

> I am glad to be able to say what was the colour of the walls of Turner's gallery, and it was Indian Red, neither pale nor dark. It was the best lighted gallery I have ever seen, and the effect got by the simplest means; a herring net was spread from end to end just above the walls, and sheets of tissue paper spread on the net, the roof itself being like that of a greenhouse. By this the light was diffused close to the pictures.[122]

Turner himself noted down the 'Blinds to bow and set in behind a moulding to exclude the sun's rays', apparently in the Tabley gallery (TB CV, p. 67a); and it is possible that he had encountered the idea of diffusing

light through nets or blinds on his visit to the Brera in 1819, where it was generally in use, or in his study of Leonardo's writings which was also stimulated by the Milanese visit.[123] In Jones's oils we can see that the pictures were hung frame to frame, as at the Exhibition; and a visitor to the gallery in 1842 recorded that recent canvases were placed on easels about the room.[124] Wornum noted twenty-four paintings of all periods, only one of which could be described as unfinished, hanging at the time of Turner's death;[125] and Jones's views show together about twenty-eight.

This brief notice of Turner's two galleries shows what care went into the choice of the setting and lighting by which the artist intended his work should be seen: the regulation of environment was an integral part of Turner's method. This care extended to the consideration of mounts and frames, whose colour Turner insisted should be of, or like, gold. In a letter of 1819 to Robert Stevenson, concerning the drawing of *The Bell Rock Lighthouse*, Turner wrote:

> If you think of framing my Drawing, do pray not leave so much margin as to the two Drawing[s] sent to me and let a small flat of matted [?] gold be next [to] the same [*diagram*].[126]

The practice in the case of drawings is confirmed by a writer shortly after Turner's death:

> I believe Turner always contemplated the union of the gold of his colour with the gold of his frame, and I know that he enjoyed it, and used to urge the hanging of frames containing his drawings in groups, without intervals between the frames, so that nothing but gold might be seen in connection with the drawing.[127]

The very rich surface texture of Turner's finished drawings, especially of the period after about 1810, demands the resonance and sparkle of a gold mat; although it is doubtful whether, since the fashion for white or off-white mats promoted by Prince Albert about the middle of the nineteenth century, much of his work has been presented in this way. When Turner was not able to enlist nature to perform this work of enrichment for him, he would improvise his own gold surround. Koch and Eastlake remarked on the ship's cable, painted to resemble gold, which Turner nailed round his *Vision of Medea* and other works, in the Roman exhibition of 1828, probably because he could find no frames large enough for his canvas in time.[128] Later, the practice seems to have been adopted almost as a matter of course. The landscape painter W.J.Müller recalled:

> When Turner prepared to exhibit one of his finest marine subjects at the Royal Academy, the picture was sent, without a frame, to Somerset House. It was hung, and Turner went on the varnishing day to work at it. His brother artists greatly admired it, and all remarked on the absence of the frame. Day after day they exclaimed,

'Where's the frame?' Turner replied, 'All right, it is coming'. Only on the morning before the private view did he make this good. He brought four lengths of the thickest ship's cable, and nailed them round the picture; this he painted with yellow ochre, and brightened the prominent parts with real gold. The effect was excellent and people went so far as to admire the richness and appropriateness of the frame.[129]

Turner was not alone in stressing the importance of the frame as an aid, or as an impediment, to the total effect of a picture. Delacroix and John Burnet, George Field and Sir Thomas Lawrence, were careful to recommend attention to it; and Burnet especially noted the contemporary practice of finishing a picture in its frame.[129] But Turner had a rare courage in his convictions; and in this practice of improvised framing, as in the careful planning of the lighting of his pictures, he followed the creation of an environment through to the end. It was certainly some sly advice of this sort which he intended by placing the canvas on which Canaletto is working in *Venice, The Bridge of Sighs* (TG 370), **27**, of 1833, within a heavy gilt frame. This picture was also the first to be conspicuously altered on the Academy walls, and it reminds us that Turner's gallery design, and his eccentric conception of improvised framing were but a prelude and, later, a parallel to the far more spectacular practical theory of Varnishing Days.

10 Varnishing Days

On his second departure from Italy in 1829, Turner wrote a nostalgic but resolute aubade to what he described as 'the land of all bliss', and which declared that the debt he owed to Italian scenery 'has become a duty/Not to be shown by words but works' (TB CCXXXVII, pp. 8a–9). In Rome he had demonstrated this intention by painting the small *View of Orvieto* (TG 511), not as a commission, nor as a normal stock picture, but simply to show the sceptical Roman public what he could do. In the context of the abandoned lectures, the motivation is a significant one, for it is a sign that Turner was already moving towards that conception of practical teaching on Varnishing Days at the Exhibition or the British Institution, which has generally been understood as mere exhibitionism, but which for Turner was at once the culmination of a lifetime of teaching, and a solution of the problem of adapting exhibits to their thoroughly heterogeneous company.

Although very little has generally been said about this aspect of his career, Turner, like the majority of English landscape painters of his period, gave much of his youth to teaching amateurs, especially young ladies, the rudiments of sketching. The rôle of the drawing-master is an important, but neglected element in the aesthetics as well as the sociology of the Picturesque. Turner seems to have begun this activity very young indeed; for in the *Marford Mill* sketchbook of about 1794, there is a note of eight lessons for a Major Fraser (TB XX, p. 17); and most of the drawing copies which have been identified by Finberg in the Turner Bequest seem to belong to the mid-nineties.[130] Even the more ambitious completed works done under Turner's supervision, which have been published by the late Mrs Finberg, and are dated 1797, show an extreme conservatism of style in relation to Turner's other work of the period, and point sharply the problem of simplification for the purposes of teaching, which were to have, ultimately, for example, such a depressing effect on the work of John Sell Cotman.[131] The system of monochrome underpainting advocated by John 'Warwick' Smith, which Turner condemned so vehemently in 1799, was precisely that which he himself, as a teacher, had been following a few years before; and the work of probably one of his most gifted pupils, William Blake of Newhouse, examples of which have recently come into the British Museum, shows the strong influence of Smith. It would be reasonable to suppose that Turner abandoned teaching after 1800 not simply because it was financially unnecessary and too demanding on his time as an Academician, but also because he found it increasingly difficult to codify his own discoveries into a teaching programme. But his methods as a landscape painter, however complicated, continued to be the subject

of open debate;[132] and his very original conceptions of the nature and scope of 'perspective', and the innovations he introduced as a Visitor to the Life School at the Academy, may be seen as his own renewed attempts to approach the problem of teaching painting from a new direction.[134] As late as the Val d'Aosta tour of 1836, Turner was demonstrating the progress of a watercolour drawing to Munro of Novar as a series of stages;[135] and, according to John Burnet, unfinished paintings—little more, it seems, than colour-beginnings—were introduced into a perspective lecture, probably with a similar object, which reminds us of the later practice of Paul Klee at the Bauhaus.[136] There is, too, some reason for thinking that Turner's well-known sensitivity to the examination of his works by artists in the Gallery was dictated less by professional jealousy or fear of damage than by a feeling that the exhibited works represented for the student the misleading end-product of a sustained and complicated process; for it seems to be true that he very rarely put unfinished canvases on show, since, in contradistinction to his lecture practice, he was not often at the Gallery to provide a clarifying commentary, nor able to give one easily, when he was. This conclusion is suggested by an account of a visit to the Turner Gallery in 1822 by the young Scottish history-painter David Scott, who was still a student and could hardly have been a rival: Scott

> was making a little memorandum of one of his pictures on the back of a card, when a servant entered and said, 'Master don't allow sketching'. I was somewhat surprised, as no one had been in the room, and the door shut. However, I hardly considered what I was doing to be sketching, so I put in the line of the distance, which took two moments. Immediately in bounced a short stoutish individual, the *genius loci* himself. He said he was sorry I had not desisted, and I replied that what I had done was a mere trifle. He muttered something about memoranda and first principles, whereon I showed it to him and tore it up. He must have a peep-hole, and yet he is really a great painter.[137]

Mere exhibition could not offer any clear instruction in 'first principles'; and with the failure of the lectures after 1828, Turner turned to a more practical approach to teaching, adapting to his purpose the well-established custom of finishing pictures on the walls during Varnishing Days.

Turner seems to have been touching on his works in the Academy as early as 1798;[138] but the practice had never been a regular nor a regulated one. In 1804 it was as an exceptional measure that, when Turner was a member of the Council, a dozen Academicians were advised that their exhibits required varnishing, and were given an appointed day on which to do it.[139] Turner this year seems to have painted much of his *Boats Carrying out Anchors and Cables* (Washington D.C. Corcoran Gallery of Art) in one of the Keeper's apartments, presumably because his own studio was not yet free of builders;[140] but by 1806 the practice among Aca-

demicians had apparently become general, and was criticized outside the Academy both as prejudicial to exhibiting non-members, who were not allowed the privilege, and, more significantly as

> it disposes [Academicians] to send their pictures in a slovenly, un-finished state; and what is worse, it induces them to adapt the colouring to the style of the pictures which may be placed in their vicinity, and give them thereby an evident advantage over their competitors.[141]

It was Martin Archer Shee, complaining forthrightly in *Elements of Art* of the glare of 'exhibition pictures' as we saw earlier, who in 1809 proposed to regulate the facilities allowed to members of the Academy on Varnish-ing Days; but his suggestion, seconded by Fuseli and accepted, that there should be a minimum of three days allotted to the practice, as opposed to the original one, could only defeat his interests and make it easier for Academicians to work more extensively within the exhibition itself.[142] Turner was one painter who took advantage of the procedure; and in 1819 his *Richmond Hill* (TG 502) was attacked for its effect on the neighbouring *Bryan's Anathema* of Richard Cook, 'which like others suffers from the flaming colours of Turner's pictures. [Hayes] spoke of the per-nicious effects arising from Painters working upon their pictures in the Exhibition by which they often render them unfit for a private room.'[143]

Turner's practice of touching, even painting considerably, on his pictures on Varnishing Days was thus well established by 1820; but a decade later it took on a wholly different aspect which demands both an analysis and an explanation. Before and during the 1820s, when the habit seems first to have come into prominence, Turner seems to have used heightening or toning-down his pictures at the Exhibition simply as a gesture of generosity or self-defence. In 1826, according to George Jones, Turner toned down the sky of *Cologne, the Arrival of a Packet Boat, Evening* (New York, Frick Collection) with lamp-black, so that it might not out-shine two flanking portraits by Lawrence.[144] The following year, on the other hand, he painted up the reds of his *Rembrandt's Daughter* (Fogg Art Museum) to 'check-mate', as he put it, the red robe of Shee's neighbouring *Portrait of John Wilde, Esq. LL.D.*[145] Shee seems to have nursed some re-sentment, for when he followed Lawrence to the Presidency in 1830, he tried to curtail the facilities for varnishing, which had doubled in days since 1809. On 27 April 1832, Constable wrote to C.R.Leslie:

> I am in the greatest alarm for the Academy. No notice of varnishing has yet come—therefore we shall not be allowed the five days. This is a sad affair to me—but I am rightly served—I should not have sent my scrambling affair. As to Turner (to whom no doubt the blow is levelled) nothing can reach him, he is in the clouds
>
> *The lovely Jessica by his side*
> *sat like a blooming Eastern bride*

I cannot complain. We set the example of cutting off a day last year—
& Shee would cut off all but one if he could. His pictures are always
'hard' before they are sent off his easil & will bear *anything being put
upon them.*[146]

Constable himself was this year to suffer a check-mating touch of red
against his *Waterloo Bridge*, from the buoy in Turner's *Helvoetsluys* (Hardie
Coll.). 'He has been here,' said Constable when he saw it, 'and fired a
gun.'[147] But the following year, in *The Bridge of Sighs, Ducal Palace and
Custom House, Venice: Canaletti Painting* (TG 370), **27**, Turner moved
from a negative to a thoroughly positive stance.

 Clarkson Stanfield's first Academy exhibit in 1833, after his election to
full membership, was a *Venice from the Dogana*, which came to Turner's
notice immediately after the hanging of the entries of members and
associates. 'Now I'll teach Stanfield to paint a picture in two days,' he is
reported to have remarked:

> In two days, then, Turner produced that splendid work [*Canaletti
> Painting*] which tended so much to obscure the merits of Stanfield's
> picture. And, however ill-natured or invidious such a circumstance
> may be considered, as personally concerning Stanfield, it cannot be
> denied that the public were gainers, inasmuch as they were better
> enabled to judge of the respective merits of the two, by a close
> examination and comparison of their paintings. The juxtaposition
> brought out more glaringly the defects of Stanfield and illustrated
> more strongly the fine powers of Turner. For, viewed from whatever
> distance, Turners work displayed a brilliancy, breadth and power,
> killing every other work in the exhibition; whereas, on the contrary
> Stanfield's looked opaque, heavy and devoid of all effect, even near,
> or at a distance.[148]

This painting, which Turner called deprecatingly a 'scrap' rather than an
important picture, seems, to us, to be very solidly painted and far from an
improvisation; but George Jones, whose *Ghent* hung next to it, recalled
how the painting of the sky turned into a game: Jones had painted his sky
very blue, and Turner

> joked with me about it, and threatened that if I did not alter it he
> would put down my bright color, which he was soon able to do by
> *adding blue to his own* [struck by Jones] his magical contrasts in his own
> picture, and laughed at his exploit and then went to work at some
> other picture—I enjoyed the joke and resolved to imitate it, and
> introduced a great deal of white into my sky, which made his look
> much too blue. The ensuing day, he saw what I had done, laughed
> heartily, slapped my back and said I might enjoy the victory.[149]

The game was, however, a serious one, and Turner repeated it rather
more publicly the following year, when the *Morning Chronicle* reported that
'Mr Turner sent the canvas and painted some of his present pictures in the

room on varnishing days' (26 May). In 1835, the painting *in situ* of the *Burning of the Houses of Lords and Commons* (Philadelphia Museum), **11**, attracted considerable attention among artists at the British Institution,[150] and, two years later still, Turner repainted there his *Regulus*, **28**, **30**, begun in Rome in 1828, in a way which suggests that Varnishing Days—for him they were now, significantly, 'Painting days'[151]—were important, not only to his technique, but also to his conception of a work.

> 'He had,' wrote Sir John Gilbert, who witnessed the process, 'been there all the morning, and seemed likely, judging by the state of the picture, to remain for the rest of the day. He was absorbed in his work, did not look about him, but kept on scumbling a lot of white into his picture—nearly all over it. The subject was a Claude-like composition—a bay or harbour—classic buildings on the banks on either side and in the centre the sun. The picture was a mass of red and yellow in all varieties. Every object was in this fiery state. He had a large palette, nothing on it but a huge lump of flake-white: he had two or three biggish hog tools to work with, and with these he was driving the white into all the hollows, and every part of the surface. This was the only work he did, and it was the finishing stroke. The sun, as I have said, was in the centre; from it were drawn—ruled—lines to mark the rays; these lines were rather strongly marked, I suppose to guide his eye. The picture gradually became wonderfully effective, just the effect of brilliant sunshine absorbing everything, and throwing a misty haze over every object. Standing sideway of the canvas, I saw that the sun was a lump of white, standing out like the boss of a shield.[152]

The sun was, as I showed in an earlier chapter, the true subject of *Regulus*, and in causing it to rise and expand so palpably on Varnishing Day, Turner was showing that his art could act out the functions of nature herself.

These transformation scenes became a leading characteristic of Turner's art in the late 1830s and 1840s, but they had scarcely been noticed before then: J.D.Passavant, touring England in 1831–2, made no reference to the practice, although he spoke of Turner's finishing work hurriedly, just in time for the Exhibition.[153] What had brought about the change? Turner's mind and his artistic development were ready for such a development after 1828; but I believe that the decisive catalytic factor in directing Turner's attention to the value and legitimacy of demonstration painting was the astounding series of London concerts given during the summers of 1831, 1832, 1833 and 1834 by Nicolo Paganini. It had been clear from the time of the violinist's early appearance that he offered his audiences as much for the eyes as for the ears:

> 'Now no one ever asks,' he wrote from Liverpool in 1832, 'if one has heard Paganini, but if one has seen him. To tell you the truth, I regret that there is a general opinion among all classes that I'm in collusion

with the devil. The papers talk too much about my outward appearance, which arouses incredible curiosity.'[154]

Paganini at once attracted a following among artists: in England Haydon, Maclise and Edwin Landseer were excited by his activities, which offered an obvious lesson to painters anxious to show that musicality was also a pictorial virtue. In Turner's Roman circle of 1828, the address of William Havell, the landscape painter, was itself compared to that of the violinist.[155] Delacroix in Paris, who conceived the brilliant image of Paganini in action (Phillips Memorial Gallery, Philadelphia) explained to his assistant, Lasalle-Bordes, the painterly virtues of a musical technique:

> We must render our visions with ease: the hand must acquire a similar facility, and this can only be achieved by similar studies. Paganini owed his astonishing execution on the violin solely to his daily practice of scales for one hour. It is the same excercise for us.[156]

We have no precise information that Turner attended any of Paganini's concerts; but his love of music and the theatre makes it very likely that he did, and he can in any case hardly have escaped the gossip about Paganini's technique surrounding his English tours, when he gave his name, for example, to a peculiarly difficult billiard *coup*. In a Petworth gouache of about 1830 (TB CCXLIV, 102) Turner imagined himself as a drawing-room performer at the easel, just as other drawings of the series show musical evenings; and in *Watteau Study* of 1831 and *Canaletti Painting* of 1833, he inaugurated the highly original subject-matter of the artist at work, not as mere *genre* in the Dutch manner, but as a demonstration of principle.

Turner had long been concerned with speed of execution: in the *Sandycombe and Yorkshire* sketchbook of about 1812 (TB CXXVII, p. 31) he noted down a story of the facility of Salvator Rosa, who

> painted a picture for the Constable of France in a day, and carried it home, which rapidity so captivated the Constable that he ordered another large one which he likewise began, finished and sent home. That [was] well paid for by purses of gold, and as [the] Constable commented which would be first weary [?] but upon the production of the 5th the employer sent 2 purses and declined the rivalship with the artist's powers of rapidity.

In his notes from Pliny's *Natural History*, Turner had compared Salvator with the chief Greek example of *sprezzatura*, Nichomachus, in a story closely parallel to his own behaviour in 1833.[157]

Hence it is not surprising that the growing emphasis on the activity of painting on Varnishing Days throughout the thirties, was matched by an increasing neglect of the products of that activity. Turner had been in the habit of sending his pictures for cleaning to W.R.Bigg, a *genre* painter expert in the techniques of Reynolds, Wilson and Claude;[158] and before 1830, the condition of his Gallery and its contents was remarked upon by

visitors as good.[159] But by 1836 Constable could write that 'some of Turner's best work is swept up off the carpet every morning by the maid and put in the dust-hole'.[160] The growing neglect, recorded by many visitors to the Gallery in the late 1830s and 1840s,[161] is in curious conflict with the painter's resolution, embodied in the Will of 1832, to leave his collection to the Nation; and that he came to realize the contradiction himself, is suggested by a letter to his dealer, Griffith, of 1844. Turner noted, not, it seems, without some complacency, that

> The large pictures I am rather fond of tho it is a pity they are subject to neglect and dirt. The Palestrina I shall open my mouth widely ere I part with it. The Pas de Calais is now in the Gallery (suffering). The Orange Merchant I could not get at—if I could find a young man acquainted with Picture cleaning and would help *me* to clean accidental stains away, [it] would be a happiness to drag them from their dark abode. To get any lined is made almost an obligation confer'd and subject to all remarks. The Stormy Picture you saw in the Parlour for Mr Foord's *Hero* to advise with about cleaning and lining, but cannot find out who was employ'd for the Ivy Bridge—so well done.[162]

It was probably for this purpose of cleaning and organization that Turner employed the young Margate painter, Francis Sherrell, as a studio assistant from 1848, the year when a new codicil to the Will reasserted the intention of keeping finished pictures together in a Turner Gallery.[163]

In the previous decade, however, Turner laid far more emphasis on the act of painting itself, and even on the origins of a work, prior to its execution. It was probably at this time that he made his confession to William Kingsley that he disliked looking at his own work, 'because the realization was always immeasurably below the conception';[164] and when Kingsley remarked that paint was flaking seriously from *Crossing the Brook*, Turner answered, 'What does it matter? the only use of the thing is to recall the impression.'[165] Turner was both reluctant to sell his most important canvases, and to allow them to be seen adequately in his Gallery: his art was produced increasingly for the consumption of a few of his fellow artists on Varnishing Days. Lord Francis Leveson-Gower, the owner of Turner's early *Bridgewater Sea-Piece* (R. & B. pl. 15) which he lent to the British Institution Old Master exhibition in the same year, asked quite understandably of the artist, in a review of 1838 in which he attacked the practice of painting on the walls of the Exhibition:

> Is it possible that the painter of this picture [*The Bridgewater Sea-Piece*], of the Italian landscape in Lord Yarborough's possession [*Festival of the Vintage at Macon*], which Wilson never exceeded, and of the other works which might be cited, can be the perpetrator of those strange patches of chrome, ultramarine and whiting which Mr Turner is wont to exhibit in these days? That these extravagancies

have their admirers (purchasers we believe they have few), especially among professional men, we are well aware, and believe that none but artists can fully appreciate the difficulties which this Paganini of the palette deals with.[166]

That Turner's fellows indeed regarded his Varnishing Day activities as instructive is clear from several accounts. Turner had worked as a favour on other, younger, artist's pictures in the Exhibition at least since 1811;[167] but from the late 30's the practice became more frequent and purposeful:

'I should think that no man could be more accurate in his observation,' Sir Edwin Landseer told the Royal Commissioners of 1863, 'or more thoroughly grounded in the education of the artist than Turner. I have seen him detect errors during the days when we met at the Academy, after the pictures were placed; and whatever he suggested, was done without question, and it was always an improvement, whether in proportion or chiaroscuro, or anything else. He was thoroughly grounded in everything, and, without exception, I should say, the best teacher I ever met with.'[168]

The brothers Redgrave were equally certain that Varnishing Days had been the only way in which the extreme individualism which characterized the structure of English art education could be mitigated: they were the English substitute for the studio system of Continental practice; and they were particularly Turner's own.[169] Sidney Cooper recorded how Turner would touch on his and other young painters' canvases in the 1840s, and in a well-known episode of 1847, Turner painted in the rainbow of Maclise's *Noah's Sacrifice*, now at Leeds.[170] Even in the year of his death, with none of his works in the Exhibition, he attended the Varnishing Days, and was much struck by Maclise's *Caxton's Printing Press* (Knebworth):

he looked at, and talked of it with Maclise, then called for a seat, and sat with the painter, expressing his pleasure by his odd and jocose remarks on passages of that noble & generous artist's admirable skill.[171]

Starting from the familiar and trivial fact of the physiological effect of environmental colour, and the need to modify a painting in the context of its surroundings, Turner developed an original and highly personal element of style, and an effective method of instruction. The brilliance of his light palette during the 1830s and 1840s was, as contemporaries realized, closely associated with the development of exhibiting conditions; and if they placed the practice of transformation rather later than we are now able to do, it was because only after 1833 did Turner seriously convert a routine necessity into a principle of art. As I have said, Turner made Varnishing Days peculiarly his own event; and as Eastlake explained in the year of their suspension, 1852, it was his prestige which had prevented their yielding to growing pressure for reform, until after his death.[172]

11 Turner and Goethe

Although Turner read and commented upon Goethe's *Theory of Colours* when he was already an old man approaching seventy; and although none of his notes were as extended as those which he had made earlier on the theoretical works of Gerard Lairesse, Opie or Shee, his attitude to Goethe is of the greatest interest both because it shows the contact of minds similar in many ways; because it reveals the last stage of some of a lifetime's interests and obsessions; and, most important, because it helps us to understand the purest essay in practical theory which Turner ever made: the pair of paintings, *Shade and Darkness—the Evening of the Deluge*, **51**, and *Light and Colour (Goethe's Theory)—the Morning after the Deluge—Moses writing the Book of Genesis*, **52**, which were exhibited in 1843 (TG 553, 554).

With one exception,[173] Turner's notes to Goethe have been rather the subject of speculation than analysis; nor do they invite it, for they are often difficult to decipher, never more than terse, and elliptical in expression at precisely those points where Goethe and Newton come most crucially into conflict. But an attempt to analyse and evaluate them is essential, for Turner gave Eastlake's translation of the *Theory* a more thorough attention than he seems normally to have devoted to any work of its type; and this without the immediate stimulus of the lectures, which had directed his earlier reading, but which had been definitively abandoned with his resignation of the Professorship in 1837. Perhaps because there was not this need to translate analysis immediately into exposition, the notes to Goethe are more haphazard than those to Opie or Shee; and their quality and interest is far more various: they are the jottings of a leisurely reader, not those of a student anxious to find the answers to a specific set of problems, and finding himself caught up in a debate. This quality of diversity extends, but it also dilutes their value as a tool for the understanding of Turner's ideas.

It would not be appropriate here to expand on the more general kinship between the artistic personalities of Turner and Goethe, anxious as they both were to feel their ways through the violence and confusion of nature and of their own temperaments, to a more permanent and stable order, and enlisting on this journey as much aid as they could from contemporary science. Certainly the general attitudes of both poet and painter towards this science were similar: still true to the remarks on the unity of nature which I quoted in an earlier chapter, Turner noted 'one uniform whole' against a passage (§738) where Goethe had observed 'that the formulae

under which the elementary appearances of nature are expressed, altogether tend in this direction, and it is easy to see that through this correspondence of expression, a correspondence in meaning will necessarily be soon arrived at'. Earlier, Turner had made symbolic circles against a paragraph (§687) asking chemists to see their work in the context of science as a whole; and similarly, he noted an exhortation (§728) for collaboration among scientists in various fields. Goethe had, however, considered that a division of labour between practice and theory might be helpful to the progress of science; and against this passage (§729) Turner noted, apparently, the distinction between mathematical and optical (i.e. visible) colour, which in his later lectures he had tried to reconcile, and which in another note to Goethe he saw as the chief barrier between science and art. In a longer and more problematical note on what he interpreted as Goethe's identification of the rainbow and the prismatic spectrum as comparable 'phenomena of nature', where Goethe's highest 'augmented' red (*Purpur*) was deficient because yellow–red and blue–red were unable to unite (§814), Turner wished to preserve a distinction; and in a comment on the following paragraph he expanded his idea to show that in the colour-circle (where all the colours bore the same ratio of extent to each other, which they did not in the rainbow):

> these [colours] cannot travel out of their course—being the product of light—not so painting: her combinations are bounded only by confustion [*sc.* confusion] and the phenomenon [*sic*] which nature exhibits.

Mathematical and 'optical' colour must, for Turner, remain distinct, whereas Goethe had been anxious to show that the division was an illusory one, although he had been unable to secure the necessary assistance with the mathematical side of his enquiries.

Eastlake had been careful to mitigate the anti-Newtonianism of Goethe's text by referring in his preface and notes to the pre-eminently artistic aspect of the *Theory*; and Turner had doubtless been introduced to it as a painter's manual. Thus he was constantly critical of what he saw as its shortcomings from this point of view. Against another paragraph on the colour-circles, which Goethe had divided by chords to give the juxtaposition of alternate colours (§816), Turner again noted that the ratios of quantity and position were immutably fixed by the triangle of colours within the circle; and he added, 'Here Goethe feels [?] not pictorial combinations'. When Goethe was anxious to allay the prejudice against theory which he had found common among painters (§900), Turner retorted that it was a 'prejudice of good more than evil', a clear echo of constant themes in his Perspective Lectures. Even when Goethe was talking—disapprovingly—of the primitive and garish 'juxtaposition of vivid colours without an harmonious balance in decorations' (§835), Turner felt touched and commented, 'Poor Painting'; and when he be-

lieved, through a misunderstanding, that Goethe was restricting the primary combinations to two (§707), he begged, 'give poor [?] Pictore a third'. When, on the other hand, Goethe turned to the 'harmonious juxtaposition' of the whole prismatic scale together (§808), Turner endorsed it approvingly: 'this is the object of Painting'. Turner's attitude to art-theory was, as I have suggested in relation to Brewster, essentially that of a professional; when Goethe seemed in his *Concluding Observations* to sanction the value of amateur work in the advancement of science, Turner countered sharply, doubtless with Goethe's own treatise in mind, 'this general[ly] does very little service to Art and frequently retards'.

Sometimes the notes were the merest clarifications of terminology, as where 'yellow–red' and 'blue–red' were converted by Turner into 'orange' and 'purple' (p. xlii); where Turner felt that Goethe's meaning was better conveyed by 'union' than 'contrast' in a passage on the neutralization of opposing colours (§273); or where Goethe's account of earlier conceptions of light (§361) was identified with 'Newton' in the margin. Sometimes Turner simply expanded Goethe's observations with examples taken from his own experience, as, for example, when the 'dense medium' interposed before the naked eye (§231) was seen as a 'cataract'; or where the impression of 'aversion' given by some uses of yellow (§771) was associated by Turner with the 'Quarantine Flag'. Against a passage on the optical mixture of blue and yellow (§823), Turner made the generalization that this would apply to *all* 'double combinations', 'if at a proper distance, that is equal to the angles they subtend'. In other notes Turner simply asked questions of Goethe: in the process of the transformation and eventual disappearance of colours (§712) 'which lasts the longest [?]'; or when Goethe spoke of the 'augmentation' of blue and yellow to red (§699) 'which first [?]' i.e. which colour becomes reddish sooner? Goethe mentioned the intolerable effect of a red cloak seen on a grey day (§776), to which Turner rejoined, 'say a bright sunny day', implying that the effect would then be very different. The question was a loaded one, and others were more so: when Goethe stated that optics in general could not dispense with mathematics, but chromatics might (§725), Turner retorted 'there lies the question': it was one which during the later stages of his Perspective Lectures he had felt very urgently himself.

Turner's reading of Goethe was sometimes careless and impatient; several points of contention arose from a simple misunderstanding or disregard of the text. In §394, Turner equated Goethe's 'objective parallex' of the rays from an extensive light-source, the sun, with 'Newtonian par-rales' [*sc.* parallels], or light travelling in parallel lines. When Goethe was referring to the mixture of blue and yellow, which 'do not . . . destroy each other', but produce green (§697), Turner's mind jumped ahead and he retorted: 'yet they do, the violet, the green and the purple [*sc.* orange] are the negatives to yellow, Red and Blue', which shows his awareness of

complementaries, but has no place in this immediate context. In §615 Turner seems to confuse *hues* with *tones*; for when Goethe states that 'few specific hues, in themselves, admitted of no change', he countered, 'not so few, because they poses [*sic*] gradation'; and, later in the same passage, he seems anxious to preserve the distinct status of these gradations, because he complains that they are 'denied' in Goethe's reference to the 'tinted patterns' which serve as the model for standard colour-terminology. Occasionally, again, Turner's remarks seem to bear little relationship to the text they qualify: he brings to his reading of Goethe some old obsessions which may be linked with the *Theory*, if at all, only through some imaginative association of ideas. Goethe refers, for example (§692), to the readiness of colours to change with the slightest mixture or change of parts, and Turner glossed this approvingly: 'this is our commixture, and in this painting becomes an art'. To a passage on the distinction between mixture by glazing and mechanical mixture in painting (§571), Turner added: 'two colours mixed less clear than one, three yet more—in Fuseli['s] words all the rest is monotony and mud'. The most casual reference to pigments in a paragraph on yellow and red (820) evokes the old preoccupation of the later lectures: 'Pigments and Colour [?] and [*sc.* are] not the same.'

But, for all their variousness and their *ad hoc* quality, Turner's notes do show that there were genuine and substantial disagreements between himself and Goethe on the nature of colour. On the one hand it is undeniable that their similarity of outlook on the broad questions of the rôle and tendency of science was matched by a common feeling for the detail of colour. Sometimes they had been struck by the same phenomena: Turner's remarkable sketch of *The Lake from Petworth House, Sunset* (NG 2701), with the setting sun burning into the line of the horizon, is a precise illustration of an observation in Goethe's *Theory*,[174] and the peculiar optical quality of Turner's rendering of Venice was never perhaps put more exactly into words than in Goethe's *Italienische Reise*, many years earlier:

> In moving across the lagoons in the intense sunlight, and watching the brightly-dressed gondoliers swinging their oars easily at the side of the gondolas, and how they made shapes against the blue sky and on the bright green surface of the water, I saw the best, the freshest painting of the Venetian School. The sunlight brought out the local colours dazzlingly, and the shadows were themselves so light that they could have served as lights in another context. The same went for the reflections in the sea-green water. Everything was painted light on light, so that the sparking foam-crests of the waves were essential to give the last, sharp, finishing touch.

(8 October 1786)

Like Turner's, Goethe's visual imagination worked strongly in retrospect, for this passage had not appeared in his diary of the moment, but was written up before its publication some twenty years later.

Turner's 'glances for study' were nevertheless not always Goethe's. He could not, as Goethe could (§392), see coloured shadows without the aid of a prism. He did not agree that 'the fainter shades of double shadows must always appear as half shadows' (§233); nor could he see that a shadow at the farthest point from the object casting it 'melts away into the bright ground'; and he felt that if Goethe had been right in supposing the production of double half-shadows around the human figure in sunlight as a result of the cross-action of light rays from an extended source, 'there would appear two men out of one' (§§394, 395). When Goethe claimed that the bright clothes of peasant women (which suggested to Turner's memory both 'Pleasure and Subjection'[174a]) could never surpass the splendour of their sky and landscape setting (§836)—a feeling fully illustrated in the Venetian passage quoted above—Turner explained, 'red Ribbons and Yellow cannot surpass in splendour light which gives them power'. But, he added, 'Goethe [says?] colors of landscape—but he sees [?] more yellow and Red than I have a notion of', although these particular colours had not been mentioned in the passage in question. Was Turner projecting his three-colour conception of light into the picture evoked by Goethe's description: red and yellow dresses, blue southern sky, and finding the combination too crude to be accepted as universal?

Sometimes Turner's quarrel seems to have been simply with the language of Goethe's exposition. In his discussion of the characteristic (i.e. non-harmonic) combinations of colours (§817), Goethe had explained that these combinations were not completely satisfactory to the eye, 'inasmuch as every characteristic quality of necessity presents itself only as a part of a whole, with which it has a relation, but into which it cannot be resolved'. Turner commented: 'this [is] too paradoxical—for if a part has a power of sig[nifying?] or impression even as a part of a whole, in to it [it] must resolve by a relation'. The objection was not, it seems, to the idea in general, but to the use of the word 'relation'. Turner occasionally felt that Goethe's account was too purely personal: 'here again particuraly [sc. particularity] admited', he noted against one of Goethe's confessions that he had not been able to secure the hoped-for assistance of a mathematical friend (§727). But it was, in the end, in matters of principle that Turner had most to dispute with Goethe, and it is here that the chief interest of the annotations lies.

When Goethe, in his account of the production of red either by 'augmentation' or, less significantly, by the use of an 'existing' colour, casually referred to the primary 'three or six colours' (pp. xlii–xliii), Turner interjected indignantly, '3 or 6 is here an Escapement of the Qu [es]t [io]n'.; for it was a problem which had much concerned him in the course of his lectures, and one which, as we saw, had been the subject of much

controversy among artists in England. Similarly, in the same place, he thought Goethe unfair to the individual status of red; and in a later passage (§284), where Goethe described an experiment with coloured lights, and omitted red from the series of orange through to violet, Turner concluded 'poor red stands for darkness'. It was with some surprise that he noted, at the end of the book, where Goethe showed the predominantly red content of a list of agreeable colour-combinations (§828), 'Red get[s] the ascendancy tho Goethe found a difficulty in first formations'. With these 'first formations' of red by the 'augmentation' of yellow–red and blue–red, Turner could hardly agree: true to his own three-colour theory, he remarked against §704, 'Here secondaries make principles [i.e. primaries]'. When Goethe seemed to be saying (§690) that any light must be coloured to be perceptible at all, Turner made the qualification that this was only so in the case of refraction at an edge; and where Goethe spoke of the inherently shadowy qualities of colours themselves, which produced greys when neutralized by mixture (p. xliii), Turner called grey nothing but 'the infinite mixture of Light and Dark'.

Just as he remained unsatisfied with Goethe's fundamental account of the production of red, so Turner felt that too little attention had been given in the *Theory of Colours* to the rôle of shade in relation to light. Paraphrasing Plotinus, Goethe had explained perception in terms of the recognition of like by like: 'If the eye were not sunny, how could we perceive light?' (p. xxxix). To Turner, this argument seemed very one-sided; and he added in the margin: 'If the eye be sunny it could not know Darkness.' Darkness had for him a positive value, and when Goethe, in surveying his own general approach to colour-theory (§744), characterized darkness simply as the absence of light, Turner complained: 'nothing about shadow or Shade as Shade and Shadow Pictorially or optically'. Turner brought to his reading of the *Theory of Colours* a preoccupation with the nature and formation of shadows which had concerned him from the earliest period of the Perspective Lectures. In a long and confused critique of Lairesse in the *Perspective* sketchbook (TB CVIII, pp. 99a–82a), Turner had attempted to reconcile the facts of light travelling in parallel lines, with its emission in all directions from every part of the source. He seems to have come down, rather uneasily, on the side of the divergency of rays, basing his argument chiefly on the lengthening shadows of sunset (pp. 85a–84a); although it must be emphasized that the argument is not at all clear, and seems not in the event to have found its way into the lectures as delivered. But it was a problem which continued to work in his mind, and he brought it constantly into the debate with Goethe. When Goethe wrote (§309) of 'the light which streams from all parts of the sun's disk', which 'will cross itself in the smallest opening, and form the angle which corresponds with the sun's apparent diameter', Turner drew a diagram of parallel rays crossing in an opening, and asked 'what is this but admitting ‖ [i.e. parallel] right lines [?]' and when Goethe attempted to

dismiss the idea of parallel rays as merely a convenient fiction (§310), Turner rejoined that they were 'of the utmost [?] [importance] and [?] make [?] all the different *shadows* [i.e. difference between the shadows] of natural and artificial Light'. Goethe wrote that even through the smallest opening the sun produced an image of its whole disk (§336), and Turner commented that this supported the theory of 'divergent [?]' lines or their action. He endorsed this in a note to a later passage (§398) on the size of the image as being larger than the opening, although at the same time, he rejected Goethe's explanation that this was due to the rays from the sun's edges, which, he said, was treating the sun wrongly as a plane; and Turner could not see that the image grew dimmer towards its circumference. Goethe was, thought Turner, inconsistent with himself in his explanation of the nature of rays of light. On the one hand he denied the reality of parallel rays (§401, bracketed by Turner), yet shortly afterwards (§404), he explained that images projected through small openings were dim because light in this case came only from a few single points on the sun's surface. 'What,' asked Turner, 'but the parrallel ray again admitted [?]' But Turner himself had not been able to reconcile completely the two sets of phenomena; for when Goethe claimed that whatever the shape of the opening, the same round image of the sun was projected on to the wall (§402), Turner denied this, saying that 'each form gives the same form offered to the ray—bundles versus crossways', which seems to find in favour of the bundles of parallel rays. The theory of parallel *or* divergent rays was for Turner a crucial one; and in his study of it, he found, as he believed, that Goethe was ranged beside Newton in opposition to his own feelings on the matter.[175] He spoke, as we saw earlier, of 'Newton's parallels', and in the same note he added (§394) 'Newton['s] principle[s] come in straight lines'. Turner here seems to be referring to the primary colours, and to have in mind the diagram, reproduced by Kirby from Newton, of parallel rays impinging on one side of a prism. When Goethe noted the decline of colours into black and their heightening into white (§559), Turner added, 'of course, but [even Goethe] admits the losing of colour, as the Newtonian formula of Light by action',[176] whereas he, as we saw in his colour-circles, wanted to represent extremes of light and dark by colours themselves.

Turner must have been well aware of the anti-Newtonian character of Goethe's *Theory*, to which Eastlake had alluded somewhat delicately in his preface; and he was clearly a little surprised when he found the two writers in agreement. When Goethe mentioned the fiction of bundles or fasces of light rays (§310), Turner retorted 'what advance [?] on Newton— one ray suffices to Light the World'.[177] 'What but Newton [?]' was his response to what he regarded as Goethe's erroneous observation of double shadows caused by the activity of the whole of the sun-image (§397). But in his attempt to distinguish the fixed ratios of the colour-circle from the more variable colours in the rainbow, which he felt Goethe had confused

(§814), Turner separated the principles of the propagation of light, expounded, as he thought, by Newton and by Goethe; and he seems to have come down on Newton's side: 'So all becomes Phenomenon except the extreme cases—what then is their produce but Light [?] Here we must choose by parallel or crossways from the edge—Newton or Goethe.'

When Goethe was attacking one of the roots of Newton's theory: that the mixture of the primary colours together produces white (§558), Turner took up the standpoint of the painter and, following out Goethe's thought that in practice the opposite was true, he noted simply: 'Mr Fuseli called [this] the corruption of colour'.[178] Although he had considered the Newtonian theory with respect in his earlier Perspective Lectures, it hardly touched his own three-colour theory, and he was only marginally concerned to defend it in his Goethe notes.[179] But, for him, the alternative to Newton was not the acceptance of Goethe, from whom, as we have seen, he differed on several important points. He did however come close to Goethe in one essential respect: in the rôle he assigned to chiaroscuro over and above colour values. We saw earlier that Turner felt Goethe had not gone far enough in his study and evaluation of shade; but he endorsed a later passage of the *Theory* (§898) that a poor disposition of light and shade in a picture could outweigh the excellence of colour-composition; and his comment on Goethe's 'Ultimate Aim' (§901): that the harmonious relations of chiaroscuro, keeping, and true and characteristic colouring should determine the success of a painting, Turner expressed what was probably his judgement of Goethe's whole theory, since theory it remained: 'Yes—this is the tr[ue] shot—but not winged the Bird.'

This constant regard for the rôle of chiaroscuro, in a symbolic as well as in a purely aesthetic context, brought Turner as a colour-theorist closer to Goethe than he was to Newton; for both the poet and the painter had developed this concern from an earlier non-Newtonian tradition of artistic theory and colour-science. For all his declared interest in causes, Turner does not seem to have been really concerned with the production of colours, but chiefly with their constitution and effects: so that he was not concerned to evaluate the rival theories of Goethe and Newton where they most decidedly clashed. The three-colour theory of Brewster, which was essential to Turner's understanding and expression of the nature of light, belonged neither to Newton nor to Goethe, and was to some extent contradicted by them both. Turner did not attack Goethe's treatment of Newtonian optics at all vehemently, although its patriotic regard for what Newton stood for might well have led him to do this, not only because his own ideas of colour were hardly Newtonian, but because many of Goethe's assumptions and conceptions had long been familiar and acceptable to him.

II

Eastlake's and Turner's instinct for treating Goethe's *Theory of Colours* as if it were primarily a painters' handbook was essentially a just one, for the treatise had been initially the product far less of a scientific than of an artistic environment. Goethe has himself admitted as much in the *Confession des Verfassers* which he appended to the first, historical, volume in 1810; and in the list of colour-theorists given in the *Materialien zur Geschichte der Farbenlehre* of this volume, less weight was generally given to the work of physicists than to writers like the dyer Louis-Bertrand Castel or the colour-printer d'Agoty, who had been concerned chiefly with practical colour-techniques. Among these theorists, Goethe had included one painter whose concern with science had been, at most, marginal: Anton Raphael Mengs, whose posthumous *Works* he had read eagerly as early as 1782, and whose ideas on colour he discussed a few years later among his artist friends in Rome.[180] In the notice of Mengs in the *Materialien*, Goethe mentioned the painter's traditional view of chiaroscuro as the basis of harmony in pictures; and he later quoted a passage—which Mengs had himself characterized as anti-Newtonian—on the three-colour theory of harmony which I discussed in the introduction.[181] More important, although Goethe did not refer to it in his account, was the painter's tonal spectrum of primaries, running from white, through yellow, red and blue, to black, and his view that red, the central colour of his scheme, 'enters into all colours. The most perfect is that which is at an equal distance from the golden [i.e. yellow–red] and violet [i.e. blue–red]'.[182] If red was a component of all colours, it must be capable of extraction from the other two primaries, yellow and blue, so that Mengs was only a step from reducing his primaries to these two, as Goethe was to do, through the doctrine of 'augmentation' in the production of red. Mengs' writing on colour was, I have suggested, also one of the sources used by Turner, who, in his colour diagrams, had stressed the tonal rather than the chromatic relationships of the three primaries.

Ever since his studies as a youth in Strasbourg, Goethe's interest in colour had been deeply affected by his contact with the colour-symbolism of traditional alchemy, with its stress on the progressive development, through colour-changes, and in stages akin to 'augmentation', of the supreme and highest red.[183] Alchemists had also stressed the tonal changes of the process: black was invariably the condition of the *prima materia*, embodying all the elements unresolved, and in some systems the final consummation was symbolized by white as well as, or rather than, red. In an earlier chapter I showed how much Loutherbourg's interest in alchemy and its related imagery had contributed to the symbolism of his art; and it may well be that his belief in only two primaries, the tonal extremes of blue and yellow, was developed from similar sources.[184] Through his early contact with Loutherbourg, this basic

idea must have been familiar to Turner long before his encounter with Goethe.

Nor can Goethe's more fundamental ideas of the nature and origin of colours have appeared to Turner to be especially new. Even if, as he confessed to his students, 'my regard for his instructions slumbered',[185] Turner showed in this very lecture that his memory of Thomas Malton's teaching was still alive; and Malton's textbook, the work of his father, produced arguments against Newton's optics which were very similar to Goethe's. 'Newton's name,' said the elder Malton, 'I highly revere; but I am persuaded that the pursuits of the greatest men are, sometimes, in themselves, trivial and merely amusing.'[186] Light, for Malton, was homogeneal, and

> As to the Phaenomenon of Colours seen through a Prism, it is really surprising; but it is only the edges of objects that are tinged or produce the Colours. A perfectly plane surface is not at all varied in its colour, when seen through a Prism; except at the Edges, when it is joined or opposed to a darker Body; and those edges are most coloured when they are parallel to the refracting Angle . . . The Colours are more intense and vivid the brighter the object, or the greater the opposition and obstruction of the Light by an opaque Object . . . the Colours [are] produced, on any surface, only where there is an opposition into a darker body.[187]

Malton, like Goethe, had based his deductions on subjective experiments with the prism, rather than on the study of the projected spectrum of a narrow beam of light refracted, which had been the chief method of Newton; and they had reached similar conclusions, although Malton's represent, of course, only one small element of Goethe's *Theory*. Far more important for Turner's optical background, both because of its more developed exposition, and because he was in contact with it over a far longer period, was the colour-theory of George Field.

Field did not deliberately and systematically oppose Newton, as Goethe had done; he was, like most English writers, deeply respectful of his genius. But his three-colour theory was necessarily antithetical to Newton's, and the conclusions which he reached are in many ways closer to Goethe's than to any other English theorist. Field had, like most of the eighteenth-century sources to whom Goethe was most consciously in debt, arrived at his system through his awareness of the needs of painters, and, especially, through his experiments in the manufacture of artists' pigments. His theoretical writing came, for the most part, after his work as a practical chemist was well-established; but this work involved the study of a wide range of alchemical or semi-alchemical technical literature, of the order, for example, of Salmon's *Polygraphice*, and this, coupled with a strong taste for literature and mythology, and an even stronger feeling of the unity of all phenomena, produced a body of synthetic quasi-scientific literature thoroughly characteristic of the period, although more readily

comparable to the thought in Germany of Steffens, Oken, Schelling or Ritter than to that of the English speculative technologists. Even in his earliest writings Field showed, in fact, an exceptional familiarity with German research, for example the red–green–violet theory of Wünsch;[188] although he does not seem to mention Goethe's *Theory* (which had been known in England at least since Thomas Young's long and searing review of 1814) until long after the appearance of Eastlake's translation, in 1845.[189] Field had, however, carried out a series of prismatic experiments which was essentially the same as Goethe's; and he expressed his results in language which was sometimes very similar: Goethe's definition of colours as the *Taten und Leiden des Lichtes*, seems to be echoed strongly in this passage in Field's treatise of 1820:

> *The principles of light and shade* are the agent and patient of every visual effect, they are therefore correlative, co-essential and concurrent; accordingly, the light of day and the sun-beam itself are compounds of light and shade . . . the principles of light and shade are co-essential and concurrent latently in the colors of pigments &c . . . when in latent concurrence the element or principle of black or shade predominates, it determines the color BLUE; when that of white or light predominates, it determines the color YELLOW, and when these principles concur without predominance, they determine the medial color RED.[190]

After studying the production of colours round a black spot on a white ground, through his lenticular prism, or *Chromascope*, Field concluded:

> It would be difficult to account satisfactorily for the production of colors in the above experiment, by the analysis of light alone, since the colored spectrum would vanish if the black spot were removed. It is to be presumed, therefore, that the principle of shade in the spot concurs with the principle of light in the ground in producing the circular iris.[191]

In the first edition of *Chromatics*, published as Field's earliest essay on colour-theory in 1817, but discussed among Royal Academicians since about 1811, he established his table of polarities very much as Goethe had done in the *Theory of Colours*, placing light, activity, oxygen and positive electricity as correlated on one side; and shade, passivity 'phlogistic or hydrogenous substance' and negative electricity on the other.[192] It would be understandable, although unnecessary and unwise to talk of Field's plagiary of Goethe, since we know at present very little about the circumstances of his work, and similar studies, coupled with a similarity of temperament, can so easily have led to comparable conclusions. What is clear is that much of the substance of Goethe's most characteristic theoretical deductions had been the subject of debate among artists in London between 1810 and 1820. Thomas Young, in his review of 1814, while he

dismissed the scientific basis of the *Theory* as 'a striking example of the perversion of the human faculties', conceded that the book would be of value to artists; and he summarized Goethe's *Confession des Verfassers*, in which the author had elaborated on the work's artistic origins, and also Heinrich Meyer's essay on colour in the history of art.[193] Similarly, in spite of the extremely liberal understanding of 'science' in the period, the subscription-list of Field's most comprehensive treatise, *Outlines of Analogical Philosophy, Being a Primary View of the Principles, Relations and Purposes of Nature, Science and Art* of 1839 contained the names of no recognized scientists in any field, although its publication was supported by more than forty artists, including Turner. We are justified historically as well as technically in excluding both Goethe and Field from the more purely scientific background of Turner's optics.

Turner's connexion with Field may possibly be placed as early as the beginning of the century, through their mutual friend, Thomas Girtin, although it seems clear that Field was never as close to Turner as he had been to Girtin and was to be to Constable in the 1820s. By the middle of the 1820s, however, Turner had become sufficiently interested in Field's ideas to subscribe to the *Outlines of Analogical Philosophy*, whose moral and aesthetic dualism, and ultimate pessimism, has much in common with the spirit of his own late art.[194] He also subscribed to the first edition of Field's second treatise on colour, the *Chromatography* of 1835, although it was probably to this work that he referred when he said to Field darkly, 'You have not told us too much', and when he reported to the young Trimmer at the end of his life that the argument was fallacious.[195] But despite the absurd lengths to which Field took his line of reasoning, we know that many individual remarks and observations were sympathetic to Turner, who, as the Goethe notes amply demonstrate, was quick to feel the fruitful possibilities of a single idea or a phrase. Field had himself disarmed Turner's first criticism by observing:

> Should the artist, as he may, find herein matter of his previous knowledge and observation, he will reflect that every reader has not the skill and experience of an artist.[196]

Generally, Turner's response was similar to his response to Goethe: that the work was too systematic and theoretical; but on the subject of the fundamental dynamism of light and shade, Turner and Field were agreed. Turner's note of the Daguerreotype in the marginalia to Goethe, and his last experiences with Mayall, were echoed by Field, who, in a review of recent optical discoveries in 1845, dilated in the 'beautiful novelty' of photography as at once demonstrating and accounting for the 'chemistry of light'.[197]

Thus the type of colour-theory represented by Goethe's work was already familiar in England, at least in outline, by 1820, and this especially among artists. It is possible, too, that Turner had been introduced to

Goethe's *Theory* itself long before he read Eastlake's translation in 1840. Of the German–Roman circle with which Turner seems to have made contact in 1819, J.D.Passavant had only recently been studying Goethe's book in Paris;[198] and Carl Friedrich von Rumohr, the chief discoverer of Raphael as a colourist, must have been familiar with the related theory of Philipp Otto Runge, whose close friend he had been during the development of that theory between 1807 and 1810.[199] Rome in 1819 was, too, alive with stories of the scandalous scepticism of Arthur Schopenhauer, who had just left, and who had, only a year or two before, published his treatise *Über das Sehn und die Farben*, which was based directly on Goethe's *Farbenlehre*.[200] During the 1820s, Eastlake met Schopenhauer in Berlin, where they discussed the theories of Lessing and Goethe on the *Laocoön*, although Eastlake does not record any references to colour,[201] and shortly after this meeting, Eastlake was with Turner in Rome.

Turner's English background, with Malton and Field, as well as his Roman contacts through Eastlake, make it very likely that by 1840 he was thoroughly familiar with the underlying principles of Goethe's *Theory of Colours*; and this may well account for the fact that he felt it unnecessary to examine and refute those principles in his notes. Certainly, too, there was much in the book with which his long experience as an artist, and his temperament as a man had led him to agree. Among Goethe's principles, the one which stirred perhaps Turner's deepest sympathies was a belief in polarities. In his discussion of poetry and painting in 1812, Turner had translated the golden morning of Thomson and Milton's 'twilight grey' into terms of active and passive colour; and this idea had entered later into his conception of the colour-equivalents of the times of day. Hence it is not surprising that the most fruitful product of his reading of Goethe should have been the pair of octagonal canvases which he exhibited in 1843 and which have their starting-point in his endorsement of Goethe's table of plus and minus polarities (§696): yellow and blue, active and passive, light and shadow, against which Turner pencilled simply, 'Light and shade'.

III

Dr Gray has rightly noted that Turner wrote 'Goethe's Theory' into the title of only one of his companion-pictures, the *Light and Colour*; and from this he has concluded that the pair, so far from endorsing Goethe's principles, are a criticism of them.[202] His assessment is surely correct; but I believe it was not a criticism of the basis of Goethe's account of the genesis of colours from light and darkness, by substituting their Newtonian origin in light alone, but an attempt to restore the equality of light and darkness as values in art and nature, which Turner felt Goethe had unduly neglected. I have attempted to show how little concerned Turner was with the anti-Newtonian basis of Goethe's ideas: for him, as his earliest notes

show, the *Theory* elaborated the neo-Platonic formulation: 'were the eye not sunny, how could we perceive light?' Turner's picture of the *Shade and Darkness* prior to the Deluge is the visual embodiment of his rejoinder to Goethe: 'If the eye be sunny [alone] it could not know darkness.'

Turner's starting-point for the two pictures was Goethe's table of polarities, where he found that the poet had expressed his own conceptions of the status of light and dark. Whether or not he took his subject-matter from John Martin's *Eve of the Deluge* (Royal Coll.), which had been exhibited with its companion, *The Assuagement* (General Assembly of the Church of Scotland), at the Royal Academy in 1841, he found in the theme a perfect vehicle to express the preoccupations of a lifetime's art. In *Shade and Darkness—the Evening of the Deluge*, with its dominant blacks and blues, its 'passive' sleeping figures, representing 'negative' disobedience, according to the caption from the *Fallacies of Hope*, Turner was concerned to restate the sublimity of darkness, the sorrow of the black sails of *Peace, Buriel at Sea* of a year earlier, Wilkie's memorial picture, in which Turner had felt constrained, as he rarely was, to make his colour symbolic.[203] *Shade and Darkness* was Turner's version of the 'awful gloom of approaching horror' which he had analysed repeatedly in Poussin's *Deluge*. But besides it he set what was essentially his own discovery as a painter, the sublimity of light. The iconography of *Light and Colour* is correspondingly less conventional and more complex than that of its companion. Its caption, from the *Fallacies*, ran:

> *The ark stood firm on Ararat: th'returning sun*
> *Exhaled earth's humid bubbles, and emulous of light*
> *Reflected her lost forms, each in prismatic guise*
> *Hope's harbinger, ephemeral as the summer fly*
> *Which rises, flits, expands and dies.*

The painting is a whirl of brightness and movement: but the relationship of the two designs is not one of optimism and pessimism. Turner replaced the traditional rainbow of the Covenant with the prismatic bubbles which account for its appearance in optical theory. They are, too, Shelley's

> *Bubbles, which the enchantment of the sun*
> *Sucks from the pale faint water-flowers, that pave*
> *The oozy bottom of clear lakes and pools,*[204]

bubbles of marsh-gas which the sun might well 'exhale' from the surface of the waterlogged world. They are, however, also the symbols of the 'bubble pleasure' of one of Turner's early poems (TB XLIX cover), which 'Bursts in his Grasp, or flies'; and which is here in the caption compared to *Ephemera*, the may-fly, that 'rises, flits, expands and dies'. The bubbles, 'Hope's harbinger', are like the rainbow, but they are also the emblems of fallacious hope.[205] Even their primary colours of red, yellow and blue, which reflect so appropriately the primitive 'lost forms' of the world before

the Flood, Turner derived from Goethe's account of the colour-sequence in bubbles of foam on drinking-chocolate (§468); and they are, on Goethe's showing, colours which can never last. Perhaps Turner was aware, and, if so, he will certainly have enjoyed the irony of the situation, that it was the very colours of bubbles, produced without the intervention of shadow, which Newton had cited in refutation of Goethe's theory, long before Goethe himself had evolved it.[206]

Just as Runge, in an early version of *Der Mittag*,[207] had made the biblical connexion between the rainbow of the Covenant and Moses' bronze serpent and the Tables of the Law, so did Turner in *Light and Colour*, by introducing the recording figure of Moses himself. St John's Gospel (III, 14–15) had proclaimed that Christ was the bronze serpent lifted up in the Wilderness, the Covenant between God and man; and the image had been perpetuated in Europe by the crucified serpent of the emblem books. But, just as the rainbow-bubble of the Covenant was no enduring sign of hope, so the brazen serpent kept for Turner its character of evil; it was in *Light and Colour*, the same twisted serpent of Medea, who 'infuriate in the wreck of hope',

> raised the poisonous snake
> High in the jaundiced sky to writhe its murderous coil.[208]

The *Deluge* pendants, like the *Angel Standing in the Sun* of 1846, **70**, the *Wreck Buoy* with its arching rainbow and the four Carthage pictures of the last years, seem to show that Turner had lost belief in the possibility of redemption; and its Christian symbols he turned to a negative and un-Christian use. Just as he felt that the sun was God, so his dark pessimism expressed itself increasingly in terms of light, and light in terms of the colour he had spent a lifetime in learning to control.

Goethe's *Theory* had been in 1840 the occasion not only of the two paintings into which Turner put the fruit of his appreciation and study; but it had also confirmed his distrust of all theory, of the capacity of any system of thought to do justice to the mass of detailed observations offered to the understanding by experience. 'Poor Dame Nature', Turner had written when Goethe was attributing colour phenomena chiefly to the workings of the human mind (§834); for he had always been anxious, since the earliest disenchantment with the Picturesque, to allow nature to reveal herself to the spectator on her own terms: this was why natural forces came to be expressed in a language which they had developed for themselves. When Goethe in the same passage had added that nature sometimes agreed with the principles which he had outlined, and sometimes not, Turner commented 'thus all that has been defined come[s] but to this'. Goethe had not succeeded in an enterprise in which Turner, too, had for many years been anxious for, and hopeful of, success. Had he known of the great weight which Goethe attributed to his work on the theory of colour, he would have found perhaps even more reason for

disillusionment and despair. But for him, as well as for Goethe, the dilemma of reconciling art and nature, theory and practice, the ridiculous and the sublime, was never one that he had found it easy to resolve. Turner's attitude to colour, and especially his refusal to accept the newly won triumph of colour-harmony, and the impetus this gave to the status and study of colour in painting, illuminates the whole of his artistic personality not only because it is as a colourist that he has been chiefly appreciated and enjoyed, but also because he felt above all things through his eyes. The world and its values was for Turner the world offered to physical vision and the attempt of the mind to understand it: the fallacies of vision were in the end both the expression and the testimony of the fallacies of hope.

Epilogue: Turner's following

When Turner died in 1851, English landscape had entered a phase of naturalism very different from the symbolic scientism which had been at the centre of his art. Those painters, like Cox and Cotman, Callcott, Stanfield and Harding, who had felt his effect in the first half of his career, did not care to follow the developments of the later period: and his younger protegés like Eastlake or Maclise, Landseer or Cooper, hardly gave themselves to pure landscape as such. Turner's public following had never declined; he kept sympathetic patrons like Windus or Munro of Novar, and critics like Lady Eastlake and Ruskin until the end. But Ruskin's advocacy of the Pre-Raphaelites, and his association of them with Turner's 'truth' should not make us forget that the Pre-Raphaelite approach to colour in landscape, with its objectivity, its cult of *plein-air* and its refusal to allegorize or paraphrase was profoundly different from his, and is as well defined as their differences in style.[1] In England, Turner's following among artists was confined almost solely to the marginal painter James Baker Pyne, whose work he praised as 'poetic' and who shared some of his theoretical interests, but who is, when he is closest to Turner, as in the *Bay of Naples* in the Victoria and Albert Museum, guilty of the flimsiest pastiche.[2] Whistler's most Turneresque works are, as Ruskin recognized, scarcely less flimsy; and Whistler had, surprisingly perhaps, very little respect for Turner, as he did not, he thought, meet 'either the simply natural or the decorative requirements of landscape art'.[3]

Although the Louvre has only very recently acquired its first genuine Turner, his rôle as a proto-Impressionist has long been upheld in the historical chart exhibited in the Impressionist gallery of the *Jeu de Paume*; and it is certainly in France, where Delacroix' friend, Richard Parkes Bonington, had imported Turner's mature style in the 1820s,[4] that we might expect to find the closest developments of his interest in colour and light. But in fact these developments are extremely difficult to plot. How much of Turner's work was known abroad in the original rather than through engravings is hard to assess. He visited Delacroix personally, but it is not known whether he took any work to show on this or on his other French visits. There is little trace of any impact on Delacroix' style, although they did share many painterly interests; and Delacroix praises Turner surprisingly generally, associating him with very different English painters like Constable, Wilkie and Lawrence.[5] Théophile Silvestre, who would have seen Turner's work in England in the 1850s, wrote of his colour a decade later as far more *outré* than Delacroix', although the

passage was quoted in part by Signac in his pamphlet on Neo-Impressionism very much in favour of Turner:

We find on looking at them [wrote Silvestre] that there is, in certain respects, a close relationship between the last manner of Delacroix, pure pink, silvery and delicious in the greys, and the last sketches of Turner. There is nonetheless not the least imitation of the English master by the French; we only remark on the almost identical colouristic aspirations in these two great painters at the end of their lives. They heighten their tonality more and more, and nature, losing its reality for them day by day, becomes a fairyland. Turner, who had begun seriously with the Flemish and Dutch genres and not, as is thought, with pastiches of Claude, came at the end of his career to the artificial and dazzling decorations of the theatre.

Rightly or wrongly he had got it into his head that the greatest artists of all schools, the Venetians not excepted, had kept well below the pure and joyful brilliance of nature, on the one hand by darkening their shadows conventionally, and on the other by not daring to come fairly to grips with all the light that creation showed in its virginity. In this frame of mind he painted his two pictures, *Colour Before the Deluge* and *Colour After the Deluge* [*sic*.]. Delacroix, a man at once more passionate and more positive than Turner, did not venture so far; but, like the English artist, he ascended involuntarily from a low harmony like the sound of a cello to a light one like the accents of an oboe.[6]

Théophile Gautier, who would also have seen Turners in London in the 1840s, gave in his *History of Romanticism* a similarly fantastic account of *Rain, Steam and Speed*, reviewing Maxime Ducamp's *Chantes Modernes*:

he sings the magic of matter, the electric telegraph, the railway-engine, that dragon of steel and fire. Reading this certainly well-made piece, we thought of a sketch by Turner, which we had seen in London and which represented a railway train coming full steam across a viaduct in a terrifying storm. It was a real cataclysm. Flashes of lightning, wings like great fire-birds, towering columns (*babels*) of cloud collapsing under the thunderbolts, rain whipped into vapour by the wind. You would have said it was the setting for the end of the world. Through all this writhed the engine, like the Beast of the Apocalypse, opening its red glass eyes in the shadows and dragging after it, in a huge tail, its vertebrae of carriages. It was certainly the sketch of an enraged fury, mingling sky and land in a single sweep of the brush; an extravaganza, but done by a genius of a madman.[7]

But French critics were also aware of Turner's naturalism. In 1836, the year of Ruskin's first defence, *L'Artiste* wrote:

There are some days in the year when the sun gives distant objects a particular beauty of colour, which has made more than one spectator exclaim: 'That really is a Turner!' No analysis can better explain the truth and the range of talent in this artist than an exclamation as natural and spontaneous as this.[8]

It is this naturalistic aspect of Turner's art which might have been expected to excite the young Impressionists on their visits to London in 1870-1. In these years they were able to see, in the National Gallery and the South Kensington Museum alone, some 110 finished oils and 150 sketches and drawings from all periods of the artist's production. And yet, although Constable's example was absorbed, conspicuously in Monet's Hyde Park Scenes, there is very little indication that Turner had much effect on their work. Certainly in retrospect their response seems to have been cool. Monet found Turner antipathetic because of 'the exuberant romanticism of his fancy', and in 1918, as his own vision returned to greater 'objectivity' in the Waterlilies series, he stated: 'At one time I admired Turner greatly; today I like him much less, he did not organise his colour enough, and he used too much of it.'[9] Similarly, Camille Pissarro, in the 1880s, expected his son Lucien to be impressed by *Rain, Steam and Speed*; *Peace, Buriel at Sea*; a Marine at South Kensington (possibly *Life Boat and Manby Apparatus* [1831] or *Line Fishing off Hastings* [1835] in the Sheepshanks Collection); a *View of St Marks* (?*Venice from the Canale della Giudecca* [1840]) and 'the little sketches touched with watercolours, of fish and fishing tackle'; but he later recognized that Turner and Constable,

> while they taught us something, showed us in their works that they had no understanding of the *analysis of shadow*, which in Turner's painting is simply used as an effect, a mere absence of light. As far as division of tones is concerned, Turner proved its value as a method among methods, but he did not apply it correctly and naturally.[10]

The story of the Impressionist debt to Turner seems to go back to Signac's *De Delacroix au Neo-Impressionisme* of 1899, where he described how,

> In 1871, during the course of a long stay in London, Claude Monet and Camille Pissarro discovered Turner. They marvelled at the assured and magic quality of his colours, they studied his work, analyzed his technique. At first they were struck by his snow and ice effects, amazed at the way he succeeded in conveying the sensation of snow's whiteness, which they themselves had failed to do with their large patches of silver white spread on flat with broad brushstrokes. They saw that these wonderful effects had been achieved not with white alone, but with a host of multicoloured strokes, dabbed in one against the other, and producing the desired effect when seen from a distance.[11]

The 'snow and ice effects' available to the Impressionists in 1871 were presumably *Cottage Destroyed by an Avalanche* (TG 489); *Snowstorm: Hannibal and His Army Crossing the Alps* (TG 490); *Frosty Morning, Sunrise* (TG 492); *Snowstorm—Steam-Boat off a Harbour's Mouth* (TG 530); *Whalers* (TG 545); *Hurrah! For the Whaler Erebus* (TG 546); *Whalers (boiling blubber) Entangled in Flaw Ice* (TG 547). None of them have extensive areas of white, or many signs of this 'pointillist' technique described by Signac. In an important sourcebook of Neo-Impressionism, O.N.Rood's *Modern Chromatics*, Turner is as a painter specifically excepted from the practice of 'optical mixture' by the use of juxtaposed colour dots; and his work is recommended for study as an example of the monochromatic gradations and chiaroscuro effects that had been especially expounded by Ruskin.[12]

In the event it was not in the Impressionist seventies or the Neo-Impressionist eighties that Turner made his greatest impact on French painting, but in the nineties, when Monet began his most Turneresque series of *Haystacks*, London, and, later, Venice (1899–1909) views; when Signac and Cross were turning away from the 'naturalism' of Seurat towards a freedom of colour which was to be influential for the Fauves, and when the young Matisse, following Pissarro's advice, and possibly also under the influence of his master, Moreau, made a pilgrimage to Turner in London, on his honeymoon.[13] Then for the first time the dealer Sedelmayer and the collector Groult were bringing Turner's late style before French artists and the Parisian public. In June 1894 Pissarro wrote to his son:

> At the moment there is a great noise about a Turner which Sedelmeyer was to sell to the Louvre for two or three hundred thousand francs. The whole thing is a machination of dealers and collectors. So an exhibition of the English School is being held; some superb Reynolds, several very beautiful Gainsboroughs, two Turners belonging to Groult which are quite beautiful, and the Turner they want to 'give' to the Louvre, which is not beautiful, far from it![14]

Not surprisingly it was less Turner the naturalist than the late 'fairy' Turner, especially the 'Venetian' Turner, who was most admired; the Turner who had been imitated for some years by Felix Ziem, a friend of Gautier, Signac and Van Gogh, and some of whose most Turneresque landscapes and marines are in the Dijon Museum. Predictably, too, this aspect of Turner attracted not landscape painters only, but also Gustave Moreau. In 1891 Moreau was with the Goncourts at the Groult collection. One of the brothers wrote of Turner:

> This picture [a Venetian scene] is one of the ten that have delighted my eyes the most. For this Turner is liquid gold, and within it an infusion of purple. This is the goldsmith's work that bowled over Moreau, *stupified* in front of this picture by a painter whose name he had never heard before. Ah! this Salute, this Doge's Palace, this sea, this

sky with the rose translucency of Pagodite, all as if seen in an apotheosis the colour of precious stones! And of colour in droplets, in tears, in congelations, the sort you see on the sides of vases from the Far East. For me it has the air of a painting done by a Rembrandt born in India.[15]

Ironically, the Turner which so astounded Moreau and the Goncourts was almost certainly one of the forgeries in which Sedelmayer dealt and which it amused Groult to keep in his collection to fool the connoisseurs.[16] But Moreau's interest had been anticipated a decade earlier by the French critic whom Ruskin had hoped would write Turner's biography, Ernest Chesneau, who, in his study, *The British School of Painters* (1884), had pointed out the similarities between Turner's and Moreau's views of art. Writing of *Apollo and Python* (TG 488), **44**, he said: 'I do not know whether the great French artist, M.Gustave Moreau, has ever seen this life-like painting, but whenever he does, he will appreciate the genius of one of his ancestors.'[17] In *Apollo*, Turner shared Moreau's admiration of Rembrandt, and they are hardly closer than that; in general the Impressionists of the seventies admired and emulated Turner for what he stood, as an expander of the concept of landscape, rather than precisely for what he did.

It is beyond the naturalism of the nineteenth century that we must look for Turner's successors: and the painter who makes the bridge between Turner and the modern period is Paul Signac, who, while he was proclaiming Turner the naturalist and proto-Impressionist in *De Delacroix au Neo-Impressionisme*, was himself discovering a very different, far more abstract artist, on the visit to London that he described as a 'pilgrimage to Turner', shortly before Matisse, in 1898.[18] On 28 March he noted in his diary:

> National Gallery. A quick glance at the Turners as a whole. From 1834 he frees himself from black and looks for the most beautiful colorations; colour for colour's sake. You would say he was mad; it seems he wanted to make up for lost time. He was fifty-five years old when he began to see really clearly—how this gives us hope.
> March 29. A serious visit to Turner . . . In sum—he freed himself from all dark tones after 1830. His colour vibrates, the pictures are composed, the colours organised. It is complete and meditated control. Then twelve years later he sacrificed everything to colour. What he loses in pre-meditation he gains in a pure and harmonious brilliance. His influence on Delacroix is incontestable. In 1834 the French master studied and understood Turner. The tones, the hues, the harmonies I have seen in Delacroix, I find again in Turner. The figures are treated with the same liberality.[19]

Back in Paris in April, Signac summed up the impact of the trip:

> The works of Turner prove to me that we must be free of all ideas of imitation and copying, and that hues must be created. The strongest

colourist will be he who creates the most . . . how can you paint *Undine giving the Ring to Masaniello* or the *Convulsionnaires de Tanger* [by Delacroix] from Nature ? . . . Make compositions more extensive, more varied in hue, more replete with *objects* (for the justification of hues: Turner's draperies), more panoramic . . .[20]

Of *Rain, Steam and Speed*, the *Deluge* pair, the *Exile and the Rock Limpet*, Signac wrote to his friend Angrand: 'These are no longer *pictures*, but aggregations of colours (*polychromies*), quarries of precious stones, *painting* in the most beautiful sense of the word'.[21]

Rain, Steam and Speed and the *Exile* were, indeed, adduced, with some reservations (Signac recognized that Turner *had* sought to load them with meaning, however fantastic), as examples of the 'discredit of subject' in modern painting, in an article for the *Encyclopédie française* in 1935.[22] In support of this thesis Signac also cited two versions of *Norham Castle on the Tweed* that he had seen in London, reproductions of which hung juxtaposed on his studio wall.[23] In the first, which Signac dated 1815, and was probably the drawing for *River Scenery* (TB CCVIII, O), **34**, he enumerated the richness of detail, and concluded: 'It is impossible to compose a picture with more elements of beauty, and to succeed more completely'. Of the second, (TG 1981), **35**, which he gave to 1835, he wrote:

> In this picture, simplified and stripped of all that is useless, the castle, the river banks, the herd of cattle, all that the painter wanted to exalt reveal themselves much more clearly than in the composition where all the elements contradict each other, injure each other, kill each other. The red spot suggests the herd better than the eight separate units of the first picture, where the artist, too much the dealer in gems, has accumulated too much beauty. In the second, the painter alone appears, the old painter who has seen his way to sacrificing all the picturesque to the pictorial.

And he then went on to draw a comparison with Monet.[24] In this enthusiasm for the stuff of painting, which goes back to the London visit of 1898, Signac laid down the basis of the modern appreciation of Turner; but he did so by treating the late work in a way that was far from Turner's intention, just as Turner's contemporaries had enlisted Rubens in support of their three-colour theory of harmony. Turner's figurative symbolism places him firmly in the Romantic generation, but his vocabulary of form and colour, as it developed in the latter half of his career, may be related to an experimental art on the borderline of twentieth-century abstraction. In 1875 an English critic wrote:

> We have no colour pictures depending solely upon colour as we have symphonies depending solely upon sound. In Turner's works we find the nearest approach; but even he, by the necessary limitation of his art, is without the property of velocity.[25]

Turner's late work was, however, very much in the minds of the English pioneers of an art attempting to unite the qualities of colour, sound and movement: A.W.Rimington and A.B.Klein (Cornwell-Clyne). Rimington had been a landscape painter, and he based his art of mobile colour closely on his experience of nature at large: 'Who has not experienced,' he asked the audience of his first colour-concert in London in 1895,

> the profound emotion, partly joyous, partly melancholy, produced by the grand procession of glorious colour-schemes presented by many a sunset? Here the changes are for the most part slow and solemn: red becomes orange, orange gold, gold again melts to delicate green and blue by almost imperceptible transitions. Numberless combinations and proportions of every colour, in ever-varying and progressing harmony, march with slow and stately measure into the night.
>
> Or again look at the restless sea, on a bright and boisterous day, with cloud squadrons charging overhead, how infinite and magical are the colour schemes presented to us! How glad and sparking the emotions we experience! How different from those called forth by the pageant of the dying sun! Then our perception of beauty was tinged with a pathos, that deepened as light yielded to darkness. Now we watch the quickest movement of a symphony where the variations are even too rapid for the eye to follow. No rest, no pause in the mazy changes of colour; the former is a procession, the latter a dance. Or again, combine the two; spread the rippling sea beneath the setting sun—how infinite in beauty and complexity becomes the very opera of colour! . . . These colour compositions of nature are under the influence of form, gradation and combination. No contrivance of earthly art can hope to rival in some directions these glorious manifestations of Nature.[26]

Klein himself acknowledged a debt to Turner; as a student at the Slade School up to 1912 he had been experimenting with landscapes directly affected by Turner's late works. His first exhibited abstractions, 'Compositions in Colour Music, and Studies in Line and Shape', which were shown in London in 1912, were painted very much in this idiom. *Uprising Consciousness* was, for example, described by a critic as 'a vapourous canvas in which clouds appear to float above an elusive dawn'.[27] From these beginnings in painting Klein developed his colour-organ of the 1920s, and took the art of colour into a field where impermanence was more radical than in anything Turner had ever conceived. Like the purely painterly developments in Signac and the Fauves, it was an abstraction from Turner, according to the aesthetic climate around 1900, rather than an attempt to understand his work as a totality. But it was nonetheless a witness to the continuing and complex impact of his art.[28]

Appendix I
Color, from Turner's second lecture[*]
(*c.* 1810?)

Altho Engraving cannot be under my compartment [?] yet if any opinion however novel or distinguished respecting color tends in any case [?] towards improvement, the time to employ [it] cannot be idle spent. It is inevitably [?] allowd that Engrav[ing] is or ought to be a translation of a Picture, for the nature of each art varies so much in the means of expressing the same objects, that lines become the language of colors [which is] the great object of the engraver's study, and, as an elegant author expresses it, he that impresses the observation or stimulates the Associate idea of a color individually is the great artist. Beside, or rather with color, if the term can be allowd to lines, light and shade is obtained; but the means or scale of color is so different to the painter, that the very means that enable him to mass his light anihilates [?] the unity of that light by the engraver. As, for instance, white scarcely exists in a Painter's scale, but is the only means the Engraver has of making his light [*margin:* for it [is] rather the vehicle [?] of color]. Red [is] the strongest ray that calls the Eye wherever placed, and holds it to the exclusion of yellow. [It] becomes a shade by tones [?] to yellow & white, [*margin:* by the Engraver shade [?], namely that of giving light to one by reducing the whole], and thence downwards till only the more [?] distinctive [?procedure] of cutting [?] a tone [?] with clarity [?] constitutes the shade or blackness of engraving. Green, brown and dark red become translated only by [the] contrasting of tone, in which the art of what is termed by [the] engraver laying the tone evinces the superiority of one Eye over another. It has been remarked that rotundity can only be expressed by swelling lines, and indeed may be drunken [?] as a proof; yet frequent difficulties occur in the crossing [of] tone to produce shade, and where they radiate towards the light in the Picture, they always appear coarse, neither calling upon the eye to accomodate [?] the idea of either softness or color. It has frequently occurred to me that, however low Heraldic engraving has fallen, and therefore [is a] derogation to the dignity of Engraving to mention; yet [?] some general idea of color is imbibed by education, so that the associated idea of Gold, Silver, Blue, Red is called upon even by the modest line. Therefore I cannot but lament that [the] formators [?] of Heraldic engraving had had more of a Painter's Eye, or [had] attained [?attended] to the painter's scale. I think that by time every vulgant [*sic.*] eye would have been acquainted with the color of lines in the course of

[*] British Museum Add. MS 46151, A, ff. 16v–17v.

education [*margin*: or at least many [?] know color by particular lines].
Every one by one look to the dotted [or] the Horizontal line, [the]
longditudal and cross lines, [would] know they mean Gold, Red, Blue and
Black. Therefore, upon a supposition, may it not be conclusive to say that
if these lines had originated [?] with the painter, that such a Theory
would have been established, [so] that the associated idea of the coloring
of each Painting would be recognized by every one who view'd an
engraving. And yet sufficient scope would remain for the ingenuity of the
engraver in broken tint, the arrangement of the whole and depth of each
line corresponding with the breadth of his light to produce a richness of
color by crossing lines. And as all ⌈strength⌊mixtures posess part of [the] primitive
colors, may it not be asked that [a] given line, when admitted as a certain
color, whether it would be any disadvantage to the engraver to pursue the
same theory throughout a work; for instance, Gold the small as yellow the
[] Blue because of sky, Red the Perpendiculars, Dark Purple the line
[?] in equal strength varying in power, it inclining of [*sc.* to] either color:
Brown by the dot ?, and Red [or] Green by dots on horizontal lines, and
Black by the union and combining of the whole. If such a system had been
established by the early Nordic Engravers, the Engravers of the present
would not improve in [their] powers of [their] skilled task, and dexterity
of clearness; but [they] would have the advantage of [] the idea to
asserting [?] the ⌈tone⌊idea of colors to those who never saw the picture from
whom [*sic*] translated; and [of] posessing the power of light and shade
upon Theoretical principles.

Appendix II
Passages on light and colour in sketchbooks and lectures[1]

A

TB CII (1808)

Light is a body in painting of the first magnitude and Reflection the medium, or in other words the $\frac{1}{2}$ light, while shade is the deprivation of light only, but with the deprivation of Reflection likewise, becomes Darkness.

There is nothing new [?] in this position [sc. proposition?] but the last [?] [part] or difference between shade and darkness. The former has been exemplified by the greatest masters from Titian's bunch of grapes, where each grape was considered as a ball; just the centre or focus of light concentrated upon [?] a point; then half light or reflection intervening between the two; and shade, if shade it can be called that admits of so large a portion of surrounding light and $\frac{1}{2}$ tint.[2] We therefore refer to the Portrait of Vandyke's of the duchess of Cleveland [sc. Countess of Southampton?][3] (dark Green) in the British Institution for the advancement *of study* [struck by T.]; [and] to the greatest part of the globe on which the figure leaned in the character of St Agnes, [which] partook broadly [?] of half light; a central speck opposite to the supposed ray of light, and the reflection opposite the shadowed part [a] circle between *from which* [struck by T.] is resting [?] upon a base from which the light struck it. The ball received a reflected light [and] another, but lower in tone opposed it, so that when I [have] to define the light and shade, it would be right to denote [?] reflected and reflecting [?] lights. Refracted lights[4] are [?] those received by all bodies, but most so by polished ones from all surrounding objects, both of light and shade, and of course where refraction is concerned, shade must become more circumscribed. Refracted light gives clearness, and by them [sic.] help [?] objects can be more defined by a judicious introduction; but they destroy force. Rembrandt is a strong instance of caution as to reflected light and Correggio to refracted light. Two instances of the strongest class may be found in the celebrated pictures of the Mill and La Notte.[5] The Mill has but one light, that is to say upon the Mill, for the sky, altho a greater body of mass [?] is reduced to black and white, [and] yet is not perceptible [sic.] of receiving [the] ray by any indication of form, but rather a glow of approaching light. But the sails of the mill are touched with the incalculable [?] ray, while all below is lost in inestimable [?] gloom without the value of reflected light, which even the sky demands, and the ray upon

the Mill insists upon, while the ½ gleam upon the water admits the reflection of the sky. Evanescent twilight [?] is all reflection but in Rembrandt it is all darkness and [a] gleam of light reactive [?] of Reflection. Refractions [are] occasioned aerially. The Notte is all light and shade in Darkness [?]. But as a solitary instance from a great master may appear contrived, and caution in following [?] his knowledge in light and shade [is necessary], let me draw another instance of that knowledge in another picture: the Cradle here,[6] where Reflections &c become only powerful in a concentrated ray [?]; and Refraction, and almost Reflection, ceases except in bodies that admit the first light. He [thus] becomes the master of artificial light and shade, let me suppose it be understood as those lights that are artificial [?], and not those beams that give light, vigour and animation to the uneventful [?]. Their effect in an abstracted sense is as distinct [?] as this [?] appearance. Nature it would be wrong to say, as we can but know but one: the rays of the sun strike parallel, while the candle [rays are] angular. One destroys shade, while the other increases it; and as reflection and refraction are increased by the influx of light, so are they concentrated [?] by an excess of shadow, produced by the light becoming a focus. The art [?all] of the Picture therefore is only and properly light and shade; the greatest shade opposed to the greatest light, as [] as the Mill is otherwise than the opposition of the light depicted [?].

B

LECTURE VI (1812) British Museum Add. MS 46151, N

That colour has been the characteristic of a painter's work cannot be disputed, and may consequently become a peculiar style; but let us hope not with systematic, Heraldic quantity [?], of which the emblematic theory of colour strongly savoured; as white, followed by red, as attributes of light and power, yellow and blue, glory, purple, authority, violet subjection, green servitude; tho they appear somewhat on the road of application by custom, in the Madonnas by Carlo Dolci, [who] doth inforce character by the peculiar cast of blue, followed by red, [so] that imitation must follow, to be known, or intended [?] or acknowledged, as [in] the robe of the Virgin, the attributes of the Deity, or of humility. If so, crudity of colour, not character of form and delineation of passion, dignity or solemnity of shade, or emanation of effulgence, becomes the object of

⌈art
⌊enquiry; not that colour, the aid of which exalts or debases, elevating the thought conceived into appearance, into substantiation by its just union and combinations with light and shade, making a whole from parts relatively appropriate, and harmoniously diffused; or [when] misapplied, destruction of gradation produces glaring inconsistency, littleness and

commonality. Colour therefore comprehends a vast portion of power in the practice of the arts. Lines and forms are defined; harmonic proportions or situations adjusted and established, subjects rendered intelligent and compatible with nature, by combinations pleasing, if not fascinating; for colour often clothes the most inauspicious formalities arising from rules, lines or localities of nature, by a diffused glow or gathering gloom, which destroys [sc. defies?] abstract definition as to tone, and prevents even contemplation of any formality therein existing. Colour is universal gradation of colour to colour, from the simple pastoral to the most energetic and sublime conceptions of form, combined with chiaroscuro; while light and shade can be classed without colour, producing likewise gradation of tone by comparable strengths of dark to light. Colour [on the other hand] possessing the like properties as [to] strength, has others, of combinations productive and destructive of light or distance, as well as an appropriate tone to [express] particular subjects [and] peculiar combinations considered or allowed, called Historic or Poetic colours. Historical colour, were we to follow the musical distinctions offered [?] to designate styles or tones of colour, of grave, soft, magnificent, as have been ascribed to Poussin, with qualifications of colours innate, as those of Fury and Anger for Phyrrus; gracious and delicate in the picture of Rebecca; langour and misery in the gathering of the Manna. Every tone must be Dorian, Lesbian, Lydian, Ionic, Bacchanal. [But, in this case] all would be historical theory and practically imprisoning, depriving those tones of [in-]explicable commixture, that appals by gloom, and drags the mind into contemplation of the past, [as] in his picture of the Deluge, distracting theory by the uniformity. He has buried the whole picture under the deep-toned lurid interval of approaching horror, gloom, defying [?] definition, yet looking alluvial [?]; calling upon those mysterious ⌈memories⌊ties which appear wholly to depend upon the association of ideas. Thus the busy power, preserving her ideal train intire; or when they would elude her watch

> *Reclaims their fleeting footsteps from the waste*
> *Of dark oblivion; thus collecting all*
> *The various forms of being to present*
> *Before the curious aim of mimic art*

the largest choice of combined properties of colours, quality and quantity of light, shade, forms and lines, at once impressive and impressing contemplation into the sentiment or feelings depicted.[7] Thus the sombre tone, the darkened yet dignified gleam which accompanied every shade of colour in the raising of Lazarus;[8] the half extinguished light on the Resurrection by Rembrandt;[9] the agonized and livid tones of Ugolino[10] ask emphatically some designation for that expressive resemblance to

which in nature, line by line and feature after feature, and to which poetic colour must assimilate to that sublime exemplar, when it stole

> *those animating charms thus*
> *colours mingle, features join*
> *and lines converge; the faint parts retire*
> *and fairer eminent [?] in light advance*
> *and every image on its neighbour smiles.*[11]

In these elevated branches of art, rules, my young friends, languish. All they can contribute here is but propriety of judgement, as to practicality, or discriminating the most proper in choice of subjects, compatibile and commensurate with the powers of art. Aerial perspective is the last limit where distance only may be said to guide figuratively the last faint and trembling ray of restrictive rule; a distance where colour becomes blended, as in the aerial medium of Claude, the glowing expanse of Cuyp or the exquisite feeling of Wilson. Gradation of line, gradation of tone, gradation of colour is all that aerial perspective can theoretically ask or practically produce. The higher qualities of sentiment, or application of intellectual feeling, forming the poetic [or] historic, or perceptions gained from nature and her works, are far beyond dictation. Here rules are conducive only to selecting compatibility, or to informing how far the qualities of the mind may combine its perceptions to avoid error or failure, in labouring to unite contending elementary or natural incongruities, to produce the feeling excited by poetic pictorial members as certain of success they ought to be pictorial numbers, *or* judicious selections of historic incidents that the active powers of the mind may not lead the imitative power of the hand into a labyrinth through false choice, and not conclude that what-ever sounds harmonious ⌈Poetic⌊ideal beauty [?] or even connected metaphor, are [*sic*] capable of receiving pictorial effects. . . . So in history, but the last is not wholly the landscape department, the most elegant, most interesting as to character, pleasing as to introductory allusions, in Poetry often lack [?] in representation; and the opposite extreme of truth and pure simplicity, lead equally wrong in the choice by poetic feeling or harmonious numbers. I shall conclude, therefore, with two [examples], Morning and Evening, that depend notwithstanding the beauty of the diction, on colour; one active, the other passive: [the one] possessing the utmost purity of glowing colour, and [the other] the last solemnity of chiaroscuro, by colour:

> *But yonder comes the powerful King of Day,*
> *Rejoicing in the East; the lessening cloud,*
> *The kindling azure, and the mountain's brow*
> *Illumin'd with fluid gold, his near approach*
> *Betoken glad.*[12]

The lessening cloud displays the most elevated power of delineation; and the kindling azure resembles Shakespeare's beautiful ballad that fancy, when established, dies.[13] The difficulty is the poetic truth: the towers and hills and streams high gleaming from afar admit the means of producing a picture;[14] [but only] by evading the superior elegance and truth of the foregoing lines and [*sic*] create a picture of *Morning*. But in the Evening by Milton:

> *Now came still evening on, and twilight gray*
> *Had in her silvery* [sc. *sober*] *livery all things clad;*
> *Silence accompanied,*[15]

where can graphic art ask incidents or aid, foil'd by a word of her own, *grey*, defining [?] dignified purity, without producing monotony of colour? Here then, rules surely cease (they only exist by the mixture of black to white); nor can they [ever hope] to define that tone which cautious nature throws round for [a] mantle at evanescent twilight, where rules must ever tremulously stand, if they dare to stipulate for hues. 'Tis there the high-born soul is told to *seek* Nature, and not pursue an humbler *quarry*.[16]

C

Of combinations, or what may be considered as such, uniformity holds the highest class to the [induction guidance of rules, as the lowest to those of lines; and by their joint informing only, can the hope of speculating upon colour be tolerated, as has been emphatically said of the material colour. If we mix two, we reduce the purity of the first; a third impairs that purity still more; and all beyond is monotony, discord and mud;[17] or, as Sir Joshua says, practice must in some cases precede theory. If not, too much time would be lost to obtain that theory, which would arrive too late for practice.[18] If Titian chose rightly in his third style of colouring, the uniform breadth or commixture takes the higher rank, supported by his matured judgement thro all the glowing brilliance of combinations full, deep, rich, pure, colouring which only [he] himself had the hardihood to condemn; tho the worldly admiration of the former style still feels disposed to hold in the balance his opinion with his practice.[19] *Can* breadth of tone constitute *all* the requisites to produce style? Undoubtedly it is a great portion of the characteristics of each master as well as *school* of art, but it cannot be *all* without excluding *all* whose works do not posess this excellency. And tho it marks a considerable enlargement of practical powers, in evincing the very nice distinction between uniformity and monotony, breadth of tone, corruption of color, baldness and insipidity, [yet] *chiaroscuro* [and] *color must* exist in *all*; and the divisions of each master would be as numerous as [the] primitives in class, [just] as our former [?] one and three [?]

combinations would, or course, as they proceeded towards this breadth, take precedence, by quantities in one class, quality in another.

Rembrandt and Van Goyen both possess uniformity and breadth of tone; but no person conversant with technicalities would call them similar. Breadth, therefore, becomes like all other elementary principles: relative and comparative; and tho using it constantly as [the] explicative or principle characteristic of style, tone cannot be wholly removed from its quality of elementary induction of rules. As to quantity, simple light and shade has its first reflexes, [which] break it upon it; refraction returns, changing shadows positive into shadows negative, shade on to shade, to the very verge of its existence. This is the arrangement of the *St Peter Martyr*[20] possessing only continued, diagonally placed *waved lines*, which Lomazzo calls serpent-like,[21] reared into form by their continued and obliquely undeterminable lines, passing through to the top of the picture as trees, undeterminable of attitude, but by the extreme lines carrying the eye towards infinitude *opposite distinct proportion* [struck by T.] by the definite proportions of architectural columns, which carry always the associated notion of their diameter and [the] proportionate height of the entablature, and brings down or checks by the known right angle of the entablature ⌈*in idea only* [struck by T.]⌊(continuity of line). And no line is allowed to interrupt that sentiment of continuity. The companion picture,[22] mistaking the P. of painting, is of architect. lines dividing the picture vertically and placed angularly. [In the *S.Peter Martyr*] the sublimity of the other arrangements of lines, by its unshackled obliquity and waved lines, obtains the associated feelings of force [and] continuity, that rushes like *the* ⌈eruptive expanding ⌊*ignited spark* from earth towards heaven, struggling as the ascending rocket with the elements, and when no more propelled by the force, its scatters round its ⌈ignited ⌊falling ⌈embers ⌊glories, seeking again its earthly bourne, while diffusing around its ⌈living ⌊mellow radiance, as the descending cherub with the palm of beatitude sheds the mellow glow of gold through the dark embrowned foliage, to the dying martyr. Thus we are presented with the two great divisions of breadth [and] light and darkness, pictorial imp . . . to be qualified by Chiaroscuro; and if they must be weighed in the balance, who will dare hold the beam, farther than comparative[ly], and by [thinking that] what has been done may be done again, by quantity? But where shall we find the rules, the proportion of weight or measure, of the other requisite: *quality*: the ⅛ of light in Rembrandt, the decimal of ⌈Guido ⌊Rubens, or the magnitudes of Correggio?[23] And who will say their respective qualities, tho attatched, dwelt [?and] rely'd upon the lines in the space and forms, as to quantity, [which] *exist*, were *created*, are *evinced*, are their respective [?] styles, [and] constitute solely the whole of their works, by portioning out this quantity?

Or that the followers [or] imitators, the prop . . . only the quantity of Correggio's *Notte*, the quantity of Guido's *Aurora*,[24] or even the lines of the *Three Trees* of Rembrandt, would give their qualities? If so, Domenichino's repetition of Titian's *St Peter Martyr* would not have lingered at Florence [*sc.* Bologna?] with the immoveable fresco of Andrea del Sarto,[25] or, to come nearer home, without the qualities of art which the lost pictures of Sir Joshua at the fire at Belvoir Castle possessed of their own,[26] wrought from his own mine, his own comprehensive power, the quantities, or approach towards the quantity of light and shade of Correggio's *Notte* would have availed but little. The recipe of Carracci[27] cannot [?] tell us [] as in that style [it] may be concurred [with], but to execute it is quite another thing. Opie has said ⌈the picture of the 3 Maries . . . ⌊that [has a] union of powers so gigantic in conception, [that] if they had been fully substantiated, the great powers of the Roman school would have sunk into comparative obscurity with the powerful Carracci;[28] [and] that the *Transfiguration* of Raphael would partake more of M.A. [] chiaroscuro, to imitate M.A. in design, Titian in color, Coreggio in force, that the Raffael in expression.[29]

Thus for style, and if breadth is to be considered as style, or its part, and $\frac{1}{8}$ of light a decimal or a magnitude, work them by the lesser means, use them by the greater, [and] their products are *two*. Force them down to rules, [and] they rise by combination, each a product of combination relatively to its union, comparative[ly] to its amalgamation. Might not the lesser truth, *rules* pervade, so rigedly enforced upon *style*?

Thus having, I trust, detailed the value ⌈short of colouring ⌊or sentiment—tho used by Akenside[30]—allowable to lines, or at least geometric qualities, if not the generic power of lines distinguishable from those used as the means of obtaining the stereography of planes, their positions and situations as mere vehicles of light, shade and colours; I shall therefore consider them as to their respective values in their common acceptation, to produce combinations constitutive of charoscuro, and, lastly, of colors. The greater truth to define breadth of style brings down the terribilita [?] of Michel Angelo, the plafonds, [the] deities of art, the prophets and sybils of the Sistina, to magnitudes. Would they become the magnitudes of Correggio's breadth; would the Aurora and the Horses of the Sun by Julio[31] assimilate [breadth], as they do in subjects? Might they possibly be united; might [they] possibly, if so, improved as to style, [which] ⌈probably ⌊might render one more aerial [?], [or] might possibly decimate each other by decimals of breadth. Increase the $\frac{1}{8}$ of Rembrandt and we have de Koning [?Koninck]; reduce the $\frac{1}{8}$ to 1/16, [and] the candle-light of Schalken gleams. Where then are the boundaries? *None.* Why then can rules, enclosing [?] round these constellations of art, receive light from them to show their value by reflexes, as in polished bodies? The principal receives the secondary, and gives it again in concentrated light; why then can rules not be content to be received

204

and acknowledged by their respective styles? Such are ungrateful [who] try to pierce

> *That solemn majesty, that soft repose*
> *Dear to the curious eye, and only found*
> *Where some few objects fill an ample ground.*[32]

or will essays its power, its limitations of breadths of shade as [of] extinction of light. It risks *extinction* of its light, expelled by style, and her breadths weakened by extension [?] It has no resting place; it must ⌈look⌊fly to- wards *Uriel* [?] in the *sun*, or, plunged into shade, half flying, half on foot

> *it plunges into the abyss of darkness*
> *plumb down it drops, till some opposing and refracting*

Plane sends it has [*sic*] many lines aloft.

This leads me to the uniform tone or breadths of color considered in practice amenable only to common light and shade, and aerial qualities which are so but by convenience, tho alas too often by caprice. These are backgrounds, too often sacrificed [?] to fill a space, which might as well be occupied by any thing else—or, in better terms, a space to be filled. There are many opinions of the subject, but one I will mention: space would be easily attained if emptyness could give it, or the anecdote of Rubens.[33]

Thus from great opinions, as well as works, the use and effect of this most difficult appendage called background, one uniform breadth of coloured shade, and misapplication of *incongruity* [struck by T.] means calculated for other purposes become so obviously at variance with common nature as to require some distinction for the other arrangements of elementary principles, and for action. But it is to these subductions of the causes and principles and laws of light *and arial* [perspective] [struck by T.] that we must place the neglect or evasion of at least arial combinations and thin gradations of colouring, tone and feeling, bartered for shadows but to relieve, and colours to excite,

> *fair*
> *As full with front in all the blaze of light,*
> *The hero of the piece should meet the sight.*

This rule as enforced by Fresnoy belongs, says Sir Joshua, to the art in its infant state; for the more advanced know that such an apparent artificial arrangement would be for that reason [in-] artificial;[34] and we still should lose

> *That solemn majesty, that soft repose,*
> *Dear to the curious eye, and only found*
> *Where few fair objects fill an ample ground.*[35]

But rules of light and shadow, however enforced by practice, should have some general principle educed from, or countenanced [by] nature, the lap of truth and natural phenomena. Artificial phenomena can always be constrained [?countenanced] by some arrangement, works or theory, as midnight shadow or meridian glow;[36] or breadth of shade pass[ing] in [-to] breadth of light; or [as] Correggio amply *lights*, and round them brings gentle shades mingling. And tho the mechanical exactitude [of] the $\frac{1}{8}$ of light to shadow as in Rembrandt, or the more extended amplitude as in Rubens, [or] the concentrated light, as in the Notte of Correggio may be portioned out; without *this* combination and endless modification of tones and affinities, arriving [*sc.* deriving] from chiaroscuro, *through colors and colord lights and shades* [struck by T.], one produces breadth, [and] the use of the other, contrast. When would the labours of building up a theory for either *end*, but at the confines of shade and the

approach of $\begin{bmatrix}\text{light}\\\text{color}\end{bmatrix}$?

Color, the use of which aids, exalts, and in the union with lights and shadows, makes a whole *when harmonious* [struck by T.]; or debases, distracts breadth and produces glaring inconsistencies.

Colors are as primitives deductable [? from white light] in succession by the prism and the incidental ray of light; and tho qualities of sentiment have been attempted, they must be left with those who framed them; and it must be admitted that [although] such have regulated some theorists, and formed their characteristic systems of pure color and arrangements, still, upon further inquiry, it would be found that form contributed mostly to the character of each master, and color to that of the different schools. And of the practice of these sentiments of color, particularly in those who follow color as sentiment, such as glory: yellow; blue: duty; red: power, as primitives; authority: purple; green: servitude, as compounds; they must be left with those who framed them as emblematical concepts [?] and typical allusions.[37]

But as to tone or strength, comparatively *red* posesses the utmost power of attracting vision, it being the first ray of light and the first which acknowledges [?] the diminishing of light, tho it is a shade to yellow, as blue is to red. Thus far as [to] primitive strengths; and in arial [perspective] yellow would be medium, red material, blue distance. White in [the] prismatic order, [as] in the rainbow, is the union or compound [of] light, as daylight; while the commixture of our material *colors* becomes the opposite, darkness.

Light is therefore color, and shadow the privation of it by the removal of these rays of color, or subduction of power; and these are to be found throughout nature in the ruling principles of diurnal variations. The *crim-*

soned morn [struck by T. and 'grey dawn' substituted], the $\begin{bmatrix}\text{yellow morning}\\\text{golden}\end{bmatrix}$ sun rise and red departing ray, in ever changing combination, are constantly

found to be by subduction or inversion [?] of [the] rays or their tangents. These are the pure combinations [of] aerial colours; the dense material of white [the] *adventitious* or pictorial means, *the means* of the gradation of colours. Hence arises the quality of its force, and each becomes a light and [a] shadow of its own power, comparative to the means; and thence opens an immense field of combinations of the primitive and comparative. Thence it proceeds to the combinations of the dense material colour and the [pictorial] means [of expressing colour]. White [is] the substitute of light, as it is the compound in aerial light; the very inverse of colourable materials mixed produces strength or weakness, lightness or, [when] equal each to each, the destruction of colour: to one the tone of colour, [to the other], corruption of colour. The science of art and her combinations [is] coloring, not color. And here we are left by theory, and where we ought to be left, for the working of genius or the excercise of talent.

Here begins the ornamental style and the $\begin{bmatrix} \text{grave gay} \\ \text{severe} \end{bmatrix}$ [?] *the tone of Lombardy* [struck by T.]. The embrowned, the gloom, is [the] medium of the Dutch $\begin{bmatrix} \text{masters} \\ \text{school} \end{bmatrix}$; the glow, of the Venetian as to tone; the depth, of the Bolognese school [*margin*: character of each school]; and these tones are upon the same principles of nature, white being the light of the cold, yellow of the *embrowned* [struck by T.] warm scale. Thus the light of the St Pt Martyr is white to the breadth or key note, blue, [and is] widely diffused over the picture as clouds upon a clear sky, contrasted with dark umber trees. [The picture] has its deepest shadows with a deep blue, which serves as the breadth of shade, and low sunk horizon.

[In] the *Marriage of Cana* by Veronese, *white*, greys and a faint medium of the yellow, with a blue sky, for the breadths of the half-tints and the lights. The colors of the figures are its shadows by contrast, [and] collectively its breadth [is] pure; tho gay, [it is] full of power. And thus the St Mark, *so called* [struck by T.] by Tintoretto is buoyant by [the] apposition of forcible combinations, [just] as comparatively it is the lightest as to degrees of *force* and execution.

Thus likewise from the [][38] the golden light and embrowned medium, tho they are both nearer and [have a] stronger quality of approach to vision in this class of degrees of strength, [in] this, blue and white, or in the former, of aerial lights, yet they are constrained to become mediums or gradations, by blue in its comparative degree of parity of light and shadow. And shadow becomes black by posessing least [*sic*] reflexes than the other colours; yet these, following as to their comparative force with blue, would create gradation of force by the more forcible [colours]. They are the near tones of dark yellow, and dark are [*sic*] expelled. This, if I may be allowed, is the scale of its powers. This is the whirlwind that $\begin{bmatrix} \text{fluctuates on} \\ \text{sweeps} \end{bmatrix}$ the foreground, with the bright flash of polished steel and iron

armour, the compelling power of colors used as shade to light, that wrought the whole to harmony.

This power is in contrary distinction to the chiaroscuro of the Bolognese School, whose colors are primitives of light by contrast of shade, not only of their own, but by the medium of half tone. [It] is shadow by the medium of reflexes, thus producing concentration of colours and of lights by shade, while [?] in the former school, light by breadth appears *spread over the whole* (light by opposition of colors of bleak purity); [and] by color; that which in power becomes purities and degrees of their own, [in] force [is] considered as shadow effected.

Thus in the concentration of lights of Correggio, the white is this means. Thus the yellow is [?has] the scale of its tones from red to brown and blue; and hence those midnight shadows become toned or tinged with other primitives, or admitted pure as means of *contrasts*.

In the ornamental or the more widely diffused style of Rubens, we still find it as an auxiliary of light and power in contrast, [or] shade and force of colors as to shadows; and its broken or grey mediums keeping up the balance against the warm colors, and enabling him to use white as a color in scale, and [the] scale of the other combinations, [the] combination of lights never [or] seldom appearing as his object.

To these primitives, or arrangements to produce combinations of them, whether used separately by some and counteracted by others, or made to unite and harmonize by the united efforts of light and shade, and of shadows as to their powers, and by reflexes used respectively as colors as well as the light and shade of colors, there is another combination of colouring [to be added], viz. the union of the many to produce the general tone, perhaps better called the combination of colour, [and] sometimes called historic tone. The corruption of colors, in as much as the one is [the] means used, [or] sought for, [is] positively indefinable.

This tone denies to theory the least indulgence. It is here referred to inferences only of what may yet be done. Theory can only refer instruction to informers by what has been done; by some having been more fortunate in combinations of coloring than others. Thus the sepulchral darkness in the *Raising of Lazarus* by Domenichino [*sc*. Guercino]; the glowing [?] brown sepulchral darkness in the *Cruxifixion* of Tintoretto; [and] the lurid gloom of [?] the pale gleaming light of Rembrandt, upon the cross and dying Saviour, enwrapped with colored shade as indescribable in tone as evanescent twilight.

[In] the *Mount of Olives* by Correggio,[39] that immeasurable tone which pervades over 2 thirds of the picture; or the tone of the *Deluge* by Poussin, carrying along earth, perishable materials, under one lurid, watery, subjugated interval of light, that sets aside all comparative theory, however obtained; tho drawn from nature and her effects, these are the materials and instruments of [our] representations and our perceptions. 'Tis here that aerial perspective has her limits; and if theory dared to

stipulate for aerial hues, peculiar colors or tones of color, she would here step to self-destruction. It is here the utmost range of art that should tell. [The] imagination of the artist dwells *enthroned* in his own recess [and] must be incomprehensible as from darkness; and even words fall short of illustration, or become illusory of pictorial appreciations. Akenside terms it the high born soul [which] should not descend to any humble quarry. For amid

> *The various forms which this full world presents*
> *Like rivals to his choice, what human breast*
> *E'er doubts, before the transient and minute,*
> *To prize the vast, the stable, the sublime.*[40]

Nature and her effects are the materials offered to our pattern of imitation with the combinations of the science of art which we received [?]; which tho asserted in the commencement by theory, here fall far short of perception, and invention and practice, and the uppermost range of art. And in the science of color, if she were to stipulate for hues and tones of color beyond mechanical principles, she would step to self destruction; for recipes of color would but extend mediocrity, and such practice could but generate manner instead of style. Nature and her effects are every day offered to our choice of imitation, to be collated with the science of art, and united by theory to practical inference. [As to] rules, here, in the uppermost range of art, perception ventures not beyond mechanical principles. These are the double affinities by which every one works in his own way; but Sylla and Charybdis lie [?] in the path; the little more, or less; the ridiculous, or sublime. Recipes for coloring or [the] quantum of light and shade could but extend into mediocrity, and general practice into manner instead of purity of style.

D

SUPPLEMENTS TO LECTURES ON LIGHT AND SHADE, AND COLOUR (1827?)
BM Add. MS 46151 BB, ff. 66–9

Mr President, Gentlemen,

Colors as primitives are deductable in succession. First the red ray, yellow the second, blue third; compounds orange, green, purple. Strength of color, strength of light and prismatic order in constant and unalterable [?] succession. The tangents of [the] rays' invariable succession prove this. Just how decisive [?] the principles are becomes somewhat comparative to the means. Glass gives the colors by separating the rays, by refracting their colors in passing; the ⌈water Rainbow⌋ by refracting the incidental angle. Water gives back reflection of the incidental parallel collectively as the orb of the ⌈medium sun⌋ shorn of his beams; and the apex of vision reflects the

images while the colors are there received only by the crystalline medium on the prismatic formation; and, passing thro the aperture, the iris of the eye, gives by its dilation to strength each color of each ray passing off; and ⌈subtend in angles ⌊receiving [?] collectively, form and its reflection of color [are] absorbed. This admits strengths, and if so strengths of the color, or the means of strength in a pictorial [?] sense. It is necessary to draw some scale of comparison, not only to know their respective powers, but [also as] means, as concording or offering [?] ⌈. . . [illeg. word] ⌊means of representation. If considered as colored rays in succession [?], the first primitives would give the secondary reflections, or refractions of them [?]: water the reflection, air the refractions. Take the cycloid of light: the prismatics give colored light [to] objects in shade; the opposite in light; and its cord [?] of refracted colored [light] by the reflection of that ray is refracted to us. The compounds [are] the right angle of this ray, the cold compounds opposed to warm [?primaries] in comparison: Blue [?yellow] and purple, orange and green. The remaining intermediates of the cycloid [?are red and blue]. Green [is] the weakest of the direct rays, yet strongest of refracted compounds, and in the rainbow disputes the ray and place of the primitive blue; but [at?] the approach of purple and yellow, the immediate follower of the strongest ray as to power, red, [it?] affiliates with it or renders them into another class: warm to the cold scale:

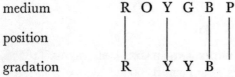

red–yellow
orange green *red* [struck] blue *yellow* [struck] purple
as to strengths comparative
color as to strengths relative
as to strengths positive

medium R O Y G B P

position

gradation R Y Y B

The two diagrams [page 115] pertain to colour. One may be considered as the material, the other that of light by position only. Suppose the yellow triangle light, red and blue shade; and hence we have grey morning, the yellow midday and crimson evening. Throw [?] the multiples of light into combinations [and] they are still colors incorruptible, yet [when] commixt [make] white. The other [shows] the principles of color by positions [*sic*].[41] Sink the yellow until it light into the red and blue, and hence two only: light and shadow, day and night; or gradation light and ⌈shade ⌊dark. Hence their combination and multiples in inverse ratio as concordates, only reciprocal as primitives in apposition: light and darkness. In combinations relative [they make] infinite and definite compounds: yellow: orange;

red: purple; blue: green. Multiples equal greys, greens, browns *black* [struck] neutrals. Multiplication [equals] black.

Mr P Gentlemen,

Light and Shade its theory inculcated by dividing the principles or cause of shade into day light, the solar light and artificial; [and] produces one class of gradation for each. As to the ratio of them, respectively proportionate or comparative, [it is] infinite. But in search of gradation or aerial perspective, the sole cause tho [*sic*. ?through] the originating cause of *all* the different [?] appearances and classes of proportionate relief *caused*. Their effects proceed thro secondary causes, intervention [?] and refrangibility; interception the cause of shade; and [the] cause of refraction without this class: the refrangibility of the sun's rays, stands as day light with *it*. Light not as the cause but the effect: shade and reflection; hence another source of gradation: light primitive, light secondary and therefore common light and shade. Divested of all its comprehensive theory, *combinations* would supply a class of proportion, strength, power and quality, which strength power and quality found to exist in the tripartite qualities of each light, we will for the present leave for the class *proportion*, and infer that possibly they possess the more extended class of gradation. Therefore proportionate gradation of common and unmixed theoretical inductions would be: first, light; reflections, second; shade, third; shadow fourth. Proportionate these with the cause, the shadow will stand as the fifth. Call in reflection, it is further removed; and by refrangibility wholly dissipated. Reflection of polished surfaces gives a change of proportion, as first the cause, second reflected the effect of [the] cause and two lights. In the next scale: first reflection, second shade, third shadow; [and] fourth would stand as shadow singly in its scale of pro-
portion ⌊to the first class in this class the refracted reflection being [?] narrowed but more luminous; and shade there increased becomes the spheriod of reflexes on which is reflected. Light by refraction, reflection of the light, shade and shadow. These reflexes and reflections are here again gradation in mass, reflection, and by concentration, *light*. Now these are the more proportionate quantities of divergency, or *light*; and, ignoring mostly [?] after the occupation of space, by one, [we] shall find that the occupation gives gradation, extent rectilinear, proportion, comparative proportion, keeping vision distant comparatively out of the question. For admit *it* but once and rectilinear flies from us even as an instructor; and instead of relying upon theory for line to class gradation of space relatively, [we] should get immediately into combinations of quality with quantity, and say that if the area of one quality of light is equal to the area of another quality of light, these quantities would be equal, and of course [so would the] shadows. In those by the angle of inclination as 90, the shade is only 78 degrees 45 min. 1.5

part of the object $67 = 30 = 2.5$ ⌊the $+ 56, 15 = 7.10m$ 45 the altitude of the

object 33.45 *once* the length of the object and a *half* 22,30 *twice* the length and 4.9m 11.15 five times the length of the *object*, beyond it stretches for infinitude. These are mensurations of altitude, and would be equal, but to conclude that the qualities are equal to the light *of a conflagration* [struck] measures [?] without considering the area of space which would *exceed the sun* [struck] [and] affirm all the elementary principles of the solar rays, or the moon's, [which] if not classed to [be] reflections, must by the parallelogram of rays be equal as to quantity and quality. Rectilinear adduced, angular must follow, which inculcates gradation by position relatively, [then] proportionately follows and becomes aerial perspective; and by quantities only would become inducted by the lines which are their spaces, were we to apply even inverse theory of vision compulsorily. Therefore [as] to proportion relatively [it] becomes theoretically [?] with light shade or reflection, according to known data. As, [for example], placing the diagram of vision [so] that a globe placed to certain angles will cover, hide [?] or make the same proportion 4 times another, placed 4 times the said distance from the eye. Work these theories [of] vision light and shade together by transposition positive or inverse; the like ratio of results [?] ensues. Take the lines which [in] the qualities of light are defined generally as parallel, the sun shadows, artificially those which are increased [and] proportion still follows, tho the quantities are different [and] the ratio of proportion contrary each to each respectively. Place these to vision, they become inverse and transposed and adverse. Take these severally and multiply them by their secondary inductions reflections; and if we have not enough combinations, add refractions; and as in the case of polished surfaces, compound refractions. These are means conjunctively or abstractedly, and if we must call them rules, we must call them so comparatively, with those principles which are derived from known causes likewise, but which are only brought to boundaries [?] by inferences from mediums simple, transparent, and, [if] we lack further complexity, translucent.

Appendix III

A NOTE ON REFLEXES AND ENGLISH LANDSCAPE (*c.* 1810?)
BM Add. MS 46151 CC

Among the mutable and infinite contrasts of light and shade, none is so difficult either to define or [to make] deductable [*sic.*] to common vision as reflexes. They enter into every effect in nature, oppose even themselves in theory, and evade every attempt to reduce them to anything like rule or practicality. What seems one day to be equally governed by one cause is destroyed the next by a different atmosphere. In our variable climate, where [all] the seasons are recognizable in one day, where all the vapoury turbulance involves the face of things, where nature seems to sport in all her dignity and [*sic*] dispensing incidents for the artist's study and deep revealing [?] more than any other; and if the human mind, according to the opinion of an eminent writer (Cumberland: Spanish Painters) [42] is like vegetables [?] [in] that it requires that mild degree of warmth that inspires without creating langour, and sufficient cold to clear the mind and check redundance, how happily is the landscape painter situated, how roused by every change of nature in every moment, that allows no langour even in her effects which she places before him, and demands most peremptorily every moment his admiration and investigation, to store his mind with every change of time and place. And, as the exertions of the higher department of our arts have most completely refuted the long admitted axioms of Winckelmann and Mirabeau [*sc.* Montesquieu or Dubos] about our northern climate [43] [so] that we may not be blind to [the] abundant advantages which nature has given us, but that we may prove her superiority [?] even in a northern line of demarcation of genius, not in theoretical speculations, but [in] practical exertions.

As it is my pride that these should be English lectures, it is natural that they should speak of English effects; and if the Italian masters are but slightly recalled [?] of it is not to follow they are to be lightly thought of in our pursuits. On the contrary, what they have done are [*sic*] to be duly weighed in our estimation, as far as contrast to ours; and the charms of Claude and all that learned Poussin drew is to [be] rated [?] without prejudice, and to be considered as [to] the truth of the climate they wished to delineate. And to the calm serene atmospheric tints of the former let us contrast the sombre majesty of the latter, and if the expression can be admissible, say that the forms [?] of Nicholas and Gaspar may be extremely appropriate to the English effects of an Italian composition of landscape. In the Pyramus & Thisbe and Dido and Eneas [44] they were indebted to

213

clouds of a northern atmosphere. The chace of Claude[45] must be classed as purely Italian (and we must conclude from the few attempts of clouded skies that he has left us to judge from, viz. the Descent of Aeneas [?][46] or the Burning of the Trojan Ships,[47] that either [*sic.*] he was incapable of that degree of sublimity so forcibly depicted by Salvator Rosa). The dignity of Nicholas [?] or the awful interest [?] [*much of the rest of this passage is obscured by a stain*] different powers was [] from different perceptions [] same effects or places. We [ought should] not lament but be pleased we have what they have done before us to judge of, select and guide us to esteem properly the advantages we have in following them and it is only that we can be inferior to them by weaker exertions or weaker interests. They have provided what they saw to be practicable in their atmosphere, and we should prove what is so in ours. An endless variety is on our side and opens a new field of novelty, if we use the deep instructing tool of Salvator, the higher style of Poussin or the milder [?] solar of Claude, the soil is British and so should be the harvest [*alternatively* 'and the harvest such'].

Check-list of books owned or quoted by Turner and used in these studies*

Titles in [square brackets] refer to works
probably but not certainly known to Turner.

ADAMS, G. *Geometrical and Graphical Essays* 2nd ed. 1797
[*An Essay on Vision*. 1789]
[*Lectures on Natural and Experimental Philosophy* 2nd ed. 1799]

AGLIONBY, W. *Painting Illustrated in Three Dialogues* 1685

AKENSIDE, M. 'Hymn to the Naiads', and 'The Pleasures of Imagination', in
R. ANDERSON, *A Complete Edition of the Poets of Great Britain* 1792–5, Vol. IX

ALGAROTTI, F. *An Essay on Painting* 1764

ANDERSON, R. *A Complete Edition of the Poets of Great Britain* 1792–5

APPOLLONIUS RHODIUS *Argonautics* trans. Fawkes, in Anderson, XIII
The Artist's Assistant in the Study and Practice of the Mechanical Sciences n.d.

BARBARO, D. *Della Perspettiva* 1568

BARRY, J. *The Works of James Barry* 1809

Bible, The Holy

BLAIR, H. *Lectures on Rhetoric and Belles Lettres* 1783

BREWSTER, SIR D. [*A Treatise on the Kaleidoscope*. 1819]
[*A Treatise on Optics*. 1831]

CALIMACCHUS, *Hymn to Apollo* trans. Pitt, in Anderson, VIII
[*Hymns*, trans. Dodds. 1755]

CUMBERLAND, R. *Anecdotes of Eminent Painters in Spain* 1782

DAYES, E. *The Works of the Late Edward Dayes* ed. Brayley 1805

DIBDIN, T. [*Melodrame Mad! or The Seige of Troy* 1819]

DUBREUIL, J. *The Practice of Perspective, written . . . by a Jesuit of Paris*
trans. Chambers 1726

The Examiner January 1809

FELIBIEN, A. *Seven Conferences on Painting* 1740

FIELD, G. *Chromatography* 1835
Outlines of Analogical Philosophy 1839

FRESNOY, C.A.DU *De Arte Graphica*, in Sir J.Reynolds, *The Works* ed. Malone.
1797 (2nd ed. 1798)

FUSELI, H. [*Lectures on Painting* 1801; 2nd series, ed. Knowles. 1830]

GOETHE, J.W.VON *Theory of Colours* trans. Eastlake. 1840

GOLDSMITH, O. *The Roman History* 1769

HALL, S.C. (ed.) *The Book of Gems* 1838

HAMILTON, J. *Stereography* 1738

HARRIS, M. [*The Natural System of Colours* 2nd ed. 1811]

HAYTER, C. *An Introduction to Perspective, Drawing and Painting* 2nd ed. 1815

* For a general list of Turner's library, B. Falk, *Turner the Painter*, 1938, pp. 255–9.

HESIOD *Theogony*, trans. Cooke, in Anderson, XIII

HOMER *Odyssey* trans. Pope, in Anderson, XII

JUNIUS, F. *The Painting of the Ancients* 1638

KIRBY, J. *Dr Brook Taylor's Method of Perspective made Easy* 3rd ed. 1768

KNIGHT, R.P. *An Analytical Inquiry into the Principles of Taste* 1805

LAMY, B. *Perspective made Easie* 1710

LANDSEER, J. *Lectures on the Art of Engraving*, 1807

LAIRESSE, G. *The Art of Painting* trans. Fritsch, 1738 (2nd ed. 1776)

LOMAZZO, G.P. *A Tracte Containing the Artes of Curious Paintinge, Carvinge & Buildinge* trans. Haydocke, 1598

MACQUER, P.J. *Elements of the Theory and Practice of Chymistry* 1764

MALTON, T. the elder *A Complete Treatise on Perspective* 1775 (2nd ed. 1778)

MALTON, T. the younger *Picturesque Tour through the Cities of London & Westminster* 1792

MENGS, A.R. *The Works of Anthony Raphael Mengs* 1796

MILTON, J. *Paradise Lost*, in Anderson, V

NEWTON, SIR I. [*Opticks*, 1704]

O'BRIEN, C. *The British Manufacturer's Companion & Callico Printer's Assistant* 1795

OPIE, J. *Lectures on Painting* 1809

PILES, R.DE *Principles of Painting* 1743

PILKINGTON, M. *Dictionary of Painters* 1770 (New ed. revised Fuseli, 1805)

PRICE, U. [*Essays* 1810]

PRIESTLEY, J. *History & Present State of Discoveries Relating to Vision, Light & Colours* 1772

Quarterly Review IV 1810

REYNOLDS, SIR J. *The Works* ed. Malone, 1797 (2nd ed. 1798)

RICHARDSON, J. *Works* 1792

ROGERS, S. *Poems* 1834

SALMON, W. *Polygraphice* 3rd ed. 1675

SENEFELDER, A. *A Complete Course of Lithography* 1819

SHAKESPEARE, W. *The Merchant of Venice*

SHEE, M.A. *Elements of Art* 1809

SHELLEY, P.B. *Lines written among the Eugenean Hills*, as 'Venice' in Hall, *Book of Gems*
[*Prometheus Unbound*]
[*Queen Mab*]

SOANE, SIR J. *Sketches in Architecture* 1793

SOMERVILLE, M. *Mechanism of the Heavens* 1831
'On the Magnetising Powers of the More Refrangible Solar Rays', *Philosophical Transactions* 1829

STUART, J. & REVETT, N. *Antiquities of Athens* I, 1767; II, 1787

THOMSON, J. *The Seasons* in Anderson, IX

WEBB, D. *An Enquiry into the Beauties of Painting* 1760

VITELLIO, *Vitellionis Mathematici . . . quam vulgo Perspectivam vocant* 1535

Check-list of biographical sources
used in these studies*

Academy of S.Luke, Rome, MS. *Congregazioni* 59, 1819

Ackerman's New Drawing Book of Light & Shadow 1809

ANDERDON, J.H. MS. notes in Extra-Illustrated sets of R.A. Catalogues
British Museum Print Room & Royal Academy Library

ARMSTRONG, SIR W. *Turner* 1902

Arnold's Magazine of the Fine Arts III 1833–4

Athenaeum 1851, p. 1383 [?P.Cunningham]

BELL, C.F. *The Exhibited Works of J.M.W.Turner* 1901
MS. notes in *ib.*, Victoria & Albert Museum Library
'Turner & His Engravers', in *The Genius of Turner* ed. Holmes. 1903
'The Oxford Almanacks' *Art Journal* LXVI 1904
MS. notes in A.J.Finberg *A Complete Inventory of Drawings in the Turner Bequest* 1909. British Museum Print Room
MS. notes in A.J.Finberg *Life of J.M.W.Turner* 1939
Victoria & Albert Museum Library
& GIRTIN, T. 'Drawings & Sketches by J.R.Cozens' *Walpole Society* XXIII 1934–5

BONACINA, L.C.W. 'Turner's Portrayal of Weather' *Quarterly Journal of the Royal Metereological Society* LXIV 1938
'Landscape Metereology in Art and Literature' *ib.* LXV 1939

BURNET, J. *Turner and His Works* 1852
'Autobiography' *Art Journal* XII 1850
Art Journal XIV 1852, p. 47

CALLOW, W. *An Autobiography* ed. Cundall 1908

COLE, H. MS. *Diary* Victoria & Albert Museum Library

COLT HOARE, R. *The History of Modern Wiltshire* I. 1822

CONSTABLE, J. *Correspondence* ed. Beckett. 1962–8

CONSTABLE, W. G. *Richard Wilson* 1954

COODE, C. E. 'Turner's First Patron' *Art Journal* 1901

COOPER, T. S. *My Life* 1890

CROFT-MURRAY, E. 'J. Henderson' *British Museum Quarterly* X 1935–6

CUNNINGHAM, A. *Life of Sir David Wilkie* 1843

CUST, L. 'The Portraits of J.M.W.Turner' *Magazine of Art* 1895

DAYES, E. *The Works of the Late Edward Dayes* ed. Brayley, 1805

DELACROIX, E. *Journal*

Diario di Roma 17 Dec. 1828

EASTLAKE, C.L. *Contributions to the Literature of the Fine Arts* 2nd series, 1870

* This list refers only to works with some biographical information. More general bibliographies are in Thieme-Becker, *Allgemeines Lexikon der Bildenden Künstler* XXXIII; A.J. Finberg *Life of J.M.W.Turner R.A.* 2nd ed. 1961; L. Gowing, *Turner: Imagination and Reality* 1966.

EASTLAKE, ELIZABETH, LADY, *The Life of Gibson* 1870
 Journals & Correspondence 1895
 Quarterly Review XCVIII 1856

ERDMAN, D. *Blake, Prophet against Empire* 1954

FALK, B. *Turner the Painter: His Hidden Life* 1938

FARINGTON, J. *Diary* ed. Grieg. 1922–8. Also typescript in British Museum Print Room

FAWKES, L.G. Letter to D.S.MacColl, 23 July 1910 (R.MacColl Coll.)

[FELTHAM, J.] *The Picture of London for 1805*

FERET, C.J. *Isle of Thanet Gazette* 23 Sept. 1916

FIELDING, T.H. *On Painting in Oil & Water Colours for Landscape and Portraits* 1839

FINBERG, A.J. *A Complete Inventory of Drawings in the Turner Bequest* 1909
 The History of Turner's Liber Studiorum 1924
 The Life of J.M.W.Turner, R.A. 2nd ed. 1961
 Introduction to Turner's Southern Coast 1929

FINBERG, H.F. 'With Mr Turner in 1797' *Burlington Magazine* XCIX 1957

FRITH, W.P. *My Autobiography & Reminiscences* 1887

GAGE, J. 'Turner and The Society of Arts' *Journal of the Royal Society of Arts* 1963
 'Magilphs and Mysteries' *Apollo* 1964
 'Turner and the Picturesque' *Burlington Magazine* CVII 1965
 'Turner's Academic Friendships: C.L.Eastlake, *Burlington Magazine* CX 1968

GILCHRIST, A. *Life of William Etty, R.A.* 1855

GIRTIN, T. & LOSHAK, D. *The Art of Thomas Girtin* 1954

GOODALL, F. *Reminiscences* 1902

GOTCH, R.B. *Maria, Lady Calcott* 1937

GOWING, L. *Turner: Imagination and Reality* 1966

GRAY, R.D. 'J.M.W.Turner and Goethe's Colour Theory' *German Studies presented to W.H.Bruford* 1962

HAMERTON, P.G. *Life of J.M.W.Turner* 1895

HANSON, N.W. 'Some Painting Materials of J.M.W.Turner' *Studies in Conservation* 1954

HART, S. *Reminiscences* 1882

HOBHOUSE, J.C. (Lord Broughton) *Recollections of a Long Life* 1910

HOLMES, SIR C. (ed.) *The Genius of Turner* 1903

HORSLEY, J.C. *Recollections of a Royal Academician* ed. Helps. 1903

HOWARD, F. *The Sketcher's Manual* 1837
 Colour as a Means of Art 1838

HUISH, M.B. *The Seine and the Loire* 1890

JONES, G. MS. *Recollections* Oxford, Ashmolean Museum

KOCH, J.A. *Moderne Kunstchronik* 1834

LAING, D. *Etchings by Sir David Wilkie* 1875

LAWRENCE, SIR T. Letter to Canova, Feb. 23 1820. Bassano, Museo Civico, MSS. Canoviani, V, 550, 3610

LEITCH, W.L. 'The Early History of Turner's Yorkshire Drawings' *Athenaeum* 1894

LESLIE, C.R. *Autobiographical Recollections* 1860
 Handbook for Young Painters 1855

LESLIE, G.D. *The Inner Life of the Royal Academy* 1914

LINDSAY, J. *J.M.W.Turner, His Life and Work: A Critical Biography* 1966
 The Sunset Ship. Poems by J.M.W.Turner 1966

MACCOLL, D.S. 'Turner's Lectures at the Academy' *Burlington Magazine* XII 1908
 National Gallery. Turner Collection 1920

MACGEORGE, A. *W.L.Leitch. A Memoir* 1884

M.I.H. *The Builder* XV. 1857

MILLAIS, J.G. *Life and Letters of Sir John Millais, P.R.A.* 1902

MILLER, T. *Turner and Girtin's Picturesque Tours Sixty Years Since* 1854

MOORE, T. *Memoirs, Journal and Correspondence* ed. Russell. 1853–6
 Letters ed. Dowden. 1964

MONKHOUSE, C. *Turner* 1929
 'J.M.W.Turner' *Dictionary of National Biography*
 The Earlier English Water-Colour Painters 1890

Morning Herald Jan.–Feb. 1818

NOBLE, L. *The Course of Empire* 1853

OPPÉ, A.P. *Alexander and John Robert Cozens* 1952
 'Talented Amateurs: Julia Gordon and her Circle' *Country Life* LXXXVI 1939

PERCY, DR J. MS. notes to Catalogue of his Drawings, British Museum Print Room

PYE, J. AND ROGET, J.L. *Notes & Memoranda respecting Turner's Liber Studiorum* 1879

[PYNE, W.H.] *Somerset House Gazette* 8 Nov. 1823

RAWLINSON, W.G. *Turner's Liber Studiorum* 2nd ed. 1906
 The Engraved Works of J.M.W.Turner 1908–13

REDDING, C. *Past Celebrities Whom I Have Known* 1866
 'The Late J.M.W.Turner' *Fraser's Magazine* XLV 1852

REDGRAVE, S. & R. *A Century of Painters* ed. Todd, 1947

REEVE, L. *Literary Gazette* 27 Dec. 1851

REINAGLE, R.R. in J.M.W.Turner *Views in Sussex* 1819

Report of the Commissioners . . . on the Royal Academy 1863

RICHMOND, G. *The Richmond Papers* ed. Stirling. 1926

ROGERS, S. *Table Talk* ed. Bishop. 1952

ROGET, J.L. *A History of the Old Water-Colour Society* 1891

Royal Academy, MS. *Minutes of Council, 1800–51*

RUSKIN, J. *Works* ed. Cook & Wedderburn, 1903–12
 Diaries ed. Evans, 1956
 Letters to Charles Elliot Norton 1905

SANDBY, W. *The History of the Royal Academy of Arts* 1862

SCOTT, W.B. *Autobiographical Notes* ed. Minto, 1892
 Memoir of David Scott 1850

SCHETKY, S.F.L. *Ninety Years of Work & Play* 1877

SOANE, SIR J. *Diary* Typescript in Sir J.Soane's Museum
 Lectures on Architecture, ed. Bolton, 1929

SOANE, MRS *Diary* Typescript in Sir J.Soane's Museum

Society of Arts *Transactions* XXII 1804

SOMERVILLE, M. *Personal Recollections of Mary Somerville* 1873

STILLMAN, W.J. *Autobiography of a Journalist* 1901

STORY, A.T. *James Holmes and John Varley* 1894

THORNBURY, W. *Life and Correspondence of J.M.W.Turner* 2nd ed. 1904

TURNER, F. *The History and Antiquities of Brentford* 1922

TURNER, J.M.W. MSS. in British Museum, National Library of Scotland; Fitz-william Museum, Cambridge; C.W.M.Turner Coll.

TWINING, H. *On the Philosophy of Painting* 1849

WEBBER, B. *James Orrock, R.I.* 1903

WORNUM, R. *The Turner Gallery* 1872

WHITLEY, W.T. *Notes on Artists* (The Whitley Papers) British Museum Print Room
Artists and Their Friends in England 1700–1799 1928
Art in England, 1800–1820 1928
Art in England, 1821–1837 1930
'Relics of Turner', *Connoisseur* LXXXVIII 1931
'Turner as a Lecturer' *Burlington Magazine* XXII 1913

ZIFF, J. ' "Backgrounds, Introduction of Architecture and Landscape" A Lecture by J.M.W.Turner' *Journal of the Warburg and Courtauld Institutes* XXVI 1963
'Copies of Claudes Paintings in the Sketchbooks of J.M.W.Turner' *Gazette des Beaux Arts* 1965
'Turner and Poussin', *Burlington Magazine* CV 1963
'J.M.W.Turner on Poetry and Painting' *Studies in Romanticism* III 1964

Notes to Introduction

1 R.de Piles, *Dialogue sur le Coloris* (1672), pp. 50–1, *cit*. B.Teyssdère, *Roger de Piles et les debats sur le coloris au siècle de Louis* XIV, 1965, p. 194, n. 3. DePiles had to some extent been anticipated by LeBlond de la Tour in 1669 (*ib.* p. 69, n. 3). The idea was publicized widely in the eighteenth century by G.Lairesse, *The Art of Painting*, tr. Fritsch, 1738, p. 155; also L-B.Castel, *L'Optique des Couleurs*, 1740, pp. 21–2; P.H.Valenciennes, *Elémens de Perspective Practique*, an VIII (1800), pp. 402–3.

2 J-F-L.Merimée, *De la Peinture à l'Huile*, 1830, pp. 291–2; *trans*. Sarsfield Taylor, 1839, pp. 263–4. *Cf.* also E.Chevreul in *Mémoires de l'Académie des Sciences*, XI, Paris, 1828, p. 518.

3 C.Blanc, *Grammaire des Arts du Dessin* (1867), *cit*. W.I.Homer, *Seurat and the Science of Painting*, 1964, pp. 17, 29. This optimism was taken up even more radically by Seurat: 'If, with the experience of art, I have been able to find scientifically the law of pictorial colour, can I not discover an equally logical, scientific and pictorial system to compose harmoniously the lines of a picture, just as I compose its colours?' (J.Rewald, *Post Impressionism*, 1956, p. 99.)

4 J.Tripier Le Franc, *Histoire du Baron Gros*, 1880, p. 603; N.Pevsner, *Academies of Art*, 1940, p. 216 (for David). Complaints about the lack of painting instruction were general in France (Teyssdère, *op. cit.* p. 162; Pevsner, *op. cit.* p. 168; J.Loquin, *La Peinture d'Histoire en France de 1747 à 1785*, 1912, pp. 81–2, 110–11); in Germany (F.Schlegel, *Sämmtliche Werke*, VI, 1846, p. 165), where, however, there seems to have been a painting class at the Weimar Drawing School from the 1770s, when Goethe was a pupil (*Schriften der Goethegesellschaft*, 43, 1930, pp. 20, 22); in Italy (S.Ticozzi in G.B.Armenini, *Dei Veri Precetti della Pittura*, 1820, pp. xxx–xxv, 108–9), where, however, Canova, who was a painter as well as a sculptor, also advo-

cated painting from the earliest years (M.Missirini, *Della Vita di Canova*, 1824, p. 322).

5 Reynolds, *Discourse*, II; Note XI to Du Fresnoy; West, in *Letters & Papers of J.S.Copley and Henry Pelham*, 1914, pp. 118–19. Isolated examples of painting in the Life School have been noticed (S.C.Hutchison, *The History of the Royal Academy*, 1968, p. 86; but *cf.* p. 111) but there was no *teaching* as such. In 1802 it was already said of the RA: '*A good school for colouring* they still want, and it has been recommended to them to purchase a collection of pictures, to which the students might resort, and compare their own productions with those of the great masters' (J.Feltham, *The Picture of London for 1802*, p. 236). The British Institution had offered loan exhibitions for copying since 1807 (T.Smith, *Recollections of the British Institution*, 1860, p. 40). There were already such facilities in Cassel, Düsseldorf, Berlin, Madrid and the Paris *École des Élèves Protegés* in the eighteenth century (Pevsner, *op. cit.* pp. 168, n. 176–7; J.Held in *Münchener Jahrbuch d. Bild. Kunst* XVII, 1966, p. 221 n. 14). For the RA in 1815, J.Farington, *Diary* (unpublished typescript in BM Print Room), 1 Dec. 1815; A.J.Finberg, *Life of J.M.W.Turner* RA, 2nd ed. 1961, p. 231.

6 *Cf.* Leonardo's remarks in *Treatise on Painting*, trans. and ed. McMahon, 1956, esp. §§180, 182; 108, 110, which seems to go back to L.B.Alberti *Della Pittura* (ed. Mallé, 1950, p. 99). On Leonardo's approach generally: J.Shearman, 'Leonardo's Colour and Chiaroscuro', *Zeitschrift f. Kunstgeschichte*, 25, 1962.

7 *On Colours*, 793 b., *trans*. Hett, Loeb ed. 1936, pp. 16–7. *Cf.* also Plato, *Timaeus*, 67 D, E; 68 A, B, C, D.

8 *De Sensu et Sensili*, Ch. IV, 442 a. C.B. Boyer, *The Rainbow. From Myth to Mathematics*, 1959, p. 48.

9 C.L.Eastlake in J.W.vonGoethe, *Theory of Colours*, 1840 (re-issue 1967), pp. 385–6 n. also Alberti, *op. cit.* p. 63; A.Filarete, *Treatise on Architecture*, trans. Spencer, 1965, II, p. 310.

10 C.Parkhurst, 'Aquilonius' Optics and Rubens' Colour', *Nederlands Kunst-Historisch Jaarboek*, XII, 1961. Rubens' own treatise, *De Lumine et Colore*, is probably that mentioned in a letter of Lullier to Peiresc of June 1635 (*Correspondence de Rubens*, ed. Rooses & Reulens, VI, 1909, p. 112). Rubens himself refers to it in a letter to Peiresc of the following March (*ib.* p. 155); and it was possibly the 'osservationi di ottica' mentioned by Bellori (*Le Vite ... 1672*, p. 247). A treatise 'sur les lumières et les ombres' was among the Rubens MSS owned by DePiles, and presumably burned in 1720 (Teyssdère, *op. cit.* pp. 218–19); but a version entitled *De Lumine et Colore* was last recorded in the hands of Rubens' descendant, Van Parys, about 1790 (Merimée, 1830, *op. cit.* p. 270). For Rubens' reputation as a theorist in the eighteenth and nineteenth centuries, see below, pp. 62–4.

11 Pliny, *Historie of the World*, trans. P.Holland, 1601, II, pp. 531–2. Turner's notes: British Museum, Add. MS 46151, BB, f. 23 ff.

12 Opposition to Pliny: H.Davy, 'Some Experiments and Observations on the Colours used in Painting by the Ancients', *Philosophical Transactions of the Royal Society*, CV, 1815, pp. 122–3; M.Calcott, *Essays towards the History of Painting*, 1836, pp. 230–4. For the three-colour interpretation in England: C.Hayter, *A New Practical Treatise on the Three Primitive Colours ... 1826*, pp. 14–15; B.R.Haydon, *Autobiography & Memoirs*, ed. Taylor, 1926, I, p. 395; *Lectures on Painting and Design*, 1844, pp. 249–53. In France, the earliest reference to the 'simple and primitive' nature of the four colours so far traced is in the anonymous *Histoire de la Peinture Ancienne extraite de L'Histoire Naturelle de Pline, Livre XXXV*, London, 1725, p. 44. J.N.Paillot de Montabert, a pupil of David, assumed like Hayter that they were the three primaries plus black (*Traité Complet de la Peinture*, 1829, II, pp. 245–6;

VII, pp. 367–8). M.E.Chevreul, like Haydon, thought that these colours, to which he added white, could be managed so as to produce the whole spectrum by simultaneous contrast (*The Principles of Harmony and Contrast of Colours*, trans. Martel, 1854, §342). A pupil of Ingres, J.C.Ziegler, who knew Chevreul's work, gave white instead of black as the fourth colour (*Traité de la Couleur et de la Lumière*, 1852, p. 15).

13 M.Harris. *The Natural System of Colours*, n.d. (re-issue 1963). Sarsfield Taylor's date of 1766 (Merimée, *op. cit.* 1839, p. 349) has generally been accepted; but on p. xxx it is given as 1776, the year in which the circle appeared in Harris' *Exposition of English Insects* (*cf.* pp. iv–viii). It cannot be earlier than 1769, since it is dedicated to Sir Joshua Reynolds, who was knighted in that year. Ignaz Schiffermüller, *Versuch eines Farbensystems*, 1772, *cf.* pp. 1–3, and Schiffermüller & Denis, *Systematisches Verzeichniss der Schmetterlinge der Wiener Gegend ... 1776*, pp. 37–9 for the origins of the circle.

14 Darwin, 'On the Ocular Spectra of Light and Colours', *Phil. Trans.*, LXXVI, 1786, repr. in E.Darwin, *Zoonomia*, 2nd ed. 1796, I, p. 568. Rumford: 'An Account of Some Experiments on Coloured Shadows' (1794) repr. in Rumford, *Philosophical Papers*, I, 1802, pp. 319–32. The paper was the basis of 'Conjectures respecting the Principles of the Harmony of Colours' (*ib.* pp. 333–40) in which he made specific recommendations for painters.

15 Goethe, *Zur Farbenlehre, Didaktischer Teil*, 1810, §§805–9, and Tafel, I, fig. 1; P.O.Runge, *Farbenkugel*, 1810, Anhang; A.Schopenhauer, *Uber das Sehn und die Farben*, 1816, §5; Merimée, 1830, pp. 289–90 (1839, pp. 261–2). Delacroix in L.Johnson, *Delacroix*, 1963, p. 56, pl. 34; also pp. 63 ff. His circle of *c.* 1839 is not copied from Chevreul (who in his early work did not support the idea of the harmony of complementaries: *Mémoires, cit.* pp. 476, 510–11), but probably done from memory; a written note on complementaries (Johnson, pp. 64, 69) of *c.* 1834 does not seem necessarily based on Chevreul, although the first general pub-

lication of Chevreul's work seems to date from that year ('Des Contrastes dans les Couleurs', *Le Magasin Pittoresque*, II, 1834, pp. 90–1, 98–9). I am grateful to Dr Lee Johnson and Dr Robert Ratcliffe for much information. In England as early as 1803 Isaac Milner stated that Humphrey Repton ('the gentleman who consulted me on this subject of shadows') 'has been accustomed, for a long time, to assist his memory when he is painting by the use of the … simple diagram (of the complementary colour circle)'; H.Repton, *Observations on the Theory and Practice of Landscape Gardening*, 1803, p. 218. Also, in general, G.E.Finley, 'Turner: An early Experiment with Colour Theory', *Journal of the Warburg and Courtauld Institutes*, XXX, 1967, pp. 357–66, with, however, severe reservations on the subject of Turner (see below, p. 250, n. 189). C.Hayter, *An Introduction to Perspective, Drawing and Painting*, 2nd ed. 1815, esp. pp. 162–3. G.Field, *Chromatography*, 1835, ch. III; *Chromatics*, 2nd ed. 1845, esp. pp. 61–2.

16 J.Barry, *Works*, 1809, I, pp. 524–6; E.Dayes, *Works*, ed. Brayley, 1805, p. 299; A.R.Mengs, *Works*, II, 1796, pp. 134–5.

17 Sir I.Newton *Opticks* (1704), Bk. I, Pt. II, Prop. III, Prob. i, expt. 7; Bk. II, Pt. III, Prop. XVI; Bk. III, Pt. I, Qu. 14.

18 One of Turner's most constant texts, C.DuFresnoy's *De Arte Graphica* (1668) was the first to take over the musical terms 'harmony' and 'chromatic' to describe colour (ll. 80, 256). The early development of the transference has been discussed by B.Teyssdère, 'Peinture et Musique: La Notion d'Harmonie des Couleurs au XVIIe Siècle Français' in *Stil und Uberlieferung in der Kunst des Abendlandes*: (Akten des 2. Internationalen Kongresses f. Kunstgeschichte Bonn. 1964), 1967, III, pp. 207 ff. The idea goes back to Aristotle (*De Sensu* … III, 439b–440a), who provided, however, the basis of a tonal, not a chromatic system. The eighteenth- and nineteenth-century developments of the conception will be treated in a forthcoming book: *Art and Action: Goethe and Romantic Painting*.

19 West and Raphael: Farington, *Diary*, March 24, 1804 (unpubl.); 13 Dec. 1817 (misdated by J.Grieg, *The Farington Diary*, VIII, 1928, p. 154); C.R.Leslie, *Autobiographical Recollections*, I, 1860, pp. 57–8. West may have conceived the rainbow theory as early as the 1770s, as it appears in relation to Vandyck in a letter of his pupil Copley of 1774 (*Letters & Papers … cit.* p. 240). It formed part of West's instructions to J.H.Ramberg in 1778/9: F.Forster-Hahn, '"The Source of True Taste". B.West's Instructions to a Young Painter for his Studies in Italy', *Journal of the Warburg and Courtauld Institutes*, XXX, 1967, p. 381. A variant was introduced into an Academy lecture of 1797 (J.Galt, *Life of West*, II, 1820, p. 115). Grose Evans has been able to trace the influence of the theory in West's painting only in the *Appeal to Coriolanus* (1770–80) (*B.West and the Taste of His Times*, 1959, p. 126).

20 E.Kant, *Critique of Judgement* (1790), trans. Meredith, 1952, §§14, 51.

21 G.Berkeley, *A New Theory of Vision* (1709), §§CIII, CLVIII; Vitellio: 'Nullum Visibilium comprehenditur solo sensa visus nisi solum luces et colores' (*Perspectiva*, 1535, p. 71). *Cf.* also DePiles, *Dialogue sur le Coloris, cit.* Teyssdère, *op. cit.* p. 491, n. 2.

22 Goethe, *Theory of Colours*, trans. Eastlake, 1840, *cit.* pp. xxxviii–xxxix.

23 e.g. R.Boyle, *Experiments and Considerations touching Colours …*, 1664 (re-issue 1964), pp. 226–7.

24 Wünsch, *Versüche und Beobachtungen über die Farben des Lichts*, 1792. Goethe, who bought a copy in 1794, made a detailed rejection of the theory (*Leopoldina Ausgabe der Schriften zur Naturwissenschaft*, ed. Matthei, Troll, Wolf, 1947 ff., I, 3, pp. 218–19, II, 3, p. 73). Goethe also owned an offprint of Thomas Young's first statement of the red-green-violet theory: 'An Account of some cases of the production of colours not hitherto described' *Phil. Trans.*, 1802, p. 395 (*cf.* Ruppert, *Goethes Bibliothek: Katalog*, 1958, No. 5295), but he ignored Young in his *Materials for the History of Colour Theory*. T.Young, *ib.* and *Lectures on Natural Philosophy*, 1807, I, p. 439.

25 G.Field, *Chromatics*, 1817, p. 56; earlier; Brook Taylor, *New Principles of Linear Perspective* ... 1719, pp. 67–70; R.Dossie, *Handmaid to the Arts*, 2nd ed. 1764, II, p. 184; J.Imison, *Elements of Science and Art*, new ed. 1803, II, p. 326; M.Gartside, *An Essay on Light and Shade* ... 1805, addenda; Rumford, *loc. cit.* Barry was far more optimistic about the artists' capacity to manage with existing pigments: *Works, cit.* I, pp. 527–8.

26 Brook Taylor, *loc. cit.*: S.Galton, 'Experiments on Colours', *Monthly Magazine*, 1799, p. 513; M.Young, 'On the Number of the Primitive Colorific Rays in Solar Light', *A Journal of Natural Philosophy, Chemistry and the Arts*, IV, 1800, p. 393; H.Howard, *A Course of Lectures on Painting*, 1848, pp. 154–5 (1833).

27 Eastlake in Goethe, *Theory, cit.* p. 358, n. c.

28 Mengs, *op. cit.* II, pp. 129–30 (*cf.* Félibien, *Entretien* V, *cit.* Teyssdère, *op. cit.* p. 308, n. 1); J.Opie, *Lectures on Painting*, 1809, pp. 131–2; P.O.Runge, *Farbenkugel*, §4. Runge's colour-studies had, however, started from the inadequacy he felt in the information supplied by such as Mengs (Letter of 1803 in *Hinterlassene Schriften*, II, 1841, [re-issue 1965] p. 195). *Farbenkugel, ed.* Hebing, 1959, p. 62. For Turner's early avoidance of the scientific problem, see below, p. 110.

29 Kant, *op. cit.* §45; *cf.* DePiles, *Principles of Painting* (1677), 1743, pp. 189–90.

30 Reynolds, *Notes and Observations on Pictures, ed.* Cotton, 1859, p. 56; C.R.Leslie, *op. cit.* I, pp. 58–9 (but, see also Note XLIV to DuFresnoy and *Works, ed.* Malone, 1798, I, pp. lxxii–lxxiii). W.T.Whitley, *Thomas Gainsborough*, 1915, pp. 213–25; also Hutchison, *op. cit.*, pp. 67–8; J.L.J. David, *Le Peintre Louis David*, 1880, pp. 27–32; M.Florisoone, 'Constable and the *Massacres de Scio*, by Delacroix', *Journal of the Warburg and Courtauld Institutes*, XX, 1957, pp. 183–4; C.D.Friedrich, *Bekenntnisse, ed.* Eberlein, 1924, pp. 261–2. See also below, Part III, chs. II, III.

31 Girodet: G.Levitine, 'Quelques Aspects peu Connus de Girodet', *Gazette des Beaux Arts*, LXV, 1965, pp. 239–45, and especially letter of Sept. 21 1806 in J.L.J.David, *op. cit.* p. 438. Runge: O.vonSimson, 'P.O. Runge and the Mythology of Landscape', *Art Bulletin*, XXIV, 1942.

Notes to Part I

1 British Museum Add. MS 46151, R. f. 55 (?1818).

2 Turner to Jane Fawkes, *cit.* W.L.Leitch, 'The Early History of Turner's Yorkshire Drawings', *Athenaeum*, 1894, p. 327. *Cf.* also to Rev.W.Kingsley: 'I know of no genius but the genius of hard work' (J.Ruskin, *Works*, XIII, 1904, p. 536).

3 *Blackwoods Edinburgh Magazine*, XL, 1836, pp. 550–1. *Cf.* W.Thackeray, 'A Second Lecture on the Fine Arts' (1839) in *Paris Sketchbook* ... ed. Saintsbury, 1908, p. 394. In 1831, the art critic of *The Tatler* (?Leigh Hunt) facetiously attributed Turner's chromatic absurdities, as he saw them, to opthalmia, or calenture (W.T. Whitley, *Art in England, 1821–1837*, 1930, p. 213). The opthalmic surgeon Liebreich developed a theory that the dazzle of the late works could be accounted for by a developing cataract after 1830 ('Turner and Mulready. On the Effect of certain faults of Vision on Painting', *Notices of the Proceedings of the Royal Institution*, VI, 1872, pp. 450–63). He was answered on equally positivist grounds by W.M.Williams (*Nature*, 1872, p. 500). For a cautious modern re-appraisal, P.D.Trevor-Roper, 'The Influence of Eye Disease on Pictorial Art', *Proc. Roy. Soc. of Medicine*, 52, Sept. 1959, p. 20 of offprint. Two pairs of Turner's spectacles, collected by Ruskin, and now in the Print Room of the Ashmolean Museum, Oxford, show that he became very short-sighted towards the end of his life, and since he was never seen wearing them while painting, this may account for his habit of working close to the canvas, without moving back to look at it, which seemed so remarkable to several observers (e.g. Finberg, *Life*, pp. 351–2).

4 For the lack of technical instruction: J.C.LeBlon, *Coloritto*, n.d. p. ii; T.Bardwell, *The Practice of Painting* ... 1756, p. 2. For 'secrets': R.M.Clay, *J.C.Ibbetson*,

1948, p. 85; Gainsborough to William Jackson, 29 Jan. 1773 (?1779) (Photocopy in Courtauld Institute, kindly communicated by Mr S.Rees-Jones). In general, 'Magilphs and Mysteries', *Apollo*, July 1964. Reynolds' pupil Northcote stressed the master's secretiveness about technique, but at the same time his willingness to make advice and pictures available to young painters (J.Northcote, *Supplement to the Memoirs of Sir Joshua Reynolds*, 1815, pp. lxxx–lxxxi, cxxx); *cf.* also p. 33 below.

5 Wyatt to Wardrop, *cit.* J.Grieg, *The Farington Diary*, II, 1923, p. 97 n. J.H. Anderdon's similar story, purporting to come from Samuel Prout through David Roberts, of a sketching party with Turner, Girtin and Prout in Wales, cannot be accurate in this form, since Prout remained in Devon until 1802. (British Museum Print Room, Anderdon RA Catalogues, 1794, p. 12 ff; 1796, opp. p. 12.)

6 Ozias Humphrey: BM Add. MSS 22949–22950. For West: *Farington Diary*, 27 May 1803 (unpublished, on Rubens); *ed. cit.* IV, 1924, p. 116 (on Titian); p. 150 (on Rembrandt). For Loutherbourg: *ib.* II, p. 236.

7 W.Thornbury, *Life and Correspondence of J.M.W.Turner*, 1904, p. 124.

8 'Magilphs and Mysteries', *Apollo*, July 1964, p. 39.

9 British Museum Print Room, *Whitley Papers*, XII, p. 1513. It is to be remembered that favourable newspaper reports were sometimes puffs supplied by the artist or a friend. This note certainly suggests inside information.

10 J.Burnet, *Turner and His Works*, 1852, p. 70.

11 The powder colours and bladders of paint now in the Tate Gallery were analysed by N.W.Hanson, 'Some Painting Materials of J.M.W.Turner', *Studies in Conservation*, 1954, pp. 164–72. A water-colour box of the 1840s, now in the Royal Academy, was published by W.T.Whitley, 'Relics of Turner', *Connoisseur*, 88, 1931, p. 198, who omitted, however, to list the second variety of cobalt in the box, 'Permanent Blue'.

12 For example, a mixture of prussian blue, emerald green and yellow seems to have been used opaque in TB CCLIX, 135, 139; and transparent in CCCXV, p. 5, CCCXVI, 5. Emerald green and prussian blue alone seem to have been used opaque in CCLXIII, 342, which is associated in style and subject with the *Wreck Buoy* oil of 1849 (Liverpool, Holt Bequest). I am greatly indebted to Miss R.D.Harley for preparing pigment washes for comparison.

13 TB CCLXIII, 106, *cf.* also 4 in this group. Finberg has put these beginnings tentatively between 1820 and 1830, but they relate directly to the oil, painted in 1810. The *Chemistry and Apuleia* sketchbook (WM 1811) is TB CXXXV, and cobalt is mentioned on p. 55a. *Cf.* also Thornbury, *op. cit.* p. 125. Cyrus Redding, from whom almost all the details of the Devon tour derive, claimed that he first met Turner about 1811 (*Past Celebrities Whom I Have Known*, 1866, 1, p. 44) and a letter of C.L.Eastlake in July 1811 suggests that he and Turner may have already been on close terms, although Eastlake was not apparently in Devon this year. (Lady Eastlake, *Memoir*, in C.L.Eastlake: *Contributions* to the *Literature of the Fine Arts*, 2nd ser., 1870, p. 23) Eastlake's scientific interests, already clear from a poem he published in 1809 (*Monthly Magazine*, pp. 585–6), were to lead to the translation of Goethe's *Theory of Colours* and the compilation of *Materials for a History of Oil Painting*; but it is unlikely that his knowledge at this stage was sufficient to have provided the recipes in Turner's notebook. A more likely source is the Italian scene-painter, James De Maria, for on p. 1 Turner notes a remedy for Maltese plague (*cf. West Briton and Cornwall Advertiser*, 6 Aug., 20 Aug., 17 Sept., 8 Oct., 1813 for plague reports);

and some of the quantities given for materials (e.g. p. 57) suggest this type of large-scale work.

14 Thornbury, *loc. cit.*

15 TB CCX (1824), esp. p. 3 (a yellow and a green).

16 Finberg, *Life*, p. 297.

17 Thornbury, *op. cit.* p. 332.

18 'William Westall was accustomed to relate how Turner's look went through him when, on one occasion, seeing a picture of the master's in which he had painted a palm-tree yellow, he ventured to approach the famous painter with trepidation and apologies, and inform him that a palm-tree was never yellow. "I have Travelled a great deal in the East, Mr Turner," he went on, "and therefore I know of what I am speaking, and I can assure you that a palm-tree is never of that colour: it is always green." "Umph!" grunted Turner, almost transfixing him with his glance. "Umph! I can't afford it—can't afford it," and with these words he walked away.' (A.T.Story, *James Holmes and John Varley, cit.* p. 121.) For Turner and trees, W.J.Stillman, *Autobiography of a Journalist*, 1, 1901, pp. 141–2.

19 Thornbury, *op. cit.* p. 125.

20 For Newman, TB LXIII (1801); Finberg, *Life*, p. 303 (1827); Thornbury, *op. cit.* p. 365 (1851). For Middleton, Finberg, *loc. cit.* For Sherborn (1842), Whitley, *art. cit.*

21 Society of Arts, *Transactions*, XXII, 1804, pp. 141–61, 216–22. This episode was unknown to me when I discussed Turner's relations with the Society, *Journal of the Royal Society of Arts*, 1963, pp. 842–6.

22 Finberg, *Life*, p. 19.

23 *Literary Gazette*, 27 December 1851, p. 923.

24 Thus F.Turner, *The History and Antiquities of Brentford*, 1922, p. 126, and C.Monkhouse, *Turner*, 1929, p. 14. But in his

article on Turner in the *Dictionary of National Biography*, Monkhouse has 'about 140'; and in fact over 200 of the engravings in the book have been tinted, apparently by different hands.

25 LB 14, *cf.* also 15. Paul Colnaghi started as a printseller in London in 1788.

26 Finberg, *Life*, p. 16 n. Sir J.Soane, *Lectures on Architecture, ed.* Bolton, 1929, p. 88.

27 W.Sandby, *The History of the Royal Academy of Arts*, I, 1862, p. 319.

28 Finberg, *Life*, p. 25. The period of Turner's connexion with Malton may be related more firmly to the early nineties if we consider a passage in an early draft of Turner's third Perspective Lecture, citing the West Towers of Westminster Abbey as an example of the vertical as well as horizontal convergence of lines as a natural appearance apparently contrary to perspective rules. He remarked that Malton 'during the progress of his work of London and Westminster mentioned the difficulty he met with ...' (BM Add MS 46151, M, f. 25). Malton's *Picturesque Tour through the Cities of London and Westminster*, noted on p. 11 of the text, dated 1792, that the view of the Abbey in pl. VII (1793) 'is too near to permit the spectator to contemplate this building at his ease,' because of the new houses around its foot 'which obtrude upon it'. Among the subscribers to this publication were Dr Monro, Soane, Porden and John Henderson other early connexions of Turner's. Further evidence of Turner's architectural practice about this time is provided by the Radley Hall Drawings (TB III, C, D) and a watercolour of the Avon Gorge, now in Bristol City Art Gallery, where the windows are wholly blacked out according to an architectural drawing convention. It is interesting that the traditional story of Turner's break with Porden depends on the painter's having refused to conform to this convention.

29 Pls IV, VII, IX, XXII, XXIV, XXVI, XXVII, XXXVI, XLI.

30 Soane Museum Transcripts, II, 161. Another reference to 'Turner' in March 1795 (III, 4).

31 Reeve, *Literary Gazette, cit.* p. 923. For Smith, Frankau, *J.R.Smith*, 1902, p. 32. Smith ceased to exhibit prints at the RA from 1792 to 1800; but *cf.* below, p. 49.

32 Turner's first two exhibited works, *The Archbishop's Palace Lambeth* (RA 1790: W.G.Rawlinson & A.J.Finberg, *The Water Colours of J.M.W.Turner*, 1909, pl. I), and *King John's Palace, Eltham* (RA 1791: Whitechapel Art Gallery, *J.M.W.Turner*, 1953, no. 106) were approx. 14 × 10 ins, about twice Girtin's average of the period; his magnificent *Malmsbury Abbey*, exhibited in 1792 and now in the Norwich Castle Museum, measures 21 × 14¾ ins, and was not matched among Girtin's known drawings until 1795/6 (Girtin & Loshak, 136).

33 C.E.Coode, 'Turner's First Patron', *Art Journal*, 1901, p. 136.

34 'Turner and the Society of Arts' *cit.* I owe the reference to the Hadley drawing to the kindness of Mr Ian Fleming-Williams.

35 *Farington Diary, ed., cit.* I, p. 243.

36 C.F.Bell and T.Girtin, 'Drawings and Sketches by J.R.Cozens', *Walpole Society*, XXIII, 1934-5, p. 22.

37 *ib.* p. 23 n. For Henderson, E.Croft-Murray, *British Museum Quarterly*, x, 1935-6, pp. 49-52. For Dayes, MS note by C.F.Bell in his copy of the first edition of Finberg, *Life*, p. 358, now in the library of the Victoria and Albert Museum.

38 T.Girtin and D.Loshak, *The Art of Thomas Girtin*, 1954, p. 31.

39 For example, TB CCCLXXIV, 4, 5, 8, derived from BM 1900-4-11-30, 31, 32 (Bell & Girtin, 25, 24, 40): BM 1915-3-13-83 (Monro School) and 1900-4-11-25 (Cozens). C.Monkhouse was perhaps the first to make a detailed comparison of a Cozens original and its 'copy' (*The Earlier English Water-Colour Painters*, 1890, pp. 60-1) and his conclusions seem generally acceptable.

40 A.P.Oppé, *Alexander and John Robert Cozens*, 1952, p. 160 n.

41 C.R.Leslie, *cit.* Oppé, *ib.* p. 108. A drawing by Turner which may help to trace his interest in Cozen's design to 1798 is in TB XL, p. 67. A roundel drawing by Cozens of the subject was reproduced in the catalogue of Walker's Galleries, *Early English Watercolours*, 1934, no. 22; and a related drawing, made on the 'blot' method, is in the Victoria and Albert Museum (E. 243–1925). The Cozens oil was sold in May 1802 (Oppé in *Burlington Magazine*, 1954, p. 21) and, at the Academy in 1808, R.Courbould showed a *Hannibal on his Passage over the Alps, pointing out to his soldiers the fertile plains of Italy*. This was neither the episode nor the mood chosen by Turner in his picture of 1810/12.

42 For the connexions of the Monro circle and Turner's early Picturesque tours, 'Turner and the Picturesque', *Burlington Magazine*, CVII, 1965, pp. 21–2. Farington reported on 5 July 1803 that Monro told him he had paid Laporte several hundred pounds for drawings and 'Turner and Girtin he afterwards employed', which might be taken to refer to a sequence of events after late 1795, when the doctor complained he already had too much of Laporte's work (*ib.* 14 Dec. 1795, unpubl.).

43 'Turner and the Picturesque' *cit.* p. 22. For Picturesque *theory*, see below, pp. 54–9.

44 [W.H.Pyne] *Somerset House Gazette*, 8 Nov. 1823, p. 67, *cf.* also T.H.Fielding, *On Painting in Oil and Water Colours for Landscape and Portraits* ... 1839, p. 90. Samuel Scott, who died in 1772, was also credited in the early nineteenth century with the first attempt to give watercolours the strength of oils. (H.Walpole, *Anecdotes of Painting*, 1849, II, p. 709 n.)

45 *Cf.* A.Chalon to T.Uwins in 1827: 'Havell ... sent some clever drawings [to the Water-Colour Society] though I find they are not popular with the members, owing to the free use of body colour' (Mrs Uwins, *Memoir of Thomas Uwins*, 1858, I, p. 184).

46 W.Bemrose, *J.Wright of Derby*, 1885, p. 95. *Cf.* also Turner's patron, Richard Colt Hoare, *The History of Modern Wiltshire*, 1822, I, p. 82.

47 See Finberg, *Life*, p. 49.

48 J.C.Horsley recorded that at a gathering including himself, Harding and Roberts, Turner and John Linnell 'inveighed warmly' against the use of white 'in any way, either as a compensation for leaving the pure white paper for lights and delicately toning it with transparent colour where required, or for washing or scraping out the spaces devoted to the light portions of the subject. Turner was generally a reticent talker, but on this occasion he wound up a strong speech by shaking his fist at Harding, Roberts and some others, who were supporting feebly the *convenience* of the vulgarising material in question, and saying quite fiercely, "If you fellows continue to use that beastly stuff, you will destroy the art of water-colour painting in our country"'. (J.C.Horsley, *Recollections of a Royal Academician, ed.* Helps, 1903, pp. 240–3). Horsley passed on a similar remark, ostensibly derived from Turner, through Munro of Novar to the Redgraves (*A Century of Painters, ed.* Todd, 1947, p. 161).

49 e.g. by H.Lemaitre, *Le Paysage Anglais à l'Aquarelle 1760–1851*, 1955, p. 223. For Turner's relationship with Alexander Cozens, below, pp. 57–8.

50 Finberg, *Life*, p. 63. *Cf.* also p. 61 for a similar remark on 21 July. It is possible that Turner worked occasionally with Smith for Monro, as he worked with Girtin, for Lot 52 of the Monro Sale, Christie, 28 June 1833, was described as 'The Villa Lanti; &c; the outlines by Turner'. Other Smith drawings were in lots 51–9.

51 Bemrose, *op. cit.* p. 26. Farington (unpublished) 29 Dec. 1794. According to an early nineteenth-century handbook, Smith's neutral grey was composed of lake, yellow ochre and Prussian Blue, and Payne's of Indigo, Raw Sienna and lake (J.W.Alston, *Hints to Young Practitioners in the Study of Landscape Painting* ... (1804), 3rd ed. 1820, pp. 28–9).

52 *Review of Publications of Fine Arts*, June 1808, *cit.* B.S.Long, *Walker's Quarterly*, No. 24, 1927, pp. 22–3.

53 'Turner and the Picturesque', *cit.* p. 22, figs. 30–1. Fresh evidence of Loutherbourg's direct contact with the Landseer Isle of Wight engraving project, for which Turner worked, has recently come to light in a letter from Mrs de Loutherbourg to John Landseer, of 30 May 1794, stating that the artist 'has made her a drawing of shanklin Chine, which she will with great pleasure lend Mr Landseer to make a print from for his book of the Isle of Wight ...' (kindly communicated by Mr J.Byam Shaw). The impact of Loutherbourg on Turner's work of the period is also shown in two watercolours of a shipwreck and a coastal scene (TB XXIII, R & V). Thomas Miller referred to 1793 as the date of a *Rochester Castle with Fishermen Drawing Boats Ashore in a Gale*, then in the collection of Dr Nixon, Bishop of Tasmania and since untraced. It was, he said, 'carefully but thinly painted, in just the manner one might suppose a water-colour artist would paint. He seems to have used semiopaque colour to scumble with, in so fluid a state that one may distinctly see where it has run down the picture from his brush ... a strong resemblance to De Loutherbourg ...' (*Turner and Girtin's Picturesque Tours ...* 1854, p. xxvii and note). Turner was at Rochester in 1793 (TB XV, A, C, D), so that according to the chronology of Miller's account, this oil would have been painted in 1794, as it was done a year after the first visit.

54 *European Magazine*, March 1782, p. 181; also Society of Arts, *Minutes of the Committee of Polite Arts*, 2 May 1806, p. 121, where Loutherbourg is referred to as 'both a practical Artist & a chemist ...'

55 Farington (unpublished) 20 Oct. 1798.

56 J.Vernet, 'Manière de Peindre de M.Casanova', *ed.* Legrange, *Archives de l'Art Français*, III, 1853–5, pp. 362–4.

57 The boldest and most complete of the series, *Dolbadern Castle* (TB LXX, O), **37**, establishes the link with Wales. The others are: TB XXXVI, U (?Coniston Old Man); TB LB (Norham Castle); TB LXX, j. All measure approx. 26 × 33 ins.

58 *Cf.* Finberg, *Life*, p. 419.

59 See West's complaint of 1803 that 'Wilson was only defficient in not understanding the value of *a ground tint*—but used the thick colour in those parts where the ground tints should prevail'. (W.G. Constable, *Richard Wilson*, 1954, p. 115.)

60 BM Add MS 22949, ff. 34v–35r. For an early nineteenth-century view that Claude used a white ground: W.Buchanan, *Memoirs of Painting*, 1824, I, pp. 110, 343–4.

61 TB LXXI, pp. 62a, 63a; TB LXXII, pp. 23, 24, 26a, 30, 33, 34, 36, 51a, 54, 60, 78a.

62 *Farington Diary*, ed., cit. I, pp. 269–70. M.Röthlisberger, *Claude Lorrain*, 1961, pp. 369–73, fig. 259 (LV, 157); pp. 436–8, fig. 301 (LV, 185).

63 G.Jones, MS *Recollections*, Oxford, Ashmolean Museum, n.p. In the 1821 Paris Sketchbook (TB CCLVIII, p. 20), Turner referred to the *Embarcation of S.Ursula* (NG 30; Röthlisberger, 118), then in the Angerstein collection since at least 1803, and lent for copying to the British Institution in 1806 (*cf.* J.Ziff, 'Copies of Claude's Paintings in the Sketchbooks of J.M.W.Turner', *Gazette des Beaux Arts*, 1965, p. 58). Other Claude Seaports from the Angerstein collection are National Gallery 5 and 14, the latter of which, *The Embarcation of the Queen of Sheba*, was the picture beside which, according to his will, Turner wished his own *Dido Building Carthage* (TG 498) to hang.

64 TB XLVII, p. 10; TB LXX, P. It is interesting that J.R.Cozens used a rather similar procedure in beginning a drawing for Beckford, now in the Soane Museum (Oppé, *op. cit.* pp. 153–4 and pl. 47). Turner's first Claudian oil, *The Vintage at Macon*, exhibited in 1803 and now in the Graves Art Gallery, Sheffield, was painted in a far from Claudian technique, although its strong diagonal chiaroscuro composition somewhat resembles Beckford's *Landscape with the Father of Psyche sacrificing at the Milesian Temple of Apollo* (LV 157). But it was apparently begun in distemper (Burnet, *op. cit.* p. 79), a procedure which was thought at the time to be characteristic of Claude (W.Buchanan, *Memoirs of Painting*, 1824, I, p. 344).

65 William Mason was still expounding the principle of colour-planes in England in the late eighteenth-century, in his poem, *The Landscape Garden*, 1772, *cit.* E.Manwaring, *Italian Landscape in Eighteenth-Century England*, 1925, p. 151. Early seventeenth century examples are *passim* in the work of Bril and Momper.

66 TB CXCVI, B. Another version of the drawing, possibly that exhibited in 1811 from the Fawkes collection, is now in the Crabtree Coll. (repr. in colour: A.J.Finberg, *Turner Water-Colours at Farnley Hall*, n.d., pl. IV).

67 MS note by C.F.Bell in his copy of Finberg *Inventory* in the Print Room of the British Museum. The identifications have recently been confirmed independently by Mr Hardy George.

68 Louis Hawse, *Burlington Magazine*, CVIII, 1966, p. 312.

69 A good example, TB CCLXIII, 289, is reproduced in colour by L.Gowing, *Turner: Imagination and Reality*, 1966, p. 29. Many drawings in this group of beginnings are on paper watermarked 1828; others are watermarked 1845 (e.g. 31). Some, like 197, 198, seem to belong in style to the first decade of the century; and 201 is surely a Thames subject of *c.* 1808. 321 seems to belong to the Swiss drawings of 1802. In general, the grouping is very confused: 344, for example, is not a 'beginning' but an exhibited work of 1830.

70 B.Webber, *James Orrock RI*, 1903, I, pp. 60–1. Leitch told a similar story to a friend of W.Shaw Sparrow, and added that Turner's friend Pickersgill was also a witness. Each drawing board had a handle screwed on to the back for easier plunging into water. 'He seemed to work on four drawings at a time, so that the first would be almost dry after the first stage, before he came back to it' (*The Genius of J.M.W. Turner*, ed. Holmes, 1903, pp. W vii–viii).

71 W.L.Leitch, *art. cit.* p. 327.

72 W.G.Constable, *op. cit.* p. 116.

73 BM Add. MS 46151, K, f. 2. It is recorded that 'The artists of [Turner's] admiration—the only artists whom he cared to talk about—were Reynolds and Girtin' and 'He lived at Twickenham, he affected to say—that he might live in sight of Sir Joshua's house upon the hill ...' ([?P. Cunningham] *Athenaeum*, 1851, p. 1383.)

74 Mrs Bray, *Life of Thomas Stothard, RA*, 1851, pp. 12–13.

75 C.R.Leslie (in 1835), *Autobiographical Recollections*, ed. Taylor, 1860, I, p. 145. A Turner copy, apparently of a Reynolds portrait, is in the Tate Gallery (5564), but it seems to be later and rather closer to Lawrence than Reynolds in colour. The original I have not traced.

76 C.L.Eastlake, *Materials for a History of Oil Painting*, II, 1869 (re-issue 1960), p. 255.

77 Finberg, *Life*, pp. 45, 53.

78 For Hopper and wax, Beechey's notes in W.Cotton, *Sir Joshua Reynolds and his Works*, 1856, p. 246. For Turner's use of it: Trimmer in Thornbury, *op. cit.* p. 251, 364 f, also TB CV, p. 10a.

79 J.Cawse, *The Art of Painting Portraits, Landscapes ... &c in Oil Colours*, 1840, pp. 23–4 n.

80 Reynolds and Grandi: *Conversations of James Northcote with James Ward*, ed. Fletcher, 1901, p. 235. As early as 1797 Grandi's methods of laying Venetian Grounds were being supported by Beechey and Opie (Farington *Diary*, 30 March [unpubl.]); and in 1806 these grounds and other materials were awarded a silver medal and a bounty at the Society of Arts, on the recommendation of Beechey, Opie, West, Shee, Northcote, Farington, Cosway, Loutherbourg and others. (*Transactions*, XXIV, pp. 85–9.) Opie painted Grandi's portrait on one of his absorbing grounds, apparently white, in a picture, now much damaged, in the Ashmolean Museum in Oxford. (J.J.Rogers, *Opie and His Works*, 1878, p. 100.)

81 Finberg, *Life*, p. 77. Farington had been using Grandi's grounds at least since 1798 (*Diary*, 12 May 1798 [unpubl.]).

82 [Anon.] *Practical Treatise on Painting in Oil Colours*, 1795, p. 157. The book is based largely on the earlier work of Thomas Bardwell. Trimmer, too, reported Turner's emphasis on dead-colouring (Thornbury, *op. cit.* p. 123).

83 Finberg, *Life*, p. 53.

84 In his *Inventory* (LX (a)), Finberg gave the group to 1801; later he revised this to 1809 for no apparent reason (*Life*, p. 159). He rightly rejected K (now *Conway Castle*) from the group as it is not a nature-study (*ib.* p. 160); but he should surely have included LXX z, a Welsh subject close in size and style, and XLIV d, another Welsh subject, smaller, but close in style. The group is close to Girtin's *Near Beddgelert* of 1799/1801 (Girtin & Loshak, No. 266).

85 See the *Trees and Pond near Bromley* (Girtin & Loshak, 273, fig. 42 (1798)), inscribed, 'drawn and colored on the spot'.

86 See the letter publ. W.T.Whitley, 'Girtin's Panorama', *Connoisseur*, LXIX, 1924, pp. 13–20.

87 Finberg, *Life*, p. 262.

88 Anecdote from Donaldson 'a few years ago' recorded by Dr John Percy in 1885 in a MS note to his Catalogue of Drawings British Museum Print Room (M 6, 7, p. 72–1). Donaldson's Roman address, possibly in his own hand, is in TB CLXXX, p. 81a.

89 W.Stokes in R.J.Graves, *Studies in Physiology and Medicine*, 1863, p. xi, *cit.* Armstrong, *op. cit.* p. 96.

90 Thornbury, *op. cit.* p. 104. Munro's account to Ruskin in Finberg, *Life*, pp. 360–1.

91 E.g. Gowing, *op. cit.* p. 33 and colour pl. p. 14. Eric Harding of the British Museum has recently claimed, however, that the blotting is due to damage in the 1928 Tate Gallery flood (M.Butlin in *Master Drawings*, VI, 1968, p. 280).

92 J.Burnet, *Turner and His Works*, p. 58. The canvas is perhaps Tate Gallery 4665;

but *cf.* below, p. 37. *Cf.* also Burnet pp. 90–1, W.Armstrong, *Turner*, 1902, pp. 130–1, W.G.Rawlinson, *The Engraved Work of J.M.W.Turner*, I, 1908, p. 126, No. 222.

93 Constable, *op. cit.* p. 109. *Cf.* also the conflicting accounts by Farington, *ib.* p. 181, pl. 46a.

94 *ib.* p. 225.

95 'Turner and the Picturesque', *cit.* p. 75, n. 2. Some Linnell sketches of this period are now in the Tate Gallery, (T. 933–5).

96 Finberg, *Life*, p. 137. *Cf.* Rothenstein and Butlin, colour pl. II.

97 'Turner . . . has said that a landscape painter may find sufficient scope for his pencil by studying the scenery on the banks of the Thames' (*Ackerman's New Drawing Book* . . . 1809, caption to pl. v), *cf.* also Turner to Etty (?before 1824): 'There is finer scenery on its banks than on any river in Italy . . .' (A.Gilchrist, *Life of William Etty RA*, I, 1855, pp. 220–1).

98 TB XC, pp. 42–3, now given by Finberg (*Life*, p. 192) to 1811/2.

99 e.g. Rothenstein & Butlin, pl. 33.

100 Thornbury, *op. cit.* pp. 120–1. The only precisely dateable episode in Trimmer's early connexion with Turner belongs to late 1811 (J.Lindsay, *J.M.W. Turner*, 1966, p. 100).

101 No. 2694, repr. in colour in L.Herrmann, *J.M.W.Turner*, 1963, pl. 5.

102 Martin Davies, *National Gallery. British School*, 1959, p. 101.

103 TB CXXX. Another Sketch from the group, *Road Leading to a Valley* (Add. L), has been discovered. Others exist outside the British Museum. Sketch A, which seems the most 'advanced' of the series and is on a lighter ground than the others, is painted on one of the boards of Ottley and Tresham's *British Gallery of Pictures*, which published Turner's *Bridgewater Sea Piece* in 1812 (R 78). One of the most 'archaic' (B) is repr. in colour by Rothenstein and

Butlin, colour pl. VI; but even this is close in style to some of the Farnley gouaches of *c.* 1816. Others, especially F and K, **42**, are more spontaneous, and close in colour to the first group of Thames oil sketches.

104 Thornbury, *op. cit.* p. 153.

105 C.Redding, 'The Late J.M.W. Turner', *Fraser's Magazine*, XLV, 1852, p. 151.

106 Tate Gallery 5524–8, Rothenstein and Butlin, pls. 72–3 and p. 38. The *Hill Town* has been convincingly dated to *c.* 1828 and can be compared with its coolly classical structure and pastel colours with gouaches in the *French Rivers* series (e.g. TB CCLIX, 38).

107 Thornbury, *op. cit.* p. 93. For the first references to Munro, Finberg, *Life*, p. 298.

108 *ib.* p. 153.

109 National Gallery 530, repr. in colour in Rothenstein & Butlin pl. XXI. The full title in the Academy catalogue was *Snow storm. Steam boat off a harbour's mouth making signals and going by the lead. The author was in this storm on the night the Ariel left Harwich.* That the alleged facts of the storm have not so far been corroborated hardly affects our argument. Kingsley's account of Turner's conversation was published by Ruskin, *Modern Painters*, V (1860), Pt. IX, ch. xii, §4 n.

110 See 'Turner and the Picturesque', *cit.* p. 76 and figs. 31–2. The engraver, Frederick Goodall, recorded an excursion of the RA Club to Richmond Hill, when Turner remarked: 'What a point in the landscape Hind Hill makes, although it is not much of a hill! But if you will only look at it long enough, you will see it grow bigger and bigger.' (F.Goodall, *Reminiscences*, 1902, p. 160.)

111 *Quarterly Review*, XCVIII, 1856, p. 41; Lady Eastlake, *Journals & Correspondence*, II, 1895, pp. 82–3; Thornbury *op. cit.* p. 292. An early example of this attitude in practice is in a drawing of *Raby Castle* of about 1817 (TB CLVI, pp. 23a–24) where the pencil drawing has been extensively

touched with small flecks of red, blue and yellow only.

112 See below, p. 114. For Chromatic Aberration: Goethe, *Theory of Colours, cit.* §423; and for a brief modern account: W.D.Wright, *The Measurement of Colour*, 3rd. ed. 1964, p. 30.

113 TB CV, cover. The remark reverses one on colour by Opie (*Lectures, cit.* p. 136), as is usual with Turner's marginal notes countering Opie's views on nature and art; for example the note to *Lectures*, p. 58, which, *pace* Gowing, *op. cit.* p. 13, refers to the study of nature rather than art.

114 Lecture V, MS in C.W.M.Turner Collection f. 14r. This MS is autograph, and seems to represent a later version of the lecture than the copied text in the British Museum (Add. MS 46151, H).

115 Thornbury, *op. cit.* p. 139. Turner's assertion that the *Norham* drawing was his fortune is supported by the enthusiastic reviews it received at the time (Finberg, *Life*, p. 49). The first version, **33**, was exhibited in 1798. The *Liber Studiorum* drawing is TB CXVIII, D. (R 57). The brilliant watercolour engraved in *River Scenery* in 1824 (R 756) is TB CCVIII, O, **34**, repr. in colour in W.G.Rawlinson & A.J.Finberg, *The Watercolours of J.M.W.Turner*, 1909, pl. XIV. Turner was still sketching the castle afresh as late as 1831 (TB CCLXVII, p. 59a). See also below, p. 126 and n. 250.

116 BM Add. MS 46151, O (1818) f. 6. Armstrong, *op. cit.* p. 247 lists related versions of 1800/4. The *Liber* plate (R 18) was published in 1809. Again, Turner was sketching the subject as late as 1831 (TB CCLXIX).

117 Akenside, *Hymn to the Naiads* in R.Anderson, *British Poets*, IX, 1794, pp. 797–8. Armstrong, *op. cit.* p. 220 for the two versions of the late oil.

118 For the transformation, Thornbury, *op. cit.* p. 105. Cf. also *The Hero of a Hundred Fights* (TG 551) exhibited in 1847. That the picture was once a good deal brighter than it now appears, see B.Webber, *op. cit.* I, p. 97. Turner seems to have

been meditating the subject from the mid-forties, for in the *Dieppe and Kent* sketch-book of 1845 (TB CCCLXI, p. 108a) is a drawing of boats at sea inscribed 'Bright Light (?) on the wreck Buoy'; and the vignette of the rainbow and wreck-buoy motif, with fish (TB CCLXIII, 342) may well be of this date.

119 'Turner and his Engravers' in C.Holmes, *The Genius . . . cit.*

120 Turner's correspondence with Wyatt was published by Finberg, *Life*, pp. 161–6, 186–7. For that with Miller, see below. For marked proofs of Cooke's *Southern Coast*, A.J.Finberg, *Introduction to Turner's Southern Coast*, 1929. Other annotated proofs noticed in W.G.Rawlinson, *The Engraved Work of J.M.W.Turner*, 1908–13.

121 C.F.Bell, *art. cit.* pp. E ii–iii. 'The Oxford Almanacks', *Art Journal*, LXVI, 1904, pp. 243–7. Bell did not, however, notice that in the published state of the engraving, Basire took little account of Turner's recommendations. Rawlinson, *op. cit.* I, p. 20.

122 Finberg, *Life*, p. 140. Bell's objection to the date and matter attributed to this letter (*art. cit.* p. E xii) seems to me un-justified, although aquatint itself was clearly not the subject of Turner's remarks.

123 TB CXVIII T.Lupton's first work for Turner was in 1816 (R.52).

124 Bell, *art. cit.* p. E iv. Turner's pleasure at Pye's rendering of his colour is also shown in some verses of about 1810 in *The Artist's Assistant* (C.W.M.Turner coll.); but they are generally too illegible to make the meaning certain.

125 W.G.Rawlinson, *Turner's Liber Studiorum*, 2nd ed. 1906, p. xlii: *cf.* also a letter of Turner to Finden '. . . Mr McQueen call'd to talk about printing my plates . . .' (Maggs Bros. 1922, no. 806; the reading differs from that given by Thornbury, *op. cit.* pp. 183–4). McQueen was printing sets of *Liber* as late as June 1845. (J.Pye & J.L.Roget, *Notes and Memoranda respecting the Liber Studiorum*, 1879, p. 71 n.)

126 Turner owned A.Senefelder, *A Complete Course of Lithography*, 1819, on which many of his notes were based (TB CCX, pp. 2–3; TB CCXI, pp. 20, 22 [*c.* 1823/4] *cf.* Senefelder, *op. cit.* pp. 159 ff., 167, 169–70, 272, 340). Turner's patron and friend, Lord de Tabley, to whom he was close about 1820, was an early amateur of lithography (W.Jerdan, *An Autobiography*, IV, 1853, p. 142. I believe the Tabley No. 3 sketchbook [TB CV] to date chiefly from 1820/1).

127 Pye & Roget, *op. cit.* pp. 67–9.

128 A.J.Finberg, *The History of Turner's Liber Studiorum*, 1924, pp. lxiii–v.

129 Rawlinson, *Liber*, p. li n. Halsted was buying in the early thirties, when Turner's will first showed clearly his intention of keeping his collection together.

130 Bell, *art. cit.* p. E xviii, is puzzled by what Turner could have done with the black chalk, since he used, in the event, so much white; but the story surely indicates that the painter was already familiar with physiological contrast effects, and could have produced the lights by contrast alone, had he wished. *Cf.* The second touched proof for Miller (p. 44 below).

131 Rawlinson, *Engraved Works*, II, p. 340.

132 Finberg, *Life*, p. 384. One of the notes on the British Museum proof reads: 'NB get on for I shall be off for my Summer trip soon.'

133 Corrected and expanded from Rawlinson, *loc. cit.*

134 Cambridge, Fitzwilliam Library.

135 Rawlinson, *loc. cit.* pp. 340–1.

136 Thornbury, *op. cit.* pp. 172–3. The second letter has been transcribed badly by Thornbury, and I give a corrected version here from the original MS in the Fitzwilliam Library, Cambridge:

Saturday 9 July 1842

My Dear Sir

I beg to thank you for the terms of the Printer and will thank you for your kindness in offering to look to the Printing

during progress—but your plate is Mr Moon's and I was asked for a plate of my own *only*. May I now trouble you further by asking him the Printer if he allows *discount* for ready Money and how many printing presses he has and if *two* or more plates were worked on at the same time—what deductions he would make in proportions

Yours most truly

J.M.W.Turner

P.S. your box has not arrived—but have the goodness to get me an answer about the Printing at your earliest convenience your proof shall be touched immediately it arrives in Q Anne St. Excuse haste & Margin [where T. has written the end of the P.S.] and all to be in time for the Post to night.

137 Cambridge, Fitzwilliam Library. Thornbury's transcript (*op. cit.* p. 171) reads '*copiously*' for '*especially*' and '*parties*' for '*post*'.

138 Bell, *art. cit.* p. E xv.

139 Rawlinson, *Engraved Work*, II, p. 393. Aquatints after Turner, printed in colour (*c.* 1818–28) are listed as R 822–6, 829; and chromo-lithographs published in 1852, of which Turner may still have known, as R 848–9.

140 The engraver of three of the Seine series of 1834 (R 463, TB CCLIX, 131; R 490; R 492, TB CCLIX, 126), Armytage, recalled how, when he took Turner some belated proofs, 'the great man was much more anxious about the safe return of his drawings than their successful translation' (M.B.Huish, *The Seine and the Loire* . . . 1890, p. viii).

141 Thornbury, *op. cit.* p. 238, also p. 633 for Turner's prices to Cooke at the same period.

142 Bell, *art. cit.* p. E xii.

143 Thornbury, *op. cit.* p. 193, Finberg, *Life*, p. 170. I am unable to understand Rawlinson's interpretation (*op. cit.* p. 362, 'Coloured Impressions') of the contract (Thornbury, p. 194) that coloured impressions were only to be made after the plate

was worn. In the 1820s, some of Ackerman's hand-tinted aquatints were published with the name of the colourist as well as that of the draughtsmen and engravers (S.T.Prideaux, *Aquatint Engraving*, 1909, p. 121).

144 J.C.LeBlon, *Coloritto, n.d.*; J.Gauthier D'Agoty, *Observations sur l'Histoire Naturelle, sur la Physique et sur la Peinture*, Pt. xv, 1755, quarto ed. pp. 153–5. Some of the later plates in this production were themselves not printed in colour, but were hand-coloured etchings. For the relationship between LeBlon and D'Agoty, see now G.Wildenstein, 'Jakob Cristoffel Le Blon ou le "Secret de Peindre en Gravant"', *Gazette des Beaux Arts*, LVI, 1960, pp. 92–5. D'Agoty himself exceeded three plates.

145 J.Kainen, *J.B.Jackson*, 1962, p. 39.

146 W.Cotton, *op. cit.* p. 229. *Cf.* also H.Walpole (Lord Orford) himself: 'want of colouring is the capital deficiency of prints' (Prideaux, *op. cit.* p. 20).

147 W.T.Whitley, *Artists and their Friends in England*, II, 1928, pp. 25–6; British Museum Print Room, *Whitley Papers*, IX, p. 1177.

148 J.T.Smith, *Nollekens and his Times*, ed. Whitten, 1920, II, p. 322; also *Morning Herald*, 1789, *cit.* Whitley, *loc. cit.*

149 For Eginton's process see especially letters of 1781 in *The Photographic Journal*, VIII, 1863, p. 395. Here, too (*ib.* 1864, p. 443), it was suggested that the process was basically an aquatint one; and this interpretation was adopted and amplified in terms of the transfer prints in albumen employed in pottery, by G.Wallis, *The Art Journal*, 1866, pp. 251–5, 269–72. I am greatly indebted to Mr Conal Shields for drawing my attention to this controversy. Whitley noticed a rival *Mimeographic Society* flourishing briefly in 1791; and as early as 1773, Benjamin Franklin had written to an aquatint engraver, P.P. Burdett of Liverpool about Burdett's 'Art of Printing in imitation of Paintings' (*op. cit.* pp. 27–30; Burdett's process was, however, a monochrome, not a colour one:

B.Nicolson, *Joseph Wright of Derby*, 1968, I, pp. 117–18).

150 J.Frankau, *op. cit.* No. 78.

151 Courtauld Institute, *Press Cuttings on the Fine Arts*, I, p. 209. W.T.Whitley, *Art in England 1800–1820*, 1928, pp. 196–7.

152 For Josi and Smith, Prideaux, *op. cit.* pp. 55–6.

153 'Il fesait des essais continuels avec le prisme, pour tracer l'effet de la lumière et la formation des différentes teintes de couleur; étude qui a specialement servi le célèbre peintre de fleurs, Jean van Huyzum ...' (*Collection* ... p. i). F.C. Lewis was engraving Chamberlaine's facsimiles at the same time as he was working for Turner on the *Liber*, and Turner seems to have approved of his work (Rawlinson, *Liber*, p. 211).

154 *Cf.* Loutherbourg's letter to Boulton and Fothergill of 17 Aug. 1777, *Photographic Journal*, cit. p. 393. For Booth's 1792 exhibition, *Whitley Papers*, *loc. cit.*; R.C.B.Gardner, 'Loutherbourg and the Polygraphic Process', *Country Life*, CIV, 1948, p. 824 f.

155 *op. cit.* p. 80; but Senefelder later (pp. 271–3) confessed to his lack of success with several stones together, and was reduced to hand-colouring a single stone in the manner of the eighteenth-century English stipple engravers. (*Cf.* also M.C. Salaman, *The Old Engravers of England* ... 1906, p. 145 and n.)

156 J.Ziff, 'Backgrounds, Introduction of Architecture and Landscape. A Lecture by J.M.W.Turner', *Journal of the Warburg and Courtauld Institutes*, XXVI, 1963, p. 145 and n.

157 BM Add. MS 46151, P, f. 1.

158 J.Barry, *Works*, 1809, I, pp. 536–7.

159 J.Evelyn, *Sculptura*, ed. C.F.Bell, 1906, p. 127.

160 BM Add. MS 46151, A, ff. 16v–17v. I have transcribed the whole passage as Appendix I.

161 J.Landseer, *Lectures on the Art of Engraving*, 1807, pp. 180–3.

162 T.Moore, *Memoirs, Journal and Correspondence*, ed. Russell, VI, 1854, p. 95. Another contemporary, the flower-painter James Sowerby, in *A New Elucidation of Colours* ... 1809, was anxious to express colour in engraving by a system of lines and dots (p. 32, *cit.* G.E.Finley, *loc. cit.* p. 366, n. 50).

163 G.Field, *Chromatics*, 1845, p. 33. In Field's scale, yellow was given a value of 3, red of 5, blue of 8 (p. 28 *et. seq.*).

164 The first *Liber* plate for which heavily touched and annotated proofs exist is *Mt.S.Gothard* (R 9), issued in 1808. *Liber* certainly represents the first series in which Turner's control over the production of engravings is pronounced.

165 Reynolds, in a comparison of a Rubens *Crucifixion* with the print by Bolswert, noted that 'a different conduct is required in a composition into colours, from what ought to be followed when it is black and white' (*Works*, *cit.* II s.v. *Recollets*). His conclusion that prints require more and larger masses of light than pictures is wholly in agreement with Turner's procedure in adapting *Calais Pier* for the (unfinished) mezzotint (R 791), as recorded by the engraver, Lupton (Thornbury, *op. cit.* pp. 196–7). Landseer, *op. cit.* p. 178. Pye: 'I attribute the distinction of the English engraver to result from a new combination of the various qualities of nature and art in the plates they engrave, particularly so in regard to landscape engraving. The best plates engraved now appear to me as being free translations from pictures, instead of being cold rigid copies. They are entirely so with regard to effect—that quality by which the English school is distinguished, whether we speak of painting or engraving ...' (*Minutes of Evidence before the Select Commitee on the Arts and Principles of Design*, 5 July 1836, §1316, p. 113). Delacroix, *Journal*, 25 January 1857: 'The foreign language of the engraver, and it is here that genius is shown, does not solely consist of imitating the effects of painting by means of his own art,

which is like another language. He has, if one may so speak, his own language . . .' How far engravings after Turner's drawings may be translations has recently been well illustrated by M.Kitson, *Turner*, 1964, pp. 54–5 (*Honfleur*, R 472; TB CCLIX, 135). The tonal schemes of drawing and engraving are quite different.

166 Bell, *art. cit.* pp. E i, E iii–iv.

167 Finberg, *Life*, p. 162.

168 See the letter to Miller of October 1842, quoted above, and a letter of 1822 in Finberg, *Life*, p. 277.

169 'Brief Memoir of Mr George Cooke', *Arnold's Magazine of the Fine Arts*, III, 1833–4, pp. 553–4.

170 Rawlinson, *Liber*, pp. 216–17.

171 Thornbury, *op. cit.* pp. 634, 636.

172 F.Goodall, *Reminiscences*, *cit.* p. 57. The reference to 'picture' make it likely that the episode refers to the engraving of *Caligula's Palace*, published in 1842, since all Goodall's other Turner engravings were after drawings. See also the remark on red as a tone, in the draft of the Second Lecture (p. 196 below).

Notes to Part II

Notes to pages 53 to 58

1 J.Ruskin, *Works*, XII, 1904, p. 500.

2 BM Add. MS 46151, H, f. 25v; s, f. 5; from Reynolds, Note VIII to Du Fresnoy.

3 T.Malton, *A Compleat Treatise on Perspective* ... 1779, Bk. I, pp. 1, 255. Turner was certainly familiar with the book by about 1808 (TB CXCV, 87, 100, 113).

4 U.Price, *Essays*, 1810, I, pp. 169–70.

5 R.P.Knight, *An Analytical Inquiry into the Principles of Taste*, 4th ed. 1808, Pt. II, ch. ii, §22. W.Gilpin, *Three Essays on Picturesque Beauty*, 2nd. ed. 1794, pp. 20–1. *Cf.* also his letter of Oct. 1782 to Lock of Norbury, later a patron of Turner: 'I have made a few attempts in colours; but I believe it will be wisdom never to let you see of them. They pretend not to any discipline, or harmony of feeling.' (C.P. Barbier, *W.Gilpin*, Exhibition Catalogue, Kenwood, London, 1959, p. 36 no. 81.)

6 Finberg, *Life*, p. 52.

7 Mr D.F.Snelgrove kindly brought these drawings, now in the Mellon Collection, to my notice.

8 Oxford, Bodleian Library, MS Eng. Misc. *c.* 391. C.P.Barbier, *W.Gilpin*, 1963, p. 38, gives this MS to *c.* 1768.

9 *op. cit.* p. 1.

10 *ib.* p. 2.

11 *ib.* pp. 2–3.

12 *ib.* p. 4.

13 *ib.* pp. 13–14.

14 Rothenstein & Butlin, colour pl. IV.

15 *cit.* C.Hussey, *The Picturesque*, 1927 (re-issue 1967), pp. 70–1; and pp. 78–9, where this conception is related to Turner's late work.

16 T.Phillips, *Lectures on the History and Principles of Painting*, 1833, p. 389.

17 J.Burnet, *Turner and his Works*, 1852, p. 19.

18 P.G.Hamerton, *Life of J.M.W.Turner*, 1895, pp. 190–1. The episode probably belongs to the period when Wells and Cristall were associated with the Water Colour Society: *c.* 1807. It can hardly be later than the early 1820s, when Wells had moved from Knockholt to Mitcham (*cf.* Finberg, *Life*, p. 281).

19 M.Gartside, *An Essay on a New theory of Colours and on Composition in General, illustrated by Coloured Blots* ... 2nd ed. 1808, p. 32. Only the first part, on Flowers, seems to have been issued.

20 TB CXXII, p. 40a; CCXII; CCLXXX, CCXCI b & c (repr. Gowing, *op. cit.* p. 25). CCLXXX, 67 is very close in character to a Gartside 'blot'. Turner owned a version of Blot 13 in Cozens's *New Method* (C.W.M.Turner Coll.), but it is significant that his chief textbook of perspective specifically attacked Cozens's doctrine in the formulation, to which he referred, of Leonardo (J.Kirby, *Dr Brook Taylor's Method of Perspective Made Easy*, 3rd ed. 1768, p. viii).

21 I believe that A.P.Oppé, *op. cit.* p. 59 ff., has given undue emphasis to the conceptual, schematic element in the system; but Cozens's argument as a whole is hardly unambiguous. See now E.H.Gombrich, *Art and Illusion*, 3rd ed. 1962, p. 157, on the conventional, non-accidental aspect of the Cozens method.

22 Finberg, *Life*, p. 99.

23 J.Ruskin, *Modern Painters*, V, pt. VIII, ch. ii, §15.

24 C.O'Brien, *The British Manufacturer's Companion and Callico Printer's Assistant*, 1795, s.v. 'Of Pattern-Drawing'.

25 Ruskin to Palgrave, 1862, *Works*, XXXVI, 1904, p. 406.

26 *Cf.* the instances of Poussin and Ruisdael noted by J.Ziff, 'Turner and Poussin', *Burlington Magazine*, CV, 1963, p. 320.

27 e.g. the collections of Monro, Colt Hoare, Beckford, Yarborough, Bridgewater, Williams-Wynn, Ashburnham.

28 Ziff, *art. cit.* p. 316.

29 At the Ryley Sale, Christie, 15 Nov. 1798, Turner bought lots 20: Fifty Studies, whole lengths (10s); 27: Sundry memorandum books with sketches from the antique (£1); 56: 22 historical sketches (9s 6d). At least some of these drawings were still in Turner's collection about 1810 (*cf.* TB CXXIX, p. 8) and about the same time Turner referred to them together with some sketchbooks in a note to Shee's *Elements of Art* (p. 8): 'Several instances of the truth of the line notwithstanding the high authority of Reynolds, that moderate abilities, aided by assiduosity and continual application will produce that which we are willing to think superior endowments. The strongest instance I know in *Ryley*, a man certainly not dull, deficient not in interlectual powers, devoted to his art; and the innumerable sketches left at his death prove how oft he corrected his design

 nor past an idle day without a line

generally dated each sketch; and I have several books so dated that show marks of improvement and prove how far common interlects can be cultivated by sheer industry and intense application. From fondness and choice he arduously pursued the Art—but alas the sterile soil denied him bread and mock'd the labourer's toil.'
Finberg's identification of some of the Academy studies in TB XVIII with Ryley's work seems doubtful.

30 A watercolour *Souvenir of Poussin* dated 1783 is in the Birmingham City Gallery

(26, 22); and another Classical drawing, dated 1797, is in the Ashmolean, Oxford (167: 130). For drawings of religious and Miltonic subjects in 1798 *cf. Work Diary*, V & A, MSS Box III, 8622, Jan.–Feb., 11 Oct. 1798.

31 Farington noted tellingly of the Titian *Fête Champêtre* (Louvre No. 1136): 'We were several of us busily employed. Turner drawing and Fuseli,—Halls,—& Shee writing their remarks' (*Diary*, 5 Oct. 1802, unpubl.) Turner did, however, make verbal notes as well (TB LXXII, pp. 56a–57a).

32 Reynolds, *Works*, *cit.* II, p. 234.

33 p. 23a. Finberg, *Inventory*, I, p. 183 read 'primitive' as 'minute'.

34 J.B.Flagg, *Life & Letters of W.Allston*, 1892, p. 192. The reference is to *The Sisters*, now in the Fogg Art Museum.

35 J.Ziff, 'Backgrounds . . .' *cit.* p. 145. Turner's continuing preoccupation with this sort of colour analysis is seen in his remarks on the *Annunciation* in the Palazzo Corsini, then attributed to Michelangelo, whose angel had 'prismatic' wings noted by Turner on two occasions in 1819 (TB CLXXI, p. 13; CLXXX, p. 1a). The picture is now in the Palazzo Barberini, attributed to Venusti.

36 For the history of this MS, see above, p. 222, n. 10.

37 Fuseli, Lecture II (1801), pp. 81–2; also in Pilkington's *Dictionary*, 1805, s.v. *cf.* De Piles on Rubens's neglect of Leonardo as a colourist (*Art of Painting*, 3rd ed. n.d., p. 107). Leonardo's colour studies were occasionally discussed in the eighteenth century because he was wrongly supposed to have anticipated Newton in distinguishing the primary colours and the nature of white light (e.g. J.J.delaLande, *Voyage d'un Français en Italie . . .* 2nd ed. 1769, p. 312, possibly derived direct from Paolo Frisi: *cf.* Frisi's *Elogio del Cavaliere Isaaco Newton*, 1778; also P.Guglielmo della Valle, *Lettere Sanesi.*, I, 1782, p. 15. These references I have from E.Verga, *Bibliografia Vinciana*

1930), but they are rarely referred to in discussions of colour in art. Barry's treatment of a (now untraced) *Saviour* in the Paolo Borghesi collection in Rome, which he compared to Giorgione, is exceptional. He concluded: 'There are passages even in Leonardo's Treatise on the Art, which directly lead to this manner and (as the book was occasionally written as matter of reflection occurred) were no doubt penned down at the time when the first ideas of his glorious improvement in the conduct of light and colours suggested itself.' (*Works, cit.* I, p. 543)

38 Deschamps, *Les Vies des Peintres Flamands*, 1753, I, p. 310, *cit.* C.L.Eastlake, *Materials for a History of Oil Painting*, I, 1847 (re-issue 1960), pp. 492–3; De Piles: 'Prenez les couleurs les plus belles comme un beau rouge, un beau jaune, un beau bleu, un beau verd, et les mettez separément les uns auprès les autres, il est certain qu'elles conserveront leur éclat et leur force en particulier et toutes ensemble; que si vous les melez, vous n'en ferez qu'une couleur de terre'. De Piles does not mention Rubens by name. (*Seconde Conversation* ... 1677, p. 303, *cit.* Teyssdère, *op. cit.* p. 268) *cf.* also Opie, *Lectures, cit.* pp. 164–5, where Rubens's method shows him to be 'a most profound theorist'.

39 W.Hogarth, *The Analysis of Beauty*, ed. Burke, 1955, p. 133.

40 *Musée de Montpellier. La Galerie Bruyas* ... 1876, pp. 361–3; *cit.* L.Johnson, *Colour in Delacroix, Theory and Practice* (unpubl. Cambridge Ph.D. Thesis, 1958, pp. 15–16. Colour detail repr. Johnson, *Delacroix, cit.* pl. 5), *cf.* also Delacroix on a Rubens nude child: 'C'est de l'arc-en-ciel fondu sur la chair ...' (G.Sand, *Impressions et Souvenirs*, 1873, p. 90, *cit. id. Colour in Delacroix*, p. 55). For a similar, slightly earlier practice in England, J.B.Flagg, *Life and Letters of Washington Allston*, 1892, p. 192.

41 Howard, *op. cit.* pp. 172–3.

42 Turner: *ib.*; *cf.* Reynolds, *Works*, II, p. 232; Fuseli in Pilkington *Dictionary*, 1805, p. 482 n, where, however, Rubens was censured for not being prismatic

enough in the 'economy of his tints'. That Turner continued to object to Rubens on the score of his infidelity to Nature is confirmed by Samuel Rogers, *Table-Talk*, ed. Bishop, 1952, p. 112, referring to a discussion with Wilkie in 1829 (Finberg, *Life*, p. 314). Turner made sketches of Rubens's *Chapeau de Paille* in 1823/4 (TB CCV, p. 44; *cf.* Reynolds, *Works*, II, p. 187); and *Helene Fourment in a Fur Wrap* in Vienna in 1840 (TB CCCXI, front cover). Mr Hardy George kindly drew my attention to this sketch.

43 Turner Sale, Christie, 25 July 1874, lot 22. The price of 8s fetched by this picture makes it very unlikely that it was a contemporary or even a very good copy.

44 Ziff, 'Backgrounds', *cit.* p. 138.

45 TB CII, pp. 15–28. I transcribe this important passage in Appendix II, A.

46 For this stage in Turner's appreciation of Rembrandt *cf.* 'Turner and the Picturesque', *Burlington Magazine, cit.* pp. 76–9.

47 The principle was recognized as such by F.Howard, *The Sketcher's Manual*, 1837, Sect. V.

48 Ziff, 'Backgrounds', *cit.* pp. 138–9. Professor Ziff's transcription of the 'Thermae' passage is incomplete. I have restored it from BM Add. MS 46151, P, f. 8v. The confusion of right and left in the account suggests that Turner was refreshing his memory of the painting from a print in reverse.

49 C.Du Fresnoy, *The Art of Painting, cit.* ll. 523–39, adduced by Ziff, *loc. cit.* Reynolds, Notes XLIII, XLI, to DuFresnoy.

50 Finberg, *Life*, no. 161, fails to reproduce the caption from Ovid:

> *Close by the sacred walls in wide Munichia's plain*
> *The God well pleased beheld the virgin train*
>
> Ovid's Metamorphoses.

given in the Academy catalogue, and on the engraving of 1842.

51 The broken bridge in *Mercury* seems to be based on the oil beginning TG 2692, which may help to date that beginning to 1810/11.

52 *Cf.* D.S.McColl, 'Turner's Lectures at the Academy', *Burlington Magazine*, XII, 1908, p. 345. I shall discuss the dating of the lectures in Chapter 6 below.

53 BM Add. MS 46151, H, ff. 37–39. The whole of this passage is transcribed in Appendix II, C.

54 *ib.* f. 37.

55 *ib.* f. 41. The *Lazarus* was probably the picture analysed by Turner in the Louvre in 1802 (TB LXXII, p. 54); and the Rembrandt may be the little painting in the Beaumont collection, now NG 43. Opie, *Lectures*, *cit.* p. 157, had a similar passage linking Tintoretto's powers of expression in this work with the Rembrandt treatment, as did Fuseli, Lectures VI, IX, *loc. cit.* II, p. 295, 365–7.

56 Lawrence to Canova, 23 Feb. [1820]; Bassano, Museo Civico, MSS Canoviani, V, 550, 3610; kindly communicated by Mr Hardy George.

57 T.Moore, *Memoirs, Journal & Correspondence*, *cit.* VII, 1856, p. 149, *cf.* also *Letters*, *ed.* Dowden, II, 1964, pp. 863–4.

58 For Eastlake's contact with Turner and his influence on the work of this Italian visit, see 'Turner's Academic Friendships: C.L.Eastlake', *Burlington Magazine*, CX, 1968, pp. 677–85.

59 J.Ruskin, *Works*, XXXV, p. 601 n.

60 N.Desenfans, *A Descriptive Catalogue . . . of some Pictures . . . purchased for the late King of Poland . . .* 3rd ed. I, 1802, p. 158.

61 C.R.Leslie, *Memoirs of Constable*, ed. Mayne, 1951, pp. 192–3; T.Phillips, *Lectures*, *cit.* p. 140 n.

62 *Cf.* A.C.Coxhead, *Thomas Stothard*, 1906, pl. facing p. 140. It seems likely that Turner's remark (to C.R.Leslie?) in admiration of Stothard's work: 'I consider

him the Giotto of the English School' (Lovell Reeve, *Literary Gazette*, 1851, p. 924; *cf.* Leslie, *Autobiographical Recollections*, *cit.* I, p. 130) should read 'Watteau'.

63 Du Fresnoy, *op. cit.* ll. 445–50. I have quoted rather more of this passage than was included in the caption to the picture.

64 *Cf.* G.Field, *Chromatography*, 2nd ed. 1841, pp. 118, 126; T.Bardwell (1756), *cit.* Schmid, *The Practice of Painting*, 1948, pp. 93–4, and, closest in time and phraseology to Turner's formulation, Thomas Phillips: 'The power of white by itself, is limited to its contrasts with other colours, and it advances or retreats in effect, accordingly as those contrasts are strong or weak; a circumstance of infinite advantage to those who know how to make a proper use of it, like Rubens, Titian, Claude, Sir Joshua Reynolds and Mr West; and appertaining to no other material we possess' (*Lectures*, *cit.* (1829), p. 354).

65 BM Add. MS 46151, H, f. 40; *cf.* also *Morning Herald*, 28 Jan. 1818.

66 Note XLIII to Du Fresnoy.

67 Turner copied Watteau's *Festival of Love* in Dresden in 1835 (TB CCCVII, p. 6a). I have been unable to substantiate a story that Turner made a copy of the Dulwich picture in 1832 (L.Herrmann, *J.M.W. Turner*, *cit.* p. 24; H.Adhémar, *Watteau*, 1950, p. 228).

68 Finberg, *Life*, p. 264. The Ingres series, beginning in 1813, repr. G.Wildenstein, *Ingres*, 1954, nos. 86, 88. In 1817 H.J.Fradelle showed a *Raphaelle and la Fornarina* at the British Institution, with the caption: 'La Fornarina is distinguished by the intimacy in which she lived with Raphaelle. He is here represented in the act of painting the celebrated picture of her, which is preserved in the Ducal Gallery at Florence.' In 1824, N.Brockenden's *La Bella Fornarina observing the progress of her portrait in Raphael's study* was still thought of as an un-English subject (*Somerset House Gazette*, 14 Feb., p. 290).

69 Curiously enough, Quatremère de Quincy, comparing the *Loggie* with the

Sistine ceiling, said that here Raphael had been obliged to give his frescoes the scale of easel paintings (*Histoire de la Vie et des Ouvrages de Raphaël*, 1824, p. 245). Turner was still sufficiently interested in Raphael in 1835 to make a (much distorted) sketch of the *Sistine Madonna* in Dresden (TB CCCVII, p. 7a).

70 As late as the early nineteenth century, Roman Church porticos were still used as picture-galleries in the absence of any regular exhibition facilities (F.Noack, *Das Deutschtum in Rom*, I, 1927, p. 500) C.F.von Rumohr distinguished Raphael from Michelangelo, Correggio and Titian in his need to have his works seen together (*Italienische Forschungen*, ed. Schlosser, 1920, p. 502).

71 A watercolour inscribed 'Raff Villa' (TB CCLXXX, 135) is related to the inset landscape in design; but seems to have little to do with the 'Casino' near the Villa Medici which was accepted as Raphael's and was painted by Ingres (Wildenstein, *op. cit.* pl. 14, no. 50 *cf.* [C.A.Eaton] *Rome in the Nineteenth Century* . . . III, 1820, pp. 96–7) I am grateful to Mr Leslie Parris for uncovering and pointing out the inscription in Turner's picture.

72 TB CXCIII, p. 85a. *cf.* Quatremère de Quincy, *op. cit.* p. 240; S.Rogers, *Italian Journal*, ed. Hale, 1956, p. 222; J.D.Passavant, *Raphael von Urbino*, 1839, I, pp. 249–50; II, p. 438. In 1820, however, Passavant still regarded the *Jonas* as by Lorenzetto after Raphael's drawings (*Ansichten über die Bildenden Künste* . . . 1820, pp. 175, 177). For an account of Raphael's eighteenth-century reputation as a sculptor, and the forgery of his work: S.Howard, 'Boy on a Dolphin: Nollekens and Cavaceppi', *Art Bulletin*, 46, 1964, esp. p. 186, n. 65, 187, n. 70. Turner's own activities as a sculptor have yet to be documented; but the crude wall tablet to his father in St Paul's, Covent Garden, might make a beginning to the *oeuvre*.

73 Raphael in göttlicher Heiterkeit ist zugleich auch der umfassendste; Keiner hat mit gleicher Leichtigkeit sich alle Richtungen in der Kunst anzueignen gewusst; in ihm scheinen sich alle Anlagen, welche einem Menschen die Vollkommenheit zu erreichen möglich machen, vereinigt zu haben. Ohne Zweifel ist er als der vollkommenste Künstler anzusehen, der je gelebt hat. *Ansichten* . . . *cit.* p. 49. *cf.* Quatremère de Quincy, *op. cit.* pp. 223, 406. This view goes back to Vasari's 2nd edition (*Le Vite*, Milan, 1810, VIII, pp. 121–2).

74 H.W.Tischbein, *Aus Meinem Leben*, 1956, p. 143; Quatremère de Quincy, *op. cit.* pp. 253–4. In 1817, however, when he was concerned with the establishment of the *Prix de Rome* for landscape, and was stressing the dangers of specialization, he had *not* included Raphael with Titian, Domenichino, Poussin and the Carracci, as history painters who were also landscapists (R.Schneider, *Quatremère de Quincy et son Intervention dans les Arts*, 1910, p. 297). *cf.* also Passavant, *Raphael*, II, pp. 435, 476, 524, 537, 581–2, 595. For the surviving landscapes of the Raphael School in the *Loggie* (1517/19): A.R.Turner, *The Vision of Landscape in Renaissance Italy*, 1966, pp. 159 ff. and fig. 115; *cf.* also p. 171 and figs. 124–5 for the early seventeenth-century landscapes in the *Loggia* above Raphael's.

75 'Mr Turner's power in the use of his pallet is so entire, that he may make the most daring use of its colours and yet command our admiration. The golden glow which he generally and so exquisitely adopts, is this year considered as exaggerated, so that the room in which he has represented Raffaelle . . . is thought to look like a furnace' (Courtauld Institute, *Press Cuttings on the Fine Arts*, II, p. 142).

76 *Cf.* J.Richardson, *Works, cit.* pp. 68–9; Reynolds, *Discourse*, V; A.R.Mengs, *Works, cit.* I, pp. 58–9, 160. Reynolds's attitude was endorsed in Turner's day by R.Duppa, *Life of Raffaello Sanzio*, 1816, pp. 80, 88; and by Lawrence in a letter of 1819 (D.E.Williams, *Life and Correspondence of Sir Thomas Lawrence*, 1831, II, p. 184).

77 e.g. BM Add. MS 46151, H, f. 26v. The reading of this passage is not entirely clear, although Turner seems to be supporting Opie's view of the desirability of eclecticism (*Lectures, cit.* pp. 116–17). In the

notes to Shee, however (pp. 36–7), Turner, recalling the activities of the French restorers in 1802, concluded: 'Notwithstanding the surface of the Transfiguration is not exactly the surface which Raphael left, yet for breadth, judicious chiaroscuro and color it must indisputably be looked at with awed veneration of his talents; and with stronger claim to [his being] a colourist than any Picture by him, not excepted the Madona della Sedia in the Louvre.' Shee, despite his placing Raphael above Michelangelo as an artist, did not make the highest claims for his colour.

78 *Abrégé de la Vie des Peintres* ... 1699, p. 178, where, however, De Piles denied to Raphael a real knowledge of chiaroscuro. Turner made a note of the Uffizi portrait: 'Raf 1512' in 1819 (TB CXCI, p. 60), a note which puzzled Professor Ziff, 'Copies from Claude's Paintings ...' *cit.* p. 56.

79 S.Rogers, *Italian Journal, cit.* pp. 234, 213.

80 C.F.vonRumohr, *op. cit.* pp. 556–7. Rumohr had been gathering material for his studies in Rome since before 1820. *cf.* also Quatremère de Quincy, *op. cit.* p. 97, where, however, the style is seen as an imitation of Venetian painting; Passavant, *Raphael,* I, pp. 198, 255.

81 Farington *Diary,* 13 Dec. 1817. For the history of West's idea, see above, p. 223, n. 19.

82 Add. MS 46151, T, ff. 3v–4 (Lecture II, 1818).

83 Ziff, 'Backgrounds', pp. 136–7. In 1803, Turner had visited the Truchsess Gallery, which showed what purported to be a number of German and Flemish Primitives (Farington, *Diary,* (unpubl.) 2 Aug.) but this enormous collection was predominantly devoted to High Renaissance and seventeenth-century masters.

84 TB CLXXV, cover. In Rome in 1828, Turner seems to have been associated with a Grossi (TB CCXXXVII, cover) who may have been the Crivelli dealer (M.Davies, *National Gallery, The Earlier Italian Schools,* 1961, p. 163).

85 Marginalia to Reichard's *Italy,* 1818, p. 58 (TB CCCLXVII). Piero di Cosimo had hardly been considered by art-historians since Vasari, although Lanzi in 1795 had praised his colour (P.Morselli, 'La Fortuna di Piero di Cosimo' in 'Ragioni di un Pittore Fiorentino, Piero di Cosimo', *L'Arte,* NS XXII, 1957, p. 155). Wackenroder's account of Piero's 'Seltsamkeiten' in the *Herzensergiessungen* (1797) are hardly criticism, and they close with a denial of his worth as an artist. One of Piero's most painterly canvases in the Uffizi, the *Liberation of Andromeda,* to which Turner may have been referring, has recently been rejected from Piero's œuvre by Mina Bacci, *Piero di Cosimo,* 1966, pp. 55–6 and pl. 55; but Turner may also have seen the *Immaculate Conception with Saints,* which was in the gallery by 1816 (*ib.* pp. 84–5).

86 TB CCCLXVII, p. 59. For a criticism, *Galerie Impériale et Royale de Florence,* 1822, pp. 57–8; also Fuseli (1808), Knowles, *op. cit.* III, p. 166. Turner also noted a 'Botticelli drawing' on the flyleaf of his guidebook.

87 In 1819 Ottley had engraved some Giotto fresco fragments from the Rogers collection (Now NG 276 as Spinello) in *The British Gallery.* Rogers also had an important collection of mediaeval miniatures (Mrs Merrifield, *Original Treatises ... on the Arts of Painting,* I, 1849 (re-issue 1967), p. xxxvii), and Turner's finely hatched and stippled technique and vivid colour for his small vignette watercolours, beginning with those for Rogers's *Italy* (1830) and *Poems* (1834), may well owe something to this type of painting. For Turner's contact with Ottley's ideas, Finberg, *Life,* p. 310. Phillips, *op. cit.* pp. x–xi.

88 TB CCXXXVII, pp. 38a–39. An architectural note of the interior of the Campo Santo is on p. 39a. For Koch, *cf.* his 'Gedanken über Malerei' in D.Strauss, *Kleine Schriften,* 1862, pp. 310–12. The Orcagna *Last Judgement,* and the Gozzoli *Noah* series noted by Turner had been engraved by Ottley in 1826 in *The Early Florentine School* (pls. XXXI, XLVI–IX). A.W.Callcott and his wife, Maria Callcott, friends of Turner's, had visited the Campo

Santo early in 1828 (R.B.Gotch, *Maria, Lady Callcott*, 1937, p. 273).

89 e.g. *Marly-sur-Seine* (*c.* 1830): no. 433; *Florence*: no. 426 (surely later than the date of *c.* 1826 given in the MS list) *Richmond Hill and Bridge* (1832 (R 257)): no. 435.

90 TB CCCXI front cover: note of Marco Basaiti's *Calling of the Sons of Zebedee*; and (p. 1) note of Zelin's (G.Bellini's) borrowing of a profile head from Mantegna. The source of the second reference eludes me, although copies by Bellini from Mantegna are known; and the date of this book may be earlier than the 1840 given by Finberg.

91 *Depositing of John Bellini's three Pictures in la Chiesa Redentore.* RA 542. In February 1841, Turner ascertained the name of the church holding the Bellinis he remembered (Thornbury, 1904, p. 329); and his reference to the painting simply as *John Bellini* in another letter of that year (Finberg, *Life*, p. 383), suggests that the painter was, for Turner, very much the subject of the picture, which seems formally a canal-scape. None of the three Madonnas in the Redentore then attributed to Bellini are now thought to be his work, but have been allocated to Alvise Vivarini and Andrea da Murano. Only one early remark by Turner on Bellini has so far come to light: in 1829 in Rome he referred to the Bellini/Titian *Feast of the Gods*, then in the Cammuccini Collection, as 'not a landscape but a background'. (D.Laing, *Etchings by Sir David Wilkie*, 1875, p. 23.) It was, however, common knowledge that this was a work of collaboration, and Turner must have known rather than sensed it.

92 The point is put most sharply in Mrs Merrifield's translation of Cennino Cennini's *Libro dell'Arte* (1844), p. x, where she compares the fourteenth-century manner of handling the brush in clearly divided strokes with Rubens.

93 *Cf.* W.Dyce in 1845 on Pinturicchio, in A.Staley, 'William Dyce and Outdoor Naturalism', *Burlington Magazine*, CV, 1963, p. 473.

94 Turner Sale, Christie, 25 July 1874: Reynolds: lot 17: Portrait of a Lady, *a sketch*; lot 23: A Female head, and a man's head—*sketches*; lot 27: Study of a Gentleman; and other figures. Lot 18, described as Lawrence: Head of a Gentleman—*a sketch*, was annotated as 'Keppel' in Christie's marked catalogue, and may possibly have been the 'Admiral Lord Keppel, a sketch', bought by Turner with 'the late Duchess of Devonshire' as Reynolds, in the Reynolds Sale, Christie, 26 May 1821; lot 10: Wilson; lot 20: *View of Sion House* (*cf.* W.G.Constable, *Wilson, cit.* p. 185); lot 21: A landscape with figures; lot 24: A pair of lake scenes; lot 25: A River Scene (*River and Cloud*, Constable, *op. cit.* p. 231, pl. 129a). Turner also had a copy of part of Titian's *Sacred and Profane Love* in the Borghese (lot 19), which he had himself copied in 1819 (TB CXCIII, p. 4). Lot 26 was: 'Venetian: Marine Deities'.

95 In the cases of the *Blacksmith* (RA 1807; TG 478), *Now for the Painter* (RA 1827, Manchester City Gallery); *Shadrach, Meshach and Abednego* (RA 1832; TG 517) and *Canaletti Painting* (RA 1833, TG 370), **27**, pictures by Wilkie, Callcott, Jones and Clarkson Stanfield were manifestly the starting points of the ideas; and occasionally there is a reminiscence of Jones in the drawings (e.g. TB CCLXXX, 139); but these incidents are hardly influences in the normal sense.

96 *Cf.* J.Ruskin, *Lectures on Art*, 1870, I, §8. W.P.Frith recorded that 'Turner's treatment of young men, and his kindness in expressing his opinion of all contemporary work, were in exact opposition to the general notion of his disposition' (*My Autobiography & Reminiscences*, I, 1887, p. 127). An example is given by Sir William Allen in a letter to John Burnet, 31 Aug. 1831: 'Turner was here the other day, he has been at Abbotsford, and by this time will be in the Island of Sky. I believe he is to do something for Cadell, he told me that he had seen my picture of the Fair Maid of Perth in London, and said much in its favour, more than I could have expected from such a man as Turner ...' (MS in Fitzwilliam Library, Cambridge).

97 Thornbury, 1904, p. 139.

98 Ruskin, *Works*, VII, 1905, p. 443 n.: 'On one occasion I made a severe remark on a sunrise by Danby, Turner caught hold of my arm and said, "Don't say that; you don't know how much such things hurt. You only look at the truth of the landscape; Mr Danby is a poetical painter."'

99 *Cf.* especially TB CCLXXX, 190, 197. Danby's conception probably goes back to designs like Flaxman's 'Statue of Four Metals' (Dante: *Inferno*, Canto XIV), which was also influential for Runge's 'Loda', from Ossian (both repr. in G.Berefelt *Philipp Otto Runge*, *Zwischen Aufbruch und Opposition*, 1961, figs 81, 82. Danby was in the Rogers–Campbell–Moore circle in the early 1830s; and had himself been deeply affected by Turner's work as a student in the early 1810s (G.Grigson, *The Harp of Aeolus*, 1947, p. 67).

100 At the Jackson Sale, Christie, 15 July 1831, Turner bought lot 3, Jackson: A parcel of sketches and groups or parts of pictures; lots 14 and 15: *id*. Thirteen Sketches of portraits; Eleven, Mr Thomas Harrison and ten others; lot 153: The Duke of Wellington, whole length, unfinished; and a group by Owen. The Duke of Wellington sketch was lot 29 at Turner's own sale, Christie, 25 July 1874; and others from the Jackson sale may have been unidentified portrait sketches in lots 7, 8, 14, 16 at the same sale. The Westall was in Turner's Sale, lot 28, bought by Waters for 3 gns.

101 Finberg, *Life*, p. 316. West's picture (ill. *Burl. Mag.*, Dec. 1968, fig. 49), is now in an American Private Collection. Other unidentified subject pictures in Turner's sale, possibly by English Artists, were: lot 3: A Battle-Piece (bt. Waters, 10s 6d); lot 6: Venus and Cupid; and Venus and Adonis (bt. Hollyer, £1); lot 12: *A Girl with Cymbals*, (bt. Eyre, £15 4s 6d: ? a version of West's *Baccante* now in the English Speaking Union, London, from the Leicester Collection); lot 13: A Sportsman and Dogs (bt. Waters, £1 2s); lot 15: A Cavern scene and a Lion. Of the unidentified landscapes: lot 10: A Landscape with Figures and Goats, may possibly have been the picture which the younger Trimmer recognized as a Tassi (Thornbury, 1904, p. 362); and the other, lot 11: A Landscape with Banditti, could conceivably, though improbably, have been a work by Henry Bright, the Norwich School landscape painter, who was thought to have sold work to Turner (*ib*. p. 98).

102 For Girtin in a landscape, TB CCXIV, p. 196 (1825); CCCX, p. 68 (1840); CCCXLVII, 66, 70 (*c*. 1840). Claude and Wilson are constantly referred to in the Italian sketchbooks of 1819, Cuyp on the Dutch Tour of 1825, and in Scotland in 1831 (TB CCLXXIII, p. 82a); Dughet in 1831 and 1834 (TB CCLXXIII, pp. 60a, 81; CCLXXXVII, p. 62a).

103 Finberg, *Life*, pp. 203–3.

104 TB CCCXLII, 63, 64, 65, 66, 70; CCCXLV, p. 12. A related watercolour, in Sir Edmund Bacon's collection, was reproduced (in reverse) in A.J.Finberg & W.G. Rawlinson, *Watercolours of J.M.W.Turner*, 1909, pl. XXII. The date 1840/1 given there is preferable to '*c*. 1836' given in the catalogue of Agnew's *Turner*, 1967, no. 75.

105 TG 553, 554: *Mercury sent to admonish Aeneas*, 555, *The Visit to the Tomb*. For a brief account of the un-Picturesque quality of Girtin's idea in the context of 1800, 'Turner and the Picturesque' *cit*. pp. 75–6. I have not been able to trace the use of the device in Turner before the 1840s.

106 Finberg, *Life*, p. 230.

107 i.e. Anton Raphael Mengs, the German painter whom Turner classes as French.

108 Notes to pp. 32–3 (C.W.M.Turner Collection). For another reading of part of this passage, Lindsay, *Turner*, p. 137.

109 Turner: TB LXXII, p. 33; Farington, *Diary* (unpubl.), 29 Sept. 1802. Turner made frequent references to Vandyke in his lectures, and his *Lady Putting on her Glove* (TG 5511) is a free version of Vandyke's *Countess of Bedford* at Petworth. The 'Portrait of a man in armour—temp Charles I' in Turner's collection (Christie: 25 July 1874, lot 9, bt. Johnson, £4) may

have been a copy of the Petworth *Earl of Stafford* by Vandyke, to which Turner made extensive reference in Lecture v (Add. MSS 46151, H, ff. 5v–6).

110 M.E.J.Delécluze, *Louis David, Son Ecole et Son Temps*, 1855, p. 290. *cf.* also *ib.* p. 113 for David's view of the feeble colouring of the French School in general.

111 Farington, *Diary* (unpubl.), 8 Sept., 1 Oct. 1802. *cf.* also M.A.Shee, *Rhymes on Art*, 2nd ed. 1805, p. 4 n., where *Sextus* and other pictures by Guérin were praised for 'a power of expression an eye for colouring and effect'; and M.A.Shee, *The Life of Sir M.A.Shee*, I, 1860, p. 249. The *Marcus Sextus* is reproduced in R.Huyghe, *Delacroix*, 1963, pl. 49.

112 Farington, *ed. cit.* II, p. 50 (4 Oct. 1802).

113 *ib.* (unpubl.) 3 Oct.

114 TB CCLXXX, 146 (R 353). The engraved version is rather closer to the David in the pose of the figure. Turner may have seen it again in London in 1815, when it was exhibited with two of David's other works (v & A *Press Cuttings*, IV, pp. 919, 923).

115 'As to the battles,' he wrote on his return, 'I have made sketches from the pictures painted by order of Bonaparte of Marnego and Eylau—Lodi I can get in London—Waterloo I have, but I desired a German bookseller in Paris to obtain any print of the above places with Austerlitz, Wagram & Friedland, and he is to write me word on what terms sketches can be had. In regard to Bonaparte's portrait, I have endeavoured to make some arrangements with a French artist who will write me word of the expense. Baron le Roy has one but nothing can induce him to let it be copied, nor will he sell the Picture. It would do well, is very like and [of] the time when Bony was first consul, I believe ...' Turner to Lockhart (?*cf. Catalogue of MSS in the National Library of Scotland*, 1938, p. 184) 4 Oct. (?) 1837. Copy by 'N.C.' National Library of Scotland, MS, 555 ff. 75–6v. I am greatly indebted to Mr Hardy George for drawing my attention to the Turner correspondence in this collection.

116 Delacroix, *Journal, cit.* 24 March 1855. In Turner's *Seine and Paris* sketchbook of *c.* 1830 there is a drawing of a studio interior (TB CCLIV, p. 2); and other drawings in the book (pp. 23a, 24) show that Turner was in Society at least occasionally on this trip.

117 Christie, 25 July 1874, lot 30 (bt. Brigg, 14s).

118 e.g. G.deRossi, *Memorie per le Belli Arti*, Rome, 1786, II, p. 63. Nagler, *Künstlerlexikon*, 1835, s.v. The Norfolk picture, or a variant of it, was referred to in the della Valle edition of Vasari's *Vite*, XI, 1794, p. 57.

119 The statement of A.Borzelli (*Napoli Nobilissima*, x, pp. 106–7) that Berger taught colour as well as history painting, seems to be based on a confusion with Paolo Girgenti (*cf.* C.Lorenzetti, *L'Accademia di Belle Arti di Napoli, 1752–1952*, 1952, p. 65, and pp. 211–12 for Berger). Berger's dossier at the Naples Academy is at present mislaid.

120 TB CCCLXVII, back cover, diagram dated '1812'. In a list of artists on the flyleaf of this book is 'Soldaini', which may refer to Benvenuti's pupil, Raffaello Soldaini.

121 Thornbury, 1904, p. 126.

122 The list (TB CXCIII, p. 99) is not always clear, but it seems to comprise, in the order given: Didier Boguet (1755–1839); Johann Christian Reinhart (1761–1847); Heinrich Voogd (1766–1839); Martin Verstappen (1773–1853); Johann Martin von Rohden (1778–1868); Joseph Rebell (1767–1828); Franz Catel (1778–1856). Theodor (possibly the Russian landscape painter Theodore Mantueff, noticed in the *Memorie Enciclopediche Romane sulle belle arti*, III (1806), pp. 14–15; or the 'Théodor' among the pensioners at the French Academy in 1809, H.Lapauze, *Histoire de l'Academie de France à Rome*, II, 1924, p. 94. *cf.* also the landscape painter mentioned in Rome in the early 1820s by Nagler, *op. cit.* XVIII, p. 307); Giambattista Bassi (1784–1852); Pierre Athanase Chauvin (1774–1832); Achille Etna Michallon

(1796–1822); Gaspare Gabrielli (d. 1828); 'Sislirz' (?possibly J.K.Schinz, in Rome, 1818–24); Joseph Anton Koch (1768–1839); Franz Kaisermann (1765–1833); Wilhelm Friedrich Gmelin (1760–1820); Friedrich Helmsdorf (1783–1852); Gregorio Fidanza (1759–1823); Lorenz Adolf Schonberger (1768–1847); Vierlint (?A. Teerlink, 1776–1857). 'Louthe' I have not been able to identify.

123 Farington, *Diary* (unpubl.), 9 June 1820. A letter from Turner to Canova was sent from the Palazzo Poli.

124 Letter dated 20 January 1820, *London Magazine*, I, 1820, p. 291.

125 e.g. Catel, Schinz, vonRhoden, Rebell, Helmsdorf, Gmelin. The catalogue of this exhibition was published by Passavant, *Ansichten . . . cit.* as an appendix.

126 *Cf. Diario di Roma*, 10 Nov. 1819, p. 1; and *Notizie del Giorno*, 9 March 1820.

127 TB CXCIII, p. 96; *cf.* also CLXXXVIII, p. 91a, and pp. 61–3a, 65a.

128 Academy of S.Luke, MS *Congregazioni*, vol. 59 (24 Nov. 1819), p. 87v.

129 Eastlake, *Contributions, cit.* pp. 60–5, 93. 'The Advantages and Disadvantages of Rome as a School of Art', *London Magazine*, I, 1820, pp. 42–8 (*cf. Contributions, cit.* p. 96).

130 *Contributions, cit.* p. 97.

131 *London Magazine, cit.* pp. 42–3, 47.

132 C.A.Eaton, *op. cit.* III, pp. 318–19.

133 TG 512 and caption. For Bassi, *Giornale Arcadico*, II, 1819, p. 282.

134 *Cf.* Koch, *Diary*, 1824: 'Wenn die Landschafter über die Kunst, und über ihr Fach nachdenken, dann ists auch aus mit der Landeschafterei. Die Kunst soll eins sein, wie die Natur, und nicht in Fächer getrennt.' (*cit.* W.Stein, *Die Erneuerung der Heroischen Landschaft nach 1800*, 1917, p. 87); also Koch to Giovanelli in 1826: 'Die Landschaft als Landschaft kann öfters wohl auch als poetisches Gemälde bestehen, wenn die lebendigen wesen darin untergeordnet sind, sodass die Landschaft die Hauptsache ist; aber die lebendigen Wesen geben ihr Ideen und Bedeutung, hierdurch entsteht ein malerisches Idyllengedicht ...' (O.vonLutterotti, 'Briefe J.A.Koch's aus Rom ...' *Veröffentlichungen des Museums Ferdinandeum in Innsbruck*, 18, 1938, p. 728). This tendency in Turner's work has been noticed by M.Kitson, *Turner*, 1964, p. 17.

135 For Chauvin: *Nouvelles Archives de l'art Français*, 3rd ser. V, 1889, p. 128; for Michallon, Lapauze, *op. cit.* pp. 141–3; on Boguet, *Gazette des Beaux Arts*, XI, 1925, p. 29.

136 The account of the award was published in the British Institution Catalogue. For the models, V & A *Press Cuttings*, III, p. 882. A reviewer identified the subject as the *Bay of Naples*, and compared it unfavourably with Turner and Callcott (Royal Academy Anderdon Catalogues, XV, 1812, facing p. 16) Glover held a one-man show in London in the early 1820s. hanging his own work beside that of Claude and Wilson, and he invited Turner to join him. Turner's enigmatic rejoinder was, 'If you are so confident, try it yourself' (J.L.Roget, *History of the Old Water-Colour Society*, 1891, I, p. 405).

137 See letters of 1807 (*Jb d. Preuss Kunstsmlg*, 59, 1938, p. 199); 1812 (O.von Lutterotti, *J.A.Koch*, 1940, p. 154); 1816–17 (*ib.* pp. 182–3).

138 Lutterotti, *op. cit.* pp. 187–8. The Englishman was possibly the dealer and miniature painter, Alexander Day, to whom Koch had been close in 1811 (*Prussian Jahrbuch, cit.* pp. 260–2).

139 1812, Lutterotti, *J.A.Koch, cit.* p. 156.

140 *Cf.* letters of 1825–6 to Giovanelli (Lutterotti, *Briefe, cit.* pp. 719–20, 722, 728) and of 1830 to Uexeküll (*Pr. Jahrbuch*, p. 277).

141 Lutterotti, *J.A.Koch, cit.* p. 180.

142 Cole to Dunlap, *c.* 1832, L.Noble, *The Course of Empire*, 1853, pp. 170–1.

143 Thornbury, 1904, p. 100. That the *Orvieto* was the finished picture is borne out by a letter of Eastlake to Maria Callcott of November 1828 (R.B.Gotch, *op. cit.* p. 279). Turner, according to his advertisement in the *Diario di Roma*, 17 Dec. 1828, showed at first only two 'paesaggi' (*Orvieto* and *Regulus* (TG 519)), for one week from 18 Dec.

144 Gotch, *op. cit.* p. 280; *cf.* Geddes to Sheepshanks, 11 April 1829: 'The people here cannot understand his style at all' (Laing, *op. cit.* pp. 21–2).

145 Lord Broughton (J.C.Hobhouse), *Recollections of a Long Life*, III, 1910, pp. 294–5. Campbell had a studio near Turner's on the Piazza Mignanelli, and associated a great deal with German, and sometimes French artists (*cf.* T.L.Donaldson in *Art Journal*, 1858, p. 107).

146 For the collaboration of Reinhart and others: J.A.Koch, *Moderne Kunstchronik, ed. Jaffé*, 1905, pp. 16–19. F.Noack (*op. cit.* I, p. 479) suggested, too, the assistance of Hess and F.Müller; stating that the poem was begun in 1800, and that Koch had resisted the suggestion that he should publish as late as 1826.

147 So grosser und grobgesinnter Pöbel sich auch einfand, die Ausstellung dieses weltberühmten Engländers, namens Turner, in Augenschein zu nehmen, so war die Waare doch zu sehr unter aller Kritik und unter der von der modernen Welt bewunderten Mittelmässigkeit, als dass es dem armen Turner nicht eben so schlimm ergangen wäre, wie wenn er sich in die Vortrefflichkeit selbst verstiegen hätte: denn diese beiden Extreme liebt unsere moderne Welt durchaus nicht, sie will die langweilige schläfrige Mittelstrasse, auf welcher man, trotz aller beschränkten Aussicht, doch nirgends anstösst. Diese Ausstellung ward fleissig besucht, belacht und bepfiffen, welches bei mittelmässigen, nicht ausserordentlichen Dingen unterbleibt. Das bekannte Cacatum non est pictum war doch auch noch ein Liedchen, wobei man lustig sein konnte, indem man ja weiss, wie wenig dazu gehört, die Leute bei guter Laune zu erhalten; es waren diese Bilder statt der goldnen Rahmen mit Schiffsauen eingefasst. Die Beschreibung derselben kann man nicht ... gut geben ... obgleich die Composition, welches die Vision der Medea vorstellen sollte, sonderbar genug war; so viel ist hinlänglich, dass in dem Bilde, es mochte von der Seite oder ganz umgekehrt aufgestellt sein, stets gleich viel zu erkennen war; im Ganzen ist es nach dem englischen Mylord-Geschmack der anglikanischen Phantasie überlassen und ungefähr das, was die Franzosen tableau fouetté nennen, und die Composition ungefähr der Art, wie solche von einem Wiener Professor, namens Schmutzer, geübt und gelehrt ward, da er zu seinen Schülern sprach: 'Schaut's wenn's erfinden oder componiren wollt's, so bindet euch die Augen zu und macht's was euch einfällt, und wenn ihr auf diese Weise etwas gemacht, wovon ihr glaubt, dass es sich gut machen könnte, so nehmt's die Binde von den Augen; solcher zufall ist oft besser als alle Pedanterie, und wenn ihr malt, so nehmt's den grössten Pinsel und besinnt euch nicht erst lange, sondern malt's frisch darauf los. *Moderne Kunstchronik: Briefe zweier Freunde in Rom und in der Tartarei über das moderne Kunstleben und Treiben; oder die Rumfordsche Suppe gekocht und geschrieben von Joseph Anton Koch in Rom*, (1834), *ed. cit.* pp. 109–10.

148 Blechen's debt to Turner has been put forward by German Scholars since 1905 (G.J.Kern, *Karl Blechen*, 1911, p. 66); but he did not arrive in Rome until May 1829 (P.O.Rave, *Karl Blechen*, 1940, p. 12), when Turner had long since left; and although Turner's pictures did not reach London until July, they seem to have been packed or dispatched in March or April (Finberg, *Life*, pp. 316–17, *cf.* A.Cunningham, *Life of Wilkie*, 1843, III, p. 13, *Burlington Magazine*, CX, 1968, pp. 680–81). There is no reference to Turner in Blechen's detailed account of his Italian trip (Rave, *op. cit.* pp. 13–18). R.Causa, *Pitloo*, 1956, pp. 75–6, has claimed Turner's influence on that Neapolitan painter; but his movements are certainly not documented for this period, and nothing in his work suggests interests that could not have been developed in French company in Rome, already clear in the rather Granet-like *S.Giorgio in Velabro* (Rome, Collegio Pontificio Olandese) of the early 1820s.

149 *Cf.* the advertisement in *Diario di Roma*, 5 Nov. 1828, p. 4.

150 Reinhart announced his commission in a letter of October 1825 (O.Baisch, *J.C. Reinhart und sein Kreis*, 1882, pp. 267–8) and in April 1829 he talked of their popular exhibition for a month in his house, before they went into the Marchese Massimi's room (*ib.* p. 274).

151 16 Oct. 1825, *ib.* p. 268.

152 Finberg, *Life*, p. 310. Eastlake's studies in Old Master techniques make his testimony an especially valuable one.

153 Hanson, *art. cit.* pp. 171–2.

154 BM Add. MS 46151, M, f. 23 (1810). *cf.* also 'Lineal perspective is the servant of light and shade, as light and shade is that of colour' (*ib.* A, f. 19).

155 Professor Ziff's attempt to associate the *Fallacies* with Langhorne's *Visions of Fancy* and other poems ('John Langhorne and Turner's "Fallacies of Hope"', *Journal of the Warburg and Courtauld Institutes*, XXVII, 1964, pp. 340–2) fails by disregarding the chronology of the situation, the fact of Langhorne's borrowing of the phrase 'fallacious hope' from Thomson (e.g. *Autumn*, l. 1258), and the meaning of some of Turner's verses. Turner used Langhorne in 1798 but never subsequently; but he had Thomson very much in mind from 1809, when writing Pope's epitaph, to 1812, when he used *The Seasons* in a lecture (J.Ziff, 'J.M.W.Turner on Poetry and Painting', *Studies in Romanticism*, III, 1964, pp. 193–215), and published the first extract of the *Fallacies*. Turner had come across the expression 'Fallacies of Vision' (optical illusions) repeatedly in his reading for lectures, for example in Kirby, Hamilton, Smith and Priestley, and himself uses the phrase often, e.g. in MS G, f. 9, which may be the fourth lecture of the 1815 or 1816 courses and in N, f. 10v.

156 Ziff, 'Backgrounds . . .', p. 124; see Appendix II.

157 W.T.Whitley, 'Turner as a Lecturer', *Burlington Magazine*, XXII, 1913, p. 205.

158 F.W.Hilles, *The Literary Career of Sir Joshua Reynolds*, 1936, p. 258. See Reynold's account here *passim* for the controversy.

159 BM Add. MS 46151, E (1818), ff. 3v–4. Turner probably had some knowledge of Edwards's teaching since he refers to the ideas of shadow of 'my predecessor' in TB CVIII, p. 84a—only to disagree with them. Edwards had, however, published *A Practical Treatise on Perspective* in 1803.

160 Farington, *Diary* (unpubl.), 10 Dec. 1804.

161 *ib.* 11 Jan. 1807; Royal Academy, *Council Minutes*, 1807, p. 8.

162 *Council Minutes*, *cit.* 1809, p. 146; 5 Jan. 1810, p. 176.

163 Finberg, *Life*, p. 160.

164 W.T.Whitley, *art. cit.* p. 206. This lecture seems, from other remarks by Soane here, to be Add. MS 46151, N (*cf.* Ziff, 'Poetry and Painting', *cit.* pp. 198–9); but later additions on colour and the relationship between poetry and painting in this MS must have been given in the last lecture of the series, since they are mentioned in a review in the *Sun* of 18 Feb.

165 Farington, *Diary* (unpubl.), 10 March 1812.

166 BM Add. MS 46151, Q, f. 6v. The dating of this series to 1814 depends on the fact that it does not correspond to the reports of the series for 1815–19; and the reference to the 'royal founder's' interest in mathematics and science must clearly refer to George III, who died in 1820. For remarks on a second (?private) course on 'rules' in 1818, MS BB f. 46.

167 J.Burnet, *Turner and his Works*, 1852, p. 84. It is possible, however, that he is referring to a course in the 1820s.

168 *Cf.* press reports collected in the *Whitley Papers*, *cit.* XII, pp. 1558–62.

169 Farington, *Diary* (unpubl.), 13 Feb. 1816; Whitley, *art. cit.* pp. 255–6. The

complaint, which was apparently not delivered, is in MS BB, f. 46, and again at the end of MS S. The new syllabus was outlined on the first page of MS O (D.S. McColl, *art. cit.* p. 345). From the unusually full and sustained reports in the *Morning Herald*, it is possible to identify most of the MSS used in the 1818 course. Lecture I: MS S; Lecture II: MS T; Lecture III: MS E; Lecture IV: *Light, Shade and Reflexies*, MS in C.W.M.Turner collection; possibly together with MS BB, ff. 19–21; Lecture V: later additions to MS O; Lecture VI: later additions to MS H.

170 Brief notices in the *Sun* for 1819 suggest that MSS V, W, X and Y were the new Lectures II, III, IV and V this year; and for this series, Turner made the new diagrams watermarked 1817 in TB CXCV. From the account given in the *British Press* on 5 January, the opening lecture seems to have been the third lecture of 1811; the second draft in MS J. The last may have been MS P on *Backgrounds*, since it had a pencilled note on the destructive fire at Belvoir Castle in October 1816, (i.e. after Turner had given his 1816 series); and no *Backgrounds* lecture was included in the 1818 course, when there was another reference to this loss in Lecture VI. MS AA, endorsed by Turner as 'the different method' seems to be the first lecture of 1821, since it has a reference to a delay in delivery; and in this year, the course began a month late. The 'Impending inconvenience' referred to in a later draft of the same lecture may well refer to disturbances due to the construction of Turner's new gallery. The watermark 1823 on a large number of lecture diagrams in the Turner Bequest suggests that the 1824 course was much remodelled, which would tally with the account of a very factual and diagrammatic Lecture I in the *European Magazine* of January that year. MS K, originally an opening lecture, was used again later in 1824, for some additional notes bear that date. I shall refer to the additions to later series of the 1820s later on.

171 Turner must have known Samuel Wale's work, which is not extant, for he used two of Wale's diagrams in his own series. (TB CXCV, 56, 79.)

172 An elaborate analysis of the contents and precise length of some of Reynolds's *Discourses* is in TB CVI.

173 MS H, ff. 5v–8v.

174 e.g. J.Richardson, *Works*, 1792, p. 39; A.J.Pernety, *Dictionaire Portatif de Peinture* ... 1757, p. 69; J.B.Deperthes, *Théorie du Paysage*, 1818, pp. 160–1.

175 Turner's use of this source has been overlooked by Ziff, 'Turner and Poussin', *cit.* pp. 319–20; and his reading of the passage differs considerably from my own, which leads me to believe that Turner is denying the validity of Félibien's classification.

176 This passage has been discussed by Ziff, 'Poetry and Painting', *cit.* pp. 200–1.

177 MS N, ff. 10v–11 (later addition). See Appendix I B. Turner is paraphrasing M.Akenside, *The Pleasures of Imagination*, I, 1744, l. 183; 1757, ll. 242–3.

178 TB CXII, p. 17 has a note on the colouring effects of lights taken from George Adams, *Geometrical and Graphical Essays*, 2nd ed. 1797, pp. 486–7. A reference to Adams' work in MS G, f. 5v is possibly to this book.

179 TB CVIII, p. 33, from G.P.Lomazzo, *op. cit.* pp. 17–18. Turner has conflated Lomazzo's phrase: '7 particularities which the Philosophers call *particularizing qualities* that is 7 substantial accidents ...' p. 40a from R.Haydocke 'Brief Censure of the Book of Colours' in *op. cit.* p. 125. Haydocke's strictures do not refer to Lomazzo's introductory chapter, but to similar ideas in the chapters on colour. Turner's interest in the topic in particular is shown by his omitting to copy out most of what comes between the colour passages. Turner may also have known the recent discussion of the materiality of light and colour in G.Adams, *Lectures on Natural and Experimental Philosophy*, 2nd ed. revised Jones, 1799, II, pp. 143–4: 'light is ... the action of a material, real substance'; and p. 424 f. of Delaval's experiments; 'he found that in all the animal subjects he examined, the colours were produced by the transmission of light from

a white ground through a transparent coloured medium', and similarly with minerals (p. 426).

180 MS Q f. 6v; *cf.* J.Kirby, *Dr Brook Taylor's Method of Perspective*, 3rd ed. 1768, 1, pp. 6, 13 and fig. 13.

181 TB CII, pp. 29–28a: notes on Carlisle's first two lectures. Notes on a third lecture are in TB CXIV, p. 6a. Finberg, *Inventory*, 1, p. 311, misread 'Carlisle' as 'Clavicle', for the passage deals with this topic too. Carlisle was elected to his Professorship in 1808, and began lecturing early in the following year. It is notable that in 1805/6 Goethe was planning to preface his *Farbenlehre* with an account of the structure and functioning of the eye, which was not in fact published (*Leopoldina Ausgabe*, *cit.* 1, 3, 1951, pp. 436–7).

182 MS B, printed by McColl, *art. cit.* p. 345.

183 Whitley, *art. cit.* p. 208; *cf.* also MS K, f. 22 (?1824).

184 MS in C.W.M.Turner Collection, 2nd draft, p. 2. The first version of the same passage, also on p. 2, is shorter, and was probably the delivered version.

185 MS N, f. 10v. The passage is close to another in MS BB, f. 56, written on the verso of a circular dated 1 January 1827. Turner attributes the phrase to 'the Jesuit'; but I have been able to find nothing similar in *The Practice of Perspective written in French by a Jesuit of Paris* [Jean Dubreuil] trans. Chambers, 1726. It is, however, as Turner adds, close to John Hamilton's *Stereography*, 1738, pp. 3–4, and to Kirby, *op. cit.* pp. 70–1.

186 In a poem on Newton's laws of gravity (TB CXI, p. 93) Turner remarked on the inscrutability of the 'first great cause'.

187 *The Art of Painting* trans. Fritsch, 1738, pp. 156–7.

188 MS H, f. 35. Turner originally wrote 'crimsoned morn' for 'grey dawn', when he was probably thinking of an earlier passage on red as the first and the last

ray. He also wrote 'golden sunrise' for 'yellow morning'. *cf.* Henrick Steffens: 'Ist nicht das Morgenroth, als die rothe Seite des grossen täglich sich bewegenden Farbenbildes anzusehen, das sich in das Helle des Tages hineinwirft; der Mittag als das herrschende Gelb, und die Abendrothe als das Violett, das sich in die finstere Nacht hinein verleirt?' (*Ueber die Beduetung der Farben in die Natur*, in P.O.Runge, *Farben-Kugel*, 1810, p. 59). These were not the colour-equivalents given by Runge in his own *Tageszeiten*, where red symbolized morning and evening, blue midday and yellow, night (Runge to Daniel Runge, 30 Jan. 1803). Turner's use of 'tangent' seems to be trigonometrical; but I have been unable to make sense of this sentence.

189 TB CLVI, pp. 23a–24. It is to this sketch, rather than to the *River Scenery* drawings adduced by Dr Finley ('Turner: An Early Experiment with Colour Theory', *cit.* p. 364) that we should perhaps trace Turner's 'pointillism'; he had observed it in Titian as early as 1802 (see above, p. 62). The hatchings of yellow and blue, and red and blue which Dr Finley points to in *Norham Castle* (TB CCVIII, o), **34**, as examples of 'optical mixture'—referring to the slightly earlier account of this technique in James Sowerby —are only special cases of a very general use of overlaid hatchings in these drawings, often in tones of the same colour; they are in no sense programmatic or theoretical. So far from becoming 'more intuitive' after 1820 (*ib.* p. 366), Turner's colour is in some respects far more conceptual than in the earlier period.

190 Here quoted from MS R, f. 18, repeated there, f. 19, in MS S, ff. 4, 5v; MS J, f. 7, *cit.* F.Algarotti, *An Essay on Painting*, 1764, p. 48; *cf.* Lomazzo, *op. cit.* pp. 17–18.

191 See his remarks to this effect in MS K, f. 6n (1824) and MS BB, f. 57 (1827).

192 MS S, ff. 9v–10. *cf.* also MS V (1819), ff. 2–5.

193 MS J, 2nd draft, f. 5v, MS K, f. 4v (probably 1811 and 1824).

194 MS N, f. 4; also in a later (?1818) note on f. 2v. *cf.* also MS G, f. 4v.

195 Reynolds, *Works, cit.* II, p. 382. Dryden gives far more emphasis to colour in his translation, which reads: '... to represent it as it was first created, without fault, either in colour or in lineament', where Bellori's original has 'emendeno la natura senza colpa di colore e di lineamento' (G.B.Bellori, *Le Vite* ... 1672, p. 4).

196 *Lectures, cit.* pp. 136–7.

197 MS Q, ff. 7v, 38. A suggestion of the derivation of primary colours from 'primary' forms is to be found in a passage of Lecture III (1819), on the infinite division of the triangle into smaller triangles by bisecting the sides: 'Thus under all the torture which Human ingenuity can frame this Germ of ⌈Figure Form lives [?] and sparkles, its diamond form darting forth its radiant lines of instruction, and piercing the dim obscure (even) of dulness with light and colour as in the prism ...' (MS W, f. 2).

198 e.g. the note (?1821) to MS L, f. 1v, contrasting the superfluity of rules offered in the optical lecture of 1819, with the mere rudiments of science in the present one: 'there should be a distinction between rules and science'. In a draft for the first lecture of 1818 (MS BB, f. 46) Turner referred to two courses, one for rules, the other for 'The principles and science of the art'.

199 MS BB, 66–7; 68–69v. The first, on colour, was originally pinned to f. 34 [?] of Lecture V (1818, MS H). The other MS, on chiaroscuro, is associated with it in format and hand. The diagrams referred to on f. 67 are TB CXCV, 178, 179, watermarked respectively 1822 and 1824 (repr. Gowing, *op. cit.* p. 23); and TB CCCXLIV, 452, is on similar paper to the MSS, with the embossed mark BATH and a crown, but is, in addition, watermarked 1823. I should prefer the date of 1827 for these MSS and diagrams, for this was the time that Thomas Phillips was preparing his own Academy lectures on painting, using similar material from Moses Harris (delivered 1829); but Turner was close to Phillips much earlier; and may well have had the information on Harris before 1825. The MSS are transcribed in Appendix ID.

200 MS L, f. 1v; for the dating, *cf.* note 198 above, *cf.* also p. 40 and n. 112.

201 MS H, ff. 7v–8v, where, however, water was denied a power to colour in the way glass did; *cf.* also TB CXII, p. 17; *Light, Shade and Reflexes*, C.W.M.Turner Collection, f. 12 n.; MS BB, f. 12v.

202 *Cf.* p. 110 and n. 179, above.

203 Phillips, *op. cit.* pp. 340–3. Phillips's annotated copy of the second edition of Harris is in the library of the Victoria and Albert Museum. On p. 4 of Phillips's additional notes is a reference to George Field's *Chromatics* of 1817, which makes it likely that the Harris was acquired after that date. For Turner's closeness to Phillips in the mid-1820s, Finberg, *Life,* pp. 293, 297.

204 'The utmost strength of the painter's pallet consists in colours termed light or dark, warm or cold, each of these classes being capable of various modifications as to the strength, or weakness, from the deepest tone to the brightest and to the most faint, which the admixture of white can produce. To this range of colours must be added, the extremes of white and black.' (*Op. cit.* pp. 335–6.)

205 *Op. cit.* pp. 340–3, 357, 361.

206 See, e.g. the development of the same rainbow with different coloration, over Durham Cathedral in TB LIII, pp. 97–8; and the note in TB CLXVI, pp. 52a–3: 'when the sky was light and the clouds flickered [?] in the ray, the bow was diffused [?] and broad. But when the cloud became [] the Bow narrowed and became the more brilliant'.

207 See below, p. 174.

208 For West see above, pp. 94–5. In 1816 Richter had exhibited at the Society of Painters in Water Colour (No. 66), *Christ giving Sight to the Blind. An Attempt to*

Improve upon a former Picture on the Same Subject, exhibited in 1812, at the Rooms of the Associated Painters ... and purchased from thence by the Directors of the British Institution. Both painting and drawing are lost, but it is recorded that the latter at least sought to embody Richter's view that the blue of the sky should colour the top of objects lit by daylight (A.T.Story, *James Holmes and John Varley*, 1894, pp. 32, 105; J.L.Roget, *A History of the Old Water-Colour Society*, 1891, I, p. 388).

209 Lecture VIII, Knowles, *op. cit.* II, pp. 336–7, 369.

210 MS note to p.v. of Field's own annotated copy of *Chromatics* (1817) in the Fitzwilliam Library, Cambridge: 'In 1814 at Sutton I showed [Dr Taylor] the MS of this work completed some years before but not published—otherwise than by showing to Farington & other Artists'. A note to p. 29 of the additional MS in this copy is dated 1811.

211 This was, for example, the scheme of Mengs, whose writings Turner studied, however disdainful he might be of his practice. (A.R.Mengs, *Works*, cit. II, pp. 118–19.)

212 *op. cit.* p. 389.

213 See pp. 202–3 (Appendix II c).

214 TB CVIII, p. 33a; from Lomazzo, *op. cit.* p. 19.

215 Gowing *op. cit.* frontispiece and the dust-jacket of the present book, for the Cleveland version in colour. This new principle was recognized in Turner by John Burnet, who noted the relationship to fresco ('Autobiography', *Art Journal*, XII, 1850, p. 277) *cf.* also F.Howard, *Colour as a means of Art*, 1838, p. 51, to which Dr Robert Ratcliffe kindly drew my attention. It is conceivable that Turner's references to 'secondary' reflexes for 'primitive' lights, in the 1827 lecture series (below, p. 210) concerns complementary shadows; but the only striking examples of this I have been able to discover in his work are in a Venetian watercolour of *c.* 1840 (TB CCCXV, p. 4) which

has pink light on the buildings to the left, with a viridian watershadow; and similarly in the 'Bellini' oil of 1841.

216 *Light and Shade* lecture (C.W.M. Turner collection), f. 22; in two drafts of the same note, Turner replaced the phrase 'the chain of art' by 'the chain of science'. For Constable, Leslie, *Memoirs*, *cit.* p. 323.

217 MS BB, f. 27–8 (Appendix III). In a dozen pages of detailed analysis of the quality of light at sunrise in the *Perspective* sketchbook (TB CVIII, pp. 91a–82a), Turner gave one example in many of his studied glance.

218 *cit.* Finberg, *Life*, p. 230.

219 Thornbury, 1904, p. 326.

220 C.O'Brien, *op. cit.* s.v. 'Of Colour-Making'.

221 A MS of this caption, dated 22 Dec. 1839, and probably given with the picture, was with Maggs Bros. 1920, n. 1775. I cannot agree with Mr J.Lindsay's suggestion (*The Sunset Ship: the Poems of J.M.W.Turner*, 1966, pp. 56–7) that these verses were anti-Newtonian, or, indeed, anti-scientific: science is rather seen as a stabilizing force against 'wild fantasy'.

222 MS H, f. 42, from M.Akenside, *Pleasures*, cit. 1757, ll. 227–31.

223 RA 1847. S.A.Hart, *Reminiscences*, 1882, pp. 94–5. The rejected vignette is TB CCLXXX, 87. Turner did incorporate Galileo's system brilliantly into his vignette to Book VI of *Paradise Lost* (R 599).

224 Mrs Somerville, *Mechanism of the Heavens*, 1831, pp. lvii, lxv.

225 M.Somerville, *Personal Recollections of Mary Somerville*, 1873, pp. 57–9, 105, 149, 244, 269. A letter from Chantrey to Turner of June 1829 mentions a 'Somervill' Turner is to meet, possibly Mrs Somerville's husband (Finberg, *Life*, p. 316).

226 Thornbury, 1904, p. 349. Mrs Somerville's paper, 'On the magnetising power

of the more refrangible solar rays' (1826), was published in the *Philosophical Transactions* for 1829 (II, pp. 132–9) and does not seem to have been reprinted, although it was referred to, for example, by Sir David Brewster, *A Treatise on Optics*, 1831, p. 92.

227 Mayall quoted by C.Monkhouse, *J.M.W.Turner*, 1929, p. 120. Mayall was, however, licensed by Richard Beard, who held the English Daguerreotype patent. (H. & A. Gernsheim, *History of Photography*, 1955, p. 108.)

228 Thornbury, 1904, pp. 349–50.

229 Gernsheim, *op. cit.* p. 86.

230 *The Richmond Papers, ed.* Stirling, 1926, p. 163.

231 For Turner's support of the training of Pound, Finberg, *Life*, p. 415. Some of Pound's engravings after Mayall are in the later volumes of the Jupp Collection of R. A. Catalogues in the Royal Academy library.

232 *Athenaeum*, 1847, p. 416. Interest in the production of coloured images by natural photographic means was developing in the late forties. (*Cf. Art Journal*, 1849, p. 131; 1851, p. 189, kindly brought to my notice by Mr C.Middleton.)

233 Phillips, *op. cit.* p. 381 : 'In nature light causes shade; in art, however paradoxical it may seem, shade is the cause of light; or, rather, light and shade reciprocally generate each other'. See also below, p. 184, for George Field on photography.

234 MS H, f. 44; MS L, f. 4 n., which seems to refer to the instrument as 'more for amusement than use'.

235 Sir David Brewster, *Treatise on the Kaleidoscope*, 1819, p. 7.

236 *ib.* pp. 134–6. *Cf.* also J.B.Purkinje; *Beobachtungen und Versuche zur Physiologie der Sinne*, 2nd. ed. 1825, I, pp. 161 ff., where there is, however, no reference to colour. For Castel: E.vonErhardt-Siebold, 'Some

Inventions of the pre-Romantic period and their influence upon Literature', *Englische Studien*, LXVI, 1931–2, pp. 253–7.

237 *Morning Herald*, 6 May 1829.

238 Brewster, *Kaleidoscope, cit.* p. 114.

239 *ib.* pp. 134–5.

240 J[ames?] E[lmes?] 'On Colour in Landscape Painting', *Arnold's Magazine of the Fine Arts*, III, 1833–4, pp. 446–7: 'Had that close scrutinizer of nature's colours, Sir David Brewster, given to the material portion of the Art a tithe of the time he spent on the Kaleidoscope and other toys, he would probably have done more for modern painters than all the letters and lectures, hints and articles, that have ever been published, and might have enabled us successfully to rival even the productions of Claude, Cuyp, Both or Burchem [*sic*], by banishing at once and for ever that flaming parrot colouring of Japan-ware hardness, and the cold drizzling weather so *unearthly* out of our modern copyings of nature'.

241 See the rather formal letter of Turner's to Thomson, concerning the *Antiquities* in 1828 (National Library of Scotland, MS 786, ff. 104–5v), and the anecdotes in Thornbury, pp. 139–40.

242 For Thomson's friendship with Brewster, W.Baird, *John Thomson of Duddingston*, 1895, p. 103. For his scientific work, *ib.* p. 50. *The Wellesley Index to Victorian Periodicals*, I, 1966, however, gives only the *Edinburgh Review* article on M.A.Shee's *Rhymes on Art* (Vol. VIII, 1806) to him.

243 Thornbury, 1904, pp. 138–9. Turner was also in Edinburgh in 1818 and 1822.

244 *Cf.* the long attack on the Newtonian Theory, *Transactions of the Royal Society of Edinburgh*, XI, 1831, p. 322 (given 1829).

245 *A Treatise on Optics*, 1831, pp. 72–4.

246 Mrs Gordon, *The Home Life of Sir David Brewster*, 3rd ed. 1881, pp. 147–8. Brewster's conception of the complementaries had been rather different before

1820: blue, for example, he regarded as the complementary of red, and green of violet, in 1819 (*Kaleidoscope, cit.* pp. 68–9).

247 *Optics, cit.* p. 276. Turner's original sketches do not include the halo (TB CCLXXIII, pp. 19–21a, 40–40a), nor does his own account of the trip some years later (Finberg, *Life,* p. 333). His rendering does not correspond in detail with Brewster's account.

248 *Optics, cit.* p. 270. Turner referred to a sunset as 'Fire and Blood' in the *Boats, Ice* sketchbook (TB CI, p. 9), and as 'Orpiment and blood' in the *Cockermouth* book (TB

CX, p. 40). For him, too, the sun was often 'shorn of his beams', e.g. MS H, f. 45 (1818), a poetic quotation whose source I have been unable to trace.

249 J.Ruskin, *Diaries,* I, 1956, p. 273.

250 See above, p. 40–1. TB CCLXIX, pp. 10a–12a (*Fall of the Clyde*); CCLXVII, p. 59a (*Norham*); *cf.* Thornbury, p. 139, for the story connected with this 1831 visit. Both the *Norham* group in the Tate Gallery (1981, 2002) and the *Clyde* oils in Pittsburgh and Port Sunlight may be earlier than the late 1830s or early 1840s traditionally given to them.

Notes to Part III

1 BM Add. MS 46151, A, f. 16v.

2 BM Add. MS 46151, BB, f. 22v.

3 *Cf.* the anecdote of George Richmond, Joseph Severn and Fuseli, in *The Richmond Papers*, *cit.* p. 8, which must refer to before 1820, when Severn left for Rome with Keats. Also, *British Press*, 5 Jan. 1819 on good attendance; and *European Magazine*, Jan. 1824 for good but deteriorating delivery. For earlier clarity of delivery, *New Monthly Magazine*, 1815 (*Whitley Papers*, *cit.* pp. 1562, 1557).

4 Victoria & Albert Museum, H.Cole's MS *Diary*, 14, 28 Jan. 1828, kindly communicated by Mr William Vaughan.

5 J.Ruskin, *Notes on the Turner Gallery at Marlborough House*, 1856–7, No. 508.

6 Victoria & Albert Museum, *Press Cuttings*, III, p. 811. *Cf.* p. 123 above.

7 Ruskin, *loc. cit.* The reference is to Pope's *Odyssey*, IX, in Anderson, *op. cit.* XII, p. 207.

8 Hesiod, *Theogony*, trans. Cooke, in Anderson, *op. cit.* XIII, v. 227 ff. and n., p. 52.

9 G.Lairesse, *The Art of Painting*, trans. Fritsch, 1738, pp. 405–6.

10 T.Cavallo, *Elements of Natural and Experimental Philosophy*, 1803, IV, p. 391. *cf.* Volta, *cit. id.*, *Treatise on Air and other Elastic Fluids*, 1781, p. 647. E.Darwin, *Temple of Nature*, 1803, p. 140 n. I owe the Cavallo reference, and others in the following account to C.H.Grabo, *A Newton among Poets. Shelley's use of Science in Prometheus Unbound*, 1930, and to J.L. Lowes, *The Road to Xanadu*, 1959.

11 Thornbury, 1904, p. 446. The reference is to Thomas Dibdin, *Melodrame Mad! or the Seige of Troy* first performed in June 1819,

Act II, scene V, p. 38. Turner's extract is from a song of Thersites, and the Polyphemus story has no place in the action.

12 Lairesse, *loc. cit.*; Hesiod, *op. cit.* v. 367 and n., p. 53, from Tzetzes: 'several parts and qualities of the sea'.

13 Some notes by Turner from the *History of Perspective* in this work (I, pp. 91–2) are in TB CII, p. 4a.

14 *op. cit.* II, pp. 569–74. An exact and exceptional attention to the phosphorescence of the sea at night was noticed by a German critic of Turner's *Naumachia* in 1799, in the longest account of this exhibition that has so far been traced (*London und Paris*, V, Weimar, 1800, pp. 4–10). I am indebted to Mr Arthur Marks for drawing my attention to this review. For the case for J.M.W.Turner's authorship of this show, *Burlington Magazine*, CVII, 1965, pp. 24–5. Since the publication of this appendix no new evidence on the question has come to light, except the negative information, for which I am grateful to Mr Jack Kunin, that one of Loutherbourg's assistants on the decor of *Omai* in 1785 had been a 'Mr Turner' (L.E.Preston, *P.J.De Loutherbourg: Eighteenth-Century Romantic Artist and Scene Designer*. Unpublished Ph.D.Thesis, University of Florida, 1957, p. 188).

15 E.Darwin, *The Botanic Garden* (1791), I, 173–8, 193–4, 197–8 and Additional Note IX.

16 Lowes, *op. cit.* p. 91 n. For Darwin's view of the relation of science and poetry, F.D.Klingender, *Art and the Industrial Revolution*, 2nd ed., revised Elton, 1968, pp. 36–40.

17 For Darwin and Wright of Derby, see F.D.Klingender, *Art and the Industrial Revolution*, 1947, p. 57; B.Nicolson, *Joseph Wright of Derby*, 1968, I, pp. 130–3.

18 J.Ruskin, *Pre-Raphaelitism* (1851): '[Thomas Lupton] told me ... that one day ... Turner came into his room to examine the progress of the plate [*Calais Pier*], not having seen his own picture for several months [*sc.* years]. It was one of those dark early pictures, but in the foreground was a little piece of luxury, a pearly fish wrought into hues like those of an opal. He stood before the picture for some moments; then laughed, and pointed joyously to the fish: "They say that Turner can't colour!" and turned away.' Lupton's plate (R 791) was begun in 1827, but remained unfinished.

19 Priestley, *op. cit.* p. 570; a fine water-colour study of mackerel, done after 1818, is in the Ashmolean, Oxford (L.Herrmann, *Ruskin and Turner*, 1968, no. 80, pl. xx; *cf.* also no. 81).

20 J.Ruskin, *Works, cit.* XIII, p. 137 and n. There seems to be no justification for Thornbury's statement (p. 445) that Phoebus was also visible once.

21 J.Stuart and N.Revett, *Antiquities of Athens*, II, 1787, ch. I, pl. I. For Turner's use of this work *cf.* MS H, f. 14v; *Reflexes* MS in C.W.M.Turner collection, f. 21v, from *op. cit.* I, 1767, pp. 44–52; also TB CXCV, 169, from *ib.* ch. v, pl. iii.

22 MS R, f. 43, refers to the supposed perspective arrangement of the horses' heads on the pediment. For the cast of the frieze, see Trimmer in Thornbury, 1904, p. 362: 'Centaurs in conflict with the Lapithae', identified by W.L.Leitch as from the Elgin marbles (A.MacGeorge, *W.L. Leitch. A Memoir*, 1884, p. 83).

23 *Cf.* C.Parkhurst, *art. cit.* above, p. 12 n. 10. M.Rooses, *L'Oeuvre de P.P.Rubens*, IV, 1890, No. 862. On a proof of an engraving of the *Woman and Boy by Candlelight*, in the Bibliotheque Nationale, Paris, Rubens himself wrote the verses: 'Quis vetet apposito, lumen de lumine tolli/Mille licet capiant, deperit inde nihil', i.e. light may be taken from light a thousand times without diminishing it (A.M.Hind, *Print Collector's Quarterly*, X, 1923, pp. 78–80). Rubens seems to have kept the picture in his own collection until his death; and

Turner may well have seen it at the British Institution in 1815, although he can hardly have known the caption.

24 Ziff, *Poetry and Painting, cit.* pp. 204–6 rightly traces Turner's use of the term in his criticism of Poussin (p. 200 below) to no more purely philosophical a source than Akenside's *Pleasures of Imagination*, 1744, III, note to v. 348. Turner's friend, Soane was a disciple of the associationist Archibald Alison, of whose *Principles of Taste* he had several copies. I owe this information to the kindness of Dr Peter Murray. In his discussion of the distinction between poetry and painting in the *Perspective Sketchbook* of *c.* 1808 (Ziff, *loc. cit.* p. 197), Turner claimed that painting was *not* concerned with association, but with natural effects; and this theory may reflect the predominantly pastoral nature of his painting at this period. The Poussin passage of 1812 was written after Turner had returned to mythological and symbolic interests, which remained more or less constant from this date.

25 *Quarterly Review*, IV, 1810, p. 376. Turner's reference to this volume of the review is in TB CXIV, cover.

26 TB CVIII, p. 89a. Turner seems to be referring to Socrates' trial, where, however, the sun was described as stone (Plato, *Apology*, 26D). Possibly Turner confused Socrates with Sophocles, who described the sun as a disk in *Antigone* 416.

27 Verses in *The Artist's Assistant*, (C.W.M. Turner coll.).

28 J.Burnet in *Art Journal*, 1852, p. 47.

29 Lovell Reeve, *Literary Gazette*, 1852, p. 20; *cf.* also S.Hart, *Reminiscences, cit.* p. 48. For a rather inconclusive discussion of the authenticity of this remark, J.Ruskin *Works*, VI, 1904, pp. 274–5.

30 Ruskin himself admitted as much in a letter of 1847 to Brown, writing rather defensively of *The Slave Ship*: 'And then, the question is not whether all that you see is indeed there, but whether your imagination has worked as it was intended to do, and whether you have indeed felt

as the artist did himself, and wished to make you ... many of the passages respecting Turner [in *Modern Painters*] are not actual descriptions of the pictures, but of that which the pictures were intended to suggest, and *do* suggest to me. I do not say that much of my conjecture may not be wrong, but I say that in the main it is rightly concluded and carried out, and that the superiority of Turner to other men consists in great measure in this very suggestiveness, it is one of the results of his own great imaginative power ...' (*Works, cit.* XXXVI, pp. 81–2).

31 *Modern Painters*, II (1846), Part III, sect. II, ch. iv, §6.

32 J.M.W.Turner, *Views in Sussex*, 1819, 'Scientific and Explanatory Notes' [by R.R.Reinagle] n.p.

33 W.B.Scott, *Autobiographical Notes, ed.* W.Minto, 1892, I, p. 84.

34 G.D.Leslie, *Inner Life of the Royal Academy*, 1914, pp. 144–5.

35 TB CXXIII, *passim.* Thornbury's insensitive detachment of the poem from its pictorial context (1904, pp. 205–19), which has been followed even more arbitrarily by Mr Lindsay (*The Sunset Ship cit.* pp. 108–116) is probably the chief reason for its never having been recognized as the probable text for the *Southern Coast* engravings, with which Cooke and his editor, William Combe, had such difficulties. Turner's correspondence with Cooke of December 1813, excerpts from which was printed in Messrs Maggs catalogue of autographs for 1931 (Nos. 1436–7), as well as two letters from Combe to Cooke, published by Thornbury (1904, pp. 189–90), suggests very strongly that the 'articles' on sites were derived directly from this poem, which was probably why Turner in the end refused to allow them to be altered, and hence published.

36 The caption was a conflation of Thomson, *Spring*, 189–205. There is evidence in the preparatory watercolour (TB XXXV, p. 84) that the rainbow was an afterthought, for much of it was scrubbed out, and a second bow substituted in the opposite direction. Apart from the flash of sunlight and the rainbow, this Rembrandtesque picture agrees closely with Thomas de Quincey's almost contemporary account of the scene: 'its [Buttermere's] margin, which is overhung by some of the loftiest and steepest of the Cumbrian mountains, exhibits on either side few traces of human neighbourhood; the level area, where the hills recede enough to allow of any, is of a wild pastoral character, or almost savage; the waters of the lake are deep and sullen; and the barrier mountains, by excluding the sun for much of his daily course, strengthen the gloomy impressions.' (*Reminiscences of the English Lake Poets*, Everyman ed. 1929, p. 37). Turner wrote on his watercolour sketch that the water was 'Black'.

37 Ziff, *Poetry and Painting, cit.* pp. 201–2. Professor Ziff has, however, claimed that Turner *was* able to make use of the poetical material in his pictures.

38 e.g. TB XC, p. 49a: *Jason arriving at Colchis* or *Ulysses at Crysa*; TB CXX, Z, verso: *Homer reciting to the Greeks his Hymn to Apollo* or *Attalus declaring the Greek States to be Free*. The former drawing is brilliantly coloured in gouache; but both the alternative episodes have a festive element, and sacrifices of thanks. (Ovid, *Metamorphoses*, VIII, for Jason; Homer, *Iliad*, I, for Ulysses.)

39 [J.Feltham] *The Picture of London for 1805* ... p. 271.

40 Indianapolis, John Herron Art Museum. The note is in TB XXV (1795) p. I, in a list including a drawing of *Chale* which may be that shown at the Academy in 1796. Beckford did not return to England until 1796 (W.Oliver, *Life of Beckford*, 1932, p. 233) and the first record so far discovered of Turner's contact with him is not until 1799 (Finberg, *Life*, p. 60). The error in describing as the *Fifth Plague* what in fact shows the seventh would perhaps be more characteristic of Turner than of Beckford, and Turner's early note does not give the number.

41 *Cf.* 'Turner and the Picturesque', *cit.* pp. 76–9.

42 *Cf. ib.* p. 79.

R 257

43 Ziff, *Poetry and Painting, cit.* pp. 207–8.

44 *Cf.* Turner's letter to John Taylor of 1811, in W.T.Whitley, *Art in England 1800–1820,* 1928, p. 181. Turner may also have been thinking of George Morland's self-portrait of 1807 (Nottingham, Castle Museum), which showed the artist at his easel, and his manservant frying sausages over the fire.

45 Six works by Clarke were in the Loutherbourg Sale, Coxe, 18 June 1812, lot 70. Clarke was also in touch with Mary Pratt, the authoress of the pamphlet on the painter's activities as a faith-healer in 1789: *A List of Cures performed by Mr and Mrs de Loutherbourg ... without Medicine, by a Lover of the Lamb of God.* (*cf.* D.Hirst, *Hidden Riches. Traditional Symbolism from the Renaissance to Blake,* 1964, pp. 259–61, 276–80.)

46 *Cf.* Clarke to the painter Henry Brooke in 1779: 'I know the science [of alchemy] to be true, but content myself without searching for it ... I believe I know the whole, and found it, if I see it right, in the temple-service' (Hirst, *op. cit.* p. 254).

47 *Cf.* A.Viatte, *Les Sources Occultes du Romantisme,* I, 1928, pp. 202–3. For Loutherbourg and Cagliostro, C.Photiades, *Count Cagliostro,* 1932, pp. 224–9.

48 A-J.Pernety: *Les Fables égyptiennes et greques,* 1758, II, p. 120. This book is not named in the Loutherbourg Sale, but it was a modest unillustrated work, and may well have escaped notice among the 'others' untitled in many lots.

49 Pernety, *op. cit.* I, p. 479. For Loutherbourg's *Jason,* W.Buchanan, *Memoirs of Painting, cit.* I, p. 276, No. 17.

50 The whole of the poem was published by D.S.MacColl, *National Gallery, Turner Collection,* 1920, No. 477. A slightly different version, incorporating variants in the MS Verse Notebook in the C.W.M. Turner collection, in J.Lindsay, *Sunset Ship, cit.* p. 103. *Cf.* also TB XCVII, pp. 83–83a.

51 Joannis de Padua, *Liber Secretorum De Lapide Philosophorum,* III, in *Aurei Velleris oder Der Guldin Schatz und Kunstkammer, Tractatus Quartus,* 1708, pp. 419–32. This book was in lot 136 of the Loutherbourg sale.

52 Pernety, *op. cit.* I, pp. 512–15, 535.

53 Thornbury, 1904, p. 115.

54 TB CVI, p. 67, has a long extract on vice and virtue from Shaftsbury's *Characteristicks* (3rd ed. 1723, II, pp. 82–3). which Turner seems, however, to have copied from H.Blair, *Lectures on Rhetoric and Belles Lettres,* 1783, I, p. 235.

55 *Ed. cit.* II, pp. 189–90, III, pp. 156, 160 n.

56 For an anti-alchemical opinion, P.J. Macquer, *Elements of the Theory and Practice of Chymistry,* I, 1764, pp. viii–ix. The third treatise in Turner's collection was *The Arts it's Assistant in the Study and Practice of the Mechanical Sciences ...* n.d. which included the 'Miscellaneous Secrets' of 'transmutation of silver into gold' and the 'Permutation of lead into silver' on pp. 283–5.

57 *Das guldin Flüss Theophrasti Paracelsi ...* in *Aurei Velleis cit. Tractatus* II, pp. 105–6. Pernety, *op. cit.* I, pp. 474–5.

58 *Argonautics,* IV, 135 *et seq.,* trans. Fawkes, in Anderson, *op. cit.* XIII, p. 302.

59 Pernety, *op. cit.* I, pp. 516–18.

60 *ib.* p. 515; for Psyche, *id. Dictionnaire Mytho-Hermetique,* 1787, pp. 44–7.

61 The draft in TB CXI, pp. 52a–53 is from Christopher Pitt's translation (Anderson, *op. cit.* VIII, 1794, p. 801). Other drafts by Turner are in *ib.* pp. 17, 26a, 39a–40, 70a, 78, 82a, 83a.

62 Pernety, *Fables, cit.* II, p. 140.

63 L-J.Girodet de Roucy Troison, *Oeuvres Posthumes,* 1829, I, pp. 95–6. For a similar sentiment in Delacroix's *Salle d'Apollon* ceiling programme, *cf.* the commentary

issued by the artist and published by Baudelaire, *The Mirror of Art*, 1955, pp. 318–19.

64 W.Dodd, *The Hymns of Callimachus* . . . 1755, p. 48.

65 *The Works of Jacob Behmen* . . . IV, 1781, pp. 83–4, 95. This edition of Boehme: was lot 126 at Loutherbourg's sale; other editions were in lots 7, 8 and 126.

66 Runge to Schildener, 10 May 1805, *Hinterlassene Schriften*, cit. I, pp. 247–8. For the landscape origins of this picture, and for Runge and Boehme: O.von Simson, 'P.O.Runge and the Mythology of Landscape', *Art Bulletin*, XXIV, 1942, p. 337.

67 *Cf.* below, p. 203.

68 J.Boehme, *loc. cit.* p. 88.

69 Pernety, *op. cit.* II, pp. 301–2, 309.

70 J.Lindsay, *Sunset Ship*, cit. p. 64 *et seq.*

71 G.Field, *Aesthetics, or the Analogy of the Sensible Sciences Indicated: The Pamphleteer*, XVII, 1820, pp. 212–13. Turner may have been in touch with Field, through Girtin, before 1802 (*cf.* Thornbury 1904, p. 222), and Field's late repetition of early ideas has already been noted.

72 TB XLII, cover. Mr Lindsay, *J.M.W. Turner*, 1966, p. 223, n. 18, has doubted Turner's authorship of this poem, but the *pentimenti* in the first and second stanzas tell in its favour. 'Babbling echo' is a reminiscence of Addison's translation of Ovid's *Metamorphoses*, Bk. III, v. 457, another passage of which (vv. 601–12), Turner used for his caption in the 1804 Academy catalogue. Professor Ziff has excluded from Turner's poetry all the verses in this book, as well as that on the cover of TB XLIX (Lindsay, *Sunset Ship*, cit. pp. 103–4), and the published captions to *Dolbadern Castle* and *Caernarvon Castle* (1800), which seem possibly to be Turner's (*Poetry and Painting*, cit. p. 194).

73 J-B.Deperthes, *Théorie du Paysage*, 1818, p. 231.

74 P.O.Runge, February 1802, *Hinterlassene Schriften*, cit. I, p. 6.

75 TB CXCIII, pp. 3–3a. Turner had been fascinated by the *Aurora* ever since he had studied Raphael Morghen's engraving after it at Oxford in 1812 (Rawlinson, *Engraved Works*, I, p. 37).

76 J.Lindsay, *J.M.W.Turner*, cit. p. 236, n. 29. *cf.* also TB XC, p. 1, in use 1811/12 (Finberg, *Life*, p. 192).

77 O.Goldsmith, *The Roman History*, 1769, I, pp. 238–9.

78 G.Adams, *An Essay on Vision*, 1789, p. 9. *Lectures*, cit. II, p. 281; cf. also *ib.* p. 334: 'The eyes are less hurt by the want of light than by the excess of it; too little light never does any harm, unless they are strained by efforts to see objects, to which the degree of light is inadequate; but too great a quantity has, by its own power, destroyed the sight. Thus many have brought on themselves a cataract, by frequently looking at the sun, or a fire; others have lost their sight, by being brought too suddenly from an extreme of darkness into the blaze of day. How dangerous the looking upon bright luminous objects is to the sight, is evident from its effects in those countries which are covered with snow, where blindness is exceeding frequent, and where the traveller is obliged to cover his eyes with crape, to prevent the dangerous, and often sudden effects of too much light . . .' Also Goldsmith, *op. cit.* p. 247.

79 Anderson, *op. cit.* IX, pp. 797–8.

80 *ib.* p. 802.

81 MS O, f. 6n, J.Lindsay, *Turner*, p. 145, has discussed the political and economic aspects of the symbolism.

82 G.Field, *Chromatography*, 2nd ed. 1841, p. 122. Etty showed a figure subject with the same title at the Academy in 1828, which may have been Turner's starting-point.

83 S.Rogers, *Poems*, 1834, p. 110. Turner's companion-piece to the *Angel: Undine giving the Ring to Masaniello* (TG 549),

develops the scientific imagery of *Ulysses* into a pessimistic symbolism such as we shall see in the *Deluge* pair of 1843. Turner seems to have taken the subject from a marriage of A.J.J.Deshayes's ballet *Masaniello*, based on Auber's *La Muette de Portici*, which ran in London from 1829 to 1835, and Jules Perrot's *Ondine* (1843–48), where the fisherman—Matteo, the type in *Masaniello* of political freedom—is enticed by the water-nymph Ondine into the sea. Here she is shown in a bubble of phosphorescent light; and in the distance the sky is reddened by a volcano in eruption, another emblem of elemental fury, which was a sensational feature of the climax of *Masaniello*. Ondine and her attendants are presented not as wilfully, but nonetheless inevitably malignant (*cf.* I.Guest, *The Romantic Ballet in England*, 1954, pp. 52, 89–90; and for *Ondine*, C.W.Beaumont, *The Complete Book of Ballets*, 1956, pp. 288–93). These dark–light pairs had been anticipated in 1842 by *Peace, Buriel at Sea*, with its funereal black, and *War, Exile and the Rock Limpet*, where blood and sunset are immediately linked (TG 528, 529). Peace is found only in darkness and the grave, and light and colour are already deadly.

84 J.Ruskin, *Works, cit.* XXXVI, p. 543. The concept of God as at once sunny and deadly Turner will have found in *Exodus*, XXXIII, 20; and Revelation, I, 16. He may also have known Tintoretto's sun-god in *The Martyrdom of S.Christopher*, in the Church of the Madonna dell'Orto, Venice, which he visited (TB CCCXIII, p. 52a; TB CCCXIV, p. 55a).

85 Anderson, *loc. cit.* p. 803.

86 Although he has perhaps overstated the case, J.H.Hagstrum has justly characterized Thomson's landscapes as figurative and allegorical rather than naturalistic. The poet was, too, like Turner, excited by the landscape aspects of Reni's *Aurora*, which he adapted in the 1744 edition of *Summer* (J.H.Hagstrum, *The Sister Arts*, 1958, pp. 259–61).

87 vv. 115–41; S.C.Hall, *The Book of Gems*, 1838, pp. 41–2, beginning, 'Sea-girt city . . .' A similar poem, of the souring of

bright promise in connexion with Venice, by Turner is in TB CCCXXXIX, cover (*c.* 1841).

88 *National Gallery. British School*, 1946 s.v.

89 The association of Shelley and this painting was made by E.T.Cook, *A Popular Handbook to the National Gallery* (many eds.), s.v.

90 MS T, f. 6v. (note of 1820s (?) to second lecture of 1818). Hall's anthology also printed Shelley's *The Cloud*; and if Turner used the 1839 edition of his poems, he will have found in Mary Shelley's preface that the poet studied the cloud 'as it sped across the heavens, while he floated in his boat on the Thames', a practice close to one revealed by Turner to Effie Ruskin: 'the way in which he studied clouds was by taking a boat which he anchored in some stream, and then lay on his back in it, gazing at the heavens for hours, and even days, till he had grasped some effect of light which he desired to transpose to canvas' (J.G.Millais, *Life & Letters of Sir John Millais PRA*, 1902, I, p. 158). The scientific background to Shelley's *Cloud* has been discussed by C.H.Grabo, *op. cit.* p. 119 ff.; and that in Turner's skies by L.C.W.Bonacina, 'Turner's Portrayal of Weather', *Quarterly Journal of the Royal Meteorological Society*, LXIV, 1938, pp. 604–8, and 'Landscape Meteorology in Art and Literature', *ib.* LXV, 1939, p. 486.

91 *Cf.* R.Wornum, *The Turner Gallery*, 1872, pp. 45–6. It may well be that the full-size 'sketches' for this series, in the Tate Gallery, which hardly have a parallel in Turner's other work, so far from being analagous to the later practice of Constable, are 'colour-beginnings' of the familiar kind, and were begun in London and rejected because they were found to be too large for their destination. All are larger than the Petworth versions.

92 La Font de Saint-Yenne in 1746; Abbé le Blanc in 1747, *cit.* C.Aulanier, *Histoire du Palais et du Musée du Louvre*, II, *Le Salon Carré*, 1950, pp. 23–4.

93 La Tour in 1755 (*ib.* p. 27 and pl. 5). For David's concern about the favourable

hanging of the *Serment des Horaces* in the Salon of 1785: J.L.J.David, *Le Peintre Louis David*, 1880, pp. 27–32.

94 Sir J.Reynolds, *Notes and Observations on Pictures*, ed. Cotton, 1859, p. 56. A similar story of Reynold's neglect of colour-impressions, when viewing some paintings by Van Dyck in the Royal Collection in C.R.Leslie, *op. cit.* I, pp. 58–9. In Note XLIV to Du Fresnoy, however, Reynolds did advocate warm pictures to counteract the effect of neighbouring ones, and a note on his second journey to Flanders shows that he was aware of the physiological reasons for his first impression of Rubens's brilliant colouring. (E.Malone in Sir J.Reynolds, *Works*, 1798, I, pp. lxxii–lxxiii.)

95 W.T.Whitley, *Thomas Gainsborough*, 1915, pp. 213–25; S.C.Hutchison, *op. cit.* pp. 67–8.

96 W.Allston, *cit.* G.Dunlap, *The Arts of Design*, ed. Brayley & Godspeed, II, 1918, p. 305.

97 *Le Beau Monde*, I, 1807, p. 164.

98 Rühle von Lilienstern (1809), in C.D.Friedrich, *Bekenntnisse*, ed. Eberlein, 1924, pp. 261–2; the altarpiece repr. in colour in H.von Einem, *Caspar David Friedrich*, 1956, pl. I.

99 Chenavard in Boyer d'Agen, *Ingres d'après une Correspondance Inédite*, 1909, pp. 168–9. This interpretation of the story has recently been accepted, in part, by M.Florisoone, 'Constable and the *Massacres de Scio* by Delacroix', *Journal of the Warburg and Courtauld Institutes*, XX, 1957, pp. 183–4.

100 *Morning Chronicle*, cit. W.T.Whitley, *Art in England, 1800–1820*, 1928, pp. 103–4.

101 Mrs Uwins, *Memoir of Thomas Uwins*, cit. pp. 299–300. *Cf.* also B.R.Haydon that he would not send his work to the new Society of Artists exhibition in 1825: 'A man might as well exhibit his pictures under the ray of a burning lens. The members are modern landscape painters who want all the staring light possible,

destroying all sentiment and all art.' (*Correspondence and Table Talk*, ed. F.W. Haydon, II, 1876, p. 106.)

102 M.A.Shee, *Elements of Art*, 1809, pp. 298–302 (no Turner note).

103 Fuseli to Roscoe, 1797, *cit.* D.Irwin, 'Fuseli's Milton Gallery: Unpublished Letters', *Burlington Magazine*, CI, 1959, p. 439; *Monthly Mirror*, Jan. 1801, *cit. ib.* p. 440. For other favourable assessments of the project, especially within the Academy, G.Schiff, *J.H.Füsslis Milton-Galerie*, 1963, pp. 24–5. Fuseli was certainly conscious of the need to finish the paintings *in situ* and he may have taken Roscoe's advice and painted the frames himself in harmony with the collection (*ib.* p. 21). Turner was present at the Gallery dinner in May 1800, although he had not been at the inaugural dinner a year earlier. (D.Erdman, *Blake: Prophet against Empire*, 1954, p. 407 n.; *cf.* also Schiff, *op. cit.* p. 27 on the dinner.)

104 H.R.Yorke, *France in 1802*, ed. Sykes, 1906, p. 158. *Cf.* also J.Carr, *The Stranger in France*, 1803, pp. 108–10; F.Schlegel, *Gemäldebeschreibungen aus Paris* ... in *Sämmtliche Werke*, 1846, VI, pp. 10, 52; for Fuseli, Knowles, *op. cit.* I, p. 258.

105 C.L.Brightwell, *Memorials of the Life of Amelia Opie*, 1854, p. 104; *cf.* Schlegel, *op. cit.* p. 52.

106 *Cf. Musee Napoleon: Notice des Tableaux des Ecoles Français et Flamande, Exposés dans la grande Galerie, dont l'ouverture a eu lieu le 28 Germinal an* vii, *et des Ecoles de Lombardie et de Boulogne, dont l'exposition a eu lieu le 25 Messidor an* IX, which helps to answer Ziff's query about the number of Claudes on show (*Copies of Claude's Paintings*, cit. p. 54).

107 Ziff, *loc. cit.* pp. 57–9, 63; No. 43 in the Louvre in 1802: *Vue d'un Port au Soleil Couchant*, or No. 45 *Une Marine par une belle Matinée*, may have been two of the following: R 93, *Seaport:* R 156, *Seaport with Ulysses restituting Chryseis to her father Chryses:* R 177, *Seaport with the Embarkation of Ulysses*, or R 43, *Harbour Scene with the Campidoglio*. For Turner's drawing of

the gallery skylight, TB CCXLIX, p. 43a; also TB CCLX, 88, 90 (mistakenly numbered 89 by Finberg), 125, all of which show the top-lights.

108 *British Press*, 3 May 1804; *Monthly Magazine*, 1803, pp. 258, 470.

109 Finberg, *Life*, p. 266.

110 *ib.* p. 113, with the conjecture that these may have been drawings of 'Egyptian or Eastern' views. But Turner had been drawing Egyptian details already for five years at least, and there is no evidence that Soane had this sort of material in his collection at this date. *Cf.* J.Soane, *Lectures on Architecture*, ed. Bolton 1929, p. 126, on gallery top-lighting; and D.Stroud, *The Architecture of Sir John Soane*, 1961, fig. 37 for the Fonthill gallery. To Finberg's list of two water-colours exhibited at Turner's Gallery in 1804 and bought by Fawkes (*Life*, p. 466) must be added the drawings, *Refectory of Kirkstall Abbey* and *St Huges denouncing vengeance on the shepherd of Cormayer*, shown respectively at the Academy in 1798 and 1803, which Soane bought from the Gallery on 3 May 1804 (Sir John Soane's Museum, Mrs Soane's notebook, abstract, p. 5); it is, indeed, possible that these were the drawings Soane had 'lent' to Turner's exhibition, and which the artist was now returning after its close.

111 In this year, too, Farington reported (*Diary*, 20 April, unpubl.) that Turner 'was very anxious about his Sea Piece [*Boats Carrying out Anchors and Cables to Dutch Men of War*, RA 183, Washington, Corcoran Gall. of Art] being under Copley's white Drapery [in *Mrs Derby as St Cecilia*, RA 184, Coxe coll. ill. J.D. Prown, *John Singleton Copley*, II, 1966, fig. 651]'. Loutherbourg also objected to the white in a picture above his (Farington, 6 April, *ed.* Grieg, II, p. 221).

112 Finberg, *Life*, p. 160. This refers to December 1809, although no expenses for lamps between 1809 and 1810 are recorded in the RA accounts. Turner did not lecture until 1811, and this year there was much experiment with lighting. Farington records the trial of a 'frame with lights',

suspended from the centre of the ceiling in the great (i.e. lecture) room (*Diary* [unpublished] 20 June) and this may be identical with the bronze lamp presented by the Prince Regent, for which Turner moved a vote of thanks in Council on 27 May (*Minutes*, pp. 290–1). This year £16 0s 6d was spent on japanned patent lamps.

113 Finberg, *Life*, pp. 122, 124.

114 *ib.* pp. 187–9. Turner's wishes were granted, but the rearrangement did not universally please. C.R.Leslie wrote on May 12 that it was impossible to see *Hannibal* at the correct viewing distance because of the crowd (*Autobiographical Recollections*, II, *cit.* p. 12).

115 Farington, *Diary* (unpubl.), 22 Apr. 1819; *cf.* V&A *Press Cuttings*, IV, pp. 1113, 1115, and RA Accounts, Lady Day to Midsummer 1817 and 1818. Gas had been used in the Academy Schools since 1813 (Hutchison, *op. cit.* p. 92).

116 T.Miller, *Turner and Girtin's Picturesque Views Sixty Years Since*, 1854, p. xxxvii. It is, however, possible that this story, which is referred simply to the Presidency of Lawrence (1820–30) belongs to 1827, when Turner showed *Rembrandt's Daughter* (Fogg Art Museum), whose redness became proverbial (*cf.* p. 167), and when £69 10s 4d was spent by the RA on up-holstery.

117 Finberg, *Life*, p. 212.

118 TB XCIX, p. 86. Finberg's dating of 1807 seems to be based on the misreading of a date on the cover. The article from *The Examiner* to which Turner referred in a note on the other cover was published on 8 Jan. 1809.

119 Sir John Soane's Museum, Diary Transcripts, IX, p. 117 (6 Nov. 1816) *cf.* Finberg, *Life*, pp. 267–8. The surveying may have had to do, however, simply with Turner's responsibility for repairs.

120 *Cf. Ninety Years of Work and Play: Sketches from the Public and Private Career of J.C.Shetky . . . by his Daughter*, 1877, p. 126.

121 Repr. Finberg, *Life*, pls. 23, 24. The drawings in TB CV have been identified on the basis of these views. Soane's watercolour of the interior of the Dulwich Gallery is Soane Museum Drawer 31, Set I, no. 14 (unrealized project). His octagonal top-lights are shown in *Ib.* plan 61. For the decoration of the new Louvre, Helmine von Chezy, *Unvergessenes*, 1858, I, pp. 270–1.

122 Quoted by L.G.Fawkes in a letter to D.S.MacColl, 23 July 1910. I am indebted to Mr René MacColl for permission to use this letter, in his possession.

123 For the lighting of the Brera, C.G. Carus, *Diary*, 17 Aug. 1821 in *Lebenserinnerungen*, II, 1865, p. 81: 'Drei Hauptsäle der Sammlung sind übrigens von musterhaft schöner Einrichtung . . . es fällt auch ein höchst günstigen Licht von oben durch eine kuppelöffnung herein und zwar so, dass eine unter der Glasdecke übergespannte Leinwand das Sonnenlicht auf solche weise mildert, wie es eben zur Betrachtung am vorteilhaftesten wirkt'. For a contrary view: K.F.Schinkel, *Tagebuch*, 3 Aug. 1824. TB CLXXV, p. 6a, has a note on the arrangement of pictures, presumably in the Brera, although I have not been able to identify them. Leonardo's ideas are in *Trattato*, 1817, pp. 70, 336, 357; and Turner's interest in his notes in the Ambrosiana is clear from MS BB, f. 54 (1826), *cf.* also TB CLXXI, p. 6.

124 MacGeorge, *op. cit.* p. 84.

125 Wornum, *op. cit.* pp. xii–xiv, *cf.* Finberg, *Life*, p. 444, n. 1. In 1808 Turner exhibited two works described by John Landseer as unfinished, in his Gallery (Finberg, *Life*, p. 147).

126 National Library of Scotland, MS 785, f. 10v.

127 MIH in *The Builder*, xv, 1857, p. 609. C.F.Bell, who first visited the Farnley Collection in the 1890s, noted that the original frames, advised by Turner and executed by Walter Fawkes, were deep and gilt (MS additions to Bell, *Exhibited Works*, V&A Library, RCN 28, pp. 168–9). For an account of the changes in mounting and

framing watercolours during the nineteenth century: M.Hardie, *Water-Colour Painting in Britain*, I, 1966, pp. 41–2.

128 *Cf.* above, p. 104, and p. 247 n. 147. The *Medea* in the Tate Gallery has recently been supplied again with a rope frame painted by Lawrence Gowing.

129 *cit.* L.Cust, 'The Portraits of J.M.W. Turner', *Magazine of Art*, 1895, pp. 249–50.

130 Delacroix, *Journal*, 13 Jan. 1857; Burnet, *An Essay on the Education of the Eye with Reference to Painting*, 1837, p. 59; Field, *Chromatography*, *cit.* p. 140. In the year of Turner's improvised frame for *Medea*, Lawrence was writing to Mrs Benjamin Gott about some large and expensive gilt frames to his portraits: 'let me beg to assure you that the comparative richness of the frames now made for them has been adopted with not the remotest view to their impression on the eye as mere splendid decoration. The pattern has been selected by me and its dimensions determined solely with a view to the advantage of the Pictures: a Frame is so *much* a part of the Picture, that almost invariably we a little change the effect or colour of some part the moment we place it in the frame, and the work as certainly is the better for it. The finest picture, seen without an appropriate Frame, loses a great advantage; as on the other hand it sustains material injury from a Frame injudiciously selected. The most unbecoming character of a frame is the *very plain and very narrow* . . the next defection is the Frame with large obtrusive Ornaments in the centre, and the corners of it. A good frame (a merely safe one for the general effect of the picture) should be sufficiently broad and rich, but the ornament of that richness composed throughout of small parts, and usually it should be unburnished . . . The Frame is the clear *Decanter* not the brush . . .' (13 Oct. 1828). When Mrs Gott refused the frames, Lawrence wrote (26 Nov.): 'I shall now only pray that the other pictures be brought up *close* to them, so that the *effect* of greater breadth of gilding may still be retained . . .' (H. Honour, 'Sir Thomas Lawrence and Benjamin Gott', *Leeds Arts Calendar*, VII,

1954, pp. 17–19). Turner's original frames conform basically to Lawrence's specifications (kindly communicated by Lawrence Gowing). *Cf.* also Sir David Brewster in *Edinburgh Review*, LXXII, 1840–1, p. 109.

131 TB XXXI, XXXII. Finberg's grouping of this heterogeneous collection of drawings is, as he himself admits, unclear. XXXI D is a slight monochrome beginning certainly not from Turner's hand; XXXII E is a highly finished and mounted drawing which it is difficult to regard as for copying at all. *Cf.* Finberg, *Life*, p. 62, for Turner on his teaching method.

132 H.F.Finberg, 'With Mr Turner in 1797', *Burlington Magazine*, XCIX, 1957, p. 48 ff.; also A.P.Oppé, 'Talented Amateurs: Julia Gordon and her Circle', *Country Life*, LXXXVI, 1939, pp. 20–1.

133 *Cf.* letter of Andrew Robertson, Sept. 1802 in *Letters and Papers, of Andrew Robertson, ed.* E. Robertson, 1897, p. 83.

134 Turner's original contribution to the teaching of the Life-Class is recorded by Maclise (A.Gilchrist, *Life of W.Etty* RA, II, 1855, p. 59) and Eastlake (*Minutes of Evidence* in *Report of the Commissioners . . . on the Royal Academy*, 1863, p. 65; but *cf.* also A.Elmore in *ib.* p. 367).

135 J.Ruskin, *Modern Painters*, V, Pt. IX, ch. xii, §4 n.

136 J.Burnet, *Turner and his Works*, 1852, p. 100.

137 W.B.Scott, *Memoir of David Scott*, 1850, p. 42.

138 Finberg, *Life*, p. 47.

139 Royal Academy, *Council Minutes*, 23 April 1804, p. 281.

140 Farington, *Diary* (unpubl.), 16, 17 April 1804. See also above p. 262, n. 111.

141 *Morning Chronicle, cit.* W.T.Whitley, *Art in England, cit.* pp. 103–4.

142 Royal Academy, *Council Minutes*, 1 March 1809, pp. 99–100 (Hutchison, *op. cit.* p. 87); Whitley, *op. cit.* pp. 140–9.

143 Farington, *Diary* (unpubl.), 2 May 1819.

144 J.Ruskin, *Diary*, 27 May 1843, in *Works*, XII, p. 131 n.; *cf.* Finberg, *Life*, pp. 295–6.

145 Lovell Reeve, *Literary Gazette*, 3 Jan. 1852, p. 20, with the mistaken reference to Dublin University instead of Trinity College, Cambridge. John Burnet, *op. cit.* pp. 25–6 did not identify the university, and neither writer mentioned Shee by name. *Rembrandt's Daughter* was reproduced in colour in *The Studio*, vol. 66, 1915–16, facing p. 278.

146 J.Constable, *Correspondence, ed.* Beckett, III, 1965, pp. 68–9. The reference to Jessica is a hit at Turner's painting, now at Petworth, exhibited in 1830.

147 Finberg, *Life*, p. 337. Constable's picture is reproduced in colour by D. Sutton: 'Constable's "Whitehall Stairs"', *Connoisseur*, CXXVI, 1955, p. 248, with (p. 252) the revealing comment from a contemporary observer that Constable would 'certainly set the Thames on fire, if anybody can'.

148 *Arnold's Magazine of the Fine Arts*, III, 1834, pp. 408–9. Finberg, *Life*, p. 341, has called this story 'absurd', but the practice was not uncharacteristic of Turner's later work, and Jones's account shows that much of the picture was painted on the Academy walls. Stanfield's painting may be that painted for the dining room at Bowood (*cf. DNB* s.v.), of which there is a photograph in the Witt Library, London.

149 G.Jones, MS *Recollections, cit.* p. 14.

150 Finberg, *Life*, pp. 351–2.

151 Turner to Emma Wells, 23 Apr. 1837, in *ib.* p. 366.

152 L.Cust, *art. cit.* pp. 248–9. Sir George Sharf, to whom Gilbert gave his account, surmised that the painting was *Queen*

Mab's Cave, exhibited in 1846, but the description hardly tallies, and would apply more closely to *Regulus*, shown at the Institution in 1837 as No. 120, when Gilbert had his *Scene from Ivanhoe* as No. 29, and a *Scene from Old Mortality* as No. 270, either one perhaps opposite Turner's picture. Lawrence Gowing kindly pointed this out to me, as well as the fact that Thomas Fearnley's oil of Turner at work, 30, belongs to this and not the later year. It shows work on *Regulus*, although the scale is wrong.

153 J.D.Passavant, *Tour of a German Artist in England*, II, 1836, p. 262.

154 G.I.C.deCourcy, *Paganini the Genoese*, II, 1957, p. 89.

155 Mrs Uwins, *Memoir of Thomas Unwins*, II, 1858, p. 237.

156 Il faudrait ... que ce dont on a la vision pût être rendu sans peine; il faut que la main acquiere également une grande prestesse et l'on n'y arrive que par de semblables études. Paganini n'a dû son étonnante exécution sur le violon qu'en s'exerçant chaque jour pendant une heure à ne faire que des gammes. C'est pour nous le même exercise. A.Robaut, *L'Oeuvre Complet de E.Delacroix*, 1885, p. 106, No. 386.

157 MS CC, f. 26v., from *The Historie of the World*, cit. II, p. 543. *Cf.* F.Junius, *The Painting of the Ancients*, 1638, pp. 120–1.

158 Constable to Leslie, 14 Jan. 1832 in *Correspondance*, cit. p. 58. Finberg, *Life*, p. 255. For Bigg's restoration of Reynolds, Farington, *Diary*, 27 March 1818, 8 Jan. 1819; for Wilson, *ib.* 22 May 1816, 27 June 1818, 8 Jan. 1819, 13 May 1819, 31 Jan. 1821; for Claude, *ib.* 26 Jan. 1816. *Cf.* also Turner's concern for the condition of *Gravesend* and *Dutch Boats* in a letter to Leicester of 1818 (C.Hussey, 'Tabley House II', *Country Life*, LIV, 1923, pp. 117–18). On the flyleaf of TB CV, Turner made detailed notes on the varnishing of five of his pictures, including, apparently, *Rafaelle and La Fornarina*, and a Gaspar.

159 T.Cole, *Diary*, 12 Dec. 1829, in L. Noble, *Life and Works of Thomas Cole*, 1964, p. 81.

160 Constable to Leslie, *Correspondence*, cit. p. 143.

161 William Callow, too, reported on the delapidation of the Gallery as early as 1837 (*An Autobiography*, ed. Cundall, 1908, p. 66).

162 Finberg, *Life*, p. 397. *Cf.* also Turner's letter of 1840 (?) to Thomas Miller showing anxiety for the condition of *Modern Italy* (National Library of Scotland, MS 590, ff. 1631–2).

163 C.J.Feret in *Isle of Thanet Gazette*, 23 Sept. 1916, first noticed by B.Falk, *Turner the Painter*, 1938, p. 213, who did not, however, record the dates of Sherrell's employment. *Cf.* also Munro of Novar to Ruskin: 'Turner had for years asked me to recommend him [a cleaner], which I was not able to do till he saw those [pictures] Mr Dujardin had cleaned for me, & which pleased him so much that he said he wd employ him as soon as he was again in his own house, which never afterwards was the case ... [Eastlake said] that he had given Mr Bentley the cleaning of [the Turner Bequest paintings], he having done so for Turner during his life and to his satisfaction (*cit.* A.J.Finberg to C.F.Bell, MS additions to Bell, *Exhibited Works*, cit. facing p. 135). Dujardin was probably John Dujardin Snr., a marine painter exhibiting in London 1820–63; [? John] Bentley cleaned and retouched *Rain, Steam and Speed*, for example, in 1857 (Eastlake to Wornum, 15 June 1857: letter in National Gallery Archive). In 1848, too, Turner withheld his work from the Exhibition, and declared he would never show again (C.R. Leslie, *Autobiographical Recollections*, cit. II, p. 294).

164 J.Ruskin, *Works*, XIII, p. 535.

165 Ruskin to C.E.Norton, 7 Aug. 1870, in *Letters of J.Ruskin to C.E.Norton*, II, 1905, p. 14.

166 *Quarterly Review*, LXII, 1838, p. 134.

167 Farington, *Diary* (unpubl.), 14, 15 April 1811.

168 *Report of the Commissioners, cit.* pp. 138–9.

169 R.&S.Redgrave, *A Century of Painters, ed. cit.* pp. 264–6; *cf.* Jones, *Recollections, cit.* p. 13.

170 T.S.Cooper, *My Life*, 1890, II, pp. 2–3, 9–10; Finberg, *Life*, pp. 416, 427–8; Thornbury, 1904, pp. 327–8. Maclise's *Noah*, repr. in T.S.R.Boase, *English Art 1800–1870*, 1959, pl. 84b.

171 G.Jones, *Recollections, cit.* p. 26.

172 W.T.Whitley, *Art in England, cit.* p. 149.

173 Dr R.D.Gray's brief account, 'J.M.W. Turner and Goethe's Colour-Theory', *German Studies presented to W.H.Bruford*, 1962, pp. 112–16, misrepresents the nature, extent and context of the notes; although the author makes a number of interesting remarks on the content of the pictures. Turner's annotated copy of Goethe's *Theory* is in the C.W.M.Turner Collection.

174 §17. The effect of this formal erosion o objects in strong sunlight was noted in Turner's work by one of the most scientific writers on aesthetics in the period (H. Twining, *On the Philosophy of Painting*, 1849, p. 164).

174a. *Cf.* Turner's brilliant sketch of Swiss Lovers (1802) TB LXXVIII, 1 (repr. Lindsay, *Turner, cit.* fig. 11).

175 About 1800 Goethe himself had agreed that in certain cases parallel light rays were not a fiction, but did account for some effects; but the view was not incorporated into the *Theory of Colours* (*Leopoldina Ausgabe, cit.* I, 3, 1951, pp. 298–300).

176 Turner was probably thinking of Newton's account of the disappearance of colours produced within the eye by blows, etc. (*Opticks*, Bk. III, Pt. I, Qu. 16; *cf.* Goethe, *Theory of Colours* §40) which he

may have conflated with the colour-sequence from white to black recorded in the literature on ocular spectra.

177 This is probably a reminiscence of Mengs, *Works, cit.* II, p. 116: 'when some shining body is very far, like the sun, then the rays are almost parallel, and differ so little in all the surface of the world enlightened at once, that the difference is imperceptible to our sight.'

178 The reference seems to be to Fuseli's Lecture IX, Knowles, *op. cit.* II, p. 356.

179 It is clear from Turner's note to Goethe's §337 that he thought that even the colours produced by the prism were reducible to three.

180 Goethe to Knebel, 26 Feb. 1782, *Italienische Reise*, March 1788, in *Leopoldina Ausgabe, cit.* II, 3, p. 42.

181 Mengs, *Works, cit.* II, pp. 134–5; Goethe, *Materialien, cit.* s.v. Goethe does not specifically quote the anti-Newtonian passage.

182 *op. cit.* pp. 118–19, 128. Goethe had illustrated this tonal spectrum in *Beitrage zur Optik*, I, 1791, §59, cards 5, 6. *Cf.* Goethe's Paralipomenon to the *Farbenlehre* (*Cotta Gesamtausgabe*, 1949, ff., XXII, p. 329): 'Wer die physische Entstehung des purpurs kennt, wird nicht paradox finden, wenn man sagt, dass diese Farbe alle andre zwar nicht actu sondern potentia, nicht atomistisch sondern dynamisch enthalte.' Mengs' primary spectrum was illustrated as a diagram by J.Burnet, *Practical Hints on Colour in Painting*, 1827, pl. I, fig. 3 and p. 8.

183 D.Gray, *Goethe the Alchemist*, 1952, esp. p. 115. One of Goethe's sources in mystical alchemy was recognized as early as the 1820s by a German theologian writing to Runge's friend Friedrich Perthes: 'It is very remarkable that even Goethe in his doctrine of colours, has been indebted to the poor Görlitz shoemaker, borrowing from his treatise, *De Signatura Rerum*, not only Boehme's ideas, but even his very words' (C.T.Perthes, *Memoirs of F.Perthes*, II, 1856, p. 258).

184 Farington, *Diary* (unpubl.), 28 March 1804: 'Loutherburgh in conversation said speaking of colours, that there are only *two original colours*, viz. *Blue & Yellow.*'

185 MS M, f. 7v.

186 *A Compleat Treatise on Perspective* . . . 1779, Bk. I, p. 1.

187 *ib.* pp. 2, 35.

188 G.Field, *Aesthetics* . . ., *cit.* pp. 218–19.

189 *Chromatics*, 2nd. ed. 1845, pp. 182 n., 185–6. Field, however, regarded Goethe's two primaries as absurd.

190 *Aesthetics*, *cit.* pp. 198–9.

191 *ib.* p. 216; *cf.* also pp. 217–18.

192 *Chromatics*, 1817, pp. 41–2. *Cf.* Goethe, *Theory*, §696.

193 [T.Young] *Quarterly Review*, x, 1814, pp. 427 *et seq.*

194 Field's book was not published until 1839, but Turner's address in the subscription list is given as 'Sandicombe Lodge, Richmond', which he had left about 1826; this address also appeared in the subscription list of *Chromatography* (1835), and it has been shown that Field planned and discussed his publications many years in advance.

195 Thornbury, 1904, p. 227.

196 *Chromatography*, 2nd. ed. 1841, p. xiv. It is conceivable that this remark was inserted in the second edition in response to Turner's criticisms.

197 *Chromatics*, 2nd. ed. 1845, p. 159.

198 A.Cornill, *J.D.Passavant*, I, 1864, p. 56.

199 P.O.Runge, *Hinterlassene Schriften*, *cit.* I, pp. 156, 188; II, pp. 349, 359, 369, 404. There is no reference to Runge in Rumohr's Roman correspondence published in *Jahrbuch d.Preuss. Knstsmlgn.* Beihefte, 1925, 1943.

200 *Cf.* Cornill, *op. cit.* p. 67.

201 C.L.Eastlake, *Contributions*, *cit.* 1870, p. 123. In 1841 Eastlake reminded Schopenhauer of this meeting when the philosopher wrote praising his translation of Goethe, and asking him to do the same for his own treatise (*A.Schopenhauer, von ihm, über ihm, ed.* Lindner and Frauenstädt, 1863, pp. 67–71; R.Borch, *Schopenhauer*, 1941, p. 267).

202 D.Gray, *German Studies*, *cit.* p. 114.

203 Thornbury, 1904, pp. 323–4; Gowing, *op. cit.* pp. 28–30, has some further comments on this story.

204 *Prometheus Unbound*, Act II, sc. ii.

205 Another poem with the line: 'And what is pleasure but a bubble' is in TB CVIII (*c.* 1808) (Lindsay, *Turner*, p. 124).

206 Sir I.Newton, *Opticks*, Bk. I, Pt. II, prop. I Theor. I, Expt. 4. Goethe passed over this argument rather hastily in the *Polemische Teil* of the *Farbenlehre*.

207 Hamburg, Kunsthalle, No. 34175. I believe Runge's letter to Tieck, 29 March 1805 (*Hinterlassene Schriften*, *cit.* I, pp. 60–1) to imply that the earth is a prison, and an obstacle to Heavenly perfection, and thus the rainbow as an emblem of *earthly* colour is a negative symbol, contrary to its significance in the Noah story, as it is in Turner's *Light and Colour*. *Cf.* also Runge to Daniel Runge 27 Nov. 1802 (*ib.* p. 20).

208 Caption, from the *Fallacies of Hope*, to *Vision of Medea* (TG 513), exhibited in 1831.

Notes to Epilogue

Notes to pages 189 and 190

1 Ruskin's chief essay linking Turner and the Pre-Raphaelites is *Pre-Raphaelitism*, 1851. It is notable that in the three last volumes of *Modern Painters* (1856–60) Ruskin developed his appreciation of the symbolic rather than the naturalistic aspect of Turner's work. Not that the P.R.B. did not recognize his status: D.G.Rossetti for example, who in 1853 disappointed G.P.Boyce by not showing 'the highest possible admiration' for him (*The Old Water-Colour Society's Club Nineteenth Annual Volume*, 1941, p. 18, kindly communicated by Dr Alastair Grieve), nevertheless described his state of mind on the night in 1849 when he wrote the manifesto of the movement, *Hand and Soul*, as 'a sort of spiritual Turner, among whose hills one ranges and in whose waters one strikes out at unknown liberty' (*D.G. Rosetti. His Family Letters*, ed. W.M.Rossetti, I, 1895, p. 415). The frankly symbolic colour, and the hatched and caked handling of Rossetti's *Beata Beatrix* (Tate Gallery) of *c.* 1863, surely owes much to Turner. W.M.Rossetti seems, too, to have respected Turner's poetry (Thornbury, 1904, p. 265 n.). For J.E.Millais' coolness towards Turner in 1851, J.G.Millais, *op. cit.* I, pp. 118–19.

2 For Turner on Pyne, Thornbury, 1904, p. 309. For Pyne as theorist, Bewick to Davison, June 1851 in *Life & Letters of W.Bewick*, ed. Landseer, 1871, II, p. 154. Pyne's views on light and colour in landscape were published in 'Tint and Tone', *The Art Union*, 1844, pp. 95–6; 'Letters on Landscape' (1839–40), *ib.* 1846, esp. pp. 84, 127–8, 164, 243–4, 277.

3 W.M.Rossetti, *The Rossetti Papers*, 1903, pp. 233–4 (information kindly supplied by Dr Alastair Grieve); *cf.* also E.R.&J. Pennell, *The Life of James McNeill Whistler*, 1911, p. 336.

4 For Bonington and Turner, M.Cormack, 'The Bonington Exhibition', *Master Drawings*, III, 1965, p. 287.

5 Delacroix to Silvestre, 31 Dec. 1858. Turner and Constable 'are real reformers. They have come out of the rut of the old landscapists. Our school, which now has plenty of talented men in this genre, has profited by their example ...' (*Cit.* P.Signac, *De Delacroix au Neo-Impressionisme*, ed. Cachin, 1964, pp. 64–5). But in his *Journal* for 8 Feb. 1860, Delacroix wrote that Turner, with Lawrence and Reynolds, and 'in general all the great English artists are marred with exaggeration, especially in their effects, which prevents their being classed with the great masters.' Delacroix shared with Turner, for example, a concern for the overall colour-rough as a means to chromatic unity. In 1857 his friend and collaborator, Paul Huet wrote to Legrain: 'Je ne sais pas si je vous intéresserai en vous parlant des palettes de Delacroix, qui font grand bruit parmi quelques artistes. Delacroix a l'habitude de préparer de riches palettes suivant le tableau, le sujet qu'il traite: il fait des tons, les numérote et en conserve des échantillons sur du papier à peindre. C'est ainsi que l'on fait circuler la palette de *Trajan*, la palette du *Christ au jardin des oliviers*, etc. etc. Ces tons, suivant moi, sont pour ainsi dire, des tons primitifs, qui viennent augmenter les couleurs nombreuses dont ce peintre fait usage. Il cherche, en tons principaux, tous les tons les plus riches qui peuvent se soutenir et aussi faire opposition.' (R.P.Huet, *Paul Huet*, 1911, p. 229.)

6 T.Silvestre, 'Documents Nouveaux sur E.Delacroix' (1864) in *Les Artistes Francais*, I, 1926, pp. 46–7. *Cf.* Signac, *op. cit.* pp. 65–6.

7 T.Gautier, *Histoire du Romantisme*, 3rd. ed. 1877, p. 371. *Rain, Steam and Speed* seems to have been especially well-known in France. Felix Bracquemond, an engraver close to the Impressionists, cited it as 'a work without special affectation' in his *Du Dessin et de la Couleur* of 1885, p. 189. *Cf.* also notes 9 and 10 below.

8 'Notice sur J.M.W.Turner', *L'Artiste*, XII, 1836, pp. 136–7. Count Raczynski, whose history of modern German painting was published in France in 1841, and who had visited Turner's London gallery, was at pains to make the same claim (*Histoire de l'Art Moderne en Allemagne*, III, p. 507 n.).

9 J.Rewald, *The History of Impressionism*, 2nd ed., 1961, p. 258; Monet to R.Gimpel, 28 Nov. 1918, in R.Gimpel, *Diary of an Art Dealer*, 1966, p. 73. Similarly, about the time of the *Haystacks* series (1890–1), Monet 'spoke of Turner with admiration —the railway one—and many of the watercolour studies from nature'. (Theodore Robinson, *Diary*, 5 Sept. 1892, in *Apollo*, 78, 1963, p. 211, kindly supplied by Mr J.House). E.Chesneau, *The English School of Painting*, 2nd. ed. 1885, pp. 153–4, notes that an early Turner, *Kilgarren Castle*, and a late one, *A Guildhall Banquet*, were auctioned publicly in Paris in 1874.

10 C.Pissarro, *Letters to his Son Lucien*, ed. Rewald, 2nd. ed. n.d. pp. 22, 356. Lucien followed his father's advice and reported from London in June 1883: 'J'ai été voir les aquarelles de Turner, c'est extraordinaire; voila ce que je trouve habile et difficile, et non pas ces trucs des autres peintres anglais . . . Il n'y a pas beaucoup de dessins dans les musées, ceux de Turner sont très serrés, et certains ressemblent a des choses d'architecte. Mais il y a deux peintures extraordinaires. L'une représente un chemin-de-fer dans le brouillard, *Rain, Wind and Speed* [*sic*] et l'autre *L'Enterremant de l'Admiral Bing* [*sic*, i.e. *Peace—Buriel at Sea*]. Les peintures plus anciennes, à mon avis, ne sont pas comparables et semblent être faites par un autre peintre, tellement elles sont differentes . . .' (J.Rewald, 'Lucien Pissarro: Letters from London 1883–1891', *Burlington Magazine*, XCI, 1949, p. 189.)

11 Signac, *op. cit.* pp. 79–80.

12 O.N.Rood, *Modern Chromatics*, 1879, pp. 279, 315, 318. The French version (*Theorie Scientifique des Couleurs*, 1881) was quoted by Signac, *op. cit.* pp. 123–4, 131. Turner's technique had been related to 'nos pointillistes' as early as 1896 by Robert de la Sizeranne (*La Peinture Anglaise Contemporaine* (1896), 3rd ed., 1904, p. 7). For Turner as an 'Impressionist', see also Sizeranne's essay in *The Genius of Turner*, ed. Holme, 1903.

13 Matisse's attitude to Turner was, however, as ambiguous as Monet's. He went to London, he told Escholier, 'especially to see the Turners. I felt that Turner must be the transition between traditional painting and Impressionism. And I did indeed find a close relationship, due to form created by means of colour, between Turner's water-colours and Claude Monet's work' (R.Escholier, *Matisse from the Life*, 1960, p. 41). Elsewhere, however, he stated that he was not much impressed (A.H.Barr, Jun., *Matisse, His Art and His Public*, 1951, p. 37). Certainly the impact of Turner's colour structures, the complex texture of his paint surface and his late palette of oranges, pinks and greens, is appreciable in Matisse's work of 1899, for example the *Still-Life against the Light* (Paris, Private Coll. Arts Council, *Matisse*, 1968, No. 10, ill. in colour on p. 9 of the catalogue).

14 C.Pissarro, *op. cit.* p. 242. The same year a proposal to buy *Ancient Italy* (1838, Paris, Groult Coll.) for the Louvre failed, largely, it seems, through the opposition of the more conservative artists, rather than the critics, who were generally in favour. Alfred Stevens, the Belgian painter, for example, proclaimed that it was a work of Turner's decadence (*Magazine of Art*, XVII, 1894, pp. xxxvi, xliv).

15 E.&J.deGoncourt, *Journal*, 12 August 1891. Moreau's enthusiasm may have helped to fire his pupil, Matisse: see n. 13 above.

16 On Groult's collection and attitude, R.Gimpel, *op. cit.* pp. 26–7.

17 E.Chesneau, *The English School of Painting*, 2nd. ed. 1885, p. 151. For the projected biography of Turner, *ib.* pp. ix–x; Ruskin, *Works*, XIII, 1904, p. lvi. In an earlier appraisal, Chesneau had written, 'Turner n'a qu'une volonté, une rêve d'une audace prodigieuse: il veut fixer la lumière' (*L'Art et les Artistes*

Modernes en France et en Angleterre, 1864, p. 91).

18 J.Rewald, 'Extraits du Journal Inedit de Paul Signac', *Gazette des Beaux Arts*, 39, 1952, p. 279.

19 *ib.* 42, 1953, pp. 31–2.

20 *ib.* 39, 1952, pp. 279–80.

21 *ib.* 42, 1953, p. 32.

22 Reprinted in Signac, *op. cit.* p. 159.

23 *Cf.* the notes on the 1898 London sketchbook (Private Coll.) in *Exposition Signac*, Paris, Louvre, 1963/4, No. 131b.

24 *loc. cit.* pp. 156–7.

25 Rev.H.R.Haweis, *Music and Morals*, 1875, *cit.* A.B.Klein, *Coloured Light: An Art Medium*, 1937, p. 5.

26 A.W.Rimington, *A New Art: Colour Music*, 1895, reprinted in Klein, *op. cit.* pp. 260–1.

27 Klein, *op. cit.* pp. 25–6. These works were destroyed during the First World War.

28 *Cf.* e.g. L.Moholy-Nagy; '. . . abstract painting can be understood as an arrested, frozen phase of a kinetic light display leading back to the original emotional, sensuous meaning of colour of which William Turner, the great English painter, was an admirable predecessor' (*Vision in Motion* (1947), 1965, p. 150).

Notes to Appendices

1 Only the most important passages, relating to art as well as nature, have been collected here. Spelling and punctuation has generally been modified and the editing has been extensive.

2 Based on Reynolds, Note XL to Du Fresnoy.

3 Vandyke's *Countess of Southampton* (Melbourne), then in the collection of Lady Lucas, seems to be implied by the following description. It was exhibited at the British Institution in 1815, and may possibly have been lent earlier as well. The sketchbook certainly seems to belong to 1808.

4 Turner seems to be using 'reflected' and 'refracted' interchangeably in this passage.

5 Rembrandt's *Mill* is now in the National Gallery of Art, Washington; Correggio's *Nativity* (*Notte*) in Dresden.

6 Rembrandt's *Holy Family* (*Cradle*) is now in the Rijksmuseum, Amsterdam. When it was in the Payne Knight collection, in 1808, it was lent to the British Institution for copying; and Turner's *Unpaid Bill* was painted as a pendant. ('Turner and the Picturesque', *Burlington Magazine*, *cit.* pp. 76–9.)

7 M.Akenside, *op. cit.* III, 1744, 11, 348–55 is the basis of this passage.

8 Probably the picture by Guercino in the Louvre, copied and studied by Turner in 1802 (TB LXXII, pp. 53–4) and noted again in the last lecture of 1818.

9 This may refer to the large etching of the *Resurrection of Lazarus*.

10 RA 1773 (Knole, Lord Sackville).

11 Akenside, *op. cit.* ll. 404–7.

12 J.Thomson, *The Seasons, Summer*, ll. 81–5. Ziff, 'Poetry and Painting', *cit.* p. 200 associated the whole of the sentence preceding this quotation with the passage; but it seems to me to be continuing the contrast with Milton.

13 Ziff, *loc. cit.* p. 201 reads 'ballad' as 'simile'; but he has identified the reference justly with the close of the song: 'Tell me, where is fancy bred' in *The Merchant of Venice*, Act III, sc. ii. Turner is perhaps referring to the fact that 'kindling azure' is, as a colour, a beautiful contradiction which must yield to physical investigation.

14 Turner is here referring to a passage in Thomson, discussed earlier in the lecture.

15 *Paradise Lost*, Bk. IV, ll. 598–600.

16 M.Akenside, *op. cit.* I, 1744, l. 183; 1757, ll. 242–3.

17 In the notes to Goethe (pp. xliii, 229) Turner attributed this idea to Fuseli, although the closest approximation I have found to it in Fuseli's published works is a passage on the corruption of colour, derived from Reynolds, in Lecture IX (Knowles *op. cit.* II, p. 356). Fuseli may well have paraphrased on other occasions a saying derived from Annibale Carracci: 'Buon Disegno e colorito di fango' (Barry, *Works, cit.* I, p. 106). *Cf.* also U.Price, *Essays, cit.* I, pp. 199–200.

18 Reynolds, Notes XXXVII, XLIII to Du Fresnoy; *cf.* also Note VIII on theory and practice.

19 I have not found a statement by Titian to this effect. Pilkington (*Dictionary* 1805, p. 601) distinguished four stages in Titian's colouring; Fuseli (Lecture, XI, 1825) two.

20 Titian's *St Peter Martyr*, studied by Turner in the Louvre and later in Venice, but now destroyed. *Cf.* **61**.

21 Lomazzo, *op. cit.* p. 17.

22 In an undated, but presumably related note to Phillips, Turner asked for the loan of prints of the *St Peter Martyr* 'and its companion with the columns [?] in the background' (BM Add. MS 50119, f. 179) which may well refer to the *Pesaro Altarpiece*, in the Frari Church, Venice.

23 Reynolds, Note XXXIX to Du Fresnoy, where, however, Rubens is assessed at a quarter of light, and Correggio is not mentioned.

24 Rome, Palazzo Rospigliosi, **66**. Turner studied this ceiling in 1819 (TB CXCIII, p. 3).

25 The Domenichino version of Titian's *S.Peter Martyr* (Bologna, Pinacoteca) Turner may well have seen in the Louvre in 1802; it had been bought in Italy in 1801 and was restored there after Napoleon's fall (E.Borea, *Domenichino*, 1965, p. 156 and colour pl. XXIII). Sarto's fresco I have been unable to identify precisely, but it may have been the *Madonna del Sacco* in the SS. Annunziata in Florence.

26 Reynold's *Nativity* and a number of portraits were destroyed in this fire in October 1816.

27 This is possibly another reference to the Carracci remark quoted in n. 17 above.

28 Opie, *Lectures, cit.* pp. 115–18.

29 Opie stressed Raphael's mastery of expression, especially in the *Transfiguration* (*op. cit.* pp. 50–1); and discussed these combinations of powers approvingly on pp. 116–17. In MS J, f. 10v, however, Turner opposed Opie's opinion of the possible compatibility of these diverse elements.

30 Possibly a reference to Akenside, *op. cit.* 1765, II, ll. 132–8, which Turner had quoted in MSS K, f. 23; L, f. 17; M, f. 25v.

31 The reference, to Giulio Romano's *Hours leading on the Horses of the Sun* is taken from Opie, *op. cit.* p. 117.

32 Adapted from Du Fresnoy, *op. cit.* ll. 218–20.

33 Turner is probably referring to Rubens's opinion of the high difficulty and importance of backgrounds, in a story quoted by Reynolds, Note XLII to Du Fresnoy.

34 Du Fresnoy, *op. cit.* ll. 181–2; Reynolds, n. XXIV.

35 See n. 32 above.

36 Du Fresnoy, *op. cit.* l. 538.

37 G.Lairesse, *op. cit.* p. 156. Turner has misread Lairesse's 'Deity' as 'duty'.

38 The title given reads something like *Deception of the Hil . . .* but I am unable to identify either the picture or its author.

39 Correggio's *Agony in the Garden*, Apsley House, Wellington Collection; or possibly the former Angerstein copy (NG 76). *Cf.* J.Burnet, *Practical Hints on Light and Shade in Painting*, 1826, pp. 25–6, pl. V, fig. 3.

40 Akenside, *op. cit.* I, 1744, l. 183; 1757, ll. 242–3, 227–31.

41 Turner is surely referring to diagram 2 here, i.e. that showing the effect of *material* mixtures, and not, as the text has it, those by 'position' in the spectrum, which constitute white light.

42 Turner seems to be quoting R.Cumberland, *Anecdotes of Eminent Painters in Spain*, 1782, I, p. 18, which refers to the 'Clear and vivid sky' and the 'dry and healthy air' favourable to the development of a Spanish School. However (p. 20), Cumberland also asserted that there was no Spanish landscape painting.

43 Winckelmann, *Geschichte der Kunst des Altertums*, ch. i, sect. ii. §II; Montesquieu: *L'Esprit des Lois*, II, 14; XII, 14; XIX, 27. S.B. Dubos, *Reflexions Critiques sur la Poésie et*

sur la Peinture, 1770, II, pp. 160–1. Turner's immediate source is probably J.Barry, 'An Inquiry into the real and imaginary obstructions to the Aquisition of the arts in England', *Works*, *cit.* II, p. 177, with references to the views of Dubos, Montesquieu and Winckelmann together.

44 N.Poussin, *Pyramus and Thisbe* (Frankfurt, Städel), *cf.* Ziff, 'Turner and Poussin', *cit.* p. 315. G.Dughet: *Storm: The Union of Dido and Aeneas* (NG 95) lent to the BI in 1807 and 1816.

45 Possibly *Ascanius Shooting the Stag of Silvia* (Oxford), Röthlisberger 222; or more probably, *Coast of Libya, with Aeneas Hunting* (Brussels), Röthlisberger 180.

46 Possibly Röthlisberger 184: *The Cumaean Sibyl Conducting Aeneas to the Infernal Shades* (lost), Earlom, II, p. 5. Companion to R 180.

47 Probably *Coast View with Trojan Women Setting Fire to Their Fleet* (New York, Metropolitan Museum), Röthlisberger 71.

List of Illustrations

Acknowledgments

The majority of the illustrations were photographed specially for this book by Anthony Barthorpe. Plate 32 was photographed by Warren Jepson & Co, Leeds. Grateful thanks are due to the Arts Council (plate 20), the Courtauld Institute (plates 24, 47, 62) and the Mansell Collection (plates 48, 65), and to the Earl of Harewood for permission to photograph the Library at Harewood House (plate 32). Other sources are acknowledged in the captions to the illustrations.

Index

Index